Praise for

CITY AND CAMPUS:
An Architectural History of South Bend, Notre Dame, and Saint Mary's

"This book is born of a deep, lifelong, and lived experience of South Bend. John W. Stamper's passion for this place is reflected in this carefully written history, and Benjamin J. Young's additions and editing honor Professor Stamper's last work. An invaluable architectural history of South Bend, the University of Notre Dame, and St. Mary's College for residents, alumni, and historians alike."
—Margaret M. Grubiak, author of *White Elephants on Campus*

"I am thrilled to witness John W. Stamper's latest work that documents and offers critical insights into South Bend, Saint Mary's College, and University of Notre Dame's parallel histories. As a Notre Dame alumna and practicing architect deeply interested in the region's sense of place, I am thankful that—through Professor Stamper's sheer will, the dedication of Jennifer Parker, and the careful editing work of Benjamin J. Young—it is presented and illustrated so thoroughly, especially as these communities grow closer than ever."
—Melissa DelVecchio, partner at Robert A.M. Stern Architects

"A well-written history of the changing residential, business, and industrial architectural styles in the city of South Bend and the neighboring University of Notre Dame and Saint Mary's College. This interesting and informative work should be read with profit by students of architecture and the public alike."
—Thomas E. Blantz, C.S.C., author of *The University of Notre Dame: A History*

"*City and Campus* is a perfect and lasting legacy to the work and passion of John Stamper's life. His devotion to the study and preservation of South Bend's historic buildings is knit together with his long tenure with the University of Notre Dame School of Architecture as only a lifetime of connectedness to both could do. Thank you, John."
—Todd Zeiger, director, Northern Regional Office, Indiana Landmarks

"John W. Stamper has done a fantastic job knitting together the histories of two world-class institutions and the northern Indiana industrial city of South Bend. In an exciting way, he has brought together how the architecture of both campuses and the city evolved over the one hundred years the book covers. A great read!"
—Travis Childs, archivist and St. Joseph County historian, The History Museum

"*City and Campus* is an ambitious and engaging book. By deftly weaving together a diverse range of buildings and sites, architectural historian and educator John W. Stamper reveals his deep understanding about the diverse forces that shape our built environment over time."
—Michelangelo Sabatino, co-author of *Modern in the Middle*

CITY AND CAMPUS

City and Campus

AN ARCHITECTURAL HISTORY OF

SOUTH BEND, NOTRE DAME,

AND SAINT MARY'S

John W. Stamper

Edited by
Benjamin J. Young

Foreword by
Dennis Doordan

University of Notre Dame Press
Notre Dame, Indiana

Published by the University of Notre Dame Press
Notre Dame, Indiana 46556
undpress.nd.edu

Published in the United States of America

Library of Congress Control Number: 2023946562

ISBN: 978-0-268-20771-7 (Hardback)
ISBN: 978-0-268-20770-0 (WebPDF)
ISBN: 978-0-268-20773-1 (Epub3)

Contents

Foreword

Architects design buildings. This simple statement leads to a second, more profound one. The buildings they design do more than simply provide shelter; they create a sense of place and communal identity, and they shape the lives of people who inhabit them. More than an account of individual buildings, therefore, the history of architecture often serves as a history of communities—their aspirations, challenges, and achievements. This is clearly the case with *City and Campus*, an invaluable contribution to the broader history of South Bend, the University of Notre Dame, and Saint Mary's College. Each is treated as an individual community with its own origin story, cast of characters, and architectural achievements. Yet their individual stories are woven together in a way that describes a whole greater than the sum of its parts.

Through his account of architectural developments, John Stamper conveys a larger story: the ambitious rise of a Midwestern industrial city along with the growth of two important institutions of Catholic higher education. A good historical account collects and arranges the facts of the subject under investigation, the who, what, when, and where of events, and provides insights into the why that drives the story. Beyond the immediate narrative, a good historical account—to use an architectural metaphor—lays the foundation on which the next generation of scholars can build their accounts. This is exactly what Stamper has accomplished; he has provided a thorough account of the urban and architectural history of the greater South Bend area between 1830 and 1930 and the definitive starting point for future studies.

So, what are the elements of this foundational work? Throughout *City and Campus*, Stamper returns to four key themes.

- Architecture and urbanism are inextricably linked. A city is a collection of buildings; each building satisfies an immediate purpose and, at the same time, contributes to the larger urban realm. The contribution may be modest in scale or grand, but together they establish a distinctive identity for the community.
- The architectural design of a building is important because *how* something is what it is, its architectural style, is critical to understanding its significance. Stamper's deft descriptions of different architectural styles are the product of his background as an architect as well as a historian.
- Good architecture requires ambitious, committed patrons willing to invest in their communities as well as their businesses. Stamper is careful to introduce the members of the South Bend community responsible for commissioning significant works of architecture. They used their wealth to advance their business interests, enhance their social positions, and promote South Bend as an attractive city as well as an industrial powerhouse. Longtime residents will recognize the names Studebaker, Oliver, Birdsell, and Sorin. Newcomers to the area will learn much about its industrial and economic history as well as its architecture.
- Good patrons hire good architects who bring their professional knowledge of urban design, architectural styles, and construction technologies to bear on the design of new buildings that elevate public taste and enrich the public realm. In his attention to the educational background and previous accomplishments of such architects as Henry Ives Cobb, Frank Lloyd Wright, and Albert Kahn, Stamper strikes an insightful balance between local developments and cosmopolitan trends in art and design.

While good scholarship endures, sadly, good scholars do not; this work is being published posthumously. Like so many of the civic-minded people he describes, John Stamper cared deeply about the place where he grew up and where he spent so much of his adult life teaching at the University of Notre Dame. It is fitting that his final contribution to the history of American architecture is a meticulous and revealing history of the place he called home.

—DENNIS DOORDAN

Editor's Note

John Stamper's *City and Campus* has a long history of its own, one that far predates my involvement as its editor. John had first undertaken to write an architectural history of the South Bend area with James Mullins in the mid-1980s, shortly after John had graduated with his Ph.D. from Northwestern University and had joined the faculty of the School of Architecture at the University of Notre Dame. For various reasons, that project never came to fruition at the time, but John maintained an abiding interest in the architecture of his hometown and university throughout his academic career, an interest heightened by his involvement in various planning and preservation boards in the South Bend area. After his publication of *The Architecture of Roman Temples: The Republic to the Middle Empire* in 2005, he returned to his South Bend project. Through the late 2000s and 2010s, he researched, wrote, and rewrote the manuscript, and, in April 2021, he pitched it to the University of Notre Dame Press. The manuscript underwent peer review over the summer of 2021, and after John received the peer reviewers' list of suggested revisions that September, he spent the next three months reworking the manuscript for resubmission to the press. By December 26, 2021—the last day, according to the timestamps on his digital files, that he worked on the project—he had made significant revisions to thirteen of the manuscript's sixteen chapters. John tragically passed away of cancer ten days later, on January 5, 2022.

After John's passing, various faculty of the Notre Dame School of Architecture committed to the task of bringing his final project to print. In May 2022, Jennifer Parker, head of the Notre Dame Architectural Library and codirector of the Historic Urban Environments Lab, invited me to take the lead

in completing John's task of revising the manuscript for resubmission to the press. The task involved combing through John's digital files and physical collections, overlaying and synthesizing his chapter drafts into a single manuscript, and gathering additional images for the project. Throughout the editorial process, I was committed to preserving John's voice, argument, and narrative as much as possible. Thus, I restricted the vast majority of my edits to matters of formatting and sentence structure, as well as to fleshing out footnotes with additional primary sources and secondary scholarship. Because John had worked so diligently in the three months after peer review to revise his manuscript, he left to me only a few additions that he had hoped to tackle but had not yet completed. Thus, while my editorial hand surfaces here and there throughout *City and Campus,* it is first, foremost, and finally John's book, the product of a long scholarly career in the field of architectural history and a lifetime of experience living and working in the city and campus he earnestly loved so much.

I wish to thank the Stamper family and the faculty of the School of Architecture at the University of Notre Dame—especially Jennifer Parker—for entrusting me with the responsibility of helping bring John's final project to print. John's wife of thirty-five years, Erika Pistorius Stamper, generously shared John's extensive research files and image collection with me, and provided helpful insight into John's heart and thought behind this project. Dennis Doordan oversaw my revisions and edits and was quick to contribute not only a foreword, but also the wealth of knowledge gained from his career in architectural history, his upbringing in South Bend, and his long friendship with John. I thank him for reviewing the manuscript, providing the foreword, and offering sage advice and suggestions. The School of Architecture graciously provided a subvention to cover the costs of indexing this book. Morgan Wilson at the Notre Dame Architecture Library provided moral support, as did Darren Dochuk, my doctoral adviser in the Department of History. Elizabeth Hogan at the University of Notre Dame Archives, Ellen Anderson at the St. Joseph County Public Library, Kristen Madden at The History Museum in South Bend, Scott Shoger at the Indiana University South Bend Archives, and Eric Walerko at the Cushwa-Leighton Library at Saint Mary's College all helped with securing permissions and high-quality scans for the images included in this book. Mark Schurr read and offered suggestions on John's first two chapters. Thomas Blantz did the same with the entire manuscript in the closing stages of editing. Marianne Cusato kindly made time to offer her expertise on

South Bend's history of urban renewal and to suggest research leads, and Simon Roennecke graciously shared files from his time as John's research assistant. At the copyediting stage, Kellie M. Hultgren truly worked wonders. She, alongside an all-star team at Notre Dame Press that included Megan Levine, Katie Campbell, Wendy McMillen, Stephanie Marchman, Matthew Dowd, and Stephen Wrinn, worked strenuously to bring *City and Campus* to print. Their tireless belief in and commitment to this project brought it to fruition.

—BENJAMIN J. YOUNG

Acknowledgments

The author wishes to acknowledge the generous assistance of numerous individuals who helped make this book possible. There have been several comprehensive surveys of South Bend carried out since the 1970s, made possible by grants from the Indiana Department of Natural Resources, Division of Historic Preservation and Archaeology, matched by funds from the city of South Bend and the Board of Commissioners of St. Joseph County. These surveys were conducted by the staff of the South Bend and St. Joseph County Historic Preservation Commission along with the architects Brian Crumlish, Donald Sporleder, and Joann Sporleder, and numerous assistants, students, and interns. A later and more comprehensive survey was carried out in the 1990s by Indiana Landmarks (formerly the Historic Landmarks Foundation of Indiana).

The majority of the research was carried out in the St. Joseph County Public Library Local History Collection and the Library of the School of Architecture at the University of Notre Dame. Research on property ownership records was made possible by the St. Joseph County Auditor's Office, and research on deed records by the South Bend Title Company was provided by Michael Lutes.

An important source of illustrations was the photographic archives at the Center for History. Especially helpful there was former curator David Bainbridge. Historian Bells Pendleton and Michael Lutes assisted in research early in the project. Simon Roennecke assisted with the illustrations. Thanks go also to Todd Zeiger, regional director of Indiana Landmarks. For assistance with typing the original manuscript, the author thanks Therryn Rassi. Thanks go

also to James Mullins for suggesting the need for this book, and to my wife, Erika Pistorius Stamper, and daughter, Alessandra Stamper, for their unstinting support throughout the entire process.

<div align="right">

—JOHN W. STAMPER
October 2021

</div>

Preface

A study of the architecture of a city and a campus requires a twofold analysis of both individual buildings and their overall urban character. The accumulation of architecture over time takes on a form and content that are together more important than any single building or space. The architecture of a city or campus includes a diverse mixture of civic, academic, and religious buildings; commercial, office, and residential structures; and the streets, parks, squares, and quads that connect them. The broad spectrum of architectural styles and building types that collectively make up the city and campus are but one piece of their overall conceptual image. The memory of a city or campus we take with us is that of an individual building or public space, but always within the context of the image of the city and campus as a whole.[1]

The historical understanding we have of a city or campus is somewhat more complicated, for it involves analyzing its architecture, urbanism, and landscaped settings in terms of the social and economic factors that made its development possible. For this we have to look at the individuals involved in creating businesses, industries, and religious and educational institutions, as well as the economic factors—financing, gifts, natural resources, transportation, and marketing practices—that made possible their industrial production, commercial growth, and institutional development.

The subject of this book is the historic architecture and urban development of South Bend, Notre Dame University, and Saint Mary's College from their earliest settlement in the 1830s and 1840s to the end of the 1920s. It traces the appearance of various architectural styles and building types, analyzing them within their historical and social contexts and linking them to the development

of particular neighborhoods, commercial and civic areas, and campus settings. This study of the development of South Bend's downtown commercial and civic core in relation to the settlement and expansion of its surrounding neighborhoods and the evolving character of the nearby campuses of Notre Dame University and Saint Mary's College is meant to paint a portrait of the city's architectural and urban character in the nineteenth and early twentieth centuries. The architecture of South Bend and its educational campuses represents a rich tradition of diverse influences, initially from Europe and the eastern United States, and later from the more immediate surroundings of the Midwest, especially Chicago. There are buildings by major architects with national reputations, but the city and its colleges have also fostered a milieu of their own, the constant interchange of ideas creating a unique blend of the local and the cosmopolitan.

South Bend is typical of Midwestern cities in that it developed rapidly in the nineteenth century as an industrial center, taking advantage of water power and river transportation provided by the St. Joseph River and its connection to Lake Michigan. Throughout the second half of the century the city's industries produced Conestoga wagons, horse-drawn carriages, plows, reapers, and sewing-machine cabinets. This further expanded in the early twentieth century with the development of automobiles, tractors, and airplane components, which could now be transported across the country by the rapidly expanding railroads. Generating great wealth for the city, this manufacturing activity enabled many of its residents and government leaders to avail themselves of the latest trends in architecture and, in some cases, the services of well-known architects such as Henry Ives Cobb, Solon Beman, Frank Lloyd Wright, and the firms Lamb and Rich from New York and Shepley, Rutan and Coolidge of Boston. Key to understanding South Bend's architecture and urban development is an analysis of the clients of these architects and builders, those who owned and developed the city's buildings, urban spaces, industrial complexes, and residences. An important theme that recurs throughout this book is the architectural patronage of the officers of the Studebaker Manufacturing Company and the Oliver Chilled Plow Company. These leading industrialists contributed in countless ways to the character and quality of South Bend's architecture and urban development. Their companies were the city's largest employers, they attracted the most people to the region to staff their burgeoning factories, and they generated its most significant cultural legacy in the arts, architecture, music, opera, and theater. This context is not simply a backdrop

but rather an integral part of a complete story. Specific connections are drawn between these individuals' social and economic backgrounds and the development of the city's architecture and urban character.

For the college campuses—Notre Dame and Saint Mary's—the focus is on Notre Dame's founder and longtime president, Father Edward Sorin, C.S.C., and the architects, both those on the Notre Dame staff and those commissioned from the professional ranks. Among the former was Brother Charles Borromeo Harding; among the latter were William Tutin Thomas, Willoughby J. Edbrooke, and Thomas Brady, none of whom are necessarily household names, but who successfully trod between architectural high styles, functional necessities, and the economic constraints of a fledgling university and college.

This book is organized according to distinct architectural periods. Chapters discuss the Pioneer Period of the early 1800s; the picturesque styles of the Civil War era; the Victorian styles of the late nineteenth-century industrial period; the turn-of-the-century shift from Neoclassicism to the Prairie School; and the broadening of architectural trends with the advent of the many Period Revival styles which appeared in the 1910s and 1920s in the city, in contrast to the embrace of the Collegiate Gothic style at Notre Dame and Saint Mary's.

Throughout the book the focus is on the architecture and urban development of the city and its college campuses, describing the range of their styles, construction techniques, functions, and symbolic roles. Each style or period of architecture represented in South Bend and its colleges is placed within the larger context of the architecture of Indiana and the Midwestern states. The sources of this architecture are analyzed, as are the many transformations in its character and the many architects and builders who participated in its creation.

Great historical cities of the United States and Europe typically project a strong urban image. That is, they possess a forceful identity, usually by the choreography of a positive urban experience. As architectural historian Diane Favro writes, only by looking at a city in a holistic manner can we understand why builders, patrons, and institutions constructed buildings when and where they did and why they chose certain building types, materials, and styles.[2] In the case of South Bend, the conceptual content interwoven within its urban fabric from 1830 to 1930 is one of rapidly growing industrialization and commercial development. In the case of Notre Dame and Saint Mary's, the underlying theme about place was defined by the sacred—the search for an architecture that represented truth and knowledge within the Catholic tradition.

A question facing any historian analyzing South Bend's architecture and urban development is whether South Bend can be considered a college town, or, more specifically, whether it was a college town during the course of the nineteenth century. The campus is about two and a half miles from downtown South Bend. A trolley line, running from South Bend to Niles, Michigan, ran through the grounds, but visits to either city were discouraged by the university's administration because of the desire to "guard against loss of time and possible exposure to temptations."[3] There were no nearby off-campus shops, restaurants, or bars for the students to go to; there was no integration of campus and commercial amenities.

One conclusion of this study suggests that there had long been two distinct paths followed in local architectural endeavors. On the one hand, South Bend's architecture was the product of large-scale industrialization that contributed to its commercial and residential development. On the other hand, Notre Dame and Saint Mary's developed as isolated, near-monastic institutions located adjacent to the city, yet outside of it and largely distinct from its social and economic context.

Notre Dame and Saint Mary's developed their own unique architecture and planning traditions, ones that can be situated within the architectural and planning traditions of nineteenth-century college and university campuses across the United States. However, parallels can be drawn between the architecture of Notre Dame and Saint Mary's and that of the city—some similar features found in buildings during the periods of the Federal style, the Gothic Revival, and the Second Empire style. It is interesting, for instance, to see ways in which the two worked together, as when Father Sorin aided in the establishment and design of parish churches throughout the city. Many of the masons and carpenters who built South Bend's residential and commercial districts were the same ones who built the educational buildings on the Notre Dame and Saint Mary's campuses. This study examines such parallels where they are readily evident, yet, at the same time, it acknowledges that the architecture and urban development of South Bend have been largely distinct from that at Notre Dame and Saint Mary's, not so much as a campus town but as a fully independent urban entity.

While both South Bend and its educational institutions continued to flourish after World War I, arguably more so during the expansion of the 1920s, the two continued to diverge in interesting ways, not just in terms of architecture, but socially and economically as well. While commercial, industrial,

and residential architecture began to deviate radically in style from industrial modern to the ubiquitous Period Revivals, architecture on the Notre Dame and St. Mary's campuses embraced the newest trend in campus architecture: the Collegiate Gothic.

Much has changed since the nineteenth century regarding the relationship of the city and its campuses. No longer are they as isolated from each other, given the recent development of Eddy Street Commons and the transformation of the Notre Dame Avenue corridor. These developments have drawn South Bend and Notre Dame into a closer spatial relationship, giving South Bend more of an identity as a college town than its traditional image of a city based on heavy industry.

More broadly, these developments go a long way toward solving some of the numerous and complex problems facing South Bend in the twenty-first century. The city's obvious urban decline in the second half of the twentieth century was a result of the closing of the Studebaker Manufacturing Company in the 1960s and the Oliver Equipment Company twenty years later. It was exacerbated by the advent of urban renewal efforts that began in the 1960s in which a long list of well-meaning city leaders—politicians, planners, bankers, developers, and property owners—initiated programs of renewal, beautification, and economic development. Unfortunately, massive government programs stimulated wholesale demolition, imposed unnecessary street and highway projects, and forced businesses to close. Ultimately, the city was worse off than when it started, its urban character as a thriving industrial city with a coherent downtown becoming a thing of the past.

The situation for South Bend today has the potential for change. New life is coming back to the city. Businesses, restaurants, offices, and most importantly, housing, are returning to the downtown even in the face of difficult economic times. Notre Dame University and Memorial Hospital, the city's two largest employers, are taking a greater interest in the city's social and economic development and its urban image. More coordinated planning is being done, new zoning ordinances have been recently adopted, and the city is encouraging and initiating streetscape improvements, waterfront development, and facade renovations. Significant also is the fact that residents are beginning to focus once again on the links between their neighborhoods and downtown. People who fled to the suburbs are beginning to recognize the advantages of living in the city, and longtime residents are taking more pride in being city dwellers.

South Bend thus has an opportunity to change the course of its urban development and architectural character, to recapture the sense of vitality and progressiveness that it had in the first one hundred years of its development. It has the opportunity to plan for its rebirth. An examination of the history of the architecture of South Bend, Notre Dame, and Saint Mary's reveals much about the character of the place and its people. It can help define its urban development as it nears its two hundredth birthday, and it can help prepare the way for a new definition and a new identity to guide its next one hundred years.

Introduction

Founded in the early nineteenth century by a group of fur traders and land speculators, the city of South Bend prospered through much of its history as a vital commercial and industrial center, producing wagons, automobiles, farm implements, aviation products, appliances, and wood cabinetry. It was a thriving and growing city that distinguished itself for its tree-lined streets and boulevards, picturesque neighborhoods for both the working class and the wealthy, and dignified civic buildings, schools, and churches. It supported two universities and colleges and became famous as the home of Notre Dame's Fighting Irish football team.

A number of individuals in the early history of South Bend created successful businesses at a time when the region was developing its agricultural and industrial base. They faced adverse weather and difficult social and economic conditions, but they managed to contribute in important ways to the development of the city's physical character, including the layout of its streets and the construction of its early buildings, bridges, highways, and railroad lines. It is to these industrial barons that we, of later generations, owe a great debt of gratitude for giving form to this distinctive Midwestern city with a rich architectural heritage.

Most of what we know about the early history of South Bend, Notre Dame, and Saint Mary's can be gleaned primarily from a series of books published between 1875 and 1922, some of them compendiums produced by the local historical society, the *South Bend Tribune*, and Chicago-based publishers, and others written as promotional literature aimed at enticing businesses to move

to the city. Complementing these books are extensive newspaper clipping files found in the Local History Collection of the St. Joseph County Public Library. Few, if any, serious studies have been written about South Bend's historic architecture within its social and economic context.

The earliest of the biographical books is *An Illustrated Historical Atlas of St. Joseph County, Indiana*, published in Chicago in 1875 by Higgins, Belden and Company. Typical of the atlases produced for virtually every county in Indiana and the Midwest, it provides a history of the city, Notre Dame, and Saint Mary's, and includes exposés on many of the city and county's leading citizens. Published in a large format, it is profusely illustrated with multicolored maps and line engravings of significant buildings in South Bend and on the Notre Dame and Saint Mary's campuses.

The second of these, *History of St. Joseph County, Indiana*, published by Charles C. Chapman and Company in 1880, provides a record of South Bend's first fifty years, a period of "Trials, sufferings, and struggles which were experienced in converting even this fertile land from its virgin wilderness into the luxuriant and densely populated country now existing."[1] The effort here was to make the history of South Bend and St. Joseph County "as full and accurate as any history ever published." It includes short biographies of "prominent men of the day, as well as the pioneers."[2]

The year 1901 saw the publication of *South Bend and the Men Who Have Made It: Historical, Descriptive, Biographical*, written by two men known only as Anderson and Cooley and published by the *South Bend Tribune*. They have nothing but lavish praise for everything and everybody, almost to the point of hyperbole. They state that it is impossible to tell what South Bend's future will bring, "but from the record of its glorious past and the living evidences of its present greatness among the cities of the west, the future years will but add lustre to her fame and coming historians will chronicle her grand achievements along the lines of increased prosperity and expanding magnitude."[3]

The next, *A History of St. Joseph County, Indiana*, published in 1907, marked more than three-quarters of a century since the county's first permanent settlement by Europeans. Its author, Timothy E. Howard (1837–1916), was one of South Bend's most dedicated public servants, beginning in 1878 as a city councilman and rising to clerk of the St. Joseph circuit court, then state senator, and, finally, becoming an associate justice of the Indiana Supreme Court. A graduate of Notre Dame, he taught there through much of his career, and he served for many years as president of the Northern Indiana Historical

Society.[4] He wrote that it was high time to put into permanent form the wealth of new and old material on the county's history compiled over the years by "students of antique historical lore" for the society.[5] This book not only provides a comprehensive historical account of South Bend's development and the principal figures who made it possible, but, more than any other, it includes in-depth architectural discussions of South Bend's civic buildings, particularly its three county courthouses, many of the city's churches, schools, and parks, and the nineteenth-century buildings on the Notre Dame and Saint Mary's campuses.

An important source of early photogravure illustrations of both the city and its colleges is *Art Work of South Bend and Vicinity*, published in 1894. Its accompanying historical text provides an overly optimistic view of the city, suggesting that it has a "cheery appearance everywhere" and that it is "truly a beautiful park in the summer time, charming to look upon and delightful as a place of permanent abode."[6]

Among these promotional pieces, all of which were based on extravagant exaggeration, is *Pictorial Souvenir of South Bend, Indiana*, published by J. J. McVicker of Chicago in 1919. McVicker intended it to be a complete portrayal of South Bend and also a work of art in itself, on account of its extensive portfolio of photographs. Calling it a civic publication, McVicker intended it to serve as a stimulus "to commerce and showing prospective investors and capitalists a true view of South Bend as an unsurpassed city in which to locate their businesses and build their homes."[7] The publication was supported financially by select businessmen of the city who contributed liberally of their time, energy, and money.

Finally, *South Bend World Famed 1922*, also lavishly illustrated, was published and dedicated to "a Greater South Bend" by Handelsman and Young, a marketing agency whose office was located in the Oliver Hotel Annex Building. The editor, C. E. Young, wrote an overambitious introduction in which he invited people to come to the city to celebrate its centennial: "The people of South Bend extend their greetings to every person everywhere and invite you to visit this city during 1923 which is to be a notable year in the middle west. It marks the One Hundredth Anniversary of Indiana's Greatest Manufacturing City— one of the oldest in the state. South Bend is One Hundred Years old and is preparing to celebrate the centennial of its founding."[8] The only problem with this generous invitation is that it was seven years too early, considering that South Bend was only platted in 1830.

Despite the exaggerations, inflated success stories, and overconfidence evident in most of these publications, much can be gleaned from them concerning the lives of individual businessmen, industrialists, and institutional leaders. The hubris can be countered by a careful study of archival information in the public library's clipping files and a careful analysis of the physical evidence itself: the city's buildings and urban fabric.

Added to these sources are the extensive archival documents available in Notre Dame's Hesburgh Library, as well as Father Edward Sorin's *The Chronicles of Notre Dame du Lac* (1992) and Marvin R. O'Connell's *Edward Sorin* (2001). Arthur J. Hope's *Notre Dame: One Hundred Years* (1942, 1948), published on the occasion of the university's one hundredth birthday, provides a wealth of anecdotes, analysis, and criticism, much of it related to architecture. Finally, Thomas E. Blantz has offered a definitive institutional history of the university in his *The University of Notre Dame: A History* (2020). Informative books about the Studebaker Corporation include William Cannon and Fred Fox, *Studebaker: The Complete Story* (1981) and Donald T. Critchlow, *Studebaker: The Life and Death of an American Corporation* (1996).

Interest in the historic architecture of South Bend has been fostered more recently by field surveys and publications carried out in the 1970s and 1980s by the Historic Preservation Commission of South Bend and St. Joseph County and, in the 1990s, by the Historic Landmarks Foundation of Indiana (now Indiana Landmarks). They have succeeded in studying and documenting the city's most important landmarks and historic districts, thus facilitating landmark designations and zoning for historic districts. Planning and design studies by generations of architecture students at the University of Notre Dame, working under the direction of such faculty members as Michael Lykoudis, Norman Crowe, Krupali Uplekar Krusche, and Jennifer Parker, have stimulated renewed interest in design quality and planning and development links between the city and campus. Since 2000, an emerging body of literature has also explored the place of African Americans in the development of South Bend's built environment and social life, including Lisa Swedarsky, *A Place with Purpose: Hering House, 1925–1963* (2009), Katherine O'Dell, *Our Day: Race Relations and Public Accommodations in South Bend, Indiana* (2010), and Gabrielle Robinson, *Better Homes of South Bend: An American Story of Courage* (2015).

As for the planning and architecture of Notre Dame, three published books have dealt with the subject. Only one of those included even a smatter-

ing of information about the architecture of the Saint Mary's campus. The first architectural history written about Notre Dame's campus was Francis Kervick's *Architecture at Notre Dame*, published in 1938, a book with fine photographs but little analysis. The next was Thomas Schlereth's *The University of Notre Dame: A Portrait of Its History and Campus* (1976), which provides a detailed narrative history of the university and its campus development from 1842 to 1976. Through extensive use of historic photographs from the university's archives, Schlereth attempted to help readers recreate and understand the Notre Dame campus as it had appeared to successive generations of students, faculty, and staff. He structured the book in such a way that readers were encouraged to take prescribed walks around the campus to follow its chronological development. He further used his tracing of the evolution of building styles to deduce information about the cultural temper and aspirations of the community, which ranged at times, according to Schlereth, from high academic achievement to ambition and its opposite, ambivalence.[9] This is the only book on architectural history that deals in a minimal way with Saint Mary's College, especially on the role of Father Edward Sorin in its development. Finally, a book by Damaine Vonada, *Notre Dame: The Official Campus Guide* (1998), provides an accurate and thorough history of most of the campus buildings.

Although South Bend is located in a part of the country that has long been dominated by much larger cities, such as Chicago, Detroit, and Indianapolis, it nevertheless evolved in the nineteenth century as both an industrial and cultural city with a rich heritage in its own right of notable personalities and accomplishments. Its northern Indiana site, about 90 miles east of Chicago and 120 miles north of Indianapolis, allowed it to prosper, in large measure because of its proximity to the principal transportation routes connecting Chicago and the East Coast.

This study of South Bend's architecture and urban image is a study of its past that is intended to illuminate its present condition. The intention is to trace the history of the city's architecture and urban development from the time of its settlement in the 1830s through its industrial expansion in the late nineteenth and early twentieth centuries, ending with the Great Depression of the 1930s and its aftermath.

The book's first chapter begins with a description of the history of the region before the founding of South Bend, the presence of indigenous peoples in the area, the influence of early French settlers and missionaries, the important economic role of fur trading, and changes that occurred after the French and

Indian War. The period from the last decade of the eighteenth century until the 1830s and 1840s was marked by the emigration of French, English, and American fur traders and settlers, who converged at the southward bend in the St. Joseph River. Here they saw an opportunity to take advantage of the transportation and power that the river offered, in addition to the potential for exploiting the abundant natural resources of the surrounding area while developing it for agricultural production. The chapter then describes the platting of the town and its settlement in the period from the 1830s to the 1850s. The architecture of this period was characterized by a modest vernacular style, log and wood-framed structures plus an occasional brick building, all built entirely of local materials. Chapter 2 discusses the founding of Notre Dame and the construction of its first buildings, its original log chapel, Old College, and the first Main Building. Saint Mary's College followed close behind, although it was initially established in the state of Michigan and then moved to its present site overlooking the St. Joseph River.

The third chapter discusses examples of Federal-style and Greek Revival buildings and houses in downtown South Bend. These structures were the first to represent building traditions brought from the East Coast, traditions disseminated primarily by pattern books and builders' handbooks. Most prominent from this period was the second St. Joseph County Courthouse, designed by a prominent Chicago architect and still in use by the county today.

Chapter 4 explores the residential neighborhoods that grew up around the downtown commercial core. Houses, schools, and churches in the Gothic Revival, Italianate, and Second Empire styles are discussed along with the sources builders used to compose their stylistic details. In most cases, the houses shown are still standing and identified by their current addresses. Since this book is focused on South Bend's history, the original owners of the houses are always named.

Chapter 5, on the subject of the city's industrial giants and their role in South Bend's development, analyzes the two dominant factors in the city's growth throughout the nineteenth century and into the twentieth: the Studebaker Manufacturing Company and the Oliver Chilled Plow Works. These huge companies, which started from humble beginnings in the 1850s, burgeoned into the region's major employers, with tens of thousands of employees manufacturing products to be shipped around the world. The architecture of these industrial giants came in two forms. First were the expansive industrial complexes on the city's south and west sides, which took advantage of an ex-

tensive network of rail lines and highways. Second was the enhancement of the city's civic and religious architecture through corporate funding of numerous churches, an opera house, library, city hall, and other buildings commissioned to help make South Bend a more cosmopolitan place for companies and their workers. The wealth that these companies brought to the community helped build the city's downtown into a thriving commercial core and made possible its most significant residential architecture. Here we first encounter the work of the prolific Chicago architect Solon A. Beman, who initially gained prominence as the designer of Pullman, Illinois, and then designed a number of remarkable religious, institutional, and office buildings in South Bend, most of them through the patronage of the Studebaker family.

Chapter 6 begins with a very distinct period of French influence, both Canadian and Parisian. The former is evident in the construction on the Saint Mary's campus of the Academy Building, designed by an architect from Montreal; the latter is evident in the expansion and transformation of Notre Dame's first Main Building into a monumental Second Empire structure that included the addition of a mansard roof and dome. These developments had an influence in the city, too, as a number of houses were built in the Second Empire style, as was South Bend's first high school, Central High School. The chapter continues with a discussion of the design and construction of Sacred Heart Basilica and the influence it had on churches in South Bend that were built in the Gothic Revival style.

Chapter 7 discusses one of the most important decades in Notre Dame's history, the 1880s, which witnessed the construction of the third Main Building—the Golden Dome—and the Latin Quad, the defining heart of the campus. It also looks at Saint Mary's, which experienced a boom in construction beginning with a master plan in 1875 and followed by the construction of four major buildings, including the Church of the Loretto and the historic Tower Building.

Chapter 8 analyzes domestic architecture in the city during the late nineteenth century, looking at examples of Stick, Queen Anne, Neo-Jacobean, Shingle, and vernacular style houses in the city's West Washington, Near East, Park Avenue, and Near Northwest neighborhoods.

The magnificent mansions discussed in chapter 9 are those of the city's two principal industrialists of the 1880s and 1890s, Clement Studebaker and J. D. Oliver, designed by two of the era's most important architects, Henry Ives Cobb of Chicago and the firm of Hugh Lamb and Charles A. Rich of New York.

Tippecanoe Place and Copshaholm are two of the city's largest and most significant architectural landmarks and represent examples of the Richardsonian Romanesque and Queen Anne styles that command not just regional but national importance. The stylistic influence of these two mansions is seen in countless houses, schools, and churches across the city. This chapter also analyzes the residences of other members of the Studebaker family and other prominent families, including the Kizers, Coquillards, and Birdsells.

Chapter 10 analyzes religious and civic buildings from 1890 to early 1900 that demonstrate the influence of the Richardsonian Romanesque style and of the Gothic Revival and Neo-Jacobean styles that emerged soon after. This chapter includes churches, schools, the public library, post offices, and fire stations, and the turn-of-the century buildings on the campuses of Notre Dame and Saint Mary's. It represents a period of transition between the Victorian era of the second half of the century and the trend toward the Neoclassical style evident after the 1893 Columbian Exposition in Chicago.

Chapter 11 addresses Neoclassical and Beaux-Arts architecture and the civic ideal in both public and private architecture during the period from 1890 to 1930. It looks at the city's major public buildings from the period, those influenced by the 1893 Columbian Exposition. The third county courthouse and the former Oliver Hotel in downtown South Bend have strong ties to contemporary Beaux-Arts buildings in Chicago such as the Art Institute and the former public library, all designed by the noted firm of Shepley, Rutan and Coolidge. Included also is a group of stately Neoclassical houses that were built along North Shore Boulevard in the first decade of the twentieth century.

Chapter 12 looks at the planning effects of the Columbian Exposition, namely the City Beautiful movement, which defined urban planning and development across the country in the early decades of the twentieth century. In South Bend it exerted a strong influence on the planning and design of parks and bridges, civic buildings, and club buildings. The movement culminated there with the Kessler Plan, a master plan for the city's parks and boulevards that was commissioned by the city council, which led to the creation of much of the city's riverfront boulevard and park systems. This chapter also analyzes office and institutional buildings constructed by the second generation of Studebaker and Oliver officials, all significant buildings designed by Beman. Also discussed is the single most significant Neoclassical building on the Notre Dame campus: Lemonnier Library.

Chapter 13 addresses one of the most innovative and prolific periods in South Bend's residential architecture, which involved three seminal movements: the Neoclassical style and its opposites, the Prairie School and the Arts and Crafts Movement. A talented group of South Bend architects, all of whom began their careers around the turn of the century, became caught up in the highly influential movement created by Louis Sullivan and Frank Lloyd Wright in Chicago and Oak Park. South Bend is fortunate to possess two houses designed by Wright himself, one from 1906, at the height of his Prairie School phase, and the other from 1948, corresponding to his later Usonian phase. The influence of the Prairie School is found throughout South Bend's residential neighborhoods, making a significant contribution to the regional Midwestern character of the city's architectural heritage. Equally important was the influence of the Arts and Crafts Movement, or Craftsman style, and its leader, Gustav Stickley, which is manifested in the Bungalow-style houses built by the hundreds in middle-class neighborhoods across the city.

Chapter 14 reviews briefly the changes in direction that occurred in South Bend during the 1920s, the period leading up to the Great Depression. It analyzes the banks, office buildings, hotels, theaters, and movie palaces that make up the core of South Bend's commercial downtown. This work was highly influenced by developments in Chicago and the work of prominent Chicago architects such as William Le Baron Jenney, Daniel Burnham, John Wellborn Root, and Louis Sullivan. This influence was manifested not just in Neoclassical and Neo-Renaissance styles, but in a whole array of styles that became popular around the country in this time of eclecticism. Significant office and industrial buildings were constructed by the Studebaker and Oliver companies, for instance, one by Albert Kahn, the foremost designer of industrial buildings in the early twentieth century. Kahn was most notable for employing the use of large plate-glass windows and rooftop light monitors in industrial architecture, which improved working conditions and productivity, while introducing streamlined architectural details in step with the Art Deco movement. A parallel eclectic development in residential architecture manifested in the Period Revival styles in the city's white-collar, upper-class neighborhoods, such as the East Jefferson Boulevard and the Twyckenham Park neighborhoods, composed mainly of the growing managerial class of the Studebaker and Oliver companies. They demanded elegant neighborhoods with substantially larger houses and wider streets than their predecessors. The styles seen from this

period include English Cottage, Tudor Revival, Georgian, Colonial Revival, Italian Palazzo, and Châteauesque. There are, in fact, so many examples of these, representing the city's explosive growth in the 1920s, that they require an altogether separate study.

Educational and religious architecture from the 1910s and 1920s generally reflected trends that developed in commercial and residential architecture at the same time. Classical, Gothic, and Georgian Revivals were all evident, and much of the institutional architecture and landscape design continued to be influenced by the City Beautiful movement. The Neoclassical style predominated after the turn of the century, both downtown and briefly at Notre Dame and Saint Mary's. After World War I, however, both educational institutions turned to the Collegiate Gothic style for their classroom and dormitory buildings, which is the subject of chapter 15. At Notre Dame this included the Lyons-Morrissey complex, Alumni and Dillon Halls, the Rockne Memorial, the Engineering Building, and the famous South Dining Hall by Ralph Adams Cram; at Saint Mary's College this is especially evident in its largest classroom, office, and dormitory building, Le Mans Hall.

Arguably the most important event of the first half of the twentieth century was the economic crash of 1929 and the Great Depression that followed in the 1930s. The decimation of the country's economy deeply affected South Bend. Many of its industrial concerns went bankrupt, as did most of its banks, hotels, and theaters. The majority of the buildings that had been constructed during the 1910s and 1920s in downtown South Bend were adversely affected by the ravages of the Depression, and many were abandoned or underutilized. The epilogue concludes by reviewing some of the issues that the city faced in the wake of the Depression and tracking the enduring influence of these issues up to the present. As South Bend searches for a new identity after the decline of its industrial base and the fragmentation of its commercial core through a decade-long process of urban renewal, possible paths to a revitalization of the city are suggested in the form of smart development strategies, preservation, and community organization.

South Bend's Settlement and Early Development

Anyone who has driven across northern Indiana on Interstate 90 would have the general impression that the city of South Bend is located in the midst of a relatively flat prairie landscape dotted with farms and woods. While northern Indiana is not generally known for its varied topography, it does, in fact, include numerous hills and river valleys, the product of receding glaciers that covered the area over ten thousand years ago. The city of South Bend is located in one of these valleys, that of the St. Joseph River. Originating in southern Michigan, the St. Joseph River enters the city from the east, angles northward through its downtown, then turns westward and again northward as it traverses the city's northside residential neighborhoods. Finally, it flows again into Michigan, passing through the cities of Niles and Berrien Springs before reaching Lake Michigan about thirty-five miles to the north at the town of St. Joseph.

The higher ground around South Bend, on either side of the valley, is made up of a series of moraines, accumulations of earth and stone that were long ago carried and finally deposited by the Huron-Saginaw lobe of the Wisconsin glacier.[1] These moraines create highlands all around the city, with the exception of the southwest side, where a vast, low-lying marsh extended as far as the Kankakee River valley in neighboring La Porte County. In all, it is a divergent landscape that changes in each direction, one that is both beautiful and expansive, marked by fields and dense forests, farms and wetlands, rolling hills, and the meandering river valley.

Added to the variety of South Bend's topography are its divergent weather patterns: hot in the summer, cold in the winter, with ample snowfall often

piled high from lake-effect precipitation as the frigid winds blow north-westerly off Lake Michigan. South Bend's architecture is influenced in part by the extremes in its weather conditions: steeply pitched roofs to shed the snow and strong wood or masonry construction to withstand the high winds of the spring and summer storm seasons. There are many cold, gray days in the winter months, times when buildings look flat and dull, lacking shadows or highlights. On sunnier winter days the reflections off the snow are almost blinding, and in summer months strong shadows are cast, with the sun reflecting off brick-patterned walls, shingled roofs, and curtained windows.

Indians, Explorers, Traders

In the seventeenth century, when the Puritans were already well established in New England, the Dutch in New York, James Oglethorpe's British in the south, and the French in Quebec and Montreal, the St. Joseph River valley and the surrounding region of the Northwest Territory were inhabited by the Miami people. They lived in scattered settlements of wigwams and subsisted by hunting, trapping, and fishing. There were as yet no wagon or stagecoach roads, no canals, and no steamboats plying the rivers. Only canoes could be used to navigate the waterways, while the forests were traversed by narrow footpaths. A natural portage of about ten miles allowed the Miami to carry their canoes from the St. Joseph River southwest to the headwaters of the Kankakee River, and from there they could travel all the way to the Mississippi River and on to the Gulf of Mexico.

The first European explorers who canoed up the St. Joseph River and crossed the portage were Father Jacques Marquette in 1675 and René-Robert Cavalier de La Salle in 1679. La Salle was conspicuous in the annals of French Canada for doing more than any of his peers to expand the French empire in North America. While holding command of Fort Frontenac on the north shore of Lake Ontario, his goal was to trace the still-uncharted Mississippi River as far as its mouth in the Gulf of Mexico.[2] He departed from Canada in his ship *Le Griffon* in August of 1679 and traveled across Lake Erie, up Lake Huron to the Straits of Mackinac, and down the west coast of Lake Michigan as far as Green Bay. Continuing on by canoe, he traveled south and followed the lake's southern shore until he landed at the mouth of the St. Joseph River. He built a fort there in 1680, called Fort Miami, which was the first French out-

post in the region and marked the site of the future lakefront towns of St. Joseph and Benton Harbor, Michigan.[3] Traveling up the river, he spent several days in a small Miami village located at the head of the portage, a site just north of South Bend, now occupied by the Riverview Cemetery.[4] Referred to as LaSalle's Landing, it is still a picturesque spot with stately trees and a panoramic view of the river.

La Salle portaged across the Kankakee River and continued on to north central Illinois, near the present-day city of Peoria, where he oversaw the building of Fort Crevecoeur to help defend the region's indigenous peoples against the Iroquois. He passed through the St. Joseph River valley again on his return trip to Fort Frontenac, Niagara, and the St. Lawrence River.[5] He eventually traveled back to his native country of France and to the Baroque architecture of the great palace and manicured gardens of Versailles, home of the French king Louis XIV. The opulence and monumentality of the king's great residence were a striking contrast to the wild, unsettled landscape La Salle had encountered in the American Midwest.

Like other cities and regions across the United States, South Bend's story at this point becomes entwined with the removal of indigenous Native American populations from their long-held territories to clear the way for the arrival of settlers from the East Coast and Europe. The St. Joseph River valley and northern Indiana in general were no less guilty than any other region in the forced migrations that followed. This is an inescapable part of South Bend's history, something it is still coming to terms with.

In 1681 La Salle returned to the portage linking the St. Joseph and Kankakee Rivers, this time as an official representative of the French crown. He secured a treaty with the Miami that forced them and several other tribes to move from Indiana, Michigan, Illinois, and Wisconsin to points farther west.[6] In so doing, he took formal possession of the vast territory in the name of Louis XIV, with the intention of opening it to settlement by French farmers, traders, and trappers in search of opportunities deep in the North American continent.[7]

Despite the treaties, the Miami were slow to leave the area, and when they did, they moved eastward rather than westward, settling at the headwaters of the Maumee River near present-day Fort Wayne. Shortly after they left their camps and villages along the St. Joseph River, they were overtaken not by French farmers and traders, but by large numbers of Potawatomi coming down from the western coastlands of Lake Michigan. They, too, were hunters

and trappers, catching ample numbers of deer, wolf, bear, fox, mink, otter, raccoon, and muskrat.[8]

The area that is now Michigan, northern Indiana, and Illinois, along with the Mississippi River corridor, remained under French control from the 1680s until the 1750s. The few French settlers who ventured to the St. Joseph River valley came through Canada by way of the St. Lawrence River and the Great Lakes, following tributaries of the Ohio and Mississippi river systems. These settlers included missionaries, fur traders, soldiers, and government officials. They brought with them ideas of religious uniformity, which meant loyalty to the Catholic Church, and of political absolutism, which kept the region subject to the direction of Versailles.[9] They built a string of frontier forts and missions, and here and there a settlement eventually became large enough to be called a town. These settlements extended from Quebec and Montreal in the north to St. Louis and New Orleans in the south. Typically located on a waterfront, they were heavily dependent on water transportation as the most effective means of communication and trade.[10]

While several pioneering families of French descent moved to the St. Joseph River valley, their numbers were not as great as La Salle had envisioned. One particularly courageous priest, Father Claude Allouez, settled in the area in 1686 to provide for the religious needs of the scattered settlers and to minister to and convert the local Native population.[11] A French Jesuit, he is believed to have established two missions in the region, the first in 1685 at a site about twelve miles north of LaSalle's Landing at present-day Niles, Michigan, which he called St. Joseph's Mission. In the eighteenth century the French turned it into a fort, and for the entire period of France's occupation it served as a center of trade and regional administration.[12] The second, established in 1686, was at the future site of the University of Notre Dame, on the south side of the larger of two lakes that now form the centerpiece of the sprawling parklike campus. Allouez called it Sainte-Marie-des-Lacs and constructed the first log chapel, to be used by French priests.[13]

The French and Indian War and the Advance of the British

The region remained in French hands until war broke out against the British in 1756 in what was known as the French and Indian War. The cause of the war was a battle not only over who would control the American Midwest and the

Mississippi River valley, but also over control of the American fur trade. In the words of historian Logan Esarey, the territory was "a veritable storehouse of wealth in valuable furs, furs which were bought from the Indian trappers, ignorant of the artificial value placed on the pelts by the Europeans, at ridiculously low prices."[14]

By 1759, Niagara and the French capital at Quebec had fallen to the English. Montreal and Detroit surrendered in 1760, thus bringing an end to the first French colonial empire in America. During the winter of that year, the British seized possession of the St. Joseph River valley and garrisoned Fort St. Joseph with British soldiers.[15] By the end of 1765, after France had ceded all of the territory east of the Mississippi to England, the French population remaining in the Northwest Territory, including those at Detroit, numbered only about six hundred families.[16]

After the British victory, both the religious practices and political governance of the region changed dramatically. The Catholic missions, including those founded in Niles and on Sainte-Marie-des-Lacs by Father Allouez eighty years earlier, were suppressed and closed, the priests taken away as prisoners to Quebec. More significant was the British government's colonial policy that opposed any measures that might have strengthened the region's settlements.[17] Instead, the government held the land and would not allow it to be sold to settlers nor used for agricultural purposes, thus impeding development throughout the Midwest. The entire fur region of America was reserved as something akin to a private reservation for King George III, whose court could now reap all of the profits.[18]

The Revolutionary War and Beyond

The American Revolutionary War broke out within fifteen years of the close of the French and Indian War in response to a series of provocations including excessive taxation and lack of political representation.[19] By the late 1780s, after the close of the Revolutionary War and the Treaty of Paris, large numbers of American settlers had started moving into the region, second- and third-generation families from the East Coast who traveled across Pennsylvania and Ohio and up from Virginia and Kentucky. Anthony Wayne built Fort Wayne on the Maumee River, American troops occupied Detroit, and in 1803, the year Thomas Jefferson purchased the Louisiana Territory from Napoleon

Bonaparte, Fort Dearborn was established on the west coast of Lake Michigan at the mouth of the Chicago River.[20] These settlements served to solidify American control of what was now officially called the Northwest Territory.[21] During the War of 1812 the Potawatomi allied with the British, but at the war's end in 1815 official relations were established between them and the United States government. The Potawatomi, who numbered about two thousand in the region, agreed to renounce their relations with the British and to accept a series of land cessions that had been negotiated over the course of the previous two decades.[22]

Indiana was established as the nineteenth state on December 11, 1816, just as the St. Joseph River valley was once again becoming an attractive commercial fur-trading region. During the oppressive period of British occupation, fur trading in the region had been generally carried out by a few large private companies with ties to George III, such as the Hudson Bay Company and the North West Company. After the close of the Revolutionary War, the fur trade was handled on a local basis by private individuals. In 1808 the New York state legislature chartered the American Fur Company, led by the German emigrant John Jacob Astor.[23] Its purpose was to buy and sell furs and other goods necessary for the establishment of village life. At first, trappers in the area of South Bend traded through posts at Fort Wayne and Detroit. Joseph Bertrand was the first agent of the American Fur Company to establish a post in the area, located on the east bank of the St. Joseph River about halfway between LaSalle's Landing and the former site of Fort St. Joseph. It was at the crossing of the Great Sauk Trail, a Native American trail turned stagecoach route that traveled from Detroit to Chicago.[24]

Amid these developments, the region experienced a rapid influx of settlers. The population of Indiana when it became a state in 1816 was less than 70,000, but emigration to the state was so great that a government census of 1820 showed that it had more than doubled in size to over 147,000 inhabitants.[25]

The Earliest American Settlers

Pierre Navarre was the first American to venture to LaSalle's Landing and set up a permanent home. He was the second person after Bertrand to establish a business representing the American Fur Trading Company to buy furs from

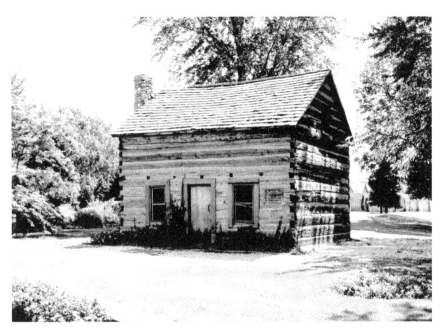

FIGURE 1.1
Navarre Log House,
Leeper Park, 1820.
(Photo by author.)

the Native Americans and sell other necessary goods to them and to travelers passing through the area or making tentative settlements in the region. Born of French parents living in Detroit, Navarre built a log house and store in 1820 on the north bank of the St. Joseph River across from present-day Leeper Park, near the Michigan Street Bridge.[26] He traded with the Native Americans in the spring and autumn, taking furs, maple sugar, baskets, and other articles in exchange for money and liquor. He further befriended them by marrying Kechoueckquay, a member of the Potawatomi tribe. He was so successful that this region of northern Indiana came to be the Astor Company's largest fur supplier on the continent.[27]

Navarre is a name that lives on today in South Bend. A replica of his log house, originally located at 123 West North Shore Boulevard, stands today in Leeper Park.[28] This replica is a reconstruction that employs the same method of notched corners and chinking between the logs as the original structure. The windows of the original house were covered with greased paper, which allowed in filtered light. The hearth was made of wet clay, which was pounded down to rocklike hardness. The chimney was formed from sticks and mud. This would be the principal type of abode for settlers in the area until the production of brick using sand from the banks of the St. Joseph River and lumber from newly established sawmills started to provide alternative materials and means of production.

In 1821 a treaty was signed in Chicago in which the Potawatomi ceded to the government land office in Fort Wayne virtually all of their remaining lands in southwestern Michigan and a small strip of land in northern Indiana, including the area of present-day South Bend.[29] Now certain that there was no danger posed by the indigenous peoples, more settlers traveled to the area and staked claims to property along the river. They included Alexis Coquillard and Lathrop Taylor, family names that are still prominent in South Bend history, identified with schools, roads, bridges, parks, and neighborhoods. Like Navarre, Coquillard was the son of French parents and moved to the St. Joseph River valley from Detroit. Also an agent of the American Fur Company, he built a trading post, Big St. Joseph's Station, in 1823, located on what is now Washington Street, near the west bank of the river. It was the first permanent structure to be built on the future site of downtown South Bend.[30]

Lathrop Taylor, an agent for the Samuel Hanna Company of Fort Wayne, moved to the St. Joseph River valley from Detroit in 1827 and built a trading post and milling company at what would later be the northeast corner of Michigan and Madison Streets. He was born in Clinton, New York, and moved with his family to Detroit at the age of six.[31] He and Coquillard called their small settlement Southold, with Taylor becoming the first postmaster. Also in 1827, surveyors began to lay out the Michigan Road, the principal north–south thoroughfare through the settlement, part of a larger project to connect Lake Michigan with the Ohio River by means of a hundred-foot-wide road.[32]

The Navarre, Coquillard, and Taylor trading posts flourished throughout the 1820s. However, as large numbers of the Potawatomi left the area, the three traders, along with other local settlers, began turning to farming to support their families. Some began to buy large tracts of land as they were made available through the Fort Wayne land office. Navarre, for instance, applied for and was granted much of the land north of his trading post, property that includes the city's present northside neighborhoods Harter Heights and North Shore Triangle. Coquillard purchased property on the east side that now makes up Coquillard Woods and the East Jefferson Boulevard neighborhood. He and Taylor also bought up most of the land that would become South Bend's commercial center.[33]

The forced removal of the Potawatomi from the St. Joseph River valley in 1838 was largely the doing of Navarre and Coquillard. The latter had the further distinction of serving as the official interpreter and government agent

responsible for carrying out the various treaties made between the United States government and the Native American communities. He and Navarre were appointed to direct the resettlement of the remaining Potawatomi, which included Navarre's own family. With one exception, as described in chapter 2, this process ended virtually all official indigenous presence in the area.[34] Not long afterward, Navarre followed his family to a Potawatomi reservation in the Great Plains, but later returned to South Bend, where he died in 1864.[35]

As the Potawatomi and other indigenous groups made their forced migration westward out of the region in the 1830s, African Americans constituted a significant presence among the settlers who took their place in the St. Joseph River valley. In 1834 Samuel Huggart, a free African American man living in Montgomery, Ohio, with familial roots in Virginia, purchased eighty acres of hilly, wooded land a few miles south of Navarre, Coquillard, and Taylor, near the present site of Potato Creek State Park. Huggart constructed a two-story, four-room clapboard house on the site. The Huggart Settlement, as it came to be called, grew up around his homestead in the 1840s and 1850s, attracting several African American families. These families built austere farms and a schoolhouse, raising livestock, planting crops, and harvesting maple sugar. They were joined by White neighbors including Esau Lamb, an abolitionist who operated a nearby sawmill, and by all accounts, White and Black settlers at Huggart Settlement lived, educated their children, and worshipped together. The Huggart Settlement's proximity to the newly constructed north–south Michigan Road, and Lamb's strident antislavery activism, made it a logical stopover on the Underground Railroad for fugitive slaves making their way north to Michigan and Canada. The settlement faded away in the 1880s and 1890s as residents relocated northward to nearby South Bend to take jobs in the city's burgeoning factories, but a historical marker and nearby Porter Cemetery remain as traces of this bygone interracial frontier community.[36]

Platting and Settling the City

Despite the decline in trade with Native Americans, the village of Southold continued to grow as the transition was made to a farming economy. Numerous buildings were constructed around Big St. Joseph Station, including more stores, houses, a jail, and a county courthouse. In 1830 St. Joseph County was surveyed by William Brookfield, a deputy United States surveyor, and in the

following year Southold, with a population of 168, was platted and its name officially changed to South Bend in reference to the southward loop in the river at present-day Leeper Park. Brookfield laid out the town on a traditional rectangular grid, one that characterized countless towns and cities across the Midwest.[37]

The grid plan was the most pervasive urban-rural form in the United States. It had first been used in the American colonies in 1638 for the plan of New Haven, Connecticut. A large square subdivided by parallel streets into nine equal squares, its center block was designated as the town common.[38] A larger version of the grid plan was used by William Penn in the layout of Philadelphia in 1682. An expanded version of New Haven, it had a public square in the center, plus additional squares in each of the four quadrants. Principal north–south and east–west streets emanating from the town square were made twice as wide as the others.

Many variations of the grid plan can be found, from New Orleans to Indianapolis, including utopian communities such as New Harmony, Indiana.[39] Most of these were idealized plans, with complete blocks all around and a delineated perimeter, placed slightly away from their waterfronts in order to maintain their linear integrity.

Like many of the early grid-planned cities, New Haven's design had significant religious connotations. Erik Vogt, in the book *Yale in New Haven: Architecture and Urbanism*, describes the nine-square grid plan as representing the essence of Puritanism, an essential biblical type recurrent throughout human and sacred history. The New Haven Colony was intended by its founders to be "the leading exemplar of the Puritan communal ideal."[40]

Penn had founded his Quaker city on the principle of religious toleration and freedom. Oglethorpe had founded Savannah, Georgia, in order to promote a colony in the New World where those confined to English jails by their creditors could find a new life. He sought not only debtors but also people of modest means who, for economic or religious reasons, felt the weight of oppression and discrimination.[41] His plan was a Cartesian grid based on a system of interlocking squares, repeated at different scales that resulted in a complex rhythmic pattern.[42]

In South Bend, there never was such a direct connection between the plan and the purpose of the city's layout. While some of its earliest settlers were French Catholic, their reason for establishing the city was a pragmatic one, based more on commercial trade than on religious ideals.[43]

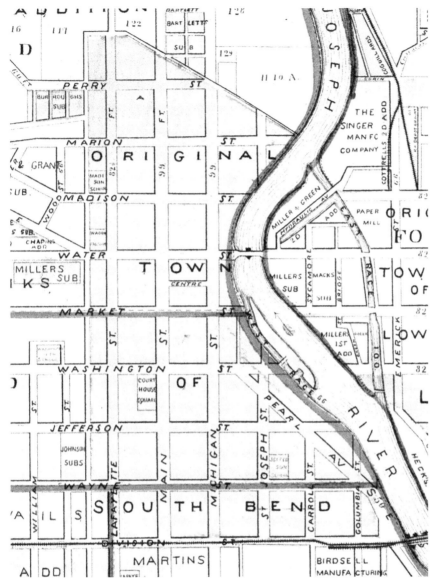

FIGURE 1.2
Plat of South Bend as surveyed by William Brookfield, 1831. From *An Illustrated Historical Atlas of St. Joseph County*, 1875. (Courtesy of St. Joseph County Public Library, Local and Family History Services Oversize Collection.)

Another tradition of city planning at work influenced the platting of South Bend and other towns and villages in St. Joseph County: the American Continental grid, which was officially established by the Continental Congress in 1785. Based on six-mile-square townships subdivided into one-mile square sections, this pattern of land survey was instituted to bring about the orderly development of the Northwest Territory after the Revolutionary War. It was eventually extended to all of the new territories that would one day make up

the forty-eight continental states, becoming the dominant model for urban-rural land development in the country.[44]

While Brookfield laid out South Bend's streets and lot lines following the model and orientation of the Continental grid, his plan had nothing resembling the ideal qualities of such cities as New Haven, Philadelphia, or Savannah. He made no effort to delineate clear boundaries distinct from the meandering line of the St. Joseph River. Instead, he ran its east–west streets directly up to the riverbank, resulting in numerous partial and angled blocks. He skewed its northern boundary at a sharp angle, and he gave no hierarchical distinction to the block designated for the county courthouse.

In all, it was a highly compromised plan. It extended nine blocks north to south and two and a half blocks east to west at its narrowest point, six and a half blocks at its widest point. The full blocks measured approximately 440 by 340 feet. The three principal north–south streets were Michigan, closest to the river, then Main and Lafayette; the three principal east–west streets were Water (LaSalle), Market (Colfax), and Washington. The grid intersected diagonally at its southeast corner with Dragoon Trail (Lincolnway East), and at its northwest corner with the State Road to Chicago (Lincolnway West). A second diagonal road, Portage Avenue, extended in a more northerly direction, leading to LaSalle's Landing and the portage.[45] Brookfield assigned only the quarter block on the southwest corner of Main and Washington Streets, the site of the present courthouse, as a public square. Curiously, he did not give this public square any special status within the gridiron plan. It was just a quarter of the block, and there was no axial approach, as would be found in numerous other county seats with courthouse squares across the state of Indiana.[46] Herein lies another distinction between the grid plan of New Haven and that of South Bend. In New Haven's case, the central block of the nine-square grid was left open as "common and undivided land," the communal sanctuary of the congregation. A wooden meeting house was built in the middle of the common in 1639, marking the physical and spiritual center of town and congregation, a plan composition that would be repeated in many towns and cities across the country.[47] The lack of a true courthouse square or town green in South Bend would forever diminish the symbolic civic role of the courthouse in South Bend's downtown urban core.

Brookfield and his clients, Coquillard and Taylor, saw the unadorned gridded street pattern in purely pragmatic terms as the most efficient means of facilitating commercial trade. The fact that there was no stockade surrounding

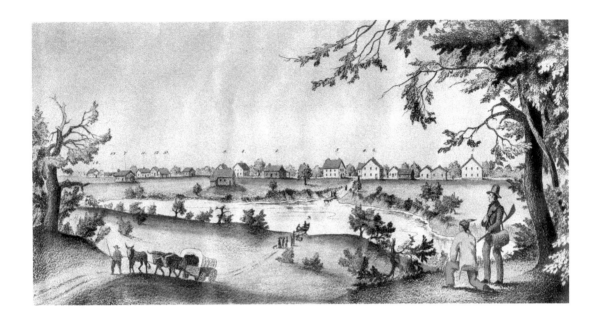

the town is evidence of the generally peaceful relations that existed by now between the Native Americans and the various competing European colonizers.

South Bend's earliest traders and merchants typically built one- and two-story buildings, often with their commercial enterprises on the first floor and their living quarters on the second. At the same time, piers were built on the riverfront, whose water rights were claimed by Coquillard and Taylor. In 1843 the East and West Races were dug by the South Bend Manufacturing Company, which retained the rights to water power on the West Race.[48] Soon mill buildings were constructed on both raceways to take advantage of hydraulic power provided by the fast river currents. Before long, a substantial number of products were shipping out, especially lumber, headed east to build houses, wagons, and boats.

A pictorial view of South Bend in 1831 portrays a small village with about eighteen buildings. The population was about 170. Coquillard's Big St. Joseph Station and three or four other structures are shown as single-story log structures. Other trading posts, houses, and the Michigan Hotel are shown as two-story, frame buildings with wood siding, gable roofs, small symmetrically placed windows, and unadorned doorways. The Jefferson Schoolhouse and other buildings are indicated as smaller, one-story, frame, wood-clad structures. In addition, the first ferry across the river, operated by Nehemiah B. Griffith, is indicated at Water (LaSalle) Street.[49]

FIGURE 1.3
View of South Bend in 1831 from the east bank of the St. Joseph River. Otto E. Stelzer, 1933. (Courtesy of St. Joseph County Public Library, Local and Family History Services Reference Collection.)

Not visible in the picture, but described in Chapman's *History of St. Joseph County*, was South Bend's first brick house, the Bainter-Smith House, erected in 1831. It was square in plan, measuring eighteen feet on a side, and was two stories high with a shingled gable roof and a chimney at one end. There was no cornice or other projection, suggesting either a vernacular or possibly Federal style. Located near the southeast corner of Main and Water Streets, it was built with brick fired in a kiln on the west bank of the St. Joseph River.[50]

The Bainter-Smith House was described in 1867 by Dr. L. Humphreys, a founding member of the St. Joseph County Historical Society: "It is not Doric, Ionic, Corinthian, Composite, nor is it Babylonish, after the style of the temple of Belna, Kasr, or the hanging gardens that Nebuchadnezzar built for his Lydian bride. It is not copied after Oriental architecture, or Chinese, where pagodas are only imitations of the design of the nomadic tent."[51] He called it instead the "quadrilateral or square style." While he was writing of a building we would call the Federal style, his ability to place it in the broader context of eight different styles is revealing of the knowledge he and many others involved with building had.

From its small beginning the town prospered and grew, its location on the St. Joseph River fostering trade with other towns and settlements in the region. For the next several decades its commercial and industrial development were both tied to the river. Coquillard alone was responsible for building a sawmill, two flour mills, and a woolen factory, all along the riverbank. Buildings for public use were erected by the county commissioners, who signed, for instance, a contract for the construction of a county jail in 1832 located at the corner of Jefferson and Lafayette Streets. Typical of vernacular buildings of the time, it was a log structure set on a brick foundation and topped by a hipped roof.[52]

The first St. Joseph County Courthouse was constructed at the northeast corner of the public square in 1831–1832 by the builder Peter Johnson for a cost of $3,000. Detailed specifications prepared by the county commissioners describe a two-story building, square in plan, with a hipped roof.[53] It measured forty feet on a side and was constructed of brick walls twenty-three feet high. A door with a transom was placed in the center of the east and north walls, both flanked by symmetrically placed windows, which were flanked by "Venetian" shutters. One surprising requirement of the county commissioners was a highly polychromatic finish on the building's exterior. The brick walls, according to the specifications, were painted with Venetian red paint, while the joints

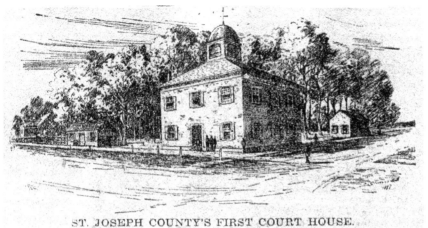

FIGURE 1.4
First St. Joseph
County Courthouse,
northeast corner of
Main and Washington
Streets. From *South
Bend Tribune*,
March 9, 1922.
(Courtesy of
St. Joseph County
Public Library.)

ST. JOSEPH COUNTY'S FIRST COURT HOUSE.

The first court house for St. Joseph county was a two story brick structure built at the northeast corner of the public square, Main street and West Washington avenue, at a cost of $3,000.

were penciled off with white lead. The cornice was painted white, the shutters green, and the doors the color of mahogany. Except for this colorful treatment, the courthouse was similar in its vernacular appearance to the first state capitol in Corydon, Indiana, which was built in 1816 by Dennis Pennington, but which featured locally quarried ashlar masonry construction, rather than brick, and little in the way of polychromatic decoration.[54]

Inside, the first level of the first county courthouse had twelve-foot-high ceilings and the second story ten. The floors were white oak, and there was an open staircase with balusters in a central hall connecting the two floors. It had a fireplace in every room, and there were four chimneys. A singular feature of the building was its cupola, which held a spire topped by a gilt wooden ball two feet in diameter and fixed at the top with a gilt wooden fish, representing water—the St. Joseph River—as well as life and fertility, suggesting the opportunities offered by the region for those who wanted to start over in a new land.

Numerous store buildings were built in a similar manner, with brick walls, two-story construction, and simple vernacular moldings and details. In 1844 a second county jail was constructed, this time in brick.[55] The first bank in St. Joseph County, a branch of the State Bank of Indiana, was opened in 1838, occupying a two-story brick building at the northeast corner of Michigan and Market Streets.[56] Just four years later it would build the town's first building in the Greek Revival style.

The East Side

Griffith established the first ferry to operate on the St. Joseph River in 1831 to connect LaSalle Street to the east bank. In 1835 a second ferry was set up to cross the St. Joseph River at Market (Colfax) Street, a block south of Griffith's, this one operated by Coquillard to connect South Bend with land he owned and wanted to develop on the river's east side.[57] He desired to take advantage of the potential offered by the river for water-powered mills. He soon sold the waterpower rights to a group of New York investors, however, who began the construction of a dam and mill races. The first dam was constructed in 1842, and the South Bend Hydraulic Company was formed to provide power to much of the growing town.[58]

This group of investors, led by Garrett V. Denniston and Joseph Fellows, also platted a second town on the east side of the river, Denniston, which was quickly built up with sawmills, woolen mills, and a myriad of other small companies involved in making wood and iron products. It was laid out in connection with their ownership of the water power on the St. Joseph River. As in the case of others, an economic panic in 1837 forced them into bankruptcy, and the county commissioners formally vacated Denniston in 1845.[59]

In the same year, Christopher Emerick platted and renamed the area the town of Lowell, after the industrial city of Lowell, Massachusetts.[60] The first wood-truss bridge to replace the early ferries was built across the river connecting Washington Street on the west side with Colfax on the east, and two years later a second wooden bridge was built at LaSalle Street, more effectively tying the two sides of the river together, improving trade and transportation.[61]

South Bend's rapid growth, inexpensive land, lumber resources, power provided by the mill races, and river and highway access continued to make industrial development attractive. By 1840 South Bend had a population of 727. The grid pattern of the original plat was extended, particularly to the south and west, and the town of Lowell continued the grid on the east side of the river. A large part of the Near East neighborhood, from St. Louis Street to Eddy Street, was platted by Samuel Cottrell in 1854 as part of the First Addition to the town of Lowell. Rights to the water power, which were then controlled by Cottrell, passed into the hands of the South Bend Power Company in 1867. While the original town of Lowell, closest to the river, was primarily industrial in use, the rest of the expanding Near East neighborhood was mainly residential. The entire area was annexed to the city of South Bend in 1866, and the first iron-truss

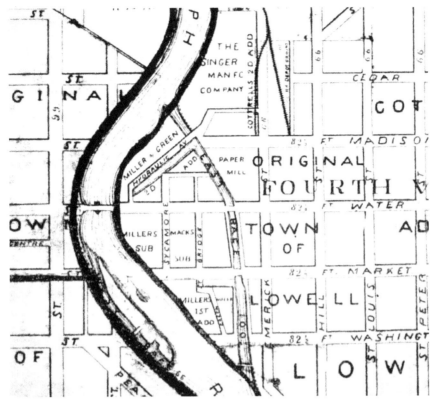

FIGURE 1.5
Plat of the Town of
Lowell, 1845. From
*An Illustrated Historical
Atlas of St. Joseph
County*, 1875.
(Courtesy of St. Joseph
County Public Library,
Local and Family
History Services
Oversize Collection.)

bridge connecting the east side with the downtown was constructed to replace the wooden bridge in the early 1870s at LaSalle Street.[62]

From Fur Trading to Water-Powered Mill Industries

South Bend's development in the period from the late seventeenth century to the 1850s can be divided into three phases. First, French explorers and missionary priests began to travel through the area in the late seventeenth century, establishing military outposts and religious missions. This lasted until the beginning of the French and Indian War, which carried on from 1756 to 1763. The second phase, marked by British occupation that lasted from 1765 to 1815, saw little new population growth or economic development. The third phase was marked by the forced migration of the Potawatomi to western lands, followed by increased immigration of French, English, and American fur traders and settlers, who converged at the southward bend in the St. Joseph River.

They saw an opportunity to take advantage of the transportation and power it offered, in addition to the potential for exploiting the abundant natural resources of the surrounding area while developing it for agricultural production. The architecture of this third phase was characterized by a modest vernacular style, with log and wood-framed structures, plus an occasional brick building, all built entirely of local materials. The third phase also saw the development of water-powered mill industries along both sides of the river, taking advantage of its strong currents as well as raceways on either side that powered flour mills, woolen mills, and other early forms of industrial production.

Between 1800 and 1850, America grew from about five million inhabitants, most of them living in towns along the East Coast, to over 23 million, now dispersed across the Midwest and the South. The strongest period of South Bend's development was part of the huge land rush that occurred in the 1830s, just as the city was platted, its governmental structure organized, and accommodations made for industrial development and communication along the St. Joseph River.

By the 1840s, builders in South Bend, influenced by pattern books and the evolving taste of the city's newest residents, began adopting the Federal-style and Greek Revival architecture, which met the needs of the expanding egalitarian population. They were simple but dignified styles that could be rendered in both wood and stone. Their connotations of classical democracy, added to their practical means of construction, made them popular styles for Midwest builders.

The Founding of Notre Dame and Saint Mary's

In 1842, eleven years after the founding of South Bend, Father Edward Sorin, along with six religious brothers, all trained in France by the community of the Auxiliary Priests of Le Mans, made their way to South Bend to establish a college. They were sent by Célestine de la Hailandière, the bishop of Vincennes, under whose supervision they had worked since arriving in the United States the previous year.[1] Vincennes, an old trading post on the Wabash River in southern Indiana, held the bishopric of the entire state plus that of eastern Illinois, including Chicago.[2]

Father Sorin led his group by foot and horseback to South Bend, stopping first at the house of Alexis Coquillard. After a brief stay, Coquillard's seventeen-year-old nephew led them to the 524-acre site at Sainte-Marie-des-Lacs, which was two miles away. It was owned by the Vincennes diocese, but Bishop Hailandière promised to give it to Sorin's group if they would reopen the old mission on the site that had probably been established by Father Allouez over 150 years earlier. More important, they were charged with founding a college and a novitiate for the brothers, and they had to do so within two years' time.[3] By 1855, thirteen years after Bishop Hailandière's promise, Sorin and his band of Holy Cross priests had succeeded in forming a college. Alongside the sisters who had founded nearby Saint Mary's College, Sorin had built a thriving young campus with a trajectory of growth epitomized by Notre Dame's newly constructed Main Building and Church of the Sacred Heart, which loomed over the northern Indiana woodlands and the village of South Bend two miles to the south.

As discussed in the previous chapter, Father Allouez had possibly established his mission at the site of Sainte-Marie-des-Lacs in 1686 to minister to the local Catholic population and to convert the Native Americans. It remained an active mission until the end of the French and Indian War in 1763, when it was closed down by the British. The site was not occupied again until 1831, when the missionary priest Father Stephen Theodore Badin settled there and built a new log chapel and a small adjacent wooden dwelling. Father Badin, born in Orléans, France, had immigrated to Baltimore, Maryland, in 1791 after the outbreak of the French Revolution.[4] The first Catholic priest to be ordained in the United States, he spent his career ministering across the Midwest. The objective, wrote historian Marvin R. O'Connell, was to "forge in America an institutionalized Catholicism on the European model—the only kind of Catholicism they knew—and to accomplish this goal required the provision of sacred space for the celebration of the sacraments, to be sure, but, hardly less crucial, permanent locations also for schools and colleges, orphanages and hospitals, convents and presbyteries."[5] From 1830 to 1832, Father Badin acquired from the government land office the entire 524-acre site now occupied by the university in order to establish one of several mission stations that were being founded along the St. Joseph River and into Michigan as far as the city of Kalamazoo. These mission stations ministered primarily to the remaining local Native American populations. He befriended the Potawatomi leader Leopold Pokagon, who was baptized and who successfully kept a small group of about two hundred Potawatomi from being removed with hundreds of other Indians to reservations west of the Mississippi.[6] Pokagon died in 1841, just one month before Father Sorin arrived.[7]

The log chapel that Father Badin had constructed was a one-and-a-half-story structure, measuring forty by twenty-four feet.[8] The brothers lived in the attic while Father Badin lived in the adjacent shed. In 1835 Father Badin sold the Lake St. Mary's site to the Vincennes diocese and moved on to other apostolates before dying in 1853 in Cincinnati. Father Badin's log structure, along with some scattered smaller buildings, were still standing at the edge of Lake St. Mary's when Father Sorin arrived in 1842. Its ground floor served as living quarters and a chapel was located in the attic. The chapel remained until it was destroyed by fire in 1856. Its site was mounded over and topped by a sixteen-foot iron cross marking it as a holy spot on the campus. The present log chapel was built in 1906 as a replica of Father Badin's original building. It was based on a plan drawn by Brother Boniface from the memories of men who had lived

in it, especially Brother Francis Xavier. Its logs were hand-hewn in the traditional manner using a broadaxe by a former enslaved person, William Arnett, and the same technique of notched corners. Its first-floor room today is a beloved sanctuary used for private masses and weddings.[9]

Notre Dame University

Father Sorin renamed the mission Notre Dame du Lac and in 1842 began construction of a new log chapel located south and east of Father Badin's original buildings. The new structure, which was not finished until the spring of 1843 due to a lack of skilled labor, measured forty-six by twenty feet.[10] An attic that carried through its entire length provided a residence for a group of religious sisters who were expected to arrive from France the following summer. A moderately tall man could touch his head to the rafters in this space. This chapel was a short-term solution to an immediate need: providing a sacred space for the young campus. It served as the college's main Catholic sanctuary until it was closed and demolished in 1848, when the much larger Church of the Sacred Heart of Jesus was constructed.

In 1843 Father Sorin posted a notice in the *South Bend Free Press* stating his intentions for founding Notre Dame. He stated, for instance, that the location is "both beautiful and healthful" and that the school can be "easily reached from any large city in the region." He described the college buildings (and the Main Building, though not yet constructed) as being "equal to anything in the United States," and he promised a "gymnasium to provide the last word in recreational facilities." He promised parents that the sisters and local physicians would provide good healthcare for their children.[11]

Father Sorin believed his mandate from Bishop Hailandière and Basil Moreau (founder and then-superior general of the Congregation of the Holy Cross) called for him to establish European-style institutional Catholicism among the region's White immigrants. He soon realized he had to add to his mission converting and ministering to the small number of Native Americans who had managed to avoid the forced migration of 1840.[12] It also became clear that he faced a lack of serious language and cultural skills. The eastern colleges, mostly of Protestant denominations, had definite advantages because they had English-speaking professors and their students largely came from wealthy backgrounds. Notre Dame's earliest professors mostly spoke French, and their

earliest students came primarily from South Bend and its surrounding rural areas and had few language skills and little cultural experience.[13]

For the college he brought a French educational system that required strict disciplinary supervision of a pupil's every waking moment.[14] This too was adjusted when the faculty became concerned that such a strict educational routine would dissuade many potential students from coming to Notre Dame. Numerous revisions were made to the curriculum and teaching methods, based largely on a plan that had been established by St. Louis University.[15] As historian Arthur J. Hope put it, the principal raison d'être for Notre Dame from the beginning was to give her students religious and moral training, an ideal that prevailed over laboratories, professional staff, or physical equipment.[16]

Notre Dame's First Main Building

The construction of the small brick building immediately adjacent to the log chapel, known as Old College, was something of an accident. In January 1843 Father Sorin had decided to begin construction of what was to be Notre Dame's first Main Building, but his plans were temporarily thwarted. Bishop Hailandière had promised to send a group of builders to Notre Dame in the spring of that year to carry out its construction, but they did not arrive until months later.[17] The delay caused a certain degree of panic within the community, as it only had one year left to establish the new college. As a stopgap, Father Sorin ordered the construction of a smaller brick structure to temporarily serve as a dormitory and dining hall for the upcoming academic year. The result was Old College, a two-story structure, square in plan and topped by a hipped roof, a building that was similar in appearance and construction technique to the first county courthouse in downtown South Bend. Located near the log chapel on the slope of the hill leading down to the lake, it still functions as a residence for the Congregation of the Holy Cross.[18]

Construction of the originally planned Main Building finally commenced in August 1843 and was completed in the summer of 1844. It was a structure that Father Sorin had designed while he was still in Vincennes, working with a carpenter and mason known only by the name Marsile. When Marsile and his two assistants arrived from Vincennes, they laid the cornerstone and began construction, which they carried on throughout the winter and summer. The first Main Building was completed in time for the start of the academic year of

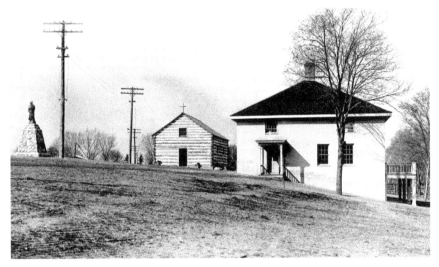

FIGURE 2.1
Campus of the
University of Notre
Dame, Log Chapel on
left, Old College on
right, 1842–1844.
(Courtesy of Notre
Dame Libraries
Special Collections.)

1844, corresponding to the granting of Notre Dame's first charter by the State of Indiana, giving it the legal status of a university.[19] There were only two other Catholic universities in the country at the time—Georgetown University (1789) and St. Louis University (1829)—the latter run by the Jesuits.

Located east of Old College on a high promontory overlooking St. Mary's Lake, the first Main Building was a brick structure, three stories high, with a raised basement. Its plan was cross-shaped, with the short arms of the cross aligned with the north–south axis that would eventually define Notre Dame Avenue. It had round-arched windows on the first floor and rectangular windows on the second and third. From the few engravings of the building available to us, its style appears to have been a vernacular Federal style, with a crossing gable roof and a front pediment. It was surmounted by a tower upon which stood an iron cross, eighteen feet high, and a clock face with the words *Tempus fugit*, "Time is fleeing."[20] Its principal features—its scale, construction techniques, and the slope of its roof—were consistent with the Federal style and also in keeping with the prevailing mode of the time in Marsile's home-town of Vincennes. One visitor described it as a four-story building "without any pretensions to architectural beauty."[21] With this new building, practically every activity of the university was combined under one roof, including refectory, classrooms, lecture hall, laboratory, library, dormitories, study halls, a museum, and the president's office.[22]

Marsile would have drawn on his own experience in Vincennes and may have had access to one or two pattern books, for instance, William Pain's *The*

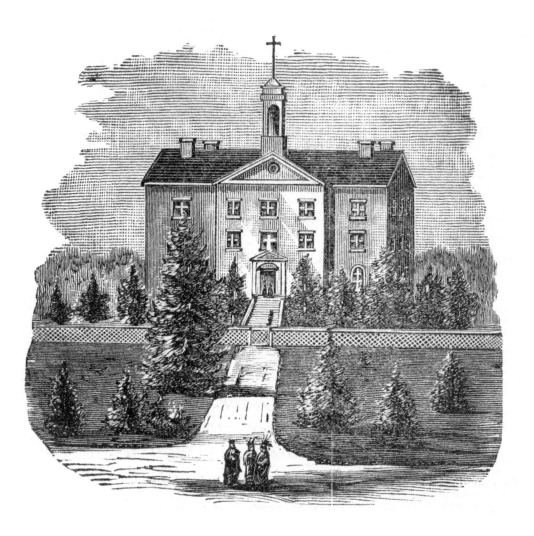

FIGURE 2.2
Main Building,
University of
Notre Dame, 1845.
(Courtesy of Notre
Dame Libraries
Special Collections.)

Practical Builder, Asher Benjamin's *The Country Builder's Assistant*, or *The Young Carpenter's Assistant* by Owen Biddle, all published around the turn of the century. There were enough planning and woodworking details in the first Main Building to suggest at least a rudimentary knowledge of the European traditions that had long influenced builders and carpenters on the East Coast.

The needs of the young university quickly outgrew the Main Building, forcing Father Sorin in 1853 to plan additions to the east and west sides providing additional space, especially for classrooms and dormitory rooms.[23] The dining room featured frescoes by the German-trained artist Jacob Ackermann, who was a member of the university's art department. The east wing included

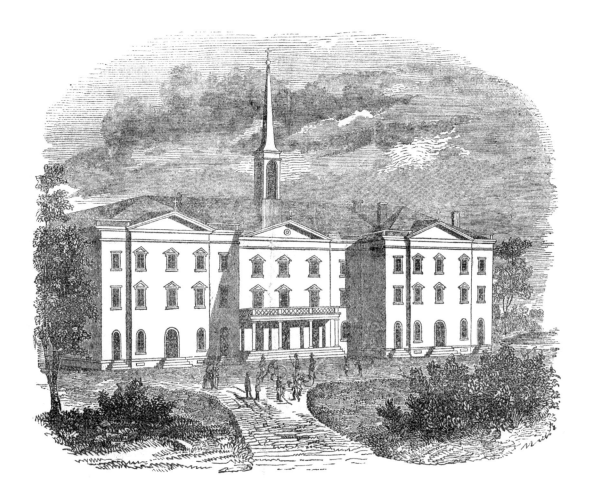

FIGURE 2.3
Main Building,
University of
Notre Dame, 1855.
(Courtesy of Notre
Dame Libraries
Special Collections.)

the university's first "exhibition hall" for performances and meetings on the second and third floors, a recreation hall on the first floor, and an armory and museum on the fourth.[24] The museum contained specimens of the natural sciences, including from ornithology.[25] The building provided a distinctive setting for the university's first two decades, accommodating well its growing student population and increasing curricular needs.

While the Main Building was being constructed, Father Sorin began to envision an expanded plan for the campus, one that included the addition of several more buildings as well as a broad tree-lined avenue extending southward from the Main Building for nearly a mile and ending at the town of Lowell.[26] As this avenue, named after the college, was leveled and paved during the early years of the 1840s, Notre Dame platted and developed property it owned

at its south end to be used as housing for staff and faculty. Called Sorinsville, it was built up with workers' cottages and small Federal-style and Greek Revival houses. Notre Dame Avenue thus became the principal connecting link between the university and Sorinsville, Lowell, and downtown South Bend.[27]

In the following years further developments on the campus itself included a series of farm buildings—an icehouse, slaughterhouse, horse barns, cattle barns, tool houses, and granaries—in the area to the south and east of Old College and the log chapel.[28] In addition, a community house and chapel for newly arriving novices was built in 1853 in the middle of a marshy area between the two lakes, a site called simply "The Island," which could only be reached by boat.[29]

The first church on the Notre Dame campus, built to replace Father Sorin's log chapel, was erected in the years between 1847 and 1852. Named the Church of the Sacred Heart of Jesus, it represented an especially important moment in the history of the university. Father Sorin reported, "The joy that this new church has caused in the whole community and in the entire congregation seems to have doubled the religious spirit of everybody."[30] Father Sorin dedicated the cornerstone in August 1847, but just as construction got under way, the university ran out of funding for the project. Construction resumed in the spring once the university obtained adequate funds, and it was completed by 1850.[31]

Located directly west and slightly south of the Main Building, it was a wooden structure measuring ninety feet in length and thirty-eight feet in width, the largest and most distinguished Catholic church in northern Indiana.[32] Designed in a style that seemed to combine Greek Revival and Carpenter Gothic, Father Sorin described it as "The style of Greek with rounded arches."[33] It had a broad twin-towered facade with two levels of classical pilasters separated by an intermediate cornice and topped by a cornice and a low-pitched pediment.[34] A large arched opening marked the central entrance, and above was a small rose window representing Heaven, its stained glass made by the Carmelites of Le Mans, France. A second, circular stained glass window, depicting the Assumption of the Blessed Virgin, was located in the wall behind the altar.[35] The rest of the windows were lancet shaped in the Gothic style. The building's twin towers were initially topped by pinnacles, but a few years after its construction, Father Sorin added a pair of bell towers capped by open-framed spires, a move that gave the building more of a Gothic appearance.[36]

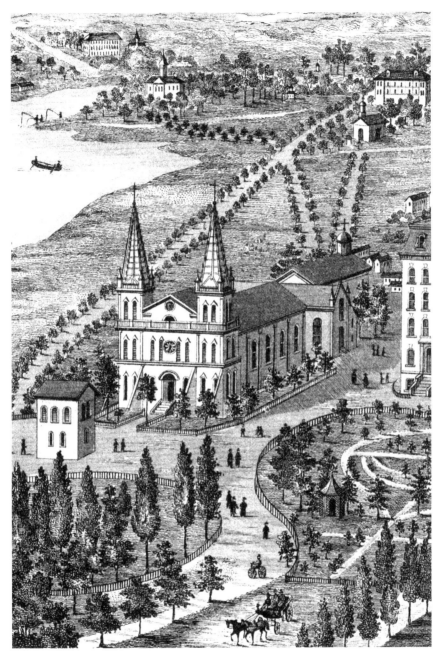

FIGURE 2.4
Church of the
Sacred Heart of Jesus,
1848–1852.
(Courtesy of
Notre Dame Libraries
Special Collections.)

The Church of the Sacred Heart of Jesus was consecrated in November 1849, with the bishops of Detroit, Vincennes, and Chicago presiding. Father Sorin stated that "It was small but very pretty," and he noted that it had three altars on which the holy mass could be celebrated all at the same time.[37]

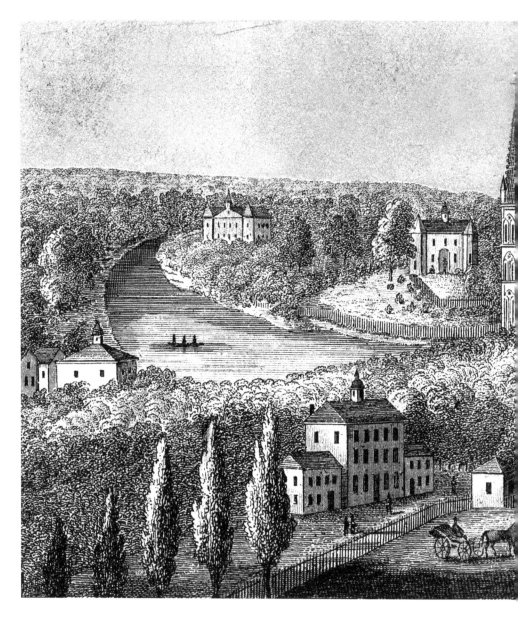

Saint Mary's College

In 1843 four Sisters of the Holy Cross traveled to South Bend from Le Mans, France, to share in the apostolate of education with the priests and brothers of the Congregation of the Holy Cross. In 1844, under the leadership of Sister Mary of Saint Angela, the sisters opened their first school, but not in South Bend. Bishop Hailandière refused to grant them permission to establish their

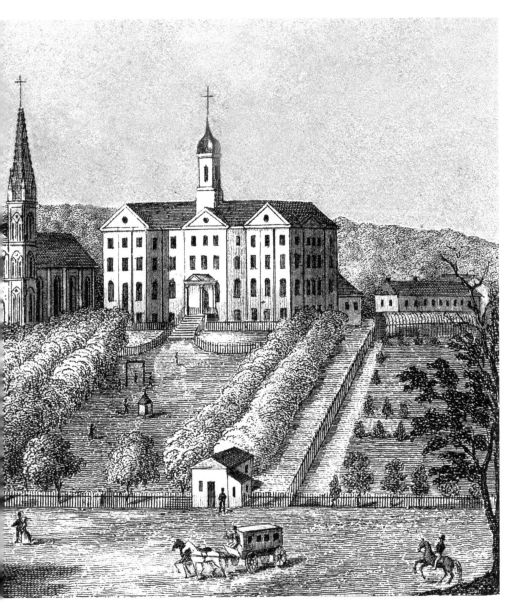

FIGURE 2.5
View of Notre Dame
campus ca. 1855,
with the new church
in the center and the
expanded Main
building at the right.
(Courtesy of Notre
Dame Libraries
Special Collections.)

school near Notre Dame. Instead, the sisters offered their first classes in the village of Bertrand, Michigan, a few miles north of Notre Dame du Lac, where the bishop of Detroit agreed to allow the school to operate. Called Saint Mary's Academy, it was a boarding school with precollegiate grades, its campus comprised of a rented house, a small chapel, and a blacksmith's shop.[38]

The village of Bertrand had been established in 1815 by Joseph Bertrand as the location of a trading post for the American Fur Trading Company,

shortly before Pierre Navarre arrived at LaSalle's Landing. Located on the east bank of the St. Joseph River, it was about halfway between LaSalle's Landing and the former site of Fort St. Joseph. It was a strategic point on the Great Sauk Trail that connected Detroit with Chicago.[39]

In 1855, under the leadership of Father Sorin and Mother Angela Gillespie, and with the approval of the new bishop of Vincennes, Jacques Maurice de St. Palais, the school was moved to its present site west of the Notre Dame campus, a 185-acre tract overlooking the St. Joseph River.[40] Some of the buildings, including the chapel, were moved from Bertrand and reconstructed at the new location.[41]

Father Sorin surmised in his *Chronicles* that it would perhaps be impossible "to find another site in all the length of the St. Joseph, so well suited and so charming as that occupied today by this Institution"; he described it as covering "a magnificent plateau bounded on the south by the river at a depth of seventy-five feet, and on the west by a rich prairie." He even included a simple line drawing of a proposed plan for the campus buildings, composed of a range of four dormitory buildings lined up in a row, with a larger building, perhaps a chapel, front and center. He wrote that one of the dormitory buildings, corresponding to the site of the future Lourdes Hall, "was entirely finished and afforded room for sixty boarders and some thirty Sisters."[42]

Whether he knew it or not, Father Sorin's linear alignment of buildings for Saint Mary's was similar to the plan for Yale Row in New Haven, Connecticut, created by amateur architect William Trumbull in 1792. Five aligned buildings were shown in Trumbull's plan: three dormitories, a chapel, and a library/recitation hall. Trumbull defended the linear arrangement, arguing that buildings placed at ninety-degree angles to each other would not have any degree of elegance or uniformity.[43] The plan of Yale Row had a strong influence on the layout of many other colleges, including Dartmouth, Brown, Amherst, Colby, Bowdoin, and Hamilton, to name only a few. Architectural historian Paul Venable Turner described it as "a bold and impressive innovation in collegiate planning."[44]

By the time the first buildings were constructed on the campuses of Notre Dame University and Saint Mary's College, South Bend had reached a formative moment in its physical history, the foundation on which the nineteenth-century city would develop. During this period of early settlement of the city and the two campuses, Father Edward Sorin was one of the most influential personalities in the region. Historian Timothy Howard described him in glow-

ing terms: "Here was united the zeal of a saint with the fervor of a patriot, the devotion of Columbus with the unselfishness of Washington."[45] The archbishop of St. Paul stated at the golden jubilee of Father Sorin's priesthood, "From the moment he landed on our shores, he ceased to be a foreigner. At once, he was an American. . . . He understood and appreciated our liberal institutions; there was in his heart no lingering fondness for the old regimes, or worn-out legitimism. For him the government chosen by the people, as Leo XIII repeatedly teaches, was the legitimate government; and to his mind the people had well chosen, when they resolved to govern themselves."[46] Under Father Sorin's leadership, Notre Dame and Saint Mary's were now fully established as Catholic educational institutions. Their work in building up these institutions helped to attract new settlers to South Bend and northern Indiana, and above all they helped raise the educational level of students who, until now, had been largely children of the backwoods.

The question of the relationship between the growing city of South Bend and its college campuses was not as straightforward as that between Yale and New Haven, for instance, where both had the common goal of Puritan excellence and leadership. South Bend was a mixed city, with several Protestant congregations—Methodist, Baptist, Presbyterian—competing with the French Catholics for influence and patronage. The priests of Notre Dame provided for the region ministry to the remaining Native American population and the establishment of a private university and college. South Bend, with its commercial developments and its water-powered mills along the East and West Races provided an attractive destination for workers from the East Coast. While they were not necessarily ideologically or religiously linked, they shared a common goal of improving and growing the northern Indiana region and the St. Joseph River valley.

South Bend's First Works of Architecture

The character of South Bend's first distinctive buildings, although influenced by European models, was adapted to American conditions. High styles were generally reduced in scale and built of indigenous materials, and they featured restrained ornamental details. Buildings on much of America's East Coast had been dominated during the colonial period by the English Baroque, more commonly known as the Georgian style.[1] It dominated residential construction in the American colonies from roughly 1700 to the 1770s, long before South Bend was founded. Influenced by the work of the British architects Christopher Wren and James Gibbs, it was brought to the colonies primarily through pattern books and building manuals, which ranged from expensive treatises to inexpensive carpenters' handbooks.[2]

The period just before and after the Revolutionary War saw a shift to more classical influences largely brought about by an English translation of Andrea Palladio's *Four Books of Architecture* (1714), Colen Campbell's *Vitruvius Britannicus* (1714), and Gibbs's *A Book of Architecture* (1728).[3] Numerous examples of this Palladian influence are found on the East Coast, from Virginia to Rhode Island, including Mount Airy in Richmond County, Virginia (1758–1762), Carter's Grove in James City County, Virginia (1750–1753), and the First Baptist Meeting House in Providence, Rhode Island (1774–1775).

Somewhat later, from about 1785 to 1840, European influence on American architecture shifted again, manifesting itself for the most part in what was called the Federal style. It was a period when the country was politically independent but still culturally and artistically allied with England.[4] As it was

developed in the United States, it was the creation of a wealthy mercantile aristocracy, concentrated primarily in the coastal communities of New England. Many of the affluent gentlemen formed the core of the Federalist Party under Alexander Hamilton, thus the term *Federal style*. It retained strong cultural ties to England, preferring not to depart in any radical way from its architectural traditions.[5] Two of New England's most important architects working in the Federal style were Charles Bulfinch, designer of the Massachusetts State House in Boston, and Samuel McIntire, the designer of numerous Federal-style houses in Salem, Massachusetts.

Federal-Style Residences

The Federal style drew heavily on the work of British architect Robert Adam and his brother James, who had a large and influential practice in Britain in the second half of the eighteenth century. Robert, the eldest brother, had traveled to Italy and the Mediterranean in the 1750s to study ancient Greek and Roman buildings under French architect and antiquarian Charles-Louis Clérisseau, as well as Giovanni Battista Piranesi, an Italian architect and artist known for his etchings of Rome's ancient and modern buildings. When Robert returned to England in 1758, The Adam brothers established an architectural practice in London, their work becoming known for incorporating ancient decorative design elements such as swags, garlands, urns, and various stylized geometric forms. In addition, they experimented with innovative plan compositions, incorporating semicircular and oval forms into otherwise rectangular and symmetrical arrangements.[6]

The Adam brothers' work became known in the United States largely through *The Practical Builder*, by William Pain, which was first published in London in 1774 and became available to American builders after its publication in Boston in 1796. Combining classical models with emotional and philosophical associations, their work represented a new romantic attitude that stood in contrast to the more academic Palladian tradition of the previous years.[7]

Houses in the Federal style were basically classical in conception, with fine proportions, simplicity of massing, symmetry, and restrained ornamentation, qualities which were evident in the first Main Building on the Notre Dame campus. Houses generally had a rectangular plan, a central hall, gabled

FIGURE 3.1
Joseph G. Bartlett
House,
720 W. Washington
Street, 1850.
(Photo by author.)

or hipped roofs, and either single or paired chimneys. They had a simple cornice and eave design, while most embellishments appeared around the front door, which was often framed with fluted pilasters and topped by a fanlight and a segmental arch.[8]

One of the earliest and most distinguished Federal-style houses in South Bend is the Joseph G. Bartlett House, at 720 West Washington Street. The grandson of Josiah Bartlett, a signer of the Declaration of Independence and

governor of New Hampshire, Joseph Bartlett came to South Bend in 1837, six years after the town's founding, and established a bakery downtown, which over the years grew into a grocery store, hardware store, and restaurant. His house, constructed in 1850, is two stories on a T-shaped plan, with a crossing gable roof, wooden front porch, and an impressive front door with sidelights and transom. The first brick house of its size in South Bend, it was designed by Bartlett's brother-in-law, Jonathan Webb, a New Hampshire contractor, who had been familiar with the work of the Adam brothers and may have had a copy of Pain's *The Practical Builder*.

To see the Bartlett House today is to view it in a very different context from its original setting. It was once the largest house on the street, enhanced by its formal, landscaped lawn. Around it were workers' cottages of wood-frame and clapboard construction. Today, in contrast, it is one of the smaller houses on the street and it is partially hidden from view by a mature stand of trees in the front lawn. None of the nearby houses have the same relation to the landscape, all of them edging up near the sidewalk with tiny front yards and wide porches. While the Bartlett House had a stately detachment from the street, these later houses engage the public realm with their porches and their close proximity to the street. They represent a different era, one in which houses were typically larger and of wood construction and residents would socialize with passersby from their front porches.

Greek Revival

The Federal style marked the first serious architecture in South Bend, but in the 1850s the more distinctive and politically motivated Greek Revival began to supersede it. As architectural historian William Pierson wrote, an interest in the Greek Revival had emerged in the second half of the eighteenth century as a means of establishing a national identity that would set itself apart from northern Europe. Greek forms were not tainted with the connotations of aristocracy or of the church, as the Roman, French, and English Renaissance traditions were. There was also the fact that Americans sympathized with the Greeks in their struggle for independence from the Turks.[9] Architectural historian Talbot Hamlin wrote that although there was a certain level of knowledge of Greek architecture in the American colonies even before the Revolution, "it required the Greek rebellion, so thoroughly and sympathetically

publicized by Byron, to set men's minds aflame with the idea of the beauty and the grandeur that was ancient Greece."[10]

It should be noted that the Greek Revival style became popular in England before it did in the United States, and that some of America's best Greek Revival buildings were inspired by British precedents, such as John Nash's Carlton House Terrace and John Soane's Board of Trade in London. While the United States was distancing itself politically from England during the second half of the eighteenth century, historian W. Barksdale Maynard wrote that its architects and builders remained eager to "be considered tasteful by English standards." Concerned that American architecture was inferior to that of Europe, they continued to look to British models, as they did to other European countries. As Maynard wrote, "Political rivalries aside, in aesthetic matters England was not considered a foreign culture, but nurturing parent to America's."[11]

Greek Revival architecture appeared sporadically at first in Philadelphia and Virginia, one of the most significant examples being Benjamin Latrobe's Bank of Pennsylvania, built in Philadelphia from 1798 to 1800.[12] The first commercial building to combine influences of both the Roman Pantheon and the Parthenon in Athens, it had a portico of six Ionic columns and a rotunda in the center topped by a low dome.

The construction of the U.S. Capitol Building in Washington, DC, at the beginning of the nineteenth century, established Greek forms and monumentality as the ideal of American governmental architecture. Further, the appointment of Latrobe as the architect of the Capitol in 1803 was a crowning victory for classical architecture in the United States. Latrobe was one of the first builders to use variants of the Greek orders in the United States in a way that was unique to the American context by designing column capitals of tobacco and maize.[13]

William Strickland and Robert Mills, both pupils of Latrobe, also did much to make the style popular. Philadelphia banker Nicholas Biddle commissioned Strickland to design his Second Bank of the United States (1821–1824) in imitation of the Athenian Parthenon, and later, Strickland became famous for his Greek-inspired design of the Tennessee State Capitol (1845–1849) in Nashville. Mills employed colossal Ionic columns in the U.S. Treasury Building in 1836. Closer to home, the New York architects Ithiel Town and Alexander Jackson Davis designed the Indiana State Capitol (1831–1835) in Indianapolis in the form of an elongated Greek temple, with a cylindrical tower rising from the center.[14]

FIGURE 3.2
State Bank of Indiana,
Michigan Street at
E. Colfax Street, 1841.
(From Anderson and
Cooley, *South Bend
and the Men Who
Have Made It*.)

Pierson describes three distinctive features of Greek Revival buildings in America from the first decades of the nineteenth century, namely scale, construction techniques, and a predominance of the gentleman amateur architect. Again, these buildings were smaller in scale than European examples. Smallness was a pervasive architectural characteristic in the first decades of the nineteenth century, a feature that set them apart as provincial in comparison to the architecture of England or France. Even the most important early government buildings in America, such as Independence Hall in Philadelphia or the Massachusetts State House, were diminutive in size and domestic in scale in comparison with their European counterparts.[15]

The second characteristic of these buildings, according to Pierson, was their structural type, based nearly always on a combination of wood and masonry. Brick or limestone walls, with a timber frame inside, was the most common structural method. Few American architects or builders, especially those practicing in the Midwest, had the knowledge or experience for structural innovation on a monumental scale comparable to European builders.[16]

The first Greek Revival building constructed in South Bend was for the State Bank of Indiana in 1841. The bank had outgrown a smaller brick build-

ing at the corner of Michigan and Market Streets that had been built only four years earlier.[17] Its builder was E. J. Peck, a carpenter and bricklayer from Indianapolis who had constructed several other banks around the state. Its cost was estimated at $11,000.[18] The design of this new building was a refined Greek temple style featuring a portico with four fluted Doric columns that supported a plain entablature and a gabled roof with a front pediment. Pilasters lined the side walls, and in the rear, a two-story wing contained offices and an apartment. Initially its interior was lit only from above through a circular skylight, but later, three windows were added to the building's north flank. The front steps, initially built of wood, were also replaced soon after construction with limestone steps.[19]

The bank was a smaller version of Strickland's Second Bank of the United States, although its columns were larger in overall proportion to the rest of the building. The fact that the bank's officers chose to imitate the style of a prominent East Coast banking institution indicates the extent to which they sought legitimacy for their company based on established eastern practice. In 1864, as state banks were legislated out of existence in favor of a national currency and a system of national banks, the building became the new headquarters of the First National Bank of South Bend.[20]

The Second County Courthouse

The most distinctive work of architecture in South Bend from the early period of its growth and settlement is the second St. Joseph County Courthouse, designed and built in 1855 by the Chicago architect John Mills Van Osdel. Although its original location was the southwest corner of Main and Washington Streets, it was moved to its present location facing Lafayette Street in 1896 to allow for construction of the third county courthouse. A national historic landmark, it is one of three surviving Greek Revival courthouses in the state of Indiana, and one of the few remaining examples of Van Osdel's work.[21]

Van Osdel designed the building in the Greek Revival style, with load-bearing walls constructed of yellow sandstone supplied by the Illinois Stone and Lime Company for a cost of $7,685.[22] It has a low-pitched gable roof in the Greek style. Its plan, which measures sixty-one feet wide and ninety-one feet long, is that of a temple, with a pronaos with four columns across and one bay deep. The portico columns have corn-leaf capitals molded in Egyptian-

FIGURE 3.3
Second St. Joseph
County Courthouse in
its original location
at the corner of
Main and Washington
Streets, 1855,
John Mills Van Osdel,
architect. (From *Art
Work of South Bend
and Vicinity*.)

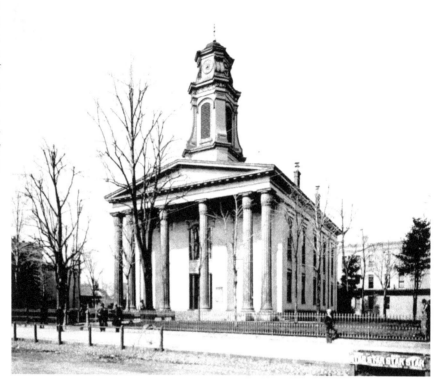

inspired bulbous forms, likely an intentional evocation of Latrobe's use of the corn-leaf capital in his design of the United States Capitol five decades earlier. While the style of the building is Greek Revival, further influences of English Baroque architecture are seen in a fifty-foot-high wooden cupola with clock face. The clock was imported from England by Reeve and Company of New York. The thirty-seven-inch bell, weighing one thousand pounds, was imported from Germany.[23]

In plan, the building's first floor contained offices, laid out on either side of a fourteen-foot-wide corridor running the length of the building. Two stairways on either side of the entrance vestibule led to a second-floor lobby and the spacious courtroom, which measured fifty-seven by fifty feet, with a twenty-foot-high ceiling. As it was the only large public hall in the county, it doubled as a space for weddings and receptions until the 1870s.

Van Osdel was one of Chicago's earliest notable architects. Born in Baltimore, Maryland, he was the son of a builder and architect. Early in his life, his family moved to New York, where his father became a successful builder. The young Van Osdel learned architecture from his father and moved to Chicago

in 1837, the year the city was incorporated, when it consisted of little more than a cluster of houses and small commercial buildings scattered around Fort Dearborn. He started his own practice, designing a number of houses and institutional buildings in the Greek Revival style. These included the first Palmer House Hotel, Tremont House Hotel, McCormick Block, Clifton House Hotel, the Kendall Building, and Old Market Hall in Chicago.[24] In Indiana, besides the South Bend courthouse, he designed the La Porte County Courthouse in 1853 (now demolished). At the time he designed the St. Joseph County Courthouse, he was working under the firm name of Van Osdel and Olmsted.

As with other builders and architects of the period, Van Osdel enhanced the skills he learned from his father largely from books. A colleague wrote, "Here [in 1835–1836] was a working man who had read every book in the Apprentices' Library. What is more, he had redrawn or redesigned every piece of work shown in those books. He had organized classes to which he had taught drawing."[25] From these books and plates he would have learned the classical vocabulary. Most of them were brought from the East Coast, including a series by Asher Benjamin and Minard Lafever, both of whom published detailed drawings of the Doric order.[26] In 1797, Benjamin published the first edition of *The Country Builder's Assistant*, and in 1806 he published an expanded version as *The American Builder's Companion*, which went through six editions.[27] In the last edition, published in 1827, he added plates of all five Greek and Roman orders, which were based on John Haviland's lesser known *The Builders' Assistant* of 1818.[28] He subsequently published *The Practical House Carpenter* (1830), *The Builder's Guide* (1839), and *Elements of Architecture* (1843), among many others, which became highly influential across the country.[29]

Lafever published his *Young Builder's General Instructor* in Newark in 1829, which further popularized ornament and construction details for Greek Revival architecture.[30] In 1833 he published *The Modern Builder's Guide*, which went through six later editions, and in 1835 he published *The Beauties of Modern Architecture*, which included reconstructed views of the Parthenon copied from the English architects James Stuart and Nicholas Revett. Like Benjamin, Lafever was a carpenter, in this case from central New York State. His books featured the two versions of the Doric and Ionic orders and one Corinthian, in addition to details for fireplaces, doors, cornices, frieze detailing, wall and window treatments, and ceiling designs.[31]

Other authors included Owen Biddle, who published *The Young Carpenter's Assistant* in 1805. His cousin, Nicholas Biddle, published in *Port Folio*

several articles that stressed the importance of Greek architecture. He was one of the first Americans to go to Greece, traveling there in 1806.[32] Also important was Peter Nicholson's *The Carpenter's New Guide*, published in Philadelphia in 1818.[33]

Many of the illustrations in these pattern books were based either directly or indirectly on the work of Stuart and Revett, who had studied and measured the Greek monuments in Athens from 1751 to 1754. They published their first volume of *The Antiquities of Athens* in 1762; it documented the post-Periclean buildings such as the Tower of the Winds, the Choragic Monument of Lysicrates, and Hadrian's Library. The second volume, documenting the buildings on the Acropolis, the Parthenon and the Erechtheum among them, was published only in 1790, two years after Stuart's death, and the third volume did not appear until 1794.[34]

Perhaps even more important in opening the eyes of European and American builders and architects to the fascinating imagery of Greek architecture was the last of the works by Giovanni and Francesco Piranesi, the twenty dramatic views of the three Greek temples in the southern Italian city of Paestum, published in the *Différentes vues de quelques restes de trois grands édifices : qui subsistent encore dans le milieu de l'ancienne ville de Pesto autrement Posidonia qui est située dans la Lucanie*, issued in 1778.[35]

It was these volumes, with their exquisitely detailed measured drawings, that began to make the architecture of Greece accessible to artists, connoisseurs, antiquarians, archaeologists, and architects, including builders on the American frontier like Van Osdel. Greek architecture began to have a profound influence on the work of numerous English architects, from Wren and Gibbs to Nicholas Hawksmoor and Robert Adam. The Tower of the Winds and the Monument of Lysicrates were adapted as colonnaded circular and octagonal tower stages for the design of church steeples, bell towers, and town-hall cupolas; refined versions of the Doric and Ionic orders came to be used extensively in the design of porticos and colonnades and as pilasters attached to monumental wall surfaces; and ornamental details based on archaeological drawings became common in religious, civic, and residential design.[36] Proper Greek proportions and details began to appear in the work of America's earliest professional architects, from Bulfinch and Latrobe to Samuel McIntire and Mills.

Van Osdel's design of such a distinguished work of architecture in South Bend, drawing as it did from these wellsprings of architectural literature,

added a level of dignity to the city's downtown despite its inadequate site. The lack of a true town square, with axial approaches at midblock, meant that the courthouse did not have a presence that was entirely fitting for the county and city's main governmental building. Its location at the corner of the block, like any commercial building of the time, lent it a less-than-exalted position within the community, a fault that can be laid directly at the feet of surveyor William Brookfield.

The building we see today is not in its original location. When plans were made for the third county courthouse in 1896, the county commissioners wanted to use the same site. Rather than demolish the old courthouse, as so many other communities had done, the commissioners decided to move it to a new location directly west of the original site and turn it 180 degrees so it faced Lafayette Street. Movers were hired to jack it off its original foundations, put rollers under it, and move it a hundred yards to the new site. It has a much taller appearance today than in its original location, as the podium was built up higher and a set of broad steps placed in front leading to the Lafayette Street sidewalk.

It succeeded as best it could, however, in providing an image of legitimacy for South Bend's governmental institutions, metaphorically linking it to elite cities such as Philadelphia and Washington. At the same time, it linked South Bend to the work of other regional Indiana architects, such as George Kyle and Francis Costigan, who constructed Greek Revival houses and civic buildings in towns such as Madison, Connersville, Lawrenceburg, and Fort Wayne.[37] The *St. Joseph County Forum* reported in 1855 that St. Joseph County was "now in possession of the most elegant, commodious and perfectly arranged court-house in the west" and should take "just pride in view of the completion of an edifice that speaks so pertinently for the advance of solid prosperity of St. Joseph County."[38]

For these earliest years in South Bend's history, the Greek style came to represent the order, the learning, and stability of the ancient Greek democracies. The builders of Greek Revival structures were creating symbols of a political ideal as much as functional buildings in which to live and work. This appropriation of a historical style was part of the larger American trend toward romanticism, that is, the urge to revive historic styles representative of past civilizations. Romantics looked longingly to the past as scholarship and learning broadened their panorama and led them to regard buildings as revelatory of the nature of the society they were built to serve.[39]

FIGURE 3.4
Second St. Joseph
County Courthouse in
its current location at
112 S. Lafayette Street.
(Photo by author.)

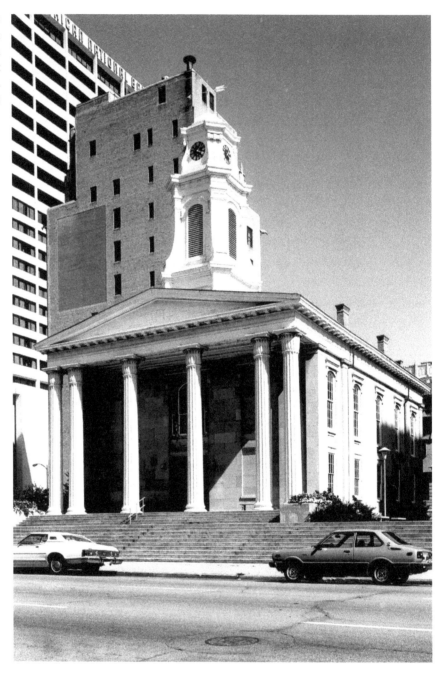

The urban image of South Bend took on a new dimension as it expanded in conjunction with Notre Dame and Saint Mary's as well as the growing number of manufacturing companies started during the 1850s and 1860s. These institutions and companies had a profound influence on the city, helping

to transform it into a major educational and industrial center. First and foremost of the industrial companies was H. & C. Studebaker (later known as the Studebaker Brothers Manufacturing Company), which grew to be the world's largest producer of wagons. It was followed by the Oliver Chilled Plow Works, the Singer Manufacturing Company, the Birdsell Manufacturing Company, and the Bendix Corporation, as well as countless smaller supporting industries. These institutions and companies remained prominent and provided much of the impetus for the city's growth and development for the next one hundred years.

Downtown South Bend expanded accordingly during the 1850s and 1860s, a time when its population more than doubled from 1,652 to 3,833.[40] In 1852 the Odd Fellows organization built a three-story brick building in the Federal style at the corner of Main and Washington Streets. In 1856 the St. Joseph Hotel was built at the northwest corner of Washington and Main Streets. A new county jail was constructed at the southwest corner of the courthouse block in 1860, featuring Gothic-style crenellations and a corner turret.[41] By midcentury South Bend had many of the commercial, civic, educational, and religious elements needed for a growing city. Another generating force behind its continued development during the second half of the nineteenth century was its location on several important transportation routes which facilitated the production of its many and growing industries.

Developing the Early Nineteenth-Century Neighborhoods

As South Bend's downtown commercial district grew during the middle decades of the nineteenth century and through the period of the Civil War, larger buildings were constructed to replace those of the early settlers. At the same time, the city expanded with the development of new residential neighborhoods. This residential growth tended to follow the major streets: Washington and Lincolnway on the west, Portage and Michigan on the north, Colfax and LaSalle on the east, old Vistula Road on the southeast, and Michigan on the south.

These neighborhoods were developed almost entirely with wood-framed, freestanding single-family homes and cottages constructed by independent builders and individual homeowners with the help of bankers and speculators. The city provided improvements to streets, many of which were at first no more than gravel, followed by brick or macadam paving. Low-, middle-, and upper-income residents alike were served by this system of private development with support from the city for infrastructure.

Immigrants from eastern and southern states, attracted to jobs in the city's flourishing industries, moved northward and settled into these neighborhoods. They included Germans, Belgians, Italians, Hungarians, and Poles, many of them bringing skills that would be useful for South Bend's industries. As the city grew, the residential areas within walking distance of the commercial center filled with these working-class residents. Wealthy residents

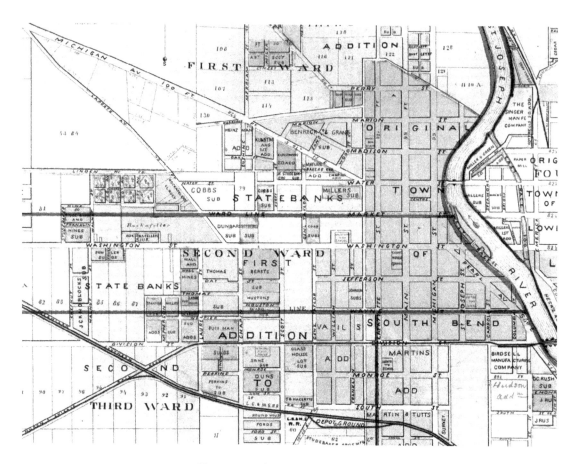

FIGURE 4.1
Plan of South Bend's
West Side. From *An
Illustrated Historical
Atlas of St. Joseph
County*, 1875.
(Courtesy of St.
Joseph County Public
Library, Local and
Family History
Services Oversize
Collection.)

constructed homes on the main streets to the north and west, while craftsmen, manufacturing laborers, and small shopkeepers occupied areas to the south and east.

The city's oldest nineteenth-century neighborhood was centered along Washington Street just west of downtown, around the site of the Bartlett House. The closest to downtown, it commenced two blocks west of Main Street and developed along a westward extension of Washington, Colfax, and LaSalle Streets. While today it is separated from downtown by two to three blocks of transitional, mixed-use buildings, vacant lots, and parking lots, in the nineteenth century it was a natural extension of the commercial district.

The West Washington Street neighborhood, the first in the city to be listed on the National Register of Historic Places, is today home to many significant houses. West Washington Street itself has the appearance of a boulevard. The street is wide and lined with trees and ample sidewalks. Many of the houses are set back from the street, and several have low stone walls along the sidewalk.

Even though its historic character is interrupted by an occasional out-of-context building or parking lot, it retains enough of its charm to be an attractive and historically interesting neighborhood.

The earliest styles of residential architecture found in these neighborhoods were the Federal style and the Greek Revival. They were followed by the Gothic Revival, various forms of vernacular builders' styles, and then later by the Italianate, Second Empire, Stick, and Queen Anne styles. The years between the 1820s and the 1860s saw the emergence of a broad popular culture and a burgeoning middle class, members of which became the new patrons of the arts and architecture. Many of them were highly educated, and their interest in architecture was fueled by the publication of more architectural handbooks and builders' manuals.[1]

Greek Revival Houses

Numerous houses were built in South Bend in the Greek Revival style, although few have survived into the twenty-first century. Several examples are

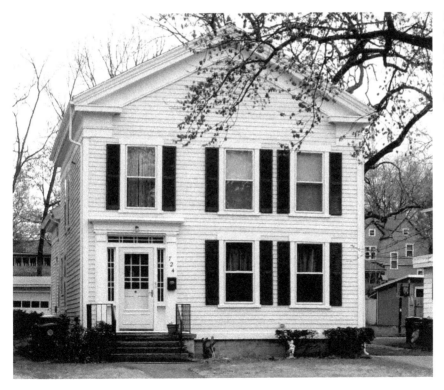

FIGURE 4.2
Gertrude Myers
Residence,
724 W. Colfax Street,
1852. (Photo by
author.)

still to be found in towns across southern Michigan, along the routes connecting Chicago and Detroit, and in southern Indiana along the Ohio River. While several examples of houses with front porches in the Greek manner had been built in South Bend in the 1840s and 1850s, none of them remain today.

The Gertrude Myers House at 724 West Colfax Avenue, built in 1852, best expresses South Bend's Greek Revival heritage. A two-story house with a front pediment and corner pilasters suggesting a temple-like appearance, its Greek Revival features include wide frieze boards under the eaves, cornice returns on the front facade, and an entrance door elaborately decorated with sidelights and a transom. It is the kind of design whose form and details could be found in books discussed in chapter 3, such as Benjamin's *The Country Builder's Assistant* or *The American Builder's Companion*, or Haviland's *The Builders' Assistant* or *The Practical House Carpenter*.

Gothic Revival

By the 1850s, as interest in the Federal and Greek Revival styles began to wane, a more picturesque mode was introduced in the form of the Gothic Revival. As Wilbur Peat describes it, interest in the Middle Ages first took hold in literature, as poems and novels by Lord Byron, Sir Walter Scott, and others who extolled the legends and historic episodes of medieval culture were widely read. Architects and builders began publishing builders' handbooks that featured picturesque elevations with Gothic forms and ornament. There was an increasing desire for more ornamentation and versatile plans as opposed to the austerity and geometric rigidity of the Greek Revival.[2]

As historian John Maass explained, in contrast to the Greek Revival house, which was designed to fit behind a traditional facade and placed in a formal garden where it could be viewed from the standpoint of Renaissance perspective, the Gothic Revival house was more picturesque, breaking free from "this academic scheme." These houses were planned from the inside out, the free layout of the rooms determining the outward image. The picturesque profile of their facades was enhanced by the effects of sunlight, shade, and foliage.[3]

In contrast to the horizontality and the bulky form of the Doric order, the Gothic Revival featured vertical or perpendicular accents with steep roofs, tall lancet-arched windows, and siding composed of vertical boards and battens. Ornamental features included hood moldings over the windows, bargeboard

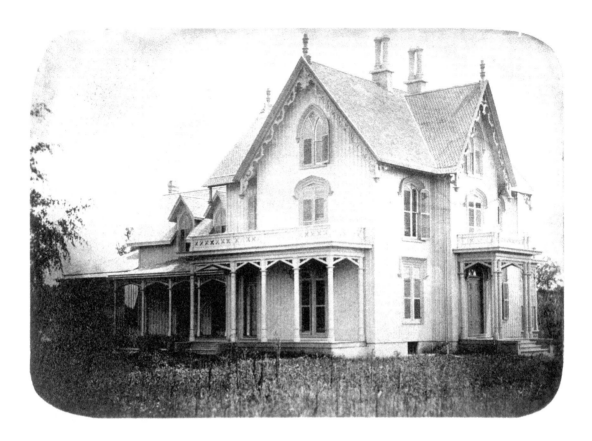

with cusped tracery along the eaves, and finials and pinnacles on the roofline. The handbooks that served as guides for builders, carpenters, and millwrights, published by Andrew Jackson Downing, Edward Shaw, Samuel Sloan, and others, were based on a broad range of precedents, from English Elizabethan or Tudor styles to the Italianate villa, and often included either castellated and turreted forms or bracketed cornices.[4]

The most impressive Gothic Revival house in South Bend is that built by Horatio Chapin, located near Navarre Street and Portage Avenue on the city's near north side. In the mid-nineteenth century this area, extending northward to the St. Joseph River, was farmland and woods. As it was platted later in the century, it was developed with a wide range of housing styles, from Greek Revival to Queen Anne, Prairie, and Bungalow styles, becoming one of the densest residential neighborhoods in the city.

Born in Bernardston, Massachusetts, in 1803, Chapin moved to Detroit in 1822, then to South Bend in 1831. He started out with a small general store and warehouse at the edge of the St. Joseph River and soon became one of the

FIGURE 4.4
Horatio Chapin
House, aerial view of
the garden.
From *South Bend,
Indiana, 1874*, by
J. J. Stoner Co.,
Madison, WI.
(Courtesy of
Library of Congress,
Geography and Map
Division.)

city's active business and religious leaders. He worked for over twenty years as a cashier at the South Bend branch of the State Bank of Indiana, and he became active in the city's religious life, serving as a presiding officer of the First Presbyterian Church. In 1855 he purchased forty acres of land located between Navarre Street and the river, and in the following year, he began construction of his house.[5]

An early history of St. Joseph County, published in 1880, offered a glowing description of him: "Mr. Chapin was a man of considerable culture, being more or less thoroughly acquainted with several branches of knowledge, such as medicine, theology, finance, horticulture and natural science. He was a man of great strength and decision of character. With Puritan firmness he stood by his convictions and principles. In his character was illustrated the rugged strength of the oak. In his long career as a businessman, those who knew him most thoroughly testify to his lifelong integrity."[6]

Chapin had an extensive library and a passionate interest in both architecture and landscape design. He likely possessed copies of two recently published books by Andrew Jackson Downing, *A Treatise on the Theory and Practice of Landscape Gardening* (1841) and *Cottage Residences* (1842).[7] The latter, which was printed in seven editions up to 1868, contained numerous woodblock illustrations of Gothic and Italianate villas set in expansive landscaped lawns. Many of the houses were designed either by Ithiel Town or Alexander Jackson Davis, two of the leading architects of the time. Davis had published *Rural Residences, Etc., Consisting of Designs, Original and Selected, for Cottages, Farm-Houses, Villas and Village Churches* in 1837. As historian Daniel D. Reiff suggested, the houses illustrated in this book could not have "been further from the current Greek Revival mode."[8]

These houses typically featured steeply pitched roofs and gables trimmed with bargeboards, vertical board-and-batten siding, and round-arched and lancet-shaped windows with hood moldings. Ample porches featured Tudor details, brackets, and heavy wood railings. The architectural pattern books assisted builders with the accuracy of details, and what made them so popular was the fact that the illustrations showed simple house types, details, interiors, and landscape plans that could be easily followed by builders in the Midwest.[9]

Downing included a written chapter in *Cottage Residences* about architectural principles and theory, emphasizing the fitness of design for its purpose, the truthfulness of architectural expression, and the symbolic qualities of architecture.[10] He wrote about the importance of learning from European examples, especially the basic elements of architecture: proportion, symmetry, variety, harmony, and unity. He cautioned against slavish imitation, however, stating that architects and builders should recognize the domestic needs and living patterns of Americans, which could be different from those of their European ancestors. For a genuine national architecture to develop in the United States, he wrote, it had to combine foreign influences with the life and spirit of our own country.[11]

What made Downing's books so attractive to Americans interested in building a house was the fact that they did not stress construction and joinery details as so many early builders' guides had done; rather, his books featured many more perspective views of houses in attractive picturesque landscape settings. The illustrations were accompanied by lengthy discussions of the various house types and styles shown. As George Tatum wrote, "Downing

completely changed the American concept of what a book on architecture should be."[12]

Chapin's house was a synthesis of ideas found in Downing's *Cottage Residences* and also seen in his later book, *The Architecture of Country Houses* (1850).[13] It is an imposing residence, especially by South Bend standards. It is three stories high and cross-shaped in plan, and it has a broad porch and a symmetrically composed gable on the front. The porch had spindle columns with crossing pattern panels at the top of each bay. The scale is large, larger than most other houses built in the neighborhood before and since.

As with the Greek Revival, numerous similar Gothic Revival and Carpenter Gothic houses were built in the towns and rural areas of northern Indiana and southern Michigan, especially along the stagecoach routes connecting Detroit with Chicago. It was a picturesque, romantic, sentimental style that recalled the Middle Ages. Horace Walpole in England had built his house, Strawberry Hill, in the Gothic Revival style, and in 1790 Benjamin Latrobe built Sedgeley House, the first Gothic Revival house in the United States. The picturesque qualities came to rival the purity of the classical forms of the Federal and Greek Revival style. The books by Davis and Downing had an enormous influence on this movement, in the words of Reiff, "helping to transform architecture in America at the dawn of the Romantic era."[14]

Chapin was fascinated not only with architecture, but with landscape gardening as well. He planted more than a hundred species of trees and shrubs, which he ordered from the East Coast. They dotted the property north of the house, making his expansive lot seem more exotic and sophisticated than that of any of his South Bend neighbors.

When Chapin died in 1871, his estate was divided between his two children, Mary and Edward. They subdivided the forty acres into lots and had a street laid out down the center of the property which they called Chapin Place, now Park Avenue. It is the oldest brick street in the city still in use. The lots sold at a brisk pace, and new houses were soon built by lawyers, businessmen, doctors, and clergymen who were becoming prosperous from South Bend's industrial and commercial development.

The original Chapin House was purchased in 1888 by Christopher Fassnacht, president of the Indiana Lumber and Manufacturing Company and vice president of the Citizen's National Bank. He made significant changes to the Chapin House, first—and most dramatically—by moving it a half-block to the south and east of its original location. He had it picked up off its foundation

and moved on a bed of logs. It was also rotated ninety degrees so it faced Navarre Street near its intersection with Portage Avenue. The yard around it was cut down to a small lot, and its original picturesque landscaped lawn was lost forever.

Fassnacht also replatted part of the Chapin subdivision into smaller lots and built several of its houses, many of them in the Queen Anne and Stick styles. Today, the neighborhood is known as Chapin Park, the second-oldest of the nineteenth-century neighborhoods and still one of the most historic neighborhoods in the city, even as it fights for survival in the face of expansion of the nearby Memorial Hospital. Fassnacht would go on to play a prominent role in the construction of the Clement Studebaker mansion and the First Presbyterian Church, both located on West Washington Street.

It is a sad chance of fate that one of South Bend's most historic neighborhoods, with its most picturesque and historic street, lined with many of the city's most significant architectural landmarks, lies directly adjacent to one of the city's most important medical institutions. While not wanting to deny the hospital's constant need for expansion, it is, however, impossible not to lament the deterioration of and encroachment on the neighborhood. There is no way to effectively mediate between the physical edge of the historic neighborhood and the expanding boundaries of the hospital. The land is too constricted and too expensive to provide an adequate buffer, and there is no other way to provide space for new medical buildings than to tear down adjacent houses. The only hope is that the hospital will turn its attention in the future to the south, toward downtown, expanding more on the underutilized commercial properties and parking lots along its southern boundary.

The Powell House

Although an 1851 revision to the Indiana Constitution outlawing any further migration of African Americans into the state would remain in effect through the end of the Civil War, South Bend's modest African American population grew in the 1850s. The 1850 census registered twenty-six African Americans living in South Bend; thirty years later, that number had risen to 184. Barbering was a common profession, and many took jobs as domestic servants in South Bend's wealthiest households.[15] During these decades, the Farrow Powell family became one of South Bend's most prominent African American

families, and their home at 420 South Main Street offers a glimpse at the home-building styles common among South Bend's working-class residents in the city's early decades.

Farrow Powell was forty-nine years old when he moved to the South Bend area in 1857 or 1858 with his wife, Rebecca, and their extended family. Born in Chatham County, North Carolina, he had ventured westward with his brothers in 1833 at twenty-four years of age, settling first in Terre Haute and later in Owen County, northwest of Bloomington. Upon arriving in South Bend, the Powell family bought the property at 420 South Main Street, as well as land in Mishawaka and at the Huggart Settlement near Potato Creek. Writing in 1922, minister and local historian Buford F. Gordon recalled that the Powells were "active in business, church, and social life of the community."[16] Farrow and Rebecca, and their daughter and son, were among the charter members of Olivet African Methodist Episcopal Church, the first Black congregation in South Bend, at its founding in 1870. At their property on Main Street, the Powells constructed a home that came to be known as the Long House because their adult children and their families built dwellings of their own as additions to the home's rear. As a result, the narrow-fronted structure reached far back into the block. Surviving images suggest the Powells' home

was an austere, two-story dwelling with clapboard siding and tall, narrow windows.[17]

As the surrounding neighborhood transitioned from residential use to commercial development in the early decades of the twentieth century, portions of the house were scrapped. Some time in the 1940s, the remaining structure was sold and became a shed at the Inwood's housewares store on South Michigan Street. In 1972 the structure was on the brink of demolition, and a group of citizens mobilized to raise funds to purchase and move it to Navarre Park, where they intended to renovate it and turn it into a house museum. Although the house was successfully moved to the park the next year, funds for the museum project never materialized, and the Powell House was vandalized several times in the 1970s before an arsonist burned it down on Halloween night in 1980. Tragically, all that remains of South Bend's most historic African American home is its concrete slab foundation and a historical marker at its final resting place in Navarre Park.[18]

Italianate and Italian Villa

Within a few years of the construction of the Chapin House and Powell House, the Italianate or Bracketed style rose to popularity. While emerging from the same literary and pictorial traditions as the Gothic Revival, it possessed what the Gothic style lacked: classical order and control. Its sources were late eighteenth-century paintings depicting northern Italianate houses and landscapes, pattern books (including Downing's *The Architecture of Country Houses*), and firsthand experience from settlers arriving from southern France and Italy.

Elements of the Italianate style were also transmitted to builders through the work of John Nash and others in England and through English architectural pattern books. As with the Gothic tradition, the Italianate style was first seen in this country in New England and New York State and was brought to the Midwest by settlers coming down the Great Lakes, the Wabash and Erie Canal, the Ohio River, and overland on the Chicago Trail. By the 1850s it had become a popular style for large country and urban houses alike and remained so until the early 1880s.

Characteristics of Italianate houses included a cubical, two-story volume; tall, narrow windows with round, segmental, or flat arches or hood moldings;

classicized columns and details; broadly projecting cornices supported by elaborate brackets with three-dimensional patterns; and delicate spindlework porches. Often a cupola or belvedere was placed at the center of the low-pitched roof, and in some cases, a prominent entrance tower echoed the square campanile of the Italian Renaissance. Such towers, according to Maass, were "frankly for pleasure." They afforded a cool retreat where the breeze blew and the views were limitless.[19] The style gained popularity rapidly as it brought classical order to residential design while at the same time being both picturesque and beautiful. Its decorative elements were mass-produced, in both wood and pressed metal, and sold through catalogs.

Downing was one of the foremost writers to promote the Italianate style with enthusiasm equal to that of the Gothic Revival. His books included examples of Italianate houses and villas, in both square and irregular plans, which appealed respectively to "the man of common sense" and "the men of imagination."[20] He argued that the villa was the best and most complete manifestation of the Italianate style:

> The *Italian style* is, we think, decidedly the most beautiful mode for domestic purposes that has been the direct offspring of Grecian art. It is a style which has evidently grown up under the eyes of the painters of more modern Italy, as it is admirably adapted to harmonize with general nature, and produce a pleasing and picturesque effect in fine landscapes. Retaining more or less of the columns, arches, and other details of the Roman style, it has intrinsically a bold irregularity, and strong contrast of light and shadow, which give it a peculiarly striking and painter-like effect.[21]

Other books that helped popularize the Italianate style included Francis Goodwin's *Domestic Architecture* (1843), J. C. Loudon's *Encyclopedia of Cottage, Farm, and Villa Architecture* (1833), and the two volumes of Samuel Sloan's *The Model Architect* (1852–1853).[22] The latter, which was one of the most durable works of its kind published in the United States, was the earliest pattern book to publish Italianate houses that were square in plan with a central roof cupola, a type that became common in the Midwest.[23]

The style had become so popular by the 1860s that some regarded it as indigenous to the United States. A writer in the November 1868 edition of *The Architectural Review and American Builders' Journal* said of the Italianate style:

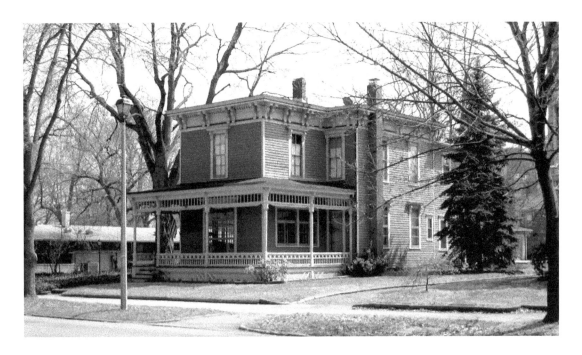

FIGURE 4.6
David Warner House,
710 W. Washington
Street, 1873.
(Photo by author.)

Its appearance is pleasing to Europeans; and, indeed it has many points about it superior to the domestic architecture of Europe.... Those prominent cornices, so highly ornamented, and those brackets, which, while they support them, give at the same time, such a distinctive feature of this style, as to be known to English architects, as American bracketed architecture . . . the features just named are, of themselves, all derived from European sources. Our climate prompted their application to our wants; and the native taste of our architects created that effect, which may now take the name of a style.[24]

Several exemplary Italianate-style houses were constructed in South Bend's West Washington Street neighborhood, including the David Warner House of 1873, at 710 West Washington Street, and the Ann Bulla House of 1882, at 1005 West Washington Street.[25] Both houses, representative examples of South Bend's architecture of the 1870s and 1880s, have recently undergone extensive restorations.

One of South Bend's most famous political figures, Schuyler Colfax, lived in an Italianate-style house located at 603 West Colfax Street. Colfax served with Ulysses S. Grant as vice president of the United States from 1869 until 1873. He was born in New York City in 1823 and moved with his family first to

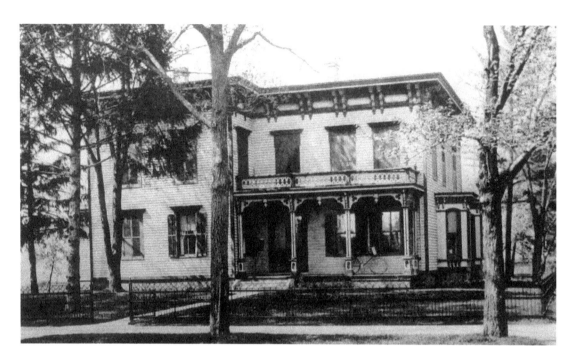

FIGURE 4.7
Schuyler Colfax
House, 601 W. Colfax
Street. (Courtesy of
The History Museum,
South Bend, Indiana.)

New Carlisle and then to South Bend in 1845. He worked as a newspaper re-
porter and founded the *St. Joseph Valley Register*. He contributed articles on
Indiana politics to the *New York Tribune* and formed a friendship with its re-
nowned editor Horace Greeley. He was elected to Congress in 1855 and served
seven terms, and he was Speaker of the House from 1863 to 1869.[26]

While serving as vice president, his term was marred by his implication,
along with several of the president's cabinet members and two congressmen, in
the Crédit Mobilier scandal. Involving illegal manipulation of construction
contracts for the Union Pacific Railroad, it became a symbol of corruption
after the Civil War. A congressional investigation revealed that the railroad's
principal stockholders created Crédit Mobilier of America in order to divert its
construction profits and give or sell stock to influential politicians in return for
favors.[27]

Colfax left Washington in 1875 a much-maligned politician. He returned
to South Bend, where he nonetheless continued to be held in high esteem by
the local community. He built his house on West Colfax Street, where he re-
sided until his death in 1885. The house then was occupied by his widow and
his son, Schuyler Colfax III, who served as South Bend's mayor from 1898 to
1902.[28] It was demolished in the 1920s to make way for the construction of a
club building that served for many years as the Progressive Club.

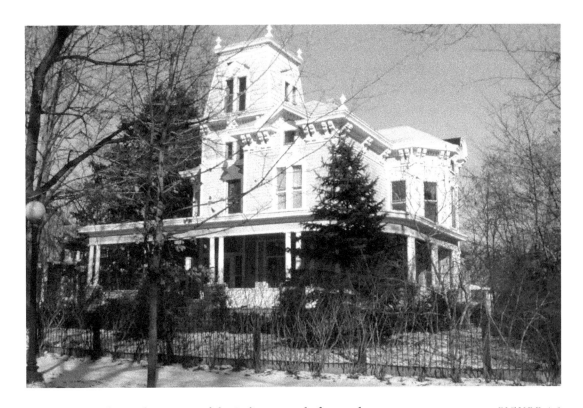

Some South Bend versions of the Italianate style featured a square tower, often thought to be characteristic of the Italian Villa style. The tower was usually placed alongside the front facade but sometimes occupied the corner where the wing intersects with the principal section of an L-shaped plan.[29] Tower roofs were either low-pitched and hipped or took the shape of a steep mansard, as seen in the Chauncey Lawton House at 405 West Wayne Street (1872). Peat wrote, "Nothing contributed more to the ostentation and pomp of a mansion, or even to a less pretentious residence, than a tower." The mansard roofs of these towers were often convex in form and contained dormer windows. Peat characterized this combination of a tower based on the mansard tradition of France combined with an otherwise Italianate building as a Transition style, a movement of the Italianate into the Franco-American style or Second Empire style.[30]

One such example was built in 1875 by Horatio Chapin's daughter, Mary, and her husband, Andrew Anderson. A lavish Italian Villa–style house located at 710 Park Avenue, it is not far from the original Chapin House.[31] It featured a three-story tower, paired brackets under the cornice, and eventually a broad veranda extending around three sides. Anderson was born in New

Developing the Early Nineteenth-Century Neighborhoods

York and attended Union College and the Albany Law School. Moving to South Bend in 1855, he joined the law firm of Thomas Stanfield and later established his own law practice in which he gained renown for handling several highly publicized murder cases. For many years, their Park Avenue house was the site of numerous social events and political gatherings.

In the case of residential architecture, we have seen that builders' manuals and pattern books often had a profound effect on its character and quality in South Bend, as it did in towns and cities across the Midwest. In some cases, the designs were copied from a pattern book with care and exactness. In other cases, a reasonably close variation was produced, though the builder took great freedom in interpretation of plans or facade details.[32] Moreover, homes such as the Powell House reveal how others among South Bend's early population constructed more spartan dwellings with an eye to practicality and the potential for ad hoc expansion and redesign. That said, houses built in the manner of the high styles represented in the pattern books demonstrate how stylistic trends circulated around the United States, and how ideas and theories about architecture changed over time, in some cases in response to international developments, such as the Greek revolution or the discovery of the Italian countryside. It is clear that South Bend was in step with trends occurring across the country.

Industrial Giants

As an industrial city, South Bend was dominated economically and socially by a handful of ambitious, resourceful, and ultimately very successful men. They built the industries that provided the economic force behind the city's development. They built the city's financial structure, many of its residential neighborhoods, and several of its downtown civic and commercial buildings. They stimulated its economic vitality and provided jobs that led to its population growth.

Among these industrialists, the Studebaker brothers and the Olivers, father and son, had more to do with shaping the city—both its economic base and its physical character—than any other group or individual. They were barons of the industrial world, masters at managing a large labor force, exploiting natural resources, and mass-producing products that were much in demand. In turn, they made themselves and their associates, as well as South Bend, very wealthy. In developing the city's commercial, civic, and religious architecture they sought to improve the quality of life for their employees, to make South Bend a better place to live and a more inviting place for prospective employees, and in the meantime, to earn profits from their extensive commercial and residential real estate investments.

A number of factors made the industrial expansion South Bend experienced in the second half of the nineteenth century and the success of the Studebakers and the Olivers possible. First, these companies constantly searched for new and better ways of doing things, invented new products, and employed the most efficient means possible to manufacture them. Second, the

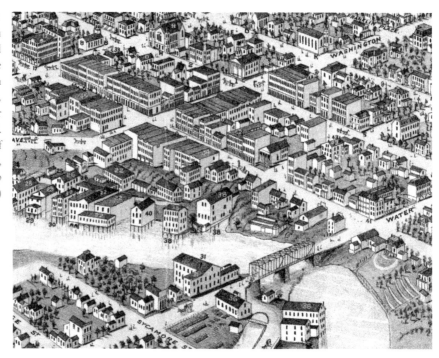

Midwest was a growing region with an ample labor supply and an expanding economy. Third, northern Indiana had abundant resources, especially lumber and power provided by the river. Fourth, transportation was an important factor in the development of the area as railroads, highways, and river transport made possible the delivery of goods to other areas of the country.

The architectural character of South Bend's industrial buildings was as diverse as the work carried on within them. The design of industrial buildings reflected a combination of factors: how materials and products were routed through the manufacturing process, where the power came from and how it was transmitted, what kind of machinery was used and where it was located, and how raw materials were received and newly made products shipped out. Over time these requirements demanded changes, thus requiring additions, alterations, renovations, and demolitions such that most of the city's factory complexes eventually reflected two or three eras of industrial architecture in terms of styles and construction techniques.[1]

The 1874 aerial view of South Bend provides a catalog of the water-powered industries located along the St. Joseph River and lining the races on either side. The river's west bank hosted the South Bend Iron Works; W. F. Smith Furniture; C. Liphart's furniture manufacturing company; Sibley, Mills,

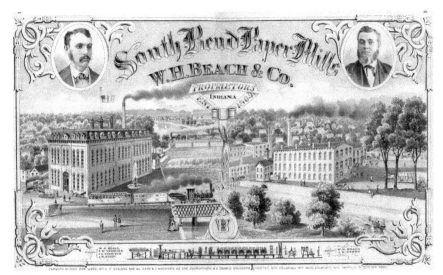

FIGURE 5.2
View of South Bend
Paper Mills, on the
East Race. From *An
Illustrated Historical
Atlas of St. Joseph
County*, 1875.
(Courtesy of St.
Joseph County Public
Library, Local and
Family History
Services Oversize
Collection.)

and Ware, machine tools manufacturers; the Eagle Manufacturing Company; and John G. Rilling's furniture factory, along with flour mills, a woolen mill, and a wagon manufacturer. Along the East Race were the Union Cabinet Manufacturing Company, South Bend Woolen Company, W. H. Beach and Company's news and book print paper mills, Josiah Thompson's furniture company, a grain drill works, and a second, unnamed woolen mill.

The paper miller Beach and Company, founded in 1869, was one of the most prominent companies located along the river and took advantage of the water power provided by the raceways. The 1874 aerial view shows two large brick buildings on the river's east bank, one fronting on Market Street (Colfax) and the other located two blocks north, facing Madison Street and the East Race. The first of these was the most architecturally distinguished. A stately building in the Second Empire style, it was three stories high with tall, round-arched windows and a mansard roof that featured three cupolas for ventilation aligned along its ridge. This building may in fact have been the first industrial structure in South Bend that was designed with as much emphasis on aesthetic appearance as on functional accommodation.

The Studebaker Manufacturing Company

The Studebaker Manufacturing Company became the largest of the corporate giants that defined South Bend as an industrial city. It was founded as the

Studebaker Wagon Works in 1852 by Henry and Clement Studebaker, the two elder sons of John Clement Studebaker, whose ancestors had immigrated to the American colonies from Solingen, Germany, in 1736.[2] Coming from a long line of metalworkers specializing in building and repairing wagons, John Clement's father had established the family's first blacksmith shop near Gettysburg, Pennsylvania, in 1790. Continuing the family business, John Clement built wagons and carriages, including a carriage used in 1824 by General Lafayette on a trip to America.[3]

By the mid-1840s, John Clement Studebaker had moved his family to Ashland, Ohio; they moved again to South Bend in 1848. He and his wife, Rebecca Mohler, had ten children, including five sons, each of whom eventually worked in the wagonmaking business. Four years after moving to South Bend, Henry and Clement Studebaker opened a blacksmith shop of their own, located in the middle of town at the southwest corner of Michigan and Jefferson Streets.[4] They ran their blacksmith business during the day while making Conestoga wagons in the evenings. These popular and efficient wagons, with bodies curved upward at the ends, were good for maneuvering over hilly and rocky roads and fording streams.[5] As the Studebaker brothers gained a reputation as wagonmakers, their business steadily increased. In 1857 they obtained a subcontract to make one hundred army wagons for a nearby factory, the Milburn Wagon Company of Mishawaka. The brothers expanded their blacksmith shop overnight, hiring dozens of new employees, adding several new forges and a kiln, and constructing a new building. They also expanded their product line by making lightweight buggies for use in cities.[6]

In 1858 a third brother, John Mohler Studebaker, joined the business. He had spent the previous five years in California repairing wagons and building wheelbarrows for gold-rush miners. Having saved up $8,000, he bought out Henry Studebaker's share of the fledgling South Bend company, and he and Clement continued expanding their operations.[7]

By the 1860s John Mohler and Clement were producing thousands of Conestoga wagons a year and selling them to settlers moving west. They also produced farm wagons, which were popular throughout the Midwest due to their quality of construction and innovative spring suspension system. The Studebakers' wide range of products also included dump wagons, buses, double-decker buses, and combination passenger and baggage wagons.[8]

The Civil War and the Reconstruction that followed proved to be an especially profitable time for the Studebakers as, following their work for the

Milburn Wagon Company, they were contracted to make hundreds of wagons for the Union army. In 1868, with 190 employees, the company was incorporated as the Studebaker Manufacturing Company, with Clement serving as president, John Mohler as treasurer, and the two youngest brothers, Peter and Jacob, as salesmen.[9]

The Studebaker Office and Showroom Buildings

Having outgrown its original site downtown, the Studebaker brothers purchased a ninety-eight-acre tract at the city's southern edge and constructed several new industrial buildings to house all of their production. Included in this new complex was a headquarters building containing offices for the Studebaker brothers, their staff, and a rapidly growing cadre of accountants, secretaries, and sales personnel. Built in 1870, it was a refined and monumental building, three stories high, designed in the Italianate style. It featured brick walls and elaborate paired brackets supporting a prominent cornice. Windows on the first floor were round-arched with pronounced keystones, while those on the second floor had segmental arches with pressed-metal hood moldings.

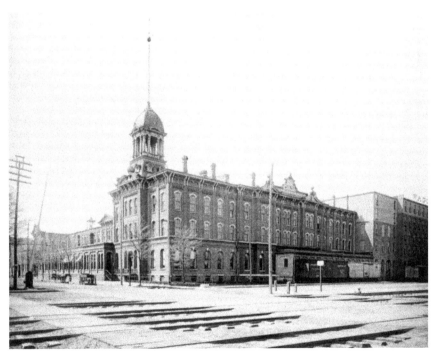

FIGURE 5.3
Studebaker
Manufacturing
Company Office
Building, 1870.
(From *Art Work of South Bend and Vicinity.*)

The main entrance on the east side projected forward and was marked by a broken segmental pediment and a hipped roof that supported a square temple-like cupola. It was an elaborate building for this Midwestern industrial town, reflecting the high aspirations the Studebaker brothers had for their company. Their concern for the image of the company as it was viewed by the outside world was indicative of nineteenth-century American industrialists' early understanding of the importance of quality design, whether in their products or in the buildings where they were made.

By 1870 the Studebaker Company was one of the country's largest suppliers of wagons, producing as many as seventy-five thousand vehicles in a single year with annual profits of over one million dollars. The Studebaker brothers used high volume, technological innovation, and extensive national marketing to be counted among the most successful businessmen in the country.[10]

Production was facilitated by the increasing number of railroads built through South Bend in the 1850s. The first was the Lake Shore & Michigan Southern, which connected Toledo and Chicago. Opened in 1851, it passed through the southern portion of the city directly adjacent to the Studebaker plant and continued eastward along the south side of the St. Joseph River to Mishawaka. Later, it opened a line from Niles to South Bend and changed its name to the Lake Shore & Michigan Central Railway.[11]

In 1879 a branch of the Grand Trunk Railroad was opened through South Bend, connecting Port Huron and Chicago.[12] Together the railroads fostered an accelerated expansion of commercial trade and manufacturing, as several trains a day stopped in the city, moving supplies and finished wagons east and west. Transport workers loaded and unloaded the trains, while laborers, agents, bankers, repair workers, and locomotive operators all had steady employment.

With their factory complex on the southwest side fully operational, the Studebaker brothers decided to better utilize their former downtown site at the corner of Michigan and Jefferson Streets as a showroom and office. In 1874 they demolished the original cluster of brick and wooden buildings and erected there a four-story structure to serve as the new home of their corporate offices, as well as an impressive showroom to display wagon and carriage models. For the city, it provided an important anchor for subsequent commercial development of the downtown area.

Although it was taller, at four stories, the new building was similar in style to the Italianate-style office building the Studebakers had built at the southern

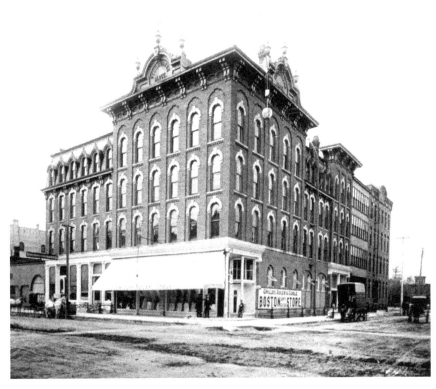

FIGURE 5.4
Studebaker
Headquarters,
corner of Michigan and
Washington Streets,
1874. (From *Art Work
of South Bend and
Vicinity*.)

edge of town. It was one of the first structures to expand the scale and quality of the city's urban buildings, establishing a new standard for design. It featured tall, round-arched windows, a symmetrical facade, and decorative paired brackets, dentils, and cornices made of pressed metal, many of the same elements found on the first building. The main block on the corner had a deeply projecting cornice with brackets, while a wing to the south was topped by a sloped roof lined with dormer windows. Both the Italianate and Second Empire styles were prevalent in commercial architecture across the United States throughout the 1860s and 1870s. Similar large, cubical buildings with rows of round-arched windows and prominent cornices can be found in nearly every city in the country. They required crews of skilled masons and woodworkers, while the proliferation of standardized, mass-produced decorative components put the latest stylistic details well within the reach of most builders.

In all, between thirty and forty buildings were constructed in the Italianate or Second Empire style in South Bend during the 1870s and 1880s. Most of them were two or three stories high and were built of brick with pressed-metal decorative elements. A prominent example was South Bend's Central High

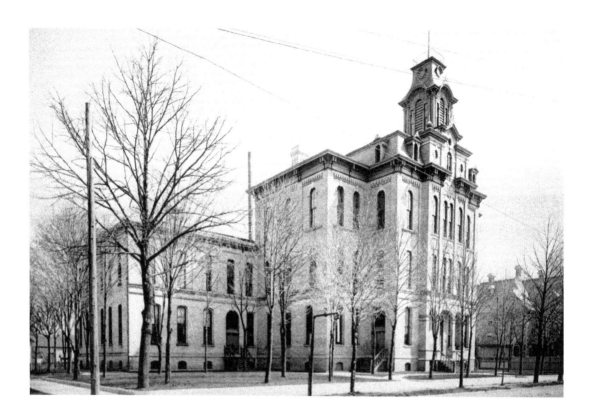

School, constructed in 1872 on West Washington Street, just west of downtown.[13] A noble three-story building, it featured a prominent bell tower marking the main entrance, tall round-arched windows, a mansard roof with dormers, and a bracketed cornice. Written accounts indicate that it was constructed of yellow brick, similar to that used in Notre Dame's earliest buildings.[14] Designed by a Chicago architect named Rose, it housed classrooms, offices, and a library. A wing added in 1886 included classrooms and science laboratories. Howard wrote that the landscaped grounds around it formed "a beautiful park, with broad stone walks, a well-kept lawn, and high over-arching trees, adding greatly to the attractiveness of the building."[15]

Many of these buildings, such as the second Odd Fellows Hall of circa 1875, were themselves replaced in a second commercial boom that occurred in the 1920s. Those that survived, such as the Studebaker Building, remained in use until their demolition in the 1970s, when the city initiated an extensive urban-renewal program. These structures gave a distinct identity to the downtown commercial district, an identity that has been much altered and transformed over the course of succeeding decades.

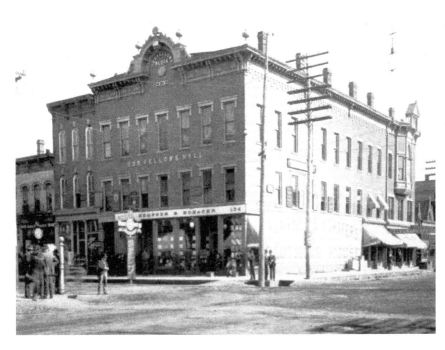

FIGURE 5.6
Odd Fellows Hall,
southeast corner of
Main and Washington
Streets, ca. 1875,
demolished 1926.
(From *Art Work of
South Bend and
Vicinity*.)

With its new headquarters and showroom firmly established downtown, marketing and promotion became a major aspect of the Studebaker Company's administrators. Its wagons and carriages were displayed prominently at the Philadelphia Centennial Exhibition in 1876, winning a gold medal and helping to establish the company's international reputation.[16] The company exhibited its wagons again in 1878, this time at the Universal Exposition in Paris, where it won a silver medal for excellence.[17]

During the 1880s one million immigrants a year entered the United States, men and women who provided cheap and dedicated labor. The employees working at Studebaker during this time were undergoing a demographic shift from northern European to eastern and southern European immigrants: Poles, Russians, Hungarians, Czechs, Slovaks, and Croatians. By the end of the decade, as many as 50 percent of Studebaker's employees were of Polish, Russian, or Hungarian descent, drawn from a labor pool that made it possible for Studebaker and other companies to thrive.[18]

In the early 1880s the company expanded its distribution system by building new showrooms across the country. It grew from one million dollars a year in revenues to two million a year. By the mid-1890s Studebaker was thought to be the largest vehicle manufacturer in the world. It made not only wagons and

carriages but also numerous specialty vehicles such as street sprinklers, sweepers, dump wagons, and carts, all for use in municipalities and by private contractors.[19]

In 1884, largely under the direction of Clement's youngest brother, Jacob F. Studebaker, the company built a distinctive high-rise building on Chicago's South Michigan Avenue, overlooking Grant Park. Jacob was the only one of the Studebaker brothers with a formal education, having attended South Bend's Old Seminary in the early 1850s and then Notre Dame. He had the most visionary sense of all the Studebaker brothers and planned for the company's expansion at the national level.

He commissioned Chicago architect Solon S. Beman to design the building with space for the manufacture and repair of carriages on the upper floors and an impressive showroom on the first floor to display their elegant phaetons and closed hansom carriages. Beman was a logical choice of designer, as in 1883 he had designed a similar downtown Chicago office building for George M. Pullman, a millionaire industrialist and founder of the Pullman Palace Car Company. Located at the corner of Michigan and Adams Streets, the nine-story Pullman Building, like the Studebaker Building, was designed in the Romanesque style, though it had an ungainly composition with multiple turrets, chimney stacks, and a multitude of windows with too many variations in profile.[20]

Beman was born in Brooklyn, New York, in 1853 and gained his architectural training through an apprenticeship in the New York office of Richard Upjohn, designer of Trinity Church (1839–1846), New York's most famous church in the Gothic Revival style from the first half of the nineteenth century.[21] Beman moved to Chicago in 1879 to execute the office-building commission for Pullman and to design Pullman, Illinois, a utopian model town located on fifty-two acres eleven miles south of Chicago. It included civic and commercial buildings, an industrial plant, and more than eighteen hundred homes. It was to be the largest commission of Beman's career, the focus of his practice for over ten years, and firmly established him as one of the country's leading experts in the architecture of industrial complexes and model company towns.[22] The Studebaker brothers would commission him to design several other important buildings in South Bend over the next twenty years.

Known today as the Fine Arts Building, the Studebaker Building featured rusticated masonry and large round-arched windows, which denoted well the Studebakers' bold and aggressive style. Yet, in contrast to the Pullman Build-

ing, it had a lighter, more refined look. Irving K. Pond, a young draftsman who worked on the Studebaker Building in Beman's office, wrote that the windows were "not Richardsonesque in mass or detail, but had the springy lilt which might be expected from one who, though large of frame, as I was, could 'do' somersaults in the air; while the carved ornament had the free flow to be expected from one whose pulse beat in rhythms. I leaned more to the lighter, airier forms of the Tuscan, than to the heavy stocky forms of the Northern Spanish Romanesque."[23]

Following the standard set by the new Chicago showroom, Jacob Studebaker oversaw the construction of other showroom buildings across the country. By 1885 he had opened regional sales offices in such far-flung cities as Sioux Falls, Iowa; Helena, Montana; Tucson, Arizona; Santa Fe, New Mexico; Denver, Colorado; and Las Vegas, Nevada.[24] The Studebaker name was by now synonymous with the wagon and carriage industry. By 1940 the company would have more than five thousand showrooms across the country.[25] Howard wrote in 1907 with some effusiveness that Jacob F. Studebaker was "a large factor in the erection of the splendid industrial monument which his kindred have erected to the glory of themselves and their descendants. The Studebaker Brothers Manufacturing Company is one of the distinctly great industries of

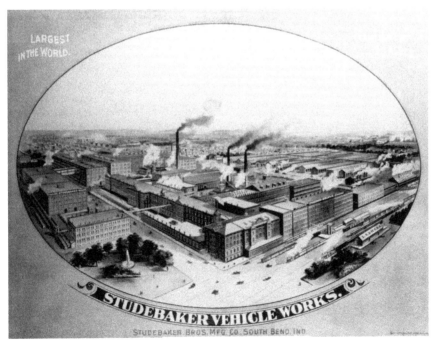

FIGURE 5.7
Aerial view of Studebaker Manufacturing Plant, ca. 1890. (Author's collection.)

the world, and none of the departments are better or more favorably known than that devoted to the output of carriages, with which Jacob F. was so long identified as manager."[26]

In the late 1880s, the Studebaker brothers expanded their complex of buildings at the south edge of the city, the site having grown to 190 acres. The Second Empire–style office building of 1870 anchored the site's northwest corner, while a warren of vernacular industrial buildings stretched out to the south and west. There was a rational organization to the complex, with each building reflecting its function in the sequence of automobile assembly, with multistory brick buildings, lower shed-roof buildings, a power plant with smokestacks, and warehouses. It was like countless industrial landscapes found across the country, from Holyoke and Lowell, Massachusetts, to Buffalo, Cleveland, Detroit, and Chicago.

While the Studebaker Manufacturing Company was South Bend's largest employer, it was not alone in manufacturing wagons and carriages in the South Bend area. There were other companies as well, including the Coquillard Wagon Works, with a large complex of three-story buildings at the northwest corner of LaSalle and Lafayette Streets; the Winkler Brothers Manufacturing Company, with a two-story brick building on East LaSalle Street; and the Birdsell Manufacturing Company, operating out of a massive five-story building constructed in 1887 on the city's southeast side at the corner of Columbia and Division Streets.[27] In Mishawaka, the Milburn Wagon Company was, for a time, one of Studebaker's biggest competitors.[28]

By the end of the century, the Birdsell Company was the fourth-largest employer in the region, its plant covering two city blocks with a total of twenty-four buildings, in addition to an eight-acre plot that accommodated lumber storage sheds. Joseph Birdsell always kept a four-year supply of lumber on hand—white oak, black birch, hickory, yellow poplar, and pine—and he always let it dry naturally in these sheds rather than using kilns, as was the practice of many other wagonmakers. In its heyday the company produced fifteen thousand wagons and fifteen hundred clover hullers each year.[29] It was only in the 1920s that the company experienced a steep decline in business and finally closed, as it failed to make the transition to building gasoline-powered machinery, as the longer-lasting Studebaker Company would do with its automobile production.

A company that gained its wealth largely by supplying the Studebaker Corporation with a needed product was the O'Brien Electric Priming Com-

FIGURE 5.8
Birdsell
Manufacturing
Company, Columbia
and Division Streets,
1887. (From *Art Work
of South Bend
and Vicinity*.)

pany, a manufacturer of varnishes for carriages. First located at the corner of Lincolnway West and LaSalle Street, the company moved to new quarters in 1882 on West Washington Street, where it continued to operate until the 1970s. Other important nineteenth-century industries included the Sibley Machine Tool Company, founded in 1874; the South Bend Foundry, established in 1879; the Malleable Steel Range Manufacturing Company; N. P. Bowsher and Company; and the South Bend Range Corporation.

Two major clothing manufacturers were located in South Bend, the A. C. Staley Manufacturing Company and the Wilson Brothers Shirt Company. Staley first established a wool business in 1855 in Plymouth, Indiana, and then moved to South Bend in 1862 to a site on the east bank of the St. Joseph River. A number of brick mill buildings were constructed there, and the company built its own hydroelectric plant. In 1907 the name was changed under new ownership to the Stephenson Underwear Mills. Wilson Brothers moved to South Bend from Chicago in 1887. Producers of men's clothing, the company built a plant on West Sample Street that eventually included nine buildings. The company prospered during World War II thanks to numerous government contracts to supply American troops. However, after the war, it declined and was finally closed in 1975.

The Campbell Paper Box Company was founded by Marvin Campbell, a former state senator, who started his company in 1893 to manufacture cartons, shirt boxes, medicine boxes, and egg case fillers. Campbell had worked as a sales manager at Studebaker. He constructed a four-story brick building at 903 South Main Street to house his company in 1900.[30]

To these companies were added numerous suppliers and other industries, from breweries and clothing manufacturers to makers of sewing-machine cabinets. South Bend had two breweries. The first was the South Bend Brewing Association, founded in 1903 and housed in a castellated medieval-style building on Lincolnway West. The second was Muessel's Brewery, established in the 1860s with a plant on Elwood Avenue. It later became Drewry's Brewery.

The Oliver Chilled Plow Works

The city's second-largest employer after the Studebaker Manufacturing Company throughout the nineteenth century was the Oliver Chilled Plow Works, established in 1855 by James Oliver (1823–1908). Writing in 1901, historians Anderson and Cooley declared the Oliver Chilled Plow Works to be "one of the greatest industrial enterprises of this progressive city, and in its special line of manufacture the largest and most extensive in the world. The fame of the 'Oliver' chilled plow has been carried to all parts of the globe where civilization and agriculture are known, and the name of James Oliver, the inventor of this greatest of agricultural implements is known throughout the world."[31]

Oliver was born in Scotland and came to the United States with his parents at the age of twelve. The Oliver family first lived in Seneca County, New York, and then moved west to Mishawaka. As a boy, James worked in Mishawaka for the Lee Company and later for the St. Joseph Iron Works, which made plows and castings.[32]

In 1855 he bought a half interest in the South Bend Iron Works, which made cast-iron plows in a small foundry housed in a brick structure on Washington Street, near the West Race of the St. Joseph River. Oliver soon obtained a contract to supply iron columns for the St. Joseph Hotel, which was being constructed at the corner of Washington and Main Streets. He later made fluted iron columns for a building at Saint Mary's College, as well as window caps, sills, weights, brackets, and cornices for the new jail built near South Bend's courthouse square.[33]

In the 1860s Oliver began experiments in the manufacture of the chilled plow, which was made by a process of cooling heated iron at a rapid rate so that it hardens with unprecedented strength. As the company grew, he took in two business partners: George Milburn from Mishawaka in 1864, and then his own son, Joseph D. Oliver. In 1868 he received a patent for his plow, which was of significantly better quality than any other on the market. In the same year, Clement Studebaker made a much-needed financial investment in the firm, enabling it to expand and giving him a stake in its future development.

During the early 1870s and 1880s, the company experienced a period of unprecedented prosperity as it doubled and tripled its production of chilled plows, making as many as three hundred thousand a year, and shipping them to such distant places as Japan, Germany, and Mexico.[34] It made a special ornate plow to display at the Columbian Exposition in 1893, just as the Studebakers had produced and exhibited a special wagon. The plow featured stalks and ears of corn carved in the horizontal beam and cornucopias on the handles.

Howard wrote glowingly of James Oliver,

A great inventor in the field of agriculture and a real benefactor to mankind, the venerable and venerated James Oliver, the discoverer of the chilled-plow process, stands out pre-eminently among the practical geniuses of the United States . . . so secure, in fact, is he in the affectionate honor of his neighbors of South Bend and Indiana, and his admirers throughout the west and the United States, that the very warmth with which he is regarded may detract somewhat from a calm consideration of his greatness as a benefactor to the world of his contribution to the progress of the primal and cosmopolitan industry of agriculture. With such men as Fulton and Morse he stands as one of the historic inventors, someone who has persevered in the development of his original idea and its application to the good of mankind.[35]

In 1875, in need of additional space, James Oliver moved the company from its foundry on the West Race to new quarters not far from the Studebaker complex on the city's southwest side, a site bounded on the east by Chapin Street and on the north by the Lake Shore & Michigan Southern and Grand Trunk railway tracks.[36] There he constructed several large industrial buildings of brick and iron-frame construction, enough to employ four hundred men to

produce three hundred plows a day. The main warehouse, which was 698 feet long, was built to house supplies of lumber, pig iron, grindstones, molding sand, coal, coke, bar iron, and dozens of other supplies necessary for producing plows. The main foundry building, which measured 750 feet long, housed five huge cauldrons supported on heavy iron columns. Towering aloft through the foundry roof, these cauldrons belched out streams of molten metal. In addition, there were buildings for fitting, grinding, and polishing. A blacksmith shop, furnished with forges and both coke and charcoal furnaces, produced the frames and wheels of the plows. A machine shop made connecting shafts, pulleys, and other accessories. A woodworking shop, 695 feet in length, produced all wooden parts used in the plows. Finally, a paint shop provided the plows' finishing and ornamentation. Power for this great enterprise was furnished by three giant Harris-Corliss engines located in two large boiler houses with tall smokestacks.[37]

In 1877 the company sold 60,000 chilled plows, with sales nearly doubling every year.[38] In 1901 it constructed all new buildings in its factory complex, all of steel-frame construction with masonry walls and tiled roofs. The largest of them was 700 feet long and 240 feet wide, with large windows and skylights down the middle of the roof.[39] The Oliver Company became one of the largest industries in South Bend, joining the Studebaker Manufacturing Company as one of the area's largest employers. By 1900 the company was producing 150,000 plows a year and employed more than 1,000 workers.[40] Like Stude-

baker, the company thrived in South Bend because of its abundance of natural resources, skilled labor, and links to important transportation routes. According to the *South Bend Tribune*, "Oliver was at one time one of the largest farm implement companies in the world. . . . Every type of plow is made in South Bend—walking, riding, tractor."[41]

A mark of progress—quite different from today's environmentally conscious standards—was reported by Anderson and Cooley: "Towering chimneys with their immense volumes of dense smoke give unmistakable evidence of the hum of industry below, and trains of loaded freight cars on the tracks within the yards and branching from several of the contiguous great railroads, carrying the products of these works to the remotest parts of the earth are convincing proofs of the magnitude and success of this great industrial enterprise."[42] By 1907 the Oliver Chilled Plow Works had grown to 2,600 employees, and in 1910 the company further expanded with the construction of a factory in Hamilton, Ontario. The Oliver Chilled Plow Works remained one of South Bend's largest employers through the first half of the twentieth century.

The Olivers' Early Residential and Civic Developments

In the 1880s, just as they were expanding their factory complex, James and J. D. Oliver began to show an interest in South Bend's residential development. First, they built large tracts of housing for their employees on the city's south and west sides, mostly one- and two-story wood-framed houses. One such neighborhood was Rum Village, located southwest of downtown, centered around Our Lady of Hungary Church and the former Oliver School. Much of the land was purchased by James Oliver from local farmers, who were gradually selling their property to builders developing workers' neighborhoods for the Studebaker as well as Oliver factories.[43]

In 1881 James and Susan Oliver purchased a large house near downtown, located at 325 West Washington Street, now the site of the Central High School building. Constructed circa 1870 by James Chess, it had three stories, with fieldstone and cut-limestone walls, and was covered by a steeply pitched slate roof with gables and dormers. Inside, it featured a main hall that was fifty feet long and a wood-paneled library. It had a veranda and a porte cochere, and in the lawn behind was a carriage house with butler's quarters on the second floor. Oliver had it completely remodeled and enlarged, even replacing all of

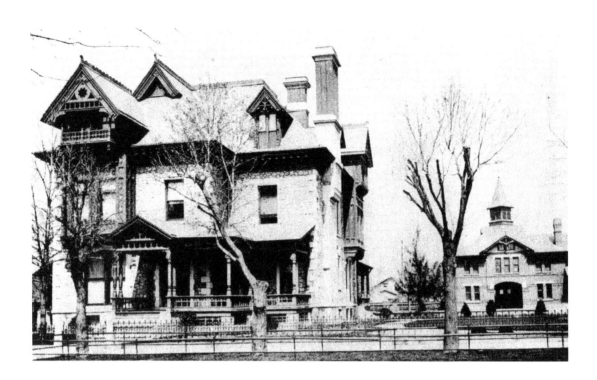

the woodwork inside. He hired an architect for the extensive remodeling project, Richard A. Waite of Buffalo, New York, who would form a close relationship with the Olivers and execute numerous other commissions for them over the next two decades.[44]

In 1883 James and J. D. Oliver initiated a larger project, Oliver Row, a complex of nine townhouses located downtown at the corner of North Main and West Colfax Streets. They commissioned Waite to design the townhouses in the latest and most fashionable style of the day. He designed a series of linked facades, three stories high on a raised basement, featuring a series of gabled fronts with double parlor windows and turrets. It was a design that combined Romanesque, Queen Anne, and Shingle style details all in a single composition.

J. D. Oliver and his wife, Anna Gertrude Wells, lived in the corner house of Oliver Row from 1885 until 1897.[45] It was there that their four children were born. Already by the early 1890s, however, they had outgrown the townhouse and, in anticipation of building a new house, began purchasing property on Washington Street near the corner of Chapin Street. This would be the site of their grand estate, known as Copshaholm, which will be described in more detail in chapter 9.

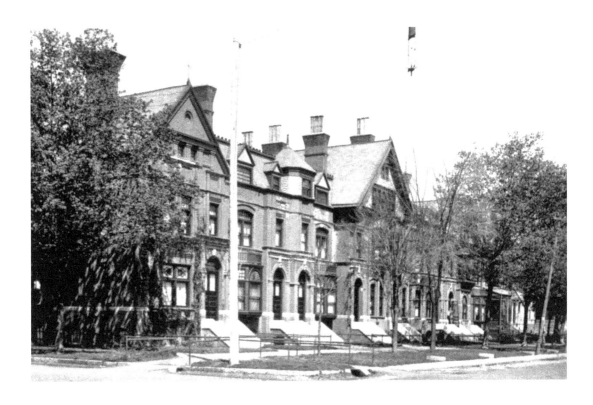

The Olivers also harbored intentions to bring cultural life to the city, partly as a way to retain employees, but also to elevate the status of South Bend as a leading Midwestern city. Having gained experience as builders of residential and industrial structures, they took on a project that would have a lasting impact on South Bend's commercial and civic development. Turning again to Waite, they commissioned him in 1884 to design a large mixed-use building for downtown to include commercial and office spaces and, more important, to house South Bend's first opera house. Located at 106 North Main Street, it was one of the first examples in South Bend of the Romanesque Revival style in commercial architecture. In the 1880s, taste had begun to shift away from the Italianate and Second Empire styles that had dominated since the 1860s and toward a new building type based on two trends in urban architecture, the Romanesque Revival style and the functional aesthetic of the early skyscraper. Built for $200,000, it was designed in two sections: the performance space and an office block containing commercial spaces, eighteen office suites, and the city's first public library. The opera auditorium was located at the rear of the site, with a lobby passing through the center of the office block to the street side.[46]

FIGURE 5.11
Oliver Row,
corner of Main and
Colfax Streets, 1883,
Richard Waite,
architect. (From *Art
Work of South Bend
and Vicinity*.)

Industrial Giants 91

FIGURE 5.12
Oliver Opera House,
114 N. Main Street,
1884, Richard Waite,
architect. (Courtesy of
The History Museum,
South Bend, Indiana.)

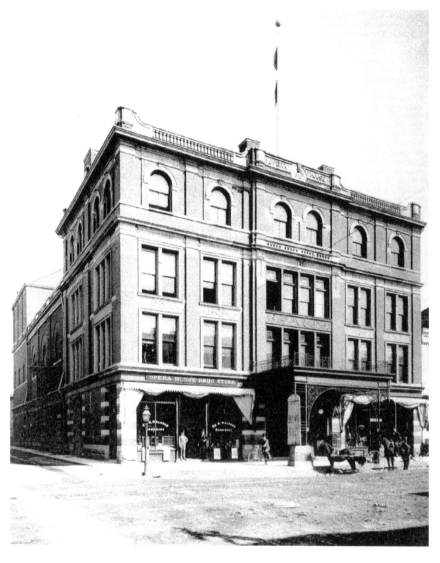

Waite designed the office block that fronted Main Street with a rusticated limestone base and redbrick upper stories. The first floor was marked by a central entrance with an iron-framed canopy flanked by shop fronts on either side. The next two floors had simple, paired rectangular windows with brick piers and terra-cotta spandrels, while the top floor featured round-arched windows. The composition was modulated by pilasters and intermediate cornices and topped by a balustrade. Although it was only four stories high, its composition reflected a base-shaft-capital motif that was becoming typical of skyscraper design in Chicago and New York.

The interiors were stylish, with expensive materials and fine craftsmanship. The lobby was paneled with Tennessee marble and mahogany, with frescoes painted on the ceiling. The theater space, which was noted for its excellent acoustics, featured ornamentation in both English Classical and Egyptian styles. A ten-foot-diameter chandelier hung from a ceiling with a painted canvas. The side walls went from yellow at the top to cranberry red at the bottom, with ivory white and tan woodwork, silvery blue box hangings, and deep yellow carpets.[47] The splendidly appointed opera house opened to a packed audience in 1885 with a production of *King Lear*, and it served for many years as a focal point for South Bend's cultural life. Both James and J. D. Oliver, as well as their families and their wide circle of friends, attended performances regularly.[48]

The influence of the Romanesque Revival style, on the Oliver Opera House and beyond, was based on a related interest in German culture and architecture that began to be felt in the middle decades of the nineteenth century. Educational methods were influenced by the Prussian Pestalozzian model, the country's first public libraries were based on German examples, and the Smithsonian Institution in Washington, DC, had German links.[49]

As architectural historian Kathleen Curran writes, the predominant style found at this time in German educational institutions—schools, libraries, and colleges—was the *Rundbogenstil*, or round-arched style. The Prussian monarch Friedrich Wilhelm IV made it the official state style for all churches, hospitals, and schools.[50] It was based on different proportions than the Italianate style and typically featured pilasters, rustication, and prominent round-arched windows.

Known as Romanesque Revival style in the United States, the round-arched style was first seen at a monumental civic scale in the Smithsonian Institution, designed in 1846 by James Renwick Jr. In New York there was the Astor Library, built from 1849 to 1853 and financed by the son of John Jacob Astor, the wealthy fur trader who had prospered from his link to South Bend.

The style became prevalent in large cities such as Boston, New York, and Chicago and was evident in much of the commercial work of influential architects such as Burnham and Root, with buildings in Chicago including the Rookery (1885–1886) and the Women's Temple (1891–1892). The taste for the Romanesque had first appeared in Chicago with Henry Hobson Richardson's Marshall Field Wholesale Store, and it was adapted by Dankmar Adler and Louis Sullivan in the Auditorium Theater, which became highly influential

throughout the Midwest. Builders and architects in the United States perceived it as a more functional mode of building than the Italianate or Second Empire styles. It represented more structural economy and required less decorative embellishment.[51]

The technical details of the skyscraper were first evident in the work of another Chicago architect, William Le Baron Jenney, with his design of the Home Insurance Company Building in 1884. This was one of the first skyscrapers in the United States, a building that combined a steel-frame structure with masonry cladding. It also incorporated the use of the elevator, and it had large window bays that made the interiors especially light-filled and naturally ventilated. To a developer faced with an increasingly competitive real estate market, a skyscraper of this type was the best way to maximize return on investment.

The Oliver Opera House was an ideal response to the urban setting of the industrial city in the way it combined its civic function with commercial stores and offices on the upper floors. It was expanded in the 1920s by the addition of three more floors. Such buildings brought vitality to the city, and this one was profitable for many years for the Oliver family.

The Oliver Opera House was also significant because it housed South Bend's first public library, which opened in 1889 with one thousand volumes. It was located on the fourth floor, where its large arched windows provided ample light for the reading room. The South Bend Board of Education passed a resolution in 1888 providing for the establishment of the public library. James Oliver loaned money to buy books, and the Singer Manufacturing Company donated chairs.[52]

As the opera house was being completed, the Olivers also commissioned Waite to design an office building for their industrial complex at the edge of town. Again in the Romanesque style, it shared many features with the opera house: round-arched windows, brick walls with limestone trim, and a limestone cornice. This two-story building also featured a prominent porch with round-arched openings and a square tower that featured the word *Oliver* prominently carved in limestone panels on all four sides.

A turn-of-the-century aerial view of the factory complex on the city's southwest side shows the office headquarters anchoring one corner of a vast complex extending south of the Lake Shore & Michigan Southern railroad tracks and west of Chapin Street. By the early years of the twentieth century, this vast complex was producing seventeen thousand plowshares a day, in ad-

FIGURE 5.13
Oliver Opera House
with addition of
top three stories.
(Photo by author.)

dition to thousands of chilled moldboards and landsides, both chilled and steel.[53]

The Olivers' contribution to South Bend's civic and commercial architecture would continue through the remainder of the century and into the twentieth with the building of a grand hotel in the center of town, financing for a

new city hall, and construction of a hydroelectric power plant on the St. Joseph River, all of which are discussed in chapter 11.

Singer Sewing Machine Company

FIGURE 5.14
Singer Sewing
Machine Factory,
425 E. Madison
Street. From *South
Bend, Indiana, 1874,*
by J. J. Stoner Co.,
Madison, WI.
(Courtesy of Library
of Congress,
Geography and
Map Division.)

Among the many other diverse industries in South Bend whose buildings rose to the level of architectural prominence was a Midwest branch of the Singer Manufacturing Company, established in South Bend in 1868 by Leighton Pine. Born in New York in 1844, Pine went to school in Manhattan and developed an early interest in photography. During the Civil War he was the official staff photographer of General Quincy Gillmore of the Union army. After the war, he went to work for a cabinetmaker who supplied cabinets for the Singer Sewing Machine Company. He came up with the idea of establishing a cabinet company in the Midwest, and he moved to South Bend in 1868 to open a factory adjacent to the East Race for the Singer Company.

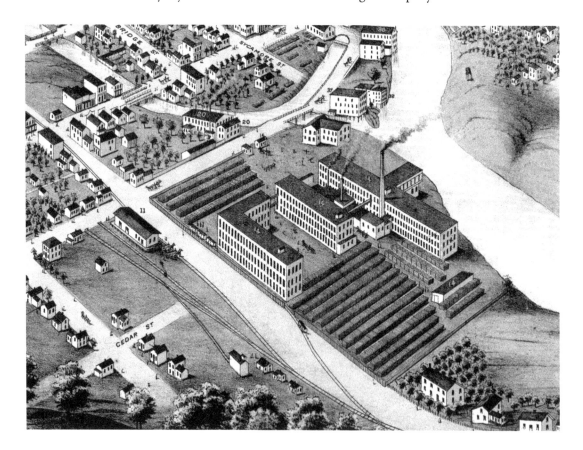

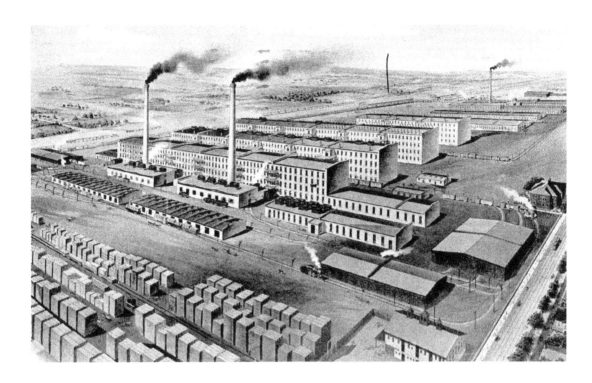

FIGURE 5.15
Singer Sewing
Machine Factory,
Western Avenue,
postcard, 1912,
unknown publisher.
(Author's collection.)

South Bend was a good location to take advantage of the nearby walnut and oak timber forests. Pine persuaded Miller and Green, the proprietors of the South Bend Hydraulic Company, to offer waterpower free of charge to encourage Singer to locate in South Bend instead of Mishawaka. The company produced cabinets in its buildings at 425 East Madison Street for the sewing machines shipped from Elizabeth, New Jersey. Pine was eventually made Singer's manager for factories in Cairo, Illinois, and in Scotland, Germany, and Russia.

The Singer sewing machine was patented by Isaac Merritt Singer in Boston, Massachusetts, in 1851. He improved on an earlier sewing machine manufactured by Orson Phelps and George Zieber, both of whom he made partners in his company. During the next decade, Singer received numerous patents for his machine, the most important being the lockstitch reciprocating shuttle. From 1853 to 1876, the sewing-machine industry grew from annual sales of 2,266 to 262,316 sewing machines and from a handful of major manufacturers in 1853 to more than thirty by 1876. Singer led all competitors in the number of units sold, both foreign and domestic.

The company's production facilities expanded during the Civil War. In 1872 Singer opened a large new manufacturing facility in Elizabethport, New

Jersey, on seventy-two acres, where it employed three thousand machinists and factory workers. The following year, the company relocated its headquarters there.

The Singer Sewing Machine Company stirred a revolution in the textile industry equivalent to Henry Ford's Model T in the automobile industry. It was the most trustworthy home appliance and deeply affected the modern way of life in the average American home. At its peak, the Singer Company had as many as eighty-six thousand employees worldwide.

By 1900 the Singer Company in South Bend had expanded into seven buildings and employed fifteen hundred workers. The following year it moved across town to a new and larger facility located at the corner of Western Avenue and Olive Street. The new plant, which covered sixty acres, consisted of four long, narrow, four-story brick buildings plus several small ones and a large lumber storage area. The company operated here until closing in 1955.

As with the Studebaker Manufacturing Company, the production of the Singer Company and other industries was facilitated by the railroads that were opened in South Bend in the middle of the century. In addition to the Lake Shore & Michigan Central Railway and the Grand Trunk Railroad, the Vandalia Railroad from Logansport, Indiana, was extended with a station at the southern edge of the town at the corner of Main and Bronson Streets. In 1929 the Grand Trunk line was elevated above the streets with an extensive bridge system across the southern and eastern portions of the city.

Street railways and inter-urbans were established in the 1870s and 1880s for local traffic and for connecting South Bend with Mishawaka. The South Bend Street Railway was organized in 1873, and in 1880 the first line was established; however, its motive power was horses and mules. In 1882 an overhead electrical trolley system was attempted on Michigan Street, and the same year a franchise was granted to the South Bend & Mishawaka Railway Company to construct a street railway between the two towns. By 1890 the two systems provided an extensive commuter line, with routes on Michigan, Washington, Jefferson, Lafayette, Taylor, and South Streets and connecting lines to the original town of Lowell and to Mishawaka on Vistula Road. By 1920 there were a total of ten streetcar lines and three bus lines. The streetcar lines were Michigan Street, Portage Avenue, Washington Avenue, Circle Avenue, Chapin Avenue, North Side, South Side, Madison Street, Hill Street, St. Mary's, and Lincolnway. The bus lines were Linden Avenue, Division Street, and Rum Vil-

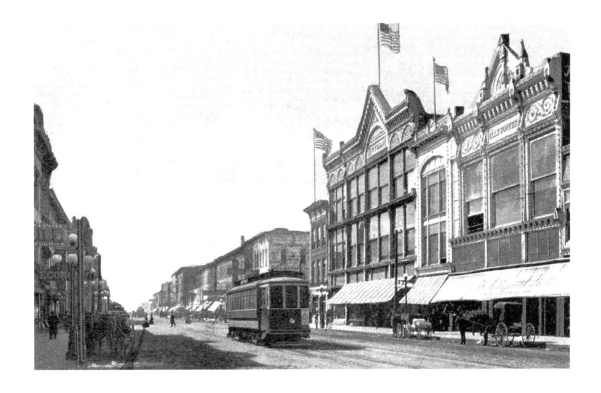

lage. The entire system was reorganized in 1899 as the Indiana Railway Company. In 1903 the Chicago, Lake Shore and South Bend Railway began to construct a commuter line between South Bend and Chicago, which remains today the South Shore Line.[54]

The Singer Company maintained an influential economic presence in South Bend around the turn of the century as a major employer, but the Studebaker and Oliver families held pride of place in the community as they added their own significant legacies to South Bend's civic, commercial, and religious architecture. While these edifices added a great deal to South Bend's urban image, they were as much a means of memorializing the Oliver and Studebaker families and keeping their names before the public as they were institutions for the use of South Bend's residents.

To most of South Bend's citizenry the industrial empire of the Studebakers and the Olivers seemed a positive thing. Certainly there were those who felt underpaid, unhappy with their working conditions, or had real grievances because of job injuries or layoffs. But for the most part, laborers were able to live decent, contented lives in a relatively secure environment, even if in the

FIGURE 5.16
View of Michigan Street in 1909 with a South Bend Street Railway car in the foreground.
(Author's collection.)

shadows of the factory complexes. Despite what some would say was exploitation of South Bend's labor market and natural resources, the Studebakers and the Olivers practiced a form of industrial paternalism that provided a livelihood for thousands and added greatly to the city's civic realm as they built opera houses, a library, hotels, power plants, churches, streets, and whole housing districts.

Institutions of Faith and Reason

The construction of new college buildings, schools, and churches in the second half of the nineteenth century went hand in hand with South Bend's commercial, residential, and industrial development. The period from the 1860s to the 1880s saw a range of large-scale Italianate, Second Empire, Victorian Gothic, and Romanesque Revival buildings, which constituted what could be called the second generation of institutional structures at both Notre Dame and Saint Mary's. The majority of these buildings were designed by noted architects or members of the Holy Cross Congregation who were experienced builders. Many of them are significant for their stylistic identities, the quality of materials used in their construction, and the execution of their decorative details. Some, more modest in scale, represent a regional vernacular version of the dominant styles. All in all, the scale and beauty of these second-generation buildings set a new standard for religious and educational architecture in South Bend and its college campuses.

Saint Mary's College in the 1860s

In the 1860s, a time when the United States was being ravaged by the Civil War, construction began on the first large, permanent building on the campus of the newly established Saint Mary's College, as did a major transformation of Notre Dame's Main Building, one that doubled its size and completely changed its stylistic character. Father Edward Sorin was the single most important person

FIGURE 6.1
Saint Mary's Academy
Building, Saint Mary's
College, 1861–1862,
William Tutin
Thomas, architect.
(From *Our City: South
Bend, Ind.*)

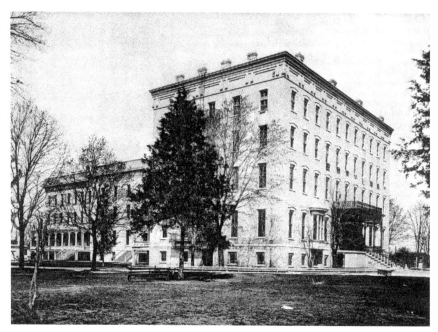

behind both projects, lobbying the bishop, raising the money, and directing the work of the architects and builders who constructed his visions in brick and mortar.

The first and oldest architecturally distinguished building on the Saint Mary's campus is the former Academy Building (now named Bertrand Hall), constructed from 1861 to 1862. Located at the campus's southeast corner, this five-story building was designed as a large cubical block in a classicized Italianate style by Montreal architect William Tutin Thomas. This was Father Sorin's first large-scale construction project of the 1860s, a building much larger and more architecturally distinguished than the first Main Building on the Notre Dame campus.

There are two possible reasons for the selection of Thomas as the designer of this college building in South Bend, Indiana, so far away from Montreal. First, the parish of St. Laurent, located just outside of Montreal, was the home of the College of St. Laurent, founded by the Fathers of Holy Cross, an institution Father Sorin occasionally visited.[1] Second, the initial contact with Thomas could have been made at the recommendation of Mother Mary of the Seven Dolors, who had governed the St. Laurent religious community in Montreal for a number of years. In June 1860 she spent several weeks at Saint Mary's College to become acquainted with Mother Mary Angela and the sisters of the

Indiana province. She presumably recommended Thomas, her fellow Canadian, to Mother Angela during that stay.[2]

The Academy Building is symmetrical about its central axis and features an entrance porch, rectangular double-hung windows, and an elaborate cornice, something akin to the Palazzo Farnese in Rome, although made of pressed-metal components rather than stone. It housed dormitory rooms, study rooms, classrooms, a refectory, and music, painting, and science rooms.[3] It was and remains today a noble building that marks the coming of age of Saint Mary's College at a time when it enrolled about two hundred students annually. When the Academy Building was completed in the summer of 1862, the fact that it was even larger than the original Main Building at Notre Dame no doubt contributed to Father Sorin's decision to carry out a major expansion on his own campus three years later.

Notre Dame University in the 1860s

The University of Notre Dame expanded rapidly during the 1860s, and Father Sorin started to consider plans to replace the original Main Building. Constructed in 1844 and enlarged in 1853, it had outgrown its original function of housing classrooms, administrative offices, dormitory rooms, study halls, a dining hall, and the library. Faced with the need for more space, Father Sorin and the university's new president, Father Patrick Dillon, had to decide whether to replace the existing building, which was only twenty years old, or to build a second structure nearby, one that would be more in keeping with the new Academy Building at Saint Mary's.[4] Because of its prominent location on axis with Notre Dame Avenue and because Father Sorin continued to believe in the efficacy of accommodating all of the university's activities in a single building, they decided to keep the existing structure and expand it to the south while adding two floors plus an attic.

The alterations, carried out in 1865 by Thomas, resulted in the building's complete transformation, changing not only its size but also its style, from the Federal style to the Second Empire style.[5] The French Second Empire— the world of Napoleon III, Baron Georges-Eugène Haussmann, and the urban transformation of Paris—had begun to influence American architecture in the 1860s. As Marcus Whiffen and Frederick Koeper wrote, the style became popular in every Western country as visitors to the Universal Expositions of

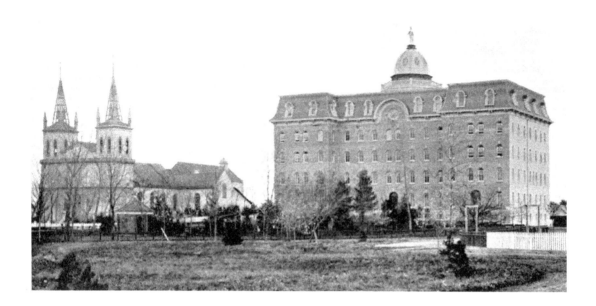

FIGURE 6.2
Second Main
Building, University
of Notre Dame, 1865,
William Tutin
Thomas, architect.
(From *A Brief History
of Notre Dame*, 1895.)

1855 and 1867 witnessed the transformation of Paris that was taking place, including vast extensions of the Louvre and the Hôtel de Ville, in addition to the construction of impressive new boulevards lined with mansard-roofed apartment buildings. The style had connotations of prestige, affluence, and authority, with buildings that were rich, exuberant, strong, and expressive. Above all, it called to mind the cosmopolitan qualities of central Paris and their universal appeal.[6] In the words of Maass, Americans liked the style because "it suited a vigorous, expanding nation."[7] Henry-Russell Hitchcock called it "a consciously 'modern' movement, deriving its prestige from contemporary Paris, not from any period of the past like the Greek, the Gothic, or even the Renaissance revivals."[8]

Characterized by the mansard roof, steeply sloped and pierced by dormer windows, this was a distinctly urban architecture that contrasted with the Gothic and Italianate styles in their country settings. These structures were typically meant to front on a boulevard, rows of them forming a dominant presence that defined an urban corridor. The dormer windows overlooked the street below in sharp contrast to the cupolas of Italianate houses, which were meant to provide a panoramic view of an expansive countryside. Wilbur Peat wrote that this new French style "adhered to the classic principle of symmetry, lucidity, and simplicity of plan, and remained faithful to Renaissance details, such as mouldings, cornices, and lintels. . . . But as in other decades, liberties were taken."[9]

The New York architect Calvert Vaux was the first to publish house designs with mansard roofs in an American pattern book. His *Villas and Cottages* of 1857 contained plates illustrating houses with both concave and convex curves in their mansard roofs and illustrated embellishments such as dormer windows and crestings.[10] Numerous house designs with mansard roofs were included in the popular *Cummings' Architectural Details* (1873), by Marcus Cummings of Troy, New York.[11] Finally, the Second Empire was a featured style in *Bicknell's Village Builder* (1870), by Amos Bicknell.[12]

The newly remodeled Main Building on the Notre Dame campus did not front on a boulevard in the typical French fashion. Rather, it terminated Notre Dame Avenue as a freestanding building. It measured 160 feet across the front, 80 feet deep, and 90 feet in height. Thomas built an entirely new front facade about twenty feet south of the original.[13] He changed the spacing and rhythm of the windows, adding pairs of windows in the place of single ones. He encased the attic level in a mansard roof shaped in a concave profile that flared out at the bottom. Its cornice featured paired brackets, while its dormer windows were topped by projecting round-arched hood moldings. The center bay was marked by a prominent arch, with the cornice forming a continuous half-circle profile as a centerpiece of the mansard roof. In the center of the arch was a circular stained glass window that marked the location of a chapel.[14] This arch motif was common with the French mansard roof and may have had a special appeal to Father Sorin as a prominent building in La Roche, in the commune of Ahuillé where he grew up, had a similar motif.

The Main Building's axis was marked further by a dome topped by a statue of Our Lady given to the university by the government of Napoleon III. Also, a wide wood-framed veranda with a broad flight of stairs extended across the facade at the main level. Bird's-eye views of the campus from the 1860s depict both the building's distinctive Second Empire style and its colossal scale. In front of the building was a formal landscaped garden in the shape of a heart, an emblem of the Holy Cross community and a prominent nineteenth-century religious symbol of French Catholicism.[15]

The Archbishop of Baltimore presided over the dedication of the new Main Building in May 1866 in front of a huge crowd of Notre Dame students, faculty, and staff, as well as residents from the South Bend community. It would represent Father Dillon's principal legacy on the campus, as he retired shortly afterward. As for Father Sorin, it fulfilled his vision of seeing distinguished

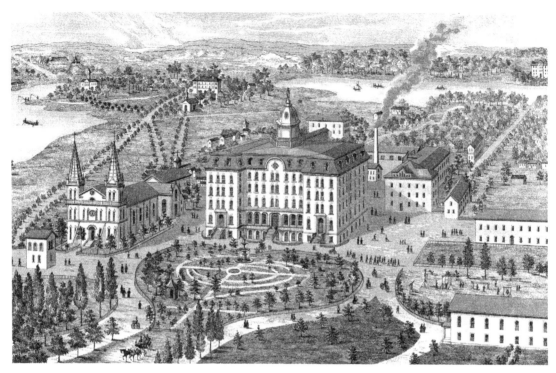

FIGURE 6.3
Second Main Building
(on the right) ca.
1866, University of
Notre Dame.
(Courtesy of Notre
Dame Libraries
Special Collections.)

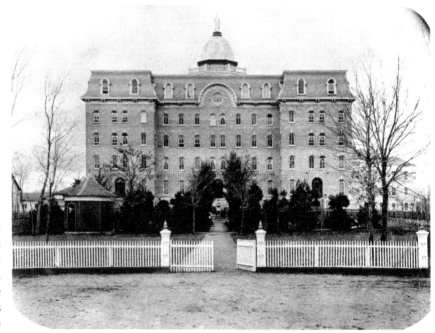

FIGURE 6.4
Second Main
Building, view from
Notre Dame Avenue.
(Courtesy of Notre
Dame Libraries
Special Collections.)

buildings, appropriately symbolic of faith and reason, on the campuses of both Saint Mary's and Notre Dame.

Although the refurbished Main Building was larger and more audacious than the Academy Building at Saint Mary's, it could be criticized for its ungainly appearance, with the mansard roof appearing ponderous if not top heavy. Then there was the dome, which was so small and set so far back from the front facade that it was barely visible to those approaching the building from Notre Dame Avenue.[16] The building would not have a long life, however, as it would once again become the focus of Father Sorin's attention in little more than a decade, for a reason unthinkable in 1866.[17]

Sacred Heart Basilica

As discussed in chapter 2, the Church of the Sacred Heart of Jesus was built to replace Father Sorin's Log Chapel in 1847 to 1852. Located directly west of the Main Building, it was a wooden structure that combined the Greek Revival and Carpenter Gothic styles. In 1869, just twenty years after the Church of the Sacred Heart of Jesus was built, and shortly after work on the Main Building's expansion was completed, Father Sorin, who was now the chairman of the university's board of trustees, decided to further enhance the campus by building yet another church to replace what he now considered to be an "old barn." The result was Sacred Heart Basilica, one of the campus's most important and enduring symbolic and spiritual landmarks.

Father Sorin initially commissioned the renowned church architect Patrick Charles Keely, perhaps the country's most noted designer of Roman Catholic churches in the mid-nineteenth century. Born in Ireland and trained as a carpenter by his father, Keely immigrated with his family to the United States in 1841, settling in Brooklyn, New York. Over the course of his long and distinguished career he designed more than five hundred churches and cathedrals, including the Cathedral of Holy Cross in Boston (1866), the Cathedral of the Holy Name in Chicago (1874), the Cathedral of Saints Peter and Paul in Providence, Rhode Island (1889), and the Cathedral of St. John the Baptist in Charleston, South Carolina (1890).[18] For Notre Dame, Keely proposed a Baroque design based on the Church of Il Gesù in Rome (1568–1582), with a twin-towered facade and a large dome.[19]

Despite Keely's growing reputation, Father Sorin considered his design to be too large and too costly for the Notre Dame campus, not to mention the fact that he did not have an appreciation for the Italian Baroque style, which was most closely associated with the Jesuits. Although Keely's plan was not used, the university honored him with the Laetare Medal in 1884 for his unrivaled contribution to Catholic church architecture across the country, having "changed the style of ecclesiastical structures and modified architectural taste in this country."[20]

Father Sorin preferred instead the French Romanesque and Gothic styles of his homeland, which he also believed would be more consistent with the French style of the second Main Building. He commissioned an alternative design, consulting this time with two colleagues from the Notre Dame community: the pastor of Sacred Heart Parish, Father Alexis Granger, and self-trained architect Brother Charles Borromeo Harding, who had been trained as a carpenter with his father while growing up in Waterford, Ireland.[21] Father Sorin may have had in mind as a model another building from his hometown in western France: the Church of Saint Benoît. It was nothing like the Baroque image proposed by Keely. Rather, it was French Romanesque in appearance with a single entrance bell tower placed in the center of the main facade.[22] While the architectural features of the French church were strictly Romanesque in style, its overall massing, with a central bell tower and gable roof, is similar to the final design of Sacred Heart Basilica.

Father Granger and Brother Harding began working on a new scheme for the basilica based on French precedents, although at some point in the process, Father Sorin consulted Thomas Brady, another professional architect experienced in church design. Brady had established a practice in St. Louis in 1865 and was well known for his designs of churches. From correspondence and publications, it is apparent that Father Sorin relied heavily on him in the design process of the basilica.[23] The *Notre Dame Scholastic* magazine reported in January of 1870, "Mr. T. Brady, architect, well-known in St. Louis, was at Notre Dame last week with plans for the new church. From what we have seen of them we may infer that the structure will be one of the finest in the West. We hope that all of the friends of Notre Dame who hope to contribute towards the erection of the church will do it as soon as possible. The success of the enterprise depends nearly entirely on the liberality of the public."[24] Although there is little agreement among scholars with knowledge of Notre Dame's campus architecture, it is apparent that late in 1869 Brady, not Keely, played an important

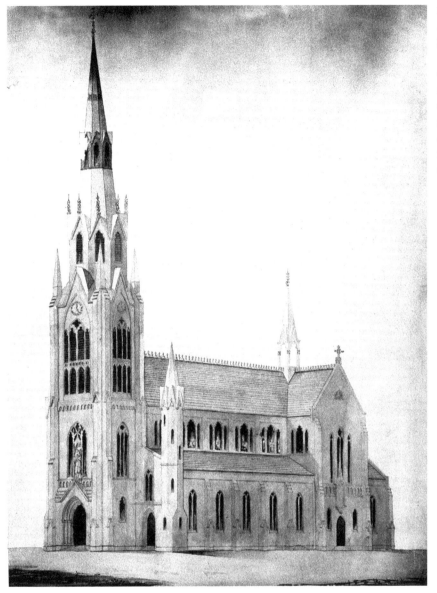

FIGURE 6.5
Design proposal for
Sacred Heart Basilica,
1870, Father Alexis
Granger, Brother
Charles Harding,
and Thomas Brady,
architects. (Courtesy
of Notre Dame
Libraries Special
Collections.)

role along with Father Granger and Brother Harding in designing the Basilica.[25] Only Brady, an experienced professional architect, could have designed and graphically represented such a refined and detailed proposal.

Needless to say, contributions poured in as the cornerstone of the basilica was laid on May 31, 1871, and the nave, choir, and transept arms were completed by 1875. The apsidal chapels and the Lady Chapel were added in 1888, and the steeple, which stands atop a 209-foot-high tower, was completed in

FIGURE 6.6
Sacred Heart Basilica,
aerial view as
constructed,
University of Notre
Dame, 1870.
(Courtesy of Notre
Dame Libraries
Special Collections.)

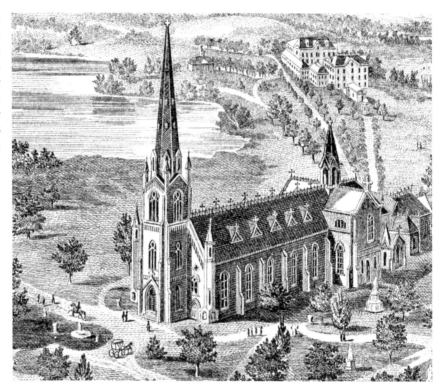

1892.[26] The Basilica's plan is based on a Latin cross, 275 feet long and 114 feet wide, with a nave and side aisles. Its Gothic features include lancet windows, engaged buttresses, polygonal corner turrets, and a steeply pitched gable roof. Its design was similar to the most famous Gothic Revival church erected in the United States at the time, Richard Upjohn's Trinity Church of 1844 in New York City.

One significant difference between the design drawing and the actual construction of the church is worthy of note. While the drawing called for the nave to have tall clerestory windows rising above the shed roofs of the side aisles, in a manner similar to Upjohn's Trinity Church, during construction it was decided to raise the height of the side aisles, thus eliminating the clerestory windows and placing the entire body of the church under a single gable roof. Windows that illuminated the nave were reduced to small dormer windows, while the windows of the side aisles were raised in height.

The bell tower, modeled closely after that of Trinity Church, is particularly expressive, first for its great height and second for the way it rises in successive stages and changes from a square plan to an eight-sided cupola, then to an

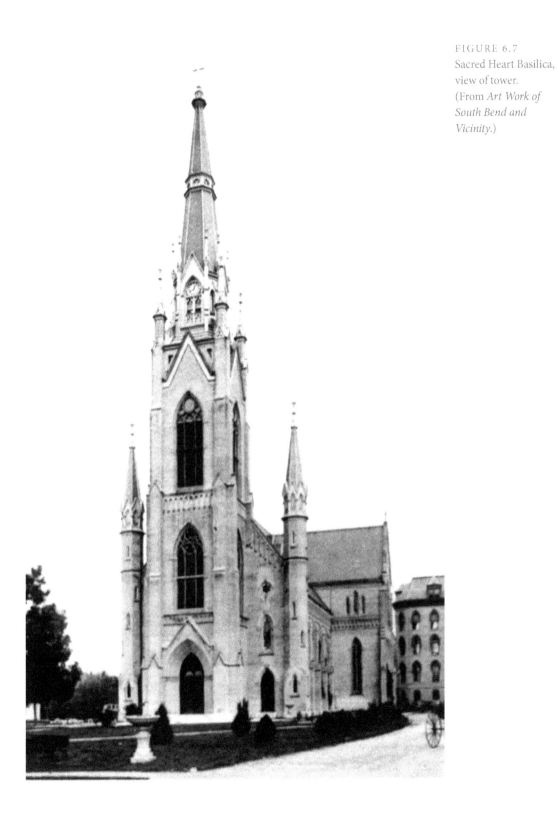

FIGURE 6.7
Sacred Heart Basilica,
view of tower.
(From *Art Work of
South Bend and
Vicinity.*)

eight-sided sphere with a cross on top. Behind the louvered arches at the top of the tower are twenty-four bells, twenty-three of which make up an antique carillon that Father Sorin had imported from France in 1852 and installed in a temporary bell tower in front of the original church. The twenty-fourth is an immense brass bell weighing over fifteen thousand pounds.[27]

The interior of the church features elegant Gothic piers with engaged colonettes supporting lancet arches and a vaulted, ribbed ceiling. The chancel is of special interest for its double pendant arches. The treatment of the ceiling with silver stars against the blue background and many of the wall frescoes were done by the Italian artist Luigi Gregori, who had been trained in Rome at the church of Santa Maria sopra Minerva and served as artist in residence at Notre Dame from 1874 to 1891.[28]

The elaborate French Gothic altar placed in the apse was designed by the atelier of Froc-Robert in Paris and originally made for the Cathedral of St. Etienne in Beauvais, France. Father Sorin purchased it from a display at the Philadelphia Centennial Exhibition in 1876.[29] He purchased a second altar in 1886, this one of a Baroque design attributed to followers of the Roman architect and sculptor Gian Lorenzo Bernini.[30] Perhaps the building's most outstanding feature is its forty-two stained glass windows, designed and executed by the Carmelite order in Le Mans, France.

St. Joseph's Catholic Church

The Gothic Revival style of Sacred Heart Basilica had an important influence on a number of South Bend's early churches. The most characteristic example was St. Joseph's Parish Church, located at the corner of LaSalle and Hill on the city's east side.[31] Built from 1880 to 1882 under the direction of Father M. P. Fallize, it featured a single bell tower projecting from the main facade, lancet-arched stained glass windows, brick walls with engaged buttresses, a crossing transept, and steeply pitched roofs. Measuring 149 feet long and 51 feet wide, it was described at the time as being in the "extenuated style of architecture," a comment on its verticality, although not a recognized stylistic designation by present-day standards.[32]

St. Joseph Parish was founded by Father Sorin in 1853 in what was then the town of Lowell. Father Sorin had built the first Catholic church and school for the residents of South Bend on this site, a brick structure, measuring just

FIGURE 6.8
St. Joseph's Church,
Hill and LaSalle
Streets, 1880, plan by
Father Edward Sorin.
(From *Art Work of
South Bend and
Vicinity*.)

twenty-two by forty feet. First known as St. Alexis's Church and later as St. Joseph's Church, its earliest parishioners were predominantly Native Americans from the surrounding area and French settlers who came to South Bend primarily from Canada.[33]

In 1857 the Diocese of Fort Wayne was established, with Reverend John Henry Luers as its first bishop. He commissioned a new church to be constructed in 1866 to replace St. Alexis, but it was destroyed by fire in 1872.[34] A third church was built a block away, on the present site of St. Joseph's High School, but it was soon outgrown, and in 1880 the congregation decided to return to the site of the previous church at the corner of LaSalle and Hill Streets.

An unnamed Chicago architect submitted plans that resulted in a new brick church structure being erected. It opened in 1882.[35] As with most other parish churches, the area around the church was soon built up with supporting structures, including a parish house in 1902 (now the rectory) and St. Joseph's Grade School in 1926. St. Joseph's Church can rightly be called the mother church of other Catholic churches within the city, including St. Patrick's, St. Hedwig's, St. Mary's, St. Casimir's, St. Stanislaus, St. Adalbert's, Holy Cross, and St. Stephen's.

The decision to demolish St. Joseph's Church and replace it with a modern building was made in 1963 by Reverend Joseph F. Murphy.[36] This controversial move was based on a structural engineer's review that pointed out needed repairs to the building's roof and its window frames. He argued that these repairs would be prohibitively expensive. The decision was protested by the recently formed Committee on the Preservation of Historic Buildings of the Northern Indiana Chapter of the American Institute of Architects, and a formal protest was signed by the committee's chairman William G. Rammel of Fort Wayne and Notre Dame professor of architecture Ernest H. Brandl. They called it "a building of great distinction and dignity" and described its bell tower as "beautifully proportioned and culminating in a graceful spire that is an architectural masterpiece in itself. . . . The spire, rising high above buildings and trees and visible from far away, has been for generations the dominant landmark of the whole neighborhood."[37]

Needless to say, its historical associations with Father Sorin, Notre Dame, and the town of Lowell could have been considered further justification for its preservation. Nevertheless, the church had not been built with the same measure of durability as Sacred Heart Basilica, and given its state of disrepair at the

time of the engineer's report, replacing it with a new church was the only way forward. The demolition of St. Joseph's Church played a significant role in the development of South Bend's preservation movement, which would have a lot of work to do throughout the 1960s and well into the 1970s, as a major push for urban renewal in the city was undertaken.

St. Hedwig's and St. Patrick's Churches

South Bend's oldest remaining church from this period is St. Hedwig's Church at 329 South Scott Street, which is also the city's oldest Polish Roman Catholic church. It was constructed in 1881 to 1883 during the pastorship of Father Valentine Czyzewski, the first Polish person in America to become a member of the Congregation of the Holy Cross. While its architect is unknown, the church was designed in the Romanesque Revival style, with a prominent bell tower in the center of the facade and distinctive round-arched doorways. It has a basilican plan, with tall round-arched windows on the sides and a curved apse at its west end. The bell tower stands 149 feet high, and its barrel-vaulted nave rises 33 feet.[38] A close look at St. Hedwig's brickwork and interior detailing suggests the work of a very skilled architect and building crew, making it one of the most significant architectural landmarks in South Bend.

Only one block away is St. Patrick's Church, located at 305 South Taylor Street and built in 1886 to 1889, replacing an earlier church on the site from 1859. Gothic Revival in style, it features two bell towers of differing heights with a rose window in the center, a design based on that of Chartres Cathedral in France. Both St. Hedwig's and St. Patrick's are built of a similar yellow brick, supplied by a brick kiln on the St. Joseph River, the same as that used in the buildings around the main quad at Notre Dame.[39] Its architect was Adolphus Druiding of Chicago, with Martin Hoban as the contractor.

The first pastor of St. Patrick's, Father Thomas Carroll, who came from Ireland, had initially been put in charge of the old St. Alexis by Father Sorin in 1859.[40] While St. Patrick's congregation was made up primarily of Irish descendants, it served other nationalities as well, including Germans, Poles, Hungarians, and Belgians, most of whom eventually founded their own parishes.

The buildings of the Notre Dame and Saint Mary's campuses, together with South Bend's schools and churches constructed from the 1860s to the

1890s, reflect a period of rapid change in terms of stylistic characteristics, yet also a consistency of scale, construction materials, and level of durability. With the exception of St. Joseph's Church, their state of preservation remains relatively good. Together, they comprise a distinct picture of the nineteenth-century city, one worthy of both preservation and continued study.

FIGURE 6.10
St. Patrick's Church,
S. Taylor Street, 1886.
(Photo by author.)

Building Notre Dame and Saint Mary's in the 1880s

The 1880s proved to be one of the most significant decades for the development of both Notre Dame's and Saint Mary's campuses. This chapter is devoted solely to their planning and development during this crucial decade, which saw the construction of many of their most iconic buildings. Historian Paul Venable Turner described Notre Dame's transition from a rural institution founded in the wilderness of northern Indiana to one that had an increasing urban character, with buildings densely grouped around the main structure in a pictorial setting.[1] There was a desire among most college administrators in this period that new buildings should be venerable and substantial. At Notre Dame and Saint Mary's, conservative and tradition-oriented, that goal was met during the 1880s by the Gothic and Romanesque styles, which evoked the taste, piety, and venerability of medieval Europe. These styles were thought to support the collegiate ideal of a community of scholars, living as a family, perpetuating the traditional curriculum, and united by a religious creed.[2]

Notre Dame's Third Main Building

An aerial lithograph of the University of Notre Dame from *An Illustrated Atlas of St. Joseph Co., Indiana*, of 1875 depicts a distinguished group of French-styled buildings: Sacred Heart Basilica and the second Main Building, with the heart-shaped landscaped parterre in front. The Main Building is shown with wings added to each end, east and west; however, they were never actually

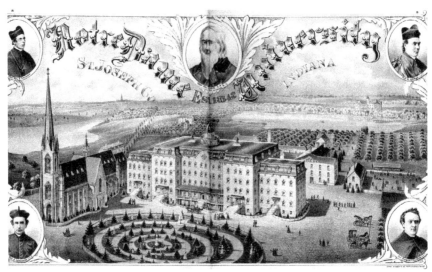

constructed. In the background are the two lakes and several service build-ings.[3] At the time this lithograph was produced, Sacred Heart Basilica was still under construction, its nave, choir, and transept arms having just been com-pleted, but its Lady Chapel and steeple still to be finished. In fact, the image shown in this illustration never came about, for in 1879, before the remaining sections were completed, a fire broke out in the Main Building that reduced it to ashes.

This calamity struck the Notre Dame campus on April 23, shortly before the end of the spring semester. An intense inferno blazed for three hours, reducing the giant building to nothing but its four outer walls and destroy-ing several nearby structures as well. Instruction came to a halt, and students were sent home early for the summer. Such a disaster had been known to close other colleges, fire being the leading cause of college failures in the nineteenth century.[4]

Father Sorin and Notre Dame's president, Father William Corby, not only made plans to rebuild but also saw this as an opportunity to build on a much larger scale. By the late 1870s, Notre Dame had a faculty of about 30 and a student body of 350. The library collection had about 7,000 volumes, many of which were rescued from the burning structure. A larger building was needed, and it had to be designed and constructed in time for the start of the next aca-demic year: September 1879.

Within a week of the fire, as the site was being cleared, Father Sorin an-nounced a national architectural competition for the design of the new Main

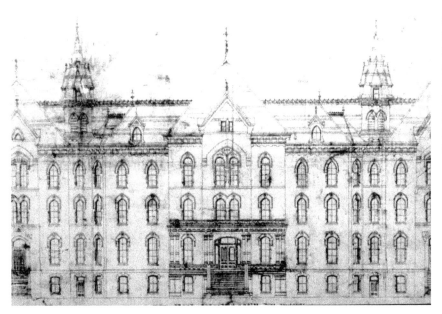

FIGURE 7.2
Design for third Main
Building, University
of Notre Dame, 1879,
Willoughby J.
Edbrooke, architect.
(Courtesy of Notre
Dame Libraries
Special Collections.)

Building. Even though architects were only given two weeks to prepare their designs, eight proposals were received. On May 14 Father Sorin and Father Corby chose a proposal by Willoughby J. Edbrooke, a thirty-five-year-old Chicago contractor and construction engineer whose practice had flourished since the Chicago Fire of 1871. Most of his experience had been in the design and construction of apartment buildings and private residences.[5]

Construction of the third Main Building was begun within a month of the fire. More than 300 laborers worked furiously through the long, hot summer days to lay more than 4,350,000 bricks to construct the building that would again house classrooms, study halls, art studios, faculty quarters, offices, chapels, the library, dormitories, dining rooms, and even a museum space. Astoundingly, the massive structure opened in time for the beginning of fall classes on September 8, 1879.[6]

It is a large building by any standard, four stories high plus an attic with dormer windows. It is a "modern Gothic" style, that is, a synthesis of Gothic, Second Empire, and Baroque influences, all of which were popular at the time. Some would call it High Victorian Gothic. Faculty member Francis Kervick wrote, "It is an eclectic and somewhat naïve combination of pointed windows, medieval mouldings, and classic columns."[7] It features a variety of window profiles, beginning at the ground floor with rectangular windows with keystones, followed by low-pitched pointed arches on the first floor, a slightly

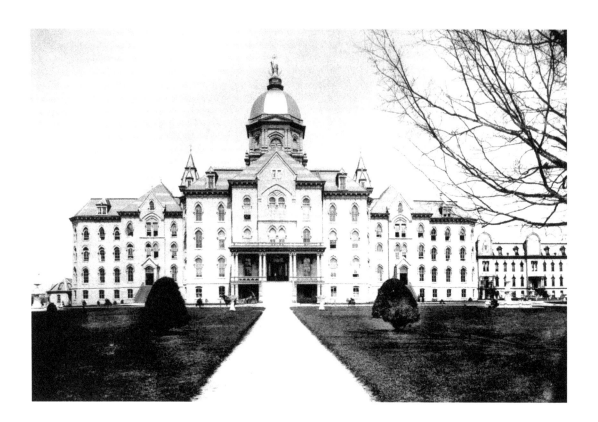

higher point on the second floor, and steeply pointed lancet arches on the third floor. All of the upper-floor windows are topped by metal hood moldings.

Its plan is in the form of an irregular Greek cross, with the south arm longer than the north and forming a T-shape across the front, its overall dimensions measuring 320 feet wide by 155 feet deep.[8] Schlereth has pointed out that despite the building's eclecticism, its overall plan and elevation are perfectly symmetrical down its north–south axis. Its central block is flanked on either side by wings and secondary blocks, giving it a pavilion-wing-pavilion motif. Each of the side wings has a tower and a central projecting bay, with iron stairs leading to secondary entrances.[9] With regard to Notre Dame's transition from a rural institution to one that had an increasing urban character with buildings densely grouped around the main structure, Turner wrote that Notre Dame's lofty Main Building "was itself a grouping of many wings and towers with a cosmopolitan character typical of a category of Catholic collegiate structures of the period."[10]

The main corridors on the building's first floor are decorated with murals depicting scenes of Christopher Columbus discovering America, painted by

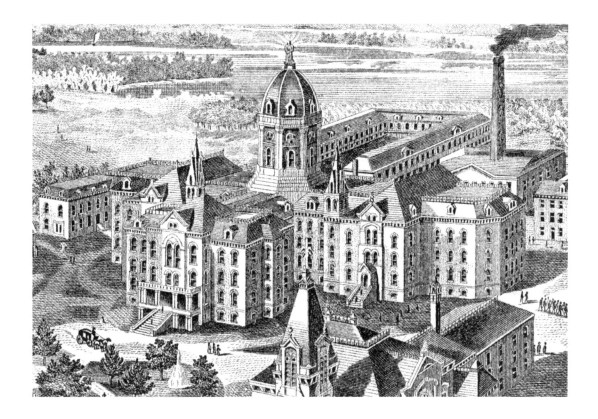

FIGURE 7.4
Aerial view of
Notre Dame Campus
in 1888.
(Courtesy of Notre
Dame Libraries
Special Collections.)

Luigi Gregori. He used as models members of the Notre Dame community, including Father Sorin and Father Walsh. For many years these images were well known across the country, and one of them was reproduced and displayed at the Columbian Exposition in Chicago in 1893.[11] They have since come in for much criticism as Columbus has fallen out of favor and as the mural's depictions of indigenous peoples have come under scrutiny. In the fall of 2020, the university elected to cover the murals with tapestries that are removable for the sake of studying the images.

The dome, which was built from 1883 to 1884, rests on an octagonal drum that rises in two stages and is detailed with classical columns, pilasters, cornices, and balustrades. A window, framed by paired pilasters and a pediment, rises through both levels on four sides. The lancet-shaped dome rises above, to a total height of 197 feet at the top of the statue of the Virgin Mary.[12]

When the dome was completed there was a debate over how it should be finished. Father Sorin wanted it to be sheathed in gold leaf, but members of the Holy Cross administrative council wanted it painted to save on costs. The issue came to a head in 1886 when Father Sorin boycotted several meetings of

the council until enough members were convinced to vote for the funding of a gilt surface. It has served as a powerful symbol of the university since its construction (indeed, *domer* has since become a nickname for Notre Dame students and alumni), and its covering in gold leaf eternally symbolizes wealth and durability.[13]

The statue perched on top of the dome was donated by the women of Saint Mary's College. Artist Giovanni Meli of Chicago was commissioned to fabricate *Our Lady of Notre Dame*, which he modeled after the sculpture of the Virgin erected by Pope Pius IX in the Piazza di Spagna in Rome.[14]

The style of the Main Building, which represents a turning away from the Federal, Greek Revival, and Second Empire styles that had previously prevailed, was influenced in part by the English social reformer and architectural critic John Ruskin. His writings helped promote the High Victorian Gothic style, which aimed at a free and creative use of traditional Gothic forms, in both England and America. English architects such as George Edmund Street and Gilbert Scott designed perhaps the best examples of the style, with buildings such as the Royal Courts of Justice and the Midland Grand Hotel at St. Pancras Station, which featured asymmetrical massing, rich polychromy, and picturesque rooflines. New York architect Peter B. Wight was credited with having produced the first High Victorian Gothic building in the United States, the National Academy of Design, in 1863.[15]

Notre Dame's Main Building was a near contemporary of Harvard University's Memorial Hall, designed by William Robert Ware and Henry van Brunt in 1865 and constructed from 1870 to 1876. This was the epitome of the High Victorian Gothic style, with steeply pitched roofs, pronounced verticality, floriated arches, gabled dormers, traceried windows, crestings, and finials. Memorial Hall's vivid polychromy, with red and black brick and yellow sandstone blocks laid up in bands and crossing diagonal patterns, was particularly eye-catching. Similar banding was used in the roof with multicolored slates. Ware and Van Brunt were influenced by the English work of Street and Scott, as well as by the Oxford Museum of Natural History by Thomas Newenham Deane and Benjamin Woodward with John Ruskin.[16]

Notre Dame's Main Building shares with Memorial Hall many of the same decorative features, although at a smaller scale. Most striking is the contrast in the use of polychromy. While most architects working in the Victorian Gothic style freely used vibrant colors, patterns, and materials, Edbrooke and Father Sorin chose to use a single color of yellow brick, which was manufactured on

the banks of the St. Joseph River. There were no variations, no colorful sandstone trim, and no patterned surfaces. With the exception of the gilt dome, this relatively monotone coloration, with only slight changes in tone over time, would become a characteristic feature of Notre Dame's campus architecture.

Another influence from abroad, one that also had links to the work of Ware and Van Brunt, was the use of slender iron columns as interior framing members in conjunction with the exterior masonry bearing walls. Many of these round columns with their Gothic capitals are still visible today in the building, having been restored during a major renovation in 1997. The French theorist, architect, and restoration specialist Eugène-Emmanuel Viollet-le-Duc, who published *Entretiens sur l'architecture* from 1863 to 1872, promoted the use of such iron framing members wedded to masonry vaulting.[17] Van Brunt referred to Viollet-le-Duc in his writings, and he translated the two-volume *Entretiens* into English in 1875, making it readily accessible to American architects such as Edbrooke.[18]

Since its construction, the Main Building has been the university's most memorable building in terms of both function and symbolism. It commands an important position at the head of the Notre Dame Avenue axis. Its dome towers over other buildings around it, and its picturesque roofline and dormers form a riveting image against the skyline. Its golden dome glistens in the sun and glows under nighttime light. It is an enduring symbol for Notre Dame alumni, students, parents of students, visitors, and residents of South Bend, a symbol of the university as an institution of higher learning, truth, and the Catholic Church. Just as the dome of St. Peter's Basilica in Rome is a universal symbol of the Roman Catholic Church, so too is the gilt dome of the Main Building a universally recognized symbol of the University of Notre Dame.

Building the Latin Quad

As the university recovered from the 1879 fire, its student body increased in numbers, its alumni multiplied across the United States, and Father Sorin had increasing success in fundraising for new construction. The result was the development over the next twenty years of the main quadrangle, extending south of the Main Building and aligned more or less symmetrically about the main north–south axis. In all, five buildings were constructed during this period: a

FIGURE 7.5
Washington Hall,
University of Notre
Dame, 1881,
Willoughby J. Edbrooke,
architect. (From *Art
Work of South Bend
and Vicinity*.)

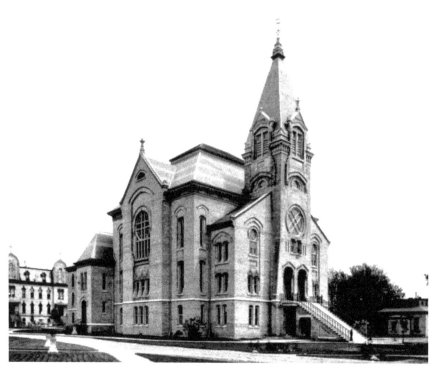

performing arts building, two classroom buildings, and two dormitories. Nicknamed the Latin Quad, it became the defining space of the campus, wooded and threaded with picturesque walks and dotted with statues and a fountain.

Because of Edbrooke's success with the Main Building, Father Sorin commissioned him to design many of the new structures, beginning with Washington Hall, which was built in two phases between 1879 and 1882. It replaced two older buildings which were demolished, the first an "exhibition hall" that had been constructed on the site in 1862 to 1864 and dedicated as Washington Hall, the only building on campus to be named after a U.S. president.[19] The second was a music hall, built from 1865 to 1866, contemporaneous with Thomas's transformation of the second Main Building.

The initial phase of construction of the new Washington Hall was the north wing, housing practice and recital rooms, an exhibition hall, and dormitory rooms.[20] Foundations for the second phase, at first intended to house a larger exhibition hall or auditorium, were built up to seven feet above ground in 1880 but then temporarily roofed over until the following year, when construction resumed. The design of this second phase was changed to accom-

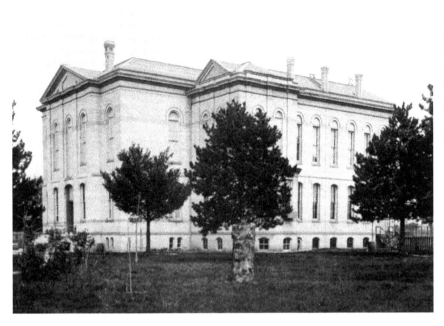

FIGURE 7.6
Science Building
(LaFortune Hall),
University of Notre
Dame, 1883,
Willoughby J. Edbrooke,
architect. (From *Art
Work of South Bend
and Vicinity*.)

modate the newly established Academy of Music, with an auditorium to seat 1,200 people.[21]

The building's exterior is composed of an eclectic mix of arches, pediments, gables, and towers meant to reflect the character of both the Main Building and Sacred Heart Basilica.[22] There is a certain quirkiness about its architecture, reflecting perhaps the influence of the Philadelphia architect Frank Furness, whose design of the Philadelphia Academy of Fine Arts shares a similar misproportioned tower and an exuberant crisscross pattern of moldings and window frames. The hall inside, with a main floor and balcony, decorated by Jacob Ackermann and Brother Frederick, provides an intimate space for plays, musicals, and dance.

With the construction of Washington Hall east of the Main Building, opposite Sacred Heart Basilica, the university had effectively established a central core of buildings. As music historian Mark Pilkinton described it, the core now consisted of (1) the Main Building, where students lived and studied, (2) the church, where the community assembled in the sacred sphere, and (3) the auditorium, where the community assembled in the secular sphere.[23]

Edbrooke's third building on the campus was the Science Building (now LaFortune Hall), built in 1883. Designed in collaboration with Father John Zahm, it was the first building constructed on the campus for the sciences.[24]

FIGURE 7.7
Sorin Hall, University
of Notre Dame,
1888–1889, Edbrooke
and Burnham,
architects. (From *Art
Work of South Bend
and Vicinity*.)

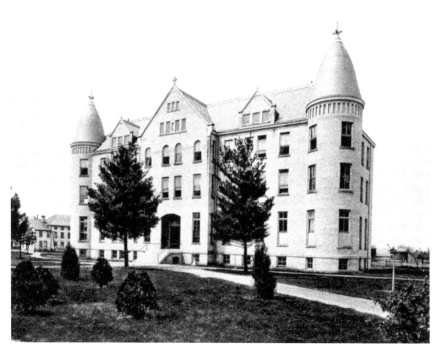

It was originally U-shaped in plan, two stories high on a raised basement, with round-arched windows, pilasters, and a hipped roof. A later addition doubled its size, and what had been its rear courtyard was turned into a small glass-enclosed atrium. Its main facade features a horseshoe-shaped stairway leading up to the first-floor entrance and down to a second entrance at the basement level.

Edbrooke's final building on the campus, commissioned from 1888 to 1889, was the legendary Sorin Hall.[25] Located just south of Sacred Heart Basilica, it further defined the Latin Quad's west side. Featuring circular turrets with conical roofs at the corners, it has the appearance of a French château, something similar to the Château de Chambord in the Loire River valley. The residence was intended for upper-level students, most of whom had until then lived in the Main Building. It was designed with single rooms, which was at that time a fairly radical contrast to the communal living the students had been used to.[26]

Edbrooke had a remarkable career in which he employed all of the popular styles of the day. He designed not just Victorian Gothic buildings, but Romanesque and Classical Revival ones as well. In the 1880s he would become

an expert in courthouse design, and from 1884 to 1889 he would build the Georgia State Capitol in the Classical style. In the 1890s he was appointed supervising architect of the United States Capitol, and he went on to build several buildings in Washington, DC, including the landmark Pennsylvania Avenue Post Office.[27] At the Columbian Exposition of 1893, he designed the U.S. government's pavilion plus seven other buildings.[28] In a sense, Edbrooke was "discovered" by Father Sorin, who picked out his proposal from seven others at a desperate time in the university's history, launching the career of this thirty-five-year-old builder from Chicago with the construction of Notre Dame's largest and most important building.

Saint Mary's College in the 1880s

Development of the Saint Mary's campus owes its design to the sketch produced by Father Sorin in 1855, the simple line drawing that was published in *The Chronicles of Notre Dame du Lac*.[29] A range of interconnected buildings was constructed to the north and west of the Academy Building, corresponding more or less to Father Sorin's sketch. The drawing indicated a large building on the central axis, rectangular in plan and projecting forward. It was flanked on either side by three buildings in line, narrow in plan, forming a continuous wall. The *Chronicles* description indicates the group of buildings was to be 360 feet long. The first to be constructed was Lourdes Hall in 1871, a long, narrow, rectangular structure in the Italianate style.[30] This building may have replaced an earlier dormitory described by Father Sorin in 1855.

Sometime around 1870, a master plan was created for the campus, commissioned by Mother Mary Angela, probably with Father Sorin's encouragement, and largely based on his plan sketch done fifteen years earlier. This master plan is shown as an aerial view in the *Illustrated Historical Atlas* of 1875 and was described in glowing terms: "The present substantial brick academy with its spacious and airy halls, its study and recitation rooms, library and museum, music halls and studio, its well-ventilated dormitories and refectories, is still only the beginning of good things to come. When the whole plan has been carried out, the present St. Mary's will be found to occupy only one-third of the St. Mary's which stands in the far-seeing eyes of its superiors."[31]

Most interesting is the fact that this aerial view shows an image of Saint Mary's considerably different from the way it was actually developed.[32]

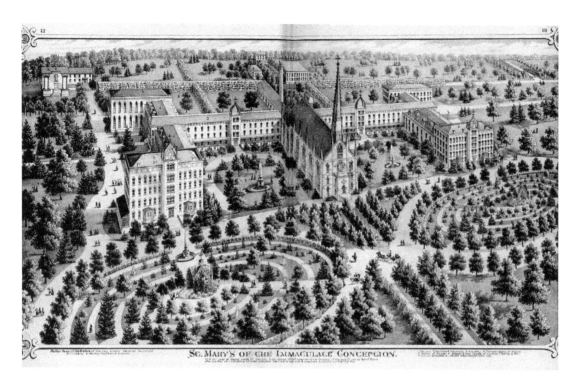

ST. MARY'S OF THE IMMACULATE CONCEPTION.

FIGURE 7.8
Master plan for Saint
Mary's College as
published in 1875.
From *An Illustrated
Historical Atlas of
St. Joseph County*,
1875. (Courtesy of
St. Joseph County
Public Library, Local
and Family History
Services Oversize
Collection.)

The linear plan originally envisioned by Father Sorin is only partly followed in the master plan, as the alignment of the buildings is interrupted in the middle by a proposed new church that stands well in front of the flanking buildings. The Academy Building, in a slightly altered form, is shown at the left of the scene. Behind it and extending to the north is Lourdes Hall, then the proposed church, then a new building, Augusta Hall, which is the northernmost wing, and finally, a fifth building to balance the Academy Building.

Augusta Hall was built in the Italianate style in 1883, twelve years after Lourdes Hall. The two buildings created a long range of four-story buildings on either side of the central building, serving as an impressive backdrop for the campus's front lawn. These two buildings alone corresponded to Father Sorin's original sketch.

In the master plan's aerial view, the magnificent new church stands in the space between Lourdes and Augusta Halls, but not in line with them as Sorin's drawing proposed. Rather, it is some distance in front of them, a prominent but isolated building serving as a centerpiece of the campus. Its architectural character is similar in appearance to Notre Dame's Sacred Heart Basilica, a Gothic-inspired structure with a rose window and bell tower above the main entrance, and lancet-arched windows, buttresses, and pinnacles along the

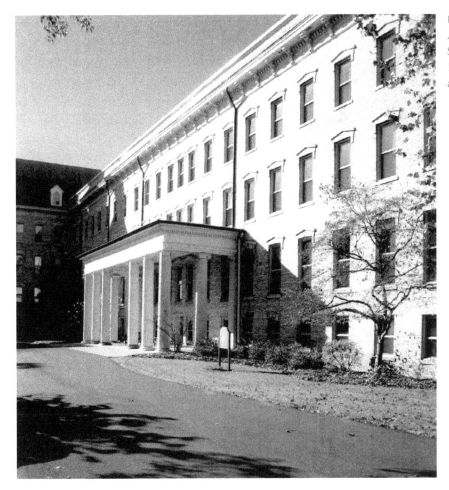

FIGURE 7.9
Augusta Hall,
Saint Mary's College,
1883. (Photo by
author.)

sides. It is an accomplished design and not the work of an amateur, perhaps a design proposed by Patrick Keely or else Thomas Brady, both of whom were involved with the design for Sacred Heart Basilica at Notre Dame in and around 1870.

This church was to be located at the head of the axis of the college's entrance avenue, forming a spiritual center from which everything else would radiate. On either side of the axis, in front, were what appeared to be landscaped oval labyrinths, one in front of the Academy Building and the other in front of its proposed mirror image, a building labeled the Novitiate and Scholastic. Each landscaped oval contained a small chapel in the center and a fountain opposite the two buildings. The oval to the left was called the "Seniors' Recreational Ground," and the one to the right was called the "Juniors' Recreational Ground." They were described in the *Atlas* for their healthful benefits: "In the

extensive grounds, interspersed with groves and walks, arbors and fountains, for the use and recreation of the pupils, contribute greatly to the uniform excellent health of the [students] of the institution. Every incentive—in the shape of riding on horseback, gardening, swings, calisthenics, croquet, graces and other games—is offered to induce sufficient exercise in the open air."[33] But there was more to the description than the purely recreational. There was also the contemplative: "The stranger finds on [her] first visit to St. Mary's an unexpected charm in this spot, so removed from all of the busy turmoil of the day and age, and yet full, to overflowing, all the most sacred interests of humanity. Meeting here seclusion without solitude, simplicity without rusticity, [she] sees a place suited to [her] own ideas of education; while for those who have spent many years among these scenes of peaceful beauty, no description of St. Mary's can ever convey an adequate idea of its charms for the eye, the heart, and the imagination."[34]

At the far upper left-hand corner of the 1875 aerial view is shown a small building labeled the Chapel and Holy House of Loretto and the "Minims Recreation Grounds." The new Church of the Loretto was built in 1885, ten years after the aerial view of the campus was published. It was located not on axis with the entrance avenue, as proposed in the master plan, but rather to the southwest of the Academy Building on a site that was closer to this original chapel. Designed in the Romanesque Revival style, the Church of the Loretto featured a circular or octagonal plan with three round-arched entrance doors, a single round-arched window above, a pair of corner turrets topped by domes, a central pediment, and a polygonal dome with a prominent cupola.

The designer of the Church of the Loretto is unknown. It is worth pointing out, however, that there is a nearly exact copy, the church of Notre Dame de Chicago, designed in 1892 by Gregory Vigeant.[35] The two buildings share the same plan, the same facade composition, the same dome and cupola, and even the same color of brick. Is it possible that Vigeant was the designer of both buildings? It was an accomplished design, refined in its details, innovative in plan, and beautifully picturesque in profile. The Church of the Loretto was tragically demolished in 1967, to be replaced by the present church designed by architect and Notre Dame graduate Paul Grillo.[36]

In 1889 the college commissioned Notre Dame's famed architect Willoughby J. Edbrooke to design a building for the gap between Lourdes and Augusta Halls at the head of the entrance drive. Edbrooke did not follow the master plan of 1875 by placing the new building in the lawn in front of them;

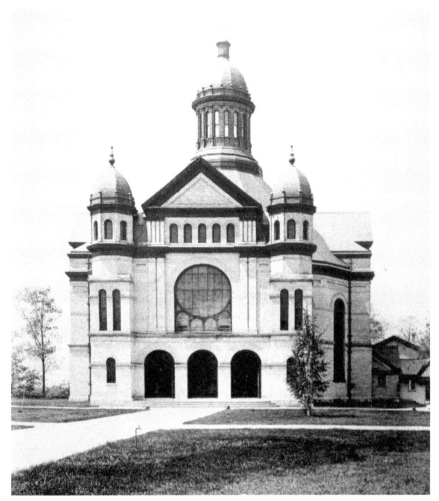

FIGURE 7.10
Church of the Loretto,
Saint Mary's College,
1885. (From *Art Work
of South Bend and
Vicinity*.)

rather, he nestled it between the two existing structures, its facade project-
ing forward only about fifty feet. Edbrooke based his design, named the
Tower Building, on the Romanesque Revival, similar to the Church of the Lo-
retto. It features a group of three round-arched windows rising through two
stories with intermediate spandrels. Above are two horizontal rows of cor-
belled brackets forming an elaborate cornice line. An aedicule with a broken
pediment rises from the center of these cornices into the steeply pitched gable.
To further enhance the composition, Edbrooke included a quarter-round win-
dow on either side of the aedicule, and he finished the composition with a
prominent cupola topped by a cross. The facade is framed at its corners by a
square tower, each with a curved mansard roof and a small cupola. Its walls are

FIGURE 7.11
Tower Building,
Saint Mary's College,
1889, Willoughby J.
Edbrooke, architect.
(Photo by author.)

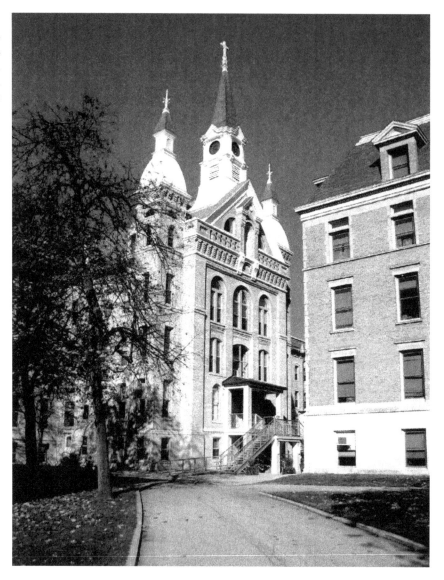

a warm, orange-toned brick with limestone trim. Unfortunately, this historic, highly decorative facade is no longer visible from the entrance road to the Saint Mary's campus, as Holy Cross Hall (formerly Collegiate Hall) was built directly in front of it in the early 1900s.[37]

The college commissioned a second building from Edbrooke in 1892, this time for a large gymnasium called Angela Hall, again in the Romanesque Revival style. It featured a row of five prominent round-arched windows across the front and a steeply pitched hipped roof supported inside by long-span

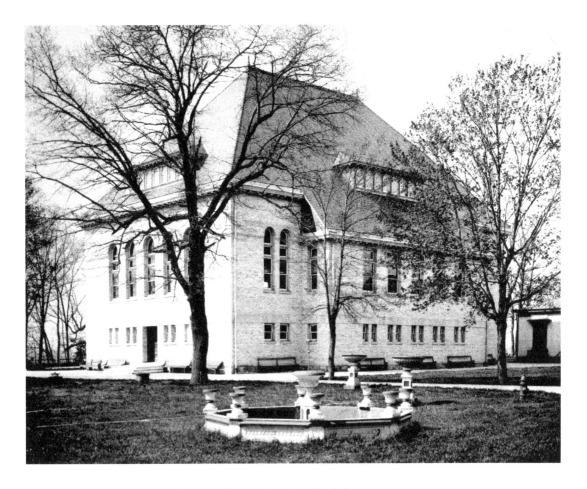

trusts. This building met the same fate as the Church of the Loretto in 1980, thus leaving only one of Edbrooke's buildings on the Saint Mary's campus.[38]

A view of the campus from the early 1900s shows a line of distinguished buildings, featuring the oldest and largest, the Academy Building, flanked on the left by Angela Hall and the Church of the Loretto and on the right by the Tower Building. While the Academy Building was designed in a French Classical style, the other three represented the favored style of the 1880s, the Romanesque Revival. It is a far different image from that of Notre Dame, even though two of the Saint Mary's buildings were designed by Edbrooke. He came onto the scene at Saint Mary's some ten years after the construction of Notre Dame's Main Building, a time marked by changing tastes—in particular, a lessening of the influence of the Victorian Gothic in favor of the Romanesque Revival.

Given that three buildings were constructed on the Saint Mary's campus between 1885 and 1892 in the Romanesque Revival style, it is important to

FIGURE 7.12
Angela Hall,
Saint Mary's College,
1892, Willoughby J.
Edbrooke, architect.
(From *Art Work of
South Bend and
Vicinity*.)

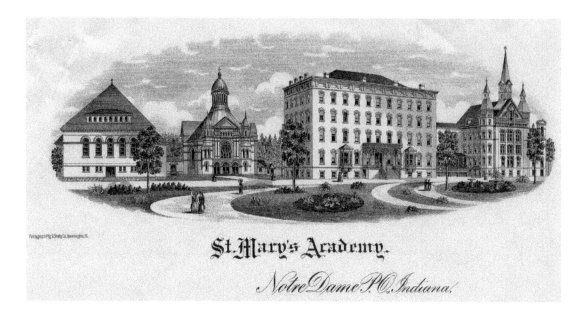

St. Mary's Academy.

Notre Dame P.O. Indiana.

FIGURE 7.13
View of Saint Mary's
campus ca. 1890,
showing, from left to
right, Angela Hall,
Church of the Loretto,
Academy Building,
Tower Building.
(Courtesy of Notre
Dame Libraries
Special Collections.)

consider the reason for the shift in taste away from the French classicism and Gothic Revival of just a few years earlier. As we have seen in chapter 5 in the discussion of the Oliver Opera House, the influence of the Romanesque Revival style was related to growing interest in German culture and architecture felt from the middle decades of the nineteenth century.[39] In the same manner, it was seen as an appropriate style for college campuses such as Saint Mary's.

Late Nineteenth-Century Residential Architecture

South Bend's residential neighborhoods expanded incrementally during the 1880s and 1890s as the Studebaker and Oliver corporations and their many supporting industries thrived, adding new personnel to their labor forces and bringing in record profits. The city's population grew from 13,390 in 1880 to 21,820 in 1890, and to over 36,000 in 1900.[1] By the mid-1890s, South Bend had many of the conveniences of most metropolitan cities. It had a modern water-works with a standpipe tower 232 feet in height, over 40 miles of street mains for water supply provided by pure artesian wells 90 feet deep. It had a modern, well-equipped fire department and an organized police force.

The year 1889 marked further progress in civic infrastructure as the city started paving its streets with brick pavers. Using pavers made in kilns along the St. Joseph River, work began on Jefferson Street, between Michigan Street and Lafayette Boulevard. Just five years later, one publication enthusiastically reported that

> The principal streets of the city are smoothly paved with cedar block and brick, and no place on the continent can boast of better sidewalks. The streets are broad, and in most instances running on parallel lines, although there are a few delightful avenues winding along the river banks, or follow-ing pioneer roads and old Indian trails at uneven angles. With a wealth of wide-spreading oaks, maples, elms and lindens bordering the street walks, the grassy lawns relieved by beds of bright foliage plants and flowers, the

bubbling fountains, the clean water, there is a cheery appearance every-where. South Bend is truly a beautiful park in the summer time, charming to look upon and delightful as a place of permanent abode.[2]

By 1906 there were thirty-six miles of brick-paved streets in the city.[3] The construction of new bridges over the St. Joseph River, replacing the outdated iron-truss spans with Melan concrete arches, added further efficiency and elegance to South Bend's streets and roads. As will be discussed in chapter 12, two of these new bridges were constructed in the first decade of the twentieth century at Jefferson Street and at LaSalle Street.[4]

The workers and midlevel managers who built wagons and farm implements in South Bend's factories lived in modest or midsized houses built in neighborhoods surrounding their industrial workplaces, as well as the Near East and Near Northwest areas. There were four predominant styles of residential architecture in these neighborhoods during the 1880s and 1890s: the Stick style, the Queen Anne style, the Neo-Jacobean style, and the Shingle style. These picturesque modes featured wood construction with clapboard and shingle siding, crossing gable and hipped roofs, and wraparound verandas.

Stick Style

The Stick style as an architectural movement in residential design was defined in 1952 by architectural historians Antoinette Downing and Vincent Scully Jr. with the publication of the book *The Architectural Heritage of Newport, Rhode Island, 1640–1915*. They used the term to describe residential construction that was characterized by wood clapboard and shingle siding, tall proportions, steeply pitched gable roofs, irregular plans, picturesque silhouettes, exposed framing members, and spindle-column porches. These houses often had a cross-shaped plan with intersecting gable roofs, rectangular double-hung windows, and porches on two or three sides. They had clapboard siding with corner trim, and often there were patterned shingles in the gables. Many had porch details with patterned panels influenced by the English architect Charles Eastlake.[5] Two of the most prominent defining examples of the Stick style on the East Coast were the John N. A. Griswold House in Newport, Rhode Island (1862–1863), by Richard Morris Hunt, and the Jacob Cram House in Middleton, Connecticut (1871–1872), by Dudley Newton.[6] The style was also used to

great effect at the Centennial Exhibition of 1876 in Philadelphia in several of the state pavilions, including New Jersey, Illinois, and Michigan.[7]

One of the earliest books that promoted the Stick style was Henry Hudson Holly's *Holly's Country Seats: Containing Lithographic Designs for Cottages, Villas, Mansions, etc.* (1863). His designs featured an emphasis on timber bracing and corner posts, common in European half-timber work. As historian Daniel Reiff wrote, "the idea of structural honesty, and the use of wood in a consciously woodlike manner, reveals the style's complex origins."[8] Stick-style designs were also found in *Woodward's Country Homes* (1865), by architect and engineer George E. Woodward. Here they were interspersed with illustrations of medieval and Gothic Revival as well as English Vernacular, Italianate, and Second Empire designs, demonstrating the broad range of styles builders could now work in.[9]

The Stick style gained popularity in the Midwest during the latter half of the 1870s, in both cities and rural areas. The development of balloon-frame construction made its widespread use possible. First used in Chicago in the 1830s, this mode of construction, employing sawn lumber such as two-by-fours nailed together, replaced heavy timbers mortised together. This, combined with the diminishing use of heavy timber framing and cross bracing, is the primary reason the Stick style gained popularity. The style superseded "traditional means of construction," in Reiff's words.[10] Stick-style dwellings, while often unappreciated, became a significant part of mass housing in the late nineteenth century and held an important place in the evolution of house design.

An early example of a Stick-style house in South Bend is the James Du-Shane House of 1878 at 720 Park Avenue. Featuring an elaborate double-story front porch with spindlework, patterned railings, and bracketed eaves, the house is nestled on a small, landscaped lot in the Chapin Park Historic District. James DuShane was one of the founders of the South Bend Public Library and the South Bend Electric Company, which introduced electric lights into South Bend.[11] Born in Pittsburgh, he graduated from the University of Michigan and moved to South Bend in 1878. He served as a high school principal and as superintendent of the city's school corporation, and still later, he became an attorney. Like his father-in-law, Andrew Anderson, who lived next door, DuShane was highly educated for a resident of a Midwestern city like South Bend. He was the type of community leader who built a dignified house for himself that was emblematic of his standing in local society. At the same time, he made important contributions to the city's judicial system and its cultural

FIGURE 8.1
James DuShane
Residence,
720 Park Avenue,
1878. (Photo by
author.)

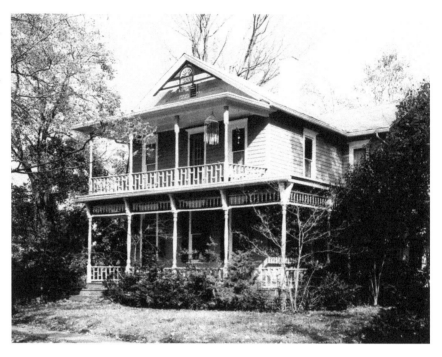

institutions, while having the foresight to promote the use of electricity, the newest form of power, which would eventually transform the city's character and its forms of industrial production.

A second example is the George Hodson House of 1889, at 723 Park Avenue, still architecturally significant even though its original front porch has been demolished. It features a square projecting window bay below a gabled tower, dormers, and an abundance of horizontal trim. George Hodson was prominently identified for nearly half a century with South Bend's construction industry and building supplies, especially windows and doors. Moving to South Bend from Burlington, New Jersey, in 1856, he and his brother worked as carpenters on the first St. Patrick's Church as well as numerous buildings for Notre Dame and Saint Mary's. Later he worked for a company located on the West Race that manufactured windows, doors, and blinds. He purchased the company in 1876 and operated it as Hodson, Stanfield and Company until 1895. He was a deacon in the First Baptist Church of South Bend, which would build a distinctive church building in the Richardsonian Romanesque style, and a director of the YMCA.[12]

Two characteristic examples of the Stick style in South Bend are located in the West Washington Historic District: first, the Edmund Meagher House

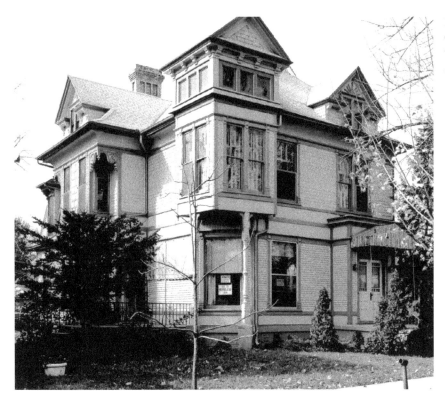

FIGURE 8.2
George Hodson House,
723 Park Avenue, 1889.
(Photo by author.)

at 730 West Washington Street (1884), which has a Stick-style porch and an elaborate second-floor bay window, and second, the Arthur Baker House (1888), next door at 726 West Washington, which features a decorative Stick-style porch on the front and side.

The Stick style also informed the design of hundreds of smaller houses built at the time for small-business owners and workers alike. They can best be described as Vernacular style, and in many cases they represent a transitional phase between the Stick style and the Queen Anne. Many of these were built in neighborhoods on the south and west sides developed by the Studebaker and Oliver families, such as Summit Place Addition, Rum Village, and the Liddesdale Addition, and neighborhoods such as St. Adalbert's Parish and Our Lady of Hungary Parish.[13] Houses in these neighborhoods were distinguished from their high-style counterparts by their smaller scale and relative lack of ornamentation, though some did sport a Stick-style porch. Two examples are the Adler Residence at 111 South Laurel Street, built in 1870, and the worker's cottage preserved on the site of Copshaholm, the J. D. Oliver mansion from the early 1880s.

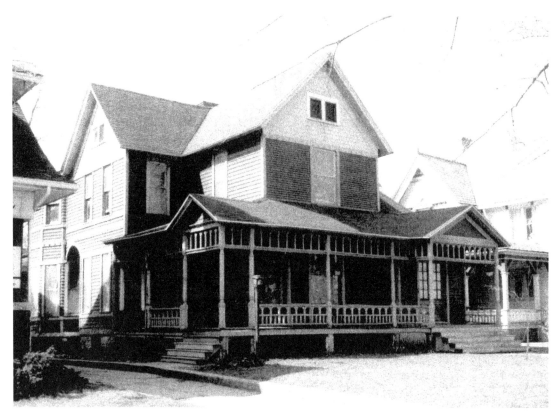

FIGURE 8.3
Arthur R. Baker
Residence,
726 W. Washington
Street (*left*), 1888;
Edmund Meagher
Residence
(*right*), 1884.
(Photo by author.)

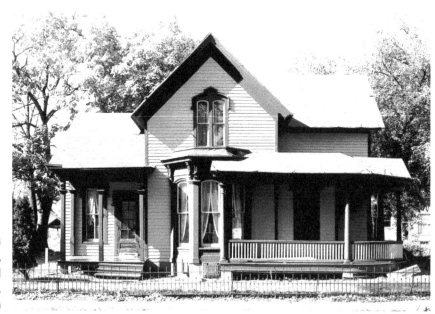

FIGURE 8.4
Adler Residence,
111 South Laurel
Street, 1870.
(Photo by author.)

FIGURE 8.5
Worker's Cottage
(moved to
Copshaholm site),
ca. 1870. (Photo
by author.)

Queen Anne

The Queen Anne style, prevalent in South Bend from 1885 to about 1905, was first made popular by the Boston architect Henry Hobson Richardson as well as the New York firm of McKim, Mead and White. Its origins are found in the houses of the British architect Richard Norman Shaw. It became a popular style for summer houses on Cape Cod and Long Island, and then, with the publication of numerous pattern books, its influence spread across the United States. Characteristic features are a picturesque roofline, broad verandas, corner towers, multiple window sizes and pairings, and a mixture of materials: brick, clapboard, and shingles. Some of the decorative detailing of Queen Anne–style houses was not unlike that of the Stick style; however, the most

pronounced difference between the two modes of building was the larger scale of Queen Anne houses, the preference for square or rectangular rather than cross-shaped plans, the use of hipped roofs rather than crossing gables, and a greater prevalence of classical detailing, especially in the porches.

Many of the Queen Anne features had also been evident in Gothic Revival architecture of the mid-nineteenth century, but again, there was a change in the scale and proportions of domestic architecture, and ornamentation came to be seen as purely decorative. A popular journal at the time, *Carpentry and Building*, published plans and images of Queen Anne–style houses and advertised an infinite array of decorative woodwork, patterned shingles, and appliqué forms that could be purchased from catalogs and shipped across the country from plants in New York and Michigan. This wealth of products available through mail order and local lumber mills alike made any combination of decorative forms possible as builders layered on columnar porches, patterned shingles, brackets, and leaded glass windows.[14]

Mail-order plan sets and specifications became an increasingly popular mode of house design and building and facilitated the spread of both Stick and Queen Anne styles in domestic architecture. One of the most important was *Palliser's Model Homes*, published in the 1870s and 1880s by Palliser, Palliser and Company of Bridgeport, Connecticut. This publication not only provided standard plans and specifications that could be ordered, but also advertised the company's business of designing buildings for clients through the mail. *Palliser's Model Homes* and *Palliser's New Cottage Homes and Details* were published in dozens of editions until well into the 1890s, providing a model for middle-class American homes. The preface to one edition stated, "The idea is no longer prevalent that good taste in Architectural design should be exercised only in regard to the erection of the more costly structures built for people of means, but on the contrary, more thought and attention is now paid to the design and erection of the smallest Cottages and Villas than has been given in the past to the more ornate and costly dwellings."[15] Similar publications that strongly influenced domestic architecture at the time were *Model Homes for the People* (1876) and *Building Plans for Modern Low Cost Houses* (1884) by the Co-operative Building Plan Association, founded and headed by Robert W. Shoppell of New York; *The Cottage Souvenir No. 2, Containing One Hundred and Twenty Original Designs in Cottage and Detail Architecture*, published in 1888 with subsequent editions, by George F. Barber of Knoxville, Tennessee;

and *The Radford Ideal Homes*, first published in several editions between 1902 and 1926 by William A. Radford of Chicago.[16]

Architectural journals published during the 1880s and 1890s likewise had an effect. For instance, *The American Architect and Building News* and *The Scientific American Architects and Builders Edition* both included large-format color illustrations of houses constructed in the Queen Anne style. *Carpentry and Building* published Queen Anne–style houses from the 1890s until 1907, when the style was no longer so fashionable.[17]

As with other residential styles, the Queen Anne style came to South Bend somewhat later than it appeared on the East Coast. Richardson's Watts Sherman House in Newport, Rhode Island, built in 1874, was one of the earliest in this country to be influenced by Richard Norman Shaw. Shaw's houses—with high roofs, steep pediments, tall narrow windows, and freely interpreted Renaissance or classical ornamentation—were the vogue in England in the 1860s. When translated by other designers, many elements of earlier periods were often included, especially medieval, Tudor, Elizabethan, or Jacobean. This resulted in the use of several names for the style, including Eastlake, Neo-Jacobean, or Free Classic.[18] It was a picturesque style in which complexity and variety were forced to the extreme. There is an irregularity of outline and floor plan, with projecting sections or bays, towers and turrets, rounded corners, and steep pyramidal roofs. Porches often had turned spindle columns, scrollwork in gable ends, and open spindle friezes. Siding included brick, clapboard, and shingles. Windows varied in size and shape, and often a leaded stained glass window was located at the stair landing.

The Watts Sherman House was particularly influenced by the publication in the March 1871 *Building News* of Shaw's design for Leyes Wood, Sussex, of 1868. A striking photolithographic image of the house in aerial perspective made a strong impression on Richardson. Leyes Wood revived late medieval and Tudor domestic forms while adding plaster decoration of semiclassical Renaissance motifs.[19] Richardson and his assistant, the young Stanford White, adopted all aspects of Shaw's design, including the entrance porch, high brick chimney, horizontal window bands alternating with stucco and half-timbered panels, shingled surfaces, and random ashlar masonry on the ground floor.

Richardson's design of the Watts Sherman House in turn influenced many architects and builders across the country, including those in South Bend. One of the earliest houses constructed in the Queen Anne style was built by Dr.

FIGURE 8.6
George and Josephine
Ford Residence,
630 W. Washington
Street, 1880–1886.
(Photo by author.)

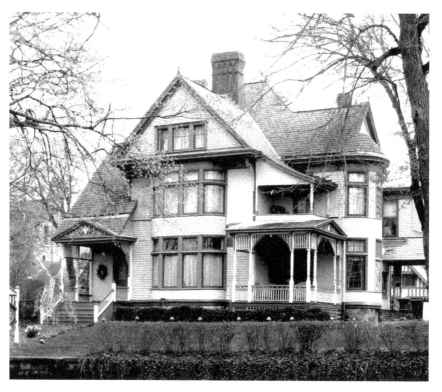

Lewis Pagin in 1880 at 630 West Washington. Most of its Queen Anne details date from 1886, when it was purchased by James Oliver, who remodeled and enlarged it to its present size before deeding it to his daughter, Josephine, and her husband, George Ford, who was at the time a U.S. congressman.[20] Significant for its corner turret, front two-level bay window, and spindle porch, it is the most expansive and beautifully detailed Queen Anne–style house in the city. Sited on a beautiful lawn, it has a low stone retaining wall along the sidewalk.

A second significant Queen Anne–style house is the Dr. George Morey House (1895) at 322 West Washington Street. Its most striking feature is an elaborate front porch with a second-floor balcony framed by a bay window and a massive stone chimney. On the other side of the chimney is a prominent corner tower. The house features a bay window with stained glass from the 1893 World's Columbian Exposition.

One of the city's most stately Queen Anne–style houses was moved to its present location at the southwest corner of West Washington and William Streets in the 1980s. Originally located on North Lafayette Boulevard, it was

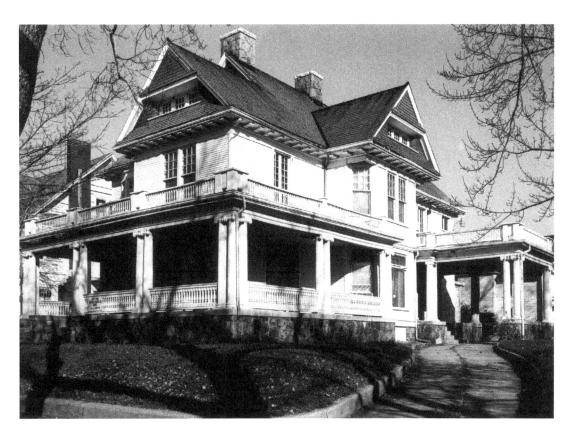

FIGURE 8.7
Samuel Good
House, 400 block of
W. Washington Street
(moved in the 1980s
from N. Lafayette
Boulevard), 1893.
(Photo by author.)

constructed in 1893 by Samuel Good. It has one of the finest Queen Anne–style porches in South Bend, with paired Ionic columns, spindlework railings and balustrades, a pronounced cornice with modillions, and a prominent attic with crossing gables. It had a distinguished stone foundation in its original location, which is now replaced by a more subdued brick foundation.

One of South Bend's earliest professionally trained architects, Charles Brehmer, designed at least two Queen Anne–style houses in the West Washington neighborhood and several on the near north side. The Leopold Eliel House at 131 South Chapin Street (1890) and the rectory for St. Patrick's Church at 309 South Taylor Street (1892) are exemplary.[21] His most distinguished work is the Jobson Paradis House at 1136 North Notre Dame Avenue (1899).

Brehmer was known for his designs of Victorian Gothic and Queen Anne–style houses and fire stations. He was born in Glencoe, Illinois, and raised in Bay City, Michigan. He attended the University of Notre Dame from 1878 to 1882 and studied engineering and architectural drafting. After working for two years in Bay City, he returned to South Bend in 1884 and established

FIGURE 8.8
Martin Hoban
Residence,
205 N. St. Louis
Boulevard, 1912.
(Photo by author.)

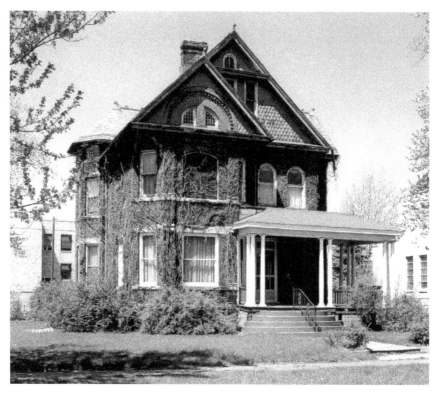

his own practice. He designed three of South Bend's fire stations in the late 1880s, Hose Company Numbers 3, 6, and 7, also in the Queen Anne style. One of his largest projects was the Arlington Hotel in Benton Harbor, Michigan. Brehmer lived at 804 North Notre Dame Avenue in a Queen Anne–style house he designed in 1884.[22]

Several Queen Anne–style houses were built after the turn of the century just north of the St. Joseph River on North Shore Drive, Marquette Avenue, and Wakewa Avenue. Featuring clapboard siding, steeply pitched roofs, shingled gables, and spindle-column porches, they include the William Rutherford House at 117 West North Shore Drive (1904), the Francis Caldwell House at 129 Marquette Avenue (1904), and the Eva Whitmer House at 102 Wakewa Avenue (1908). A variation of the Queen Anne style is seen in the Judge Thomas W. Slick House at 103 West North Shore Drive (1906), which features twin front gables and a symmetrical front porch.

The Martin Hoban House at 205 North St. Louis Boulevard was one of the last Queen Anne–style houses built in South Bend, its construction dating from 1912. The house is built of brick with a crossing gable roof and features a

prominent front bay window with a pair of quarter-round paired windows set in a brick arch in the gable. It was built by Hoban himself, who moved to South Bend from Maine in 1856 as one of the first Irish settlers of the area. Hoban was a prominent building contractor in the city and constructed several buildings at Notre Dame University, Saint Mary's College, and St. Hedwig's and St. Patrick's churches. He helped lay brick streets, built a retaining wall in Howard Park, and built Engine House Number 4. He was also active politically, having served as a city councilman.[23]

Neo-Jacobean

John Mohler Studebaker, Clement Studebaker's younger brother, was the first of the five brothers to build an architecturally significant house in South Bend, constructing "Sunnyside" in 1881. Located at 1219 East Jefferson Boulevard, in what was then considered a suburban area, the site bordered the edge of a vast tract of rolling, wooded land owned by the family. It was an area they would eventually develop into one of the city's most exclusive residential neighborhoods. Called by Timothy Howard "one of the beautiful sights of our city," the

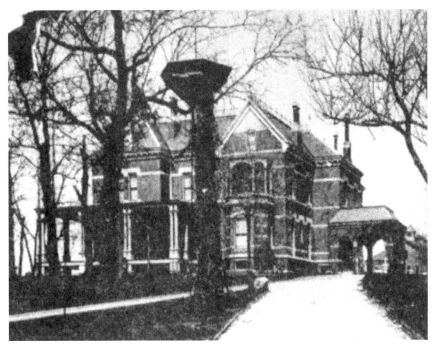

FIGURE 8.9
John M. Studebaker House, Sunnyside, Conestoga Drive, 1881, demolished 1950s. (From *South Bend and the Men Who Have Made It.*)

house was a rambling two-story brick structure with an entrance tower, reflecting a version of the Queen Anne popularly known as Neo-Jacobean.[24] From photographs, it appears to have combined rectangular and round-arched windows in addition to bay windows. It had a porch wrapping around two sides, elaborate bracketed eaves, and a porte cochere.

Describing the near-contemporary work of Hunt in New York, historian Sarah Bradford Landau detects a fusion of the Gothic and the Neo-Grec with the aim of aligning his work with High Victorian Gothic. The molded rectangular lintels of Sunnyside, with their simple incised designs, bear a close resemblance to those of Hunt's Presbyterian Hospital in New York (1869–1872); the feature became a hallmark of the American Neo-Grec, which typically combined French, Adamesque, Egyptian Revival, and other motifs in a richly eclectic polychromatic mélange.[25]

Howard also described the man who built this impressive mansion: "In this age of colossal enterprise and marked intellectual energy the prominent and successful men are those whose abilities, persistence, and courage lead them into large undertakings and to assume the responsibilities and labors of leaders in their respective vocations. Mr. Studebaker has made a life of grand success, steadily overcoming the difficulties and obstacles in his path and working his way upward to the place where success places the laurel on the victor's brow."[26] There was a lot here to suggest the idea of grandeur in relation to Studebaker, a man with an outsized penchant for achievement, the future head of a giant enterprise, a man who undertook large endeavors and achieved enormous rewards. When it was built, his house was the largest in South Bend, a direct reflection on his prowess as a business leader.

The area around Studebaker's house, also referred to as Sunnyside, is bordered today by Colfax Street on the north, Eddy Street on the west, Jefferson Boulevard on the south, and Sunnyside Street on the east. The history of Sunnyside is somewhat vague, as several large and lavishly decorated homes built there in the nineteenth century by various Studebaker relatives have been demolished. John Mohler Studebaker's house was one; another was the house of his youngest brother, Jacob F. Studebaker, located at 1227 East Jefferson Boulevard. It too was a large brick structure in the Neo-Jacobean style; it was accompanied by a carriage house which survives. Jacob's house was demolished in 1918 to make way for the Cyrus Schafer House; John Mohler's was demolished in the 1950s.[27]

Architectural historian Mary Corbin Sies wrote that after the end of the Civil War and up to the outbreak of World War I, architects and home builders for upper-class residents evinced a dual aim that was both personal and reform-minded. They sought to accommodate and formalize their own lifestyle and social position in a suitable setting and to devise a model environment that would address problems inherent in the older neighborhoods they left behind. Principles they followed, according to Sies, were efficiency, technology, nature, family, individuality, community, and beauty. It was a program of scientifically appointed and artistically designed single-family houses with plenty of outdoor space, which became "the most prominent American residential ideal of the twentieth century."[28] Sies wrote further that "we have to understand the social and cultural aims that influenced these men and women who decided on the form of their houses. These houses were a repository of the social ambitions, anxieties and cultural ideals of those who designed them and resided in them."[29]

Sies was writing about suburban houses built between 1877 and 1917 in ideal suburban communities in Short Hills, New Jersey; Philadelphia, Pennsylvania; Kenilworth, Illinois; and Minneapolis, Minnesota. While her examples emerged after the Civil War, in the case of South Bend, this occurred during the 1880s and 1890s, spurred on by the prosperity brought about by the Studebaker and Oliver factories.[30]

Shingle Style

An adaptation of the Queen Anne tradition was the development of the Shingle style, which appeared in the early 1880s, primarily in the seaside resorts of the northeastern states. One example is the Isaac Bell House in Newport, Rhode Island, by McKim, Mead and White (1883). Unlike the Queen Anne style, it did not emphasize decorative detailing at the doors, windows, cornices, or porches. Rather, it aimed for the effect of a complex shape enclosed within a smooth surface of shingles that unifies the composition. When decorative detailing is present, it is used sparingly.[31]

As early as 1850, A. J. Downing had recommended shingle cladding as an appropriate material for cottages because of its naturalness and its associations with America's colonial past. Shingle siding did not become a popular

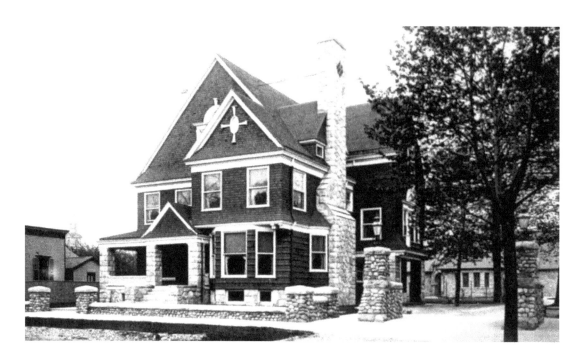

FIGURE 8.10
Charles Arthur
Carlisle Residence,
131 S. Taylor Street,
1894. (From *Art Work
of South Bend and
Vicinity*.)

material, however, until the 1880s, when it was used as a decorative element in Queen Anne architecture, especially in horizontal bands between floors and in the gabled ends of roofs.[32] Eventually it was adapted as the primary cladding for houses whose plan and volume often followed closely the Queen Anne tradition, with the exception of the use of more unifying rooflines or, in many cases, a gambrel roof. Precedents for the latter could be found in colonial houses in New England from the seventeenth century. Examples of Shingle-style houses, ranging from modest dwellings to seaside estates of the wealthy, were featured regularly in *The American Architect and Building News* throughout the 1880s.[33] Plan sets for Shingle-style houses could be purchased from any number of mail-order publications, such as *Shoppell's Modern Houses* or *The Radford American Homes*.[34]

An important example of the Shingle style in South Bend can be seen in the Charles A. Carlisle House, located at 131 South Taylor Street. Designed and built by Robert L. Braunsdorf in 1894, it is distinguished for the extensive use of shingles, a prominent Palladian window in its broad front gable, and its stone porch and chimneys. Its picturesque profile features a steeply pitched hipped roof and tall chimneys.

Braunsdorf, another of South Bend's earliest architects, was born in Danzig, Prussia, and educated in Holzminden, Germany, where he graduated in

1864. He became a carpenter and later moved to New York. He came to South Bend in 1871, established a contracting business, and began his architectural practice in 1890.[35]

Carlisle, a director and purchasing agent for the Studebaker Brothers Manufacturing Company, married Anna Studebaker, the only daughter of Clement Studebaker. This house is located at the rear of the Studebaker estate. His career reads like an idyllic American success story based on business, travel, and social connections. Anderson and Cooley describe the character and social standing of the Carlisles in the most exalted manner: "Mr. Carlisle and his estimable wife are most popular in social circles in this and other cities, and devote themselves largely to works of benevolence and charity. Among the treasures of his home are numerous testimonials, records, and other memorials bearing tribute to the deeds and accomplishments of his ancestors. Personally Mr. Carlisle is a thoroughly progressive American, who has won hosts of warm friends, and enjoys the esteem of the entire community."[36]

Before moving to South Bend in 1892 he held numerous jobs in Ohio with railway companies, including as private secretary and general manager of the Toledo and Ohio Central Railway. While he worked for the Studebaker Company he also served as the general manager and purchasing agent of the Chicago and South Bend Railroad, secretary of the South Bend Fuel and Gas Company, and vice president of the National Real Estate Association of America. The many social organizations he belonged to included the Sphinx Club of New York, the Columbia Club of Indianapolis, the Chicago Athletic Club, the Indian Club of South Bend, the Country Club of the St. Joseph Valley, and the Milburn Memorial Methodist Church. His house, as described in *South Bend and the Men Who Have Made It*, was "beautiful and luxurious," and he collected "one of the most extensive and best selected libraries owned by a private individual."[37]

The Stick, Queen Anne, Neo-Jacobean, and Shingle styles employed in the design of residential architecture in the 1880s and 1890s were in keeping with trends nationwide and were widely disseminated across the country through pattern books and mail-order publications. These were the styles employed by the white-collar workers, managers, and officers of South Bend's manufacturing enterprises, effectively transforming neighborhoods and—with their larger rooms, ample windows, and open porches—fostering healthier living conditions for their inhabitants.

Magnificent Mansions

Just as the Studebakers and the Olivers were rivals in the world of industry, so too did they rival each other in building magnificent mansions on the city's west side. The two families' industrial success allowed them to enjoy elegant, if not luxurious, lifestyles in South Bend. They built their attractive residences in the midst of their workers' neighborhoods and within walking distance of their sprawling industrial complexes. They spent lavishly on their homes, using the best materials—fieldstone, granite, glazed tiles, mahogany, and marble—sparing no expense in creating the most beautiful domestic spaces possible. At the same time, they incorporated the newest technologies, including advances in heating, ventilation, and sanitation, elevators, and household appliances and gadgets.

The two most prominent of these houses are Tippecanoe Place, constructed by Clement Studebaker from 1884 to 1885, and Copshaholm, built by Joseph D. Oliver from 1894 to 1896. Both are of monumental scale, at least by South Bend's standards. They sit on beautifully landscaped sites and are important for South Bend's architectural legacy, especially given the fact that they still remain as well-preserved, economically viable landmarks within the community.

Tippecanoe Place: The Clement Studebaker Residence

In Timothy Howard's early twentieth-century assessment of South Bend's leading industrialists, men who overcame great obstacles and achieved unparalleled success was the recurrent theme. With regard to Clement Studebaker, the builder of Tippecanoe Place, Howard wrote:

There are rare characters in the world's history who have both the tact and the force of character to overcome all obstacles caused by lack of early education, and take their place not only among the material forces of their country but with the cultured and professionally trained, who have had every advantage afforded by the universities of two continents. But eminent common sense, a great heart and the courtesy of an inborn gentleman will overcome all artificial considerations. . . . Perhaps half a dozen times in a generation a family of characters bearing these strong traits comes to the surface and holds the unbounded admiration of the country. The Studebaker family is of this great democracy, and none of its representatives was more typical of its admirable characteristics than the late Hon. Clem Studebaker.[1]

A man with a national if not international reputation, admired by others of his class and social standing, Clement Studebaker built a great mansion that represented his success not only to the world outside of South Bend, but also to the city's residents and to his four brothers and their families. Of all the houses constructed by members of the Studebaker family, his residence was to be the largest, most magnificent, most enduring, and most significant in the history of American architecture.

The story of Tippecanoe Place begins with an earlier house on the site, located at the corner of West Washington and South Scott Streets. Clement Studebaker purchased the property in 1868, conveniently located four blocks west of the St. Joseph County Courthouse and a few blocks north of the Studebaker industrial complex. An existing house on the site, formerly the William Ruckman house, was square in plan with a raised basement, a wide veranda across the front, and a hipped roof with a belvedere at the top. Studebaker remodeled it in the early 1870s, transforming it into the Second Empire style by the addition of a central projecting bay and a mansard roof with dormers in the manner of the second Main Building on the Notre Dame campus. He and his wife, Ann Milburn Studebaker, filled its rooms with a sizable collection of antique furniture, artworks, and books, much of it purchased during a trip to Europe in 1875.[2]

In the mid-1880s, Clement and Ann decided to build a new house for themselves, one that would be appropriately emblematic of their success in the industrial world. They wanted a house that would exceed in grandeur John Mohler Studebaker's Sunnyside and catch the attention of their industrial ri-

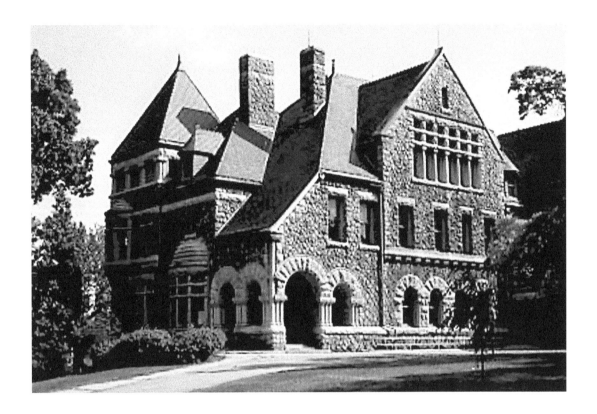

vals in other cities across the country. In a word, they wanted to put themselves, the company, and South Bend on the map.

In 1886 Clement commissioned Chicago architect Henry Ives Cobb to design a new mansion to replace the existing house. It would not be unreasonable to ask why Studebaker did not hire Solon Beman, who was supervising at the same time the construction of the Studebaker showroom in Chicago. Did he hire Cobb because he had just designed the audacious house in the Gothic Revival style for Potter Palmer, one of Chicago's richest landowners and developers? Studebaker was very concerned with his image, just as he was with the marketing of his company, and he would have aspired to be in the same league as Palmer. A residence designed by the same architect as arguably Chicago's most ostentatious house of the time would be a mark of both his business success and his cultural standing among America's industrial elites.

A contemporary of Beman, Cobb received his architectural training at MIT and Harvard and then traveled in Europe for a year, making the continental grand tour that was so essential to an architect's education. He settled in

FIGURE 9.1
Tippecanoe Place,
Clement and Ann
Studebaker House,
W. Washington Street,
1886–1888, rebuilt
1889–1890, Henry
Ives Cobb, architect.
(Photo by author.)

Magnificent Mansions 157

Chicago in 1882 and formed a partnership with Charles S. Frost. At the time the office was commissioned to design the Studebaker mansion, it was working on a commission for the Newberry Library in Chicago, a massive stone building in the Romanesque Revival style. Cobb would go on to design many of the original buildings on the campus of the University of Chicago, as well as the Chicago Opera House, Chicago Athletic Club, Chicago Historical Society, and the Old Post Office.[3] Architectural historian Edward Wolner writes that Cobb designed more of Chicago's prominent civic and cultural institutions than any other of its architects, "filling a huge institutional void that Chicago's architect-giants did not."[4]

Cobb's many buildings were designed in a variety of styles that were popular at the time, ranging from the Gothic and Romanesque Revival to the Classical Revival. He was especially adept at designing in the Collegiate Gothic style, which he used throughout his designs for the main quadrangle buildings at the Hyde Park campus of the University of Chicago. However, he was also influenced by the work of Boston architect Henry Hobson Richardson, who had designed numerous churches, houses, courthouses, libraries, and train stations throughout the United States in the style famously known as Richardsonian Romanesque.

Richardson was initially influenced by the École des Beaux-Arts in Paris, where he studied, and by French Romanesque architecture, which he knew largely through books.[5] It was a style that he used creatively and effectively for houses and large-scale civic and commercial buildings alike, from the Ames Gate Lodge in North Easton, Massachusetts, and the Robert Treat Paine House of Waltham, Massachusetts, to the Allegheny County Courthouse in Pittsburgh. He also designed two buildings in Chicago during the 1880s, the Marshall Field Wholesale Store and the John Glessner House. These buildings all influenced Cobb's design of the Studebaker mansion's heavy stone walls, elegant profile, and impressive woodwork details. The Glessner House in particular, built for a prominent Chicago industrialist whose biography in many ways paralleled the Studebakers', was influential in its pairing of an interior courtyard, which evoked a rural romanticism, with the intimidatingly tall stone exterior that encased it, reflecting a desire for insulation from the social strife and class conflict that festered in Gilded Age Chicago.[6] Richardson's influence was widespread, as reflected in an 1890 article from *The American Architect and Building News* that stated "every issue of ours with one of his designs was studied in a thousand offices and imitated in hundreds."[7]

The Richardsonian Romanesque style became popular because many believed it reflected the conditions of American life in an industrial society: rugged, bold, enduring. Architectural critic Montgomery Schuyler wrote that its main tendency "is to clumsiness and crudity and rudeness. . . . Where mass and weight and power are to be expressed it leaves nothing to be desired."[8] The style lent to the residence of an industrial giant such as Studebaker connotations of a magnificent European castle. It was employed not only in domestic architecture, but also in numerous public buildings. Several courthouses constructed during the 1890s in Indiana, for instance, were in the Richardsonian Romanesque style, including those in the towns of Winamac, Connersville, and Rushville. They featured rough stonework, bold and massive details, arched windows, and wide, semicircular doorways. Although Richardson died in 1886, his influence dominated public architecture in the Midwest until the early 1890s, when it began to be superseded by the Classical Revival. Yet architects have been more willing to acknowledge his influence in residential design and freer to either imitate him directly or adopt and elaborate upon the suggestions his work furnished.[9] Schuyler wrote in 1891, "The body of Romanesque work in this country is now more extensive, and upon the whole more meritorious than the building of any style which our architects had previously taken as the point of departure for a 'movement,' excepting only the Gothic revival."[10] Historian Jon Dilts stated that his style was "both impressive and cost effective."[11] Its massive stone walls could be plain or fancy and could be adapted to limited budgets.

In the case of the Studebaker mansion, the walls are anything but plain, and it is clear that there were few budgetary limitations. Construction began in 1886 and was completed in 1888. The older house on the site, which had been the Studebaker's home since 1868, was moved around the corner to 202 South Scott Street, where it remained until its demolition in the 1950s.

Studebaker named his new mansion Tippecanoe Place in honor of President William Henry Harrison and the Battle of Tippecanoe. Harrison had run his presidential campaign in 1840 with the slogan "Tippecanoe and Tyler too," references to his victorious battle against an allied tribe of Native Americans at the mouth of the Tippecanoe River just north of Lafayette, Indiana, and to his vice president, John Tyler. Clement Studebaker was a personal friend of the president's grandson, Benjamin Harrison, who was himself elected president in 1888. Studebaker attended the inauguration and was invited to a lavish dinner in the White House.[12]

The builders of Tippecanoe Place, Christopher Fassnacht and Robert L. Braunsdorf, brought years of experience to the project, both as contractors and architects. Fassnacht owned C. Fassnacht Company and later the Indiana Lumber and Manufacturing Company. (His purchase of Chapin House and work as a land developer are mentioned in chapter 4.) Braunsdorf, whom we first encountered in chapter 8, had by now gained a reputation as a talented and creative architect. In addition to his work on the Studebaker mansion, he designed the houses of Frederick S. Fish and Charles A. Carlisle, and downtown he designed a commercial building known as the Muessel Block. He no doubt played an important role in both the design and construction supervision of the Studebaker mansion.[13]

The site of the Studebaker mansion was the largest residential lot in South Bend at the time, measuring 296 feet along Washington Street and 395 feet along Taylor Street, with an additional plot at its southwest corner where the Studebakers built stables and a greenhouse. They marked the entire perimeter of the site with a three-foot-high fieldstone wall.[14] The mansion itself is set far back from the street on a bluff, with a winding drive leading up the hill to a porte cochere on its west side. It was described in *Unrivaled Chicago* (1897), a guidebook produced by Rand, McNally, and Company: "It stands upon a natural elevation, surrounded by smoothly shaved lawns, which slope to the north and east, and are broken here and there by beds of brilliant flowers. There are several fine old oaks to the south and east. With its massive walls, its turrets and the irregular roofs, it looks like some feudal castle which has been set down in the midst of a busy nineteenth-century town, and yet produces no effect of incongruity."[15]

Encompassing forty rooms on four levels, with a total of 23,744 square feet, Tippecanoe Place was at the time easily the largest house in South Bend, if not all of northern Indiana. Its Richardsonian Romanesque design featured massive stone walls, round-arched windows and doors, a sheltering entrance porch, square and round towers and, at the rear, a wide veranda with stone columns. The window and door frames and arches are of rough stone. Even the transoms and mullions are stone bars.[16]

The stone used in the exterior walls is irregular Indiana fieldstone, with sandstone and granite trim. Wolner suggests that the hues of red, gray, and pink may have been a toned-down version of the boulder walls in one or two of Richardson's late houses.[17] The stones were boulders taken from farm fields in St. Joseph County, where they had been deposited by glaciers several mil-

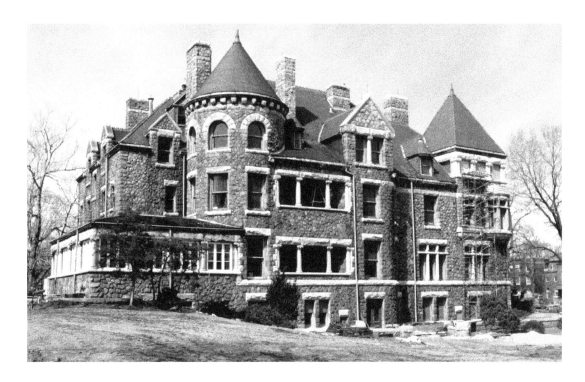

FIGURE 9.2
Tippecanoe Place
ca. 1900, showing
random fieldstone
walls. (Photo by
author.)

lennia earlier. Cobb and Studebaker wanted to use local materials, and the stones were shaped by local workmen. There is a beauty in their rough edges, varied colors, and massiveness, heaviness, and sense of permanence.[18]

Every detail contributed to the unity of the mansion's design, from the round-arched windows with their massive stone voussoirs and the clustered colonettes—some very short and stout with delicate foliate carvings—to the bay windows and the pair of round-arched openings marking the entrance porch. Its picturesque quality is enhanced by its massing and roof forms. Its Washington Street facade is marked by three roof profiles that merge together in a crescendo effect from east to west: first the pyramidal roof of a square turret whose top story was originally open, then a hipped roof with a dormer, and finally, a shed roof that spills down to the low entrance porch. Two prominent chimneys provide a vertical counterpart to the sloping roof forms. The mansion has a baronial look about it, representing hard work, business, and the fruits of industry.

Inside, among the forty rooms are twenty fireplaces—each different in appearance—and forty chandeliers. The Richardsonian Romanesque and Eastlake styles predominate throughout the interior, with fine woods of contrasting colors—maple, oak, mahogany.[19]

The fireplaces were the most commanding symbols of domesticity, the hearth having a clear symbolic meaning. The rapidly developing use of furnaces and stoves was already making fireplaces unnecessary for warmth. The appeal, as Gwendolyn Wright observed in *Moralism and the Model Home*, was not functional but evocative. The idea of family members gathered around a hearth evoked notions of familial protection and togetherness. The twenty beautiful fireplaces, elaborated with arches, inglenooks, and cornices, suggests the exalted belief of the Studebakers in the cohesion of their family.[20]

The Great Hall, measuring forty-five by twenty-seven feet, with oak-paneled walls and beamed ceiling, is emblematic of the mansion's interior spaces. It features an impressive open stairway cascading down from the second floor in three flights, with massive wooden newel posts, thick balusters, handrails, and a reclining winged lion standing guard at the base. A row of five windows with deep window seats and heavy curtains lines the west wall. The fireplace in the opposite wall features Pompeiian red marble and an elaborate mantel with a large beveled mirror and shelves on the sides for books and bric-a-brac. The center of the room was occupied in the Studebakers' time by a large oak table, and the floor was covered with Turkish rugs.[21]

In the fall of 1888, before the house was completed, the Studebakers hosted one of the largest private receptions in South Bend's history. There were more than two hundred guests in attendance, including visitors from abroad and several out-of-town guests who eventually moved to South Bend.[22] The following year, the Studebakers held an even larger party with more than six hundred guests to celebrate Clement and Ann's twenty-fifth wedding anniversary. A full orchestra played at the head of the grand staircase while eight waiters in full dress served one hundred guests at a time in the three dining rooms on the lower level.[23]

Having proved to himself that Tippecanoe Place was perfect for large formal gatherings, Clement made plans to host delegates of the Pan-American Conference in October 1889 during their six-week, cross-country rail tour of the United States. He sought international recognition, and he knew the business potential of showing off the Studebaker Company to foreign dignitaries. Tragedy struck, however, when a fire broke out in the house, reducing it nearly to rubble. It started in a closet on the first floor and spread to the upper floors, which were destroyed, including an art collection in the fourth-floor gallery. Much of the furniture in the basement and main floors was rescued while the fire raged overhead, and the stone walls remained more or less intact.[24]

Clement Studebaker's heart and soul had gone into his mansion, and like Father Sorin at Notre Dame ten years earlier, he was not about to be discouraged by such a calamity. He began to rebuild immediately after the fire, and his family returned to its newly refinished rooms in 1890. Studebaker lived there until his death in 1901, and his widow lived there until her death in 1916. Their eldest son, Colonel George M. Studebaker, lived in the house with his family until he was forced to give it up during the Depression. It was purchased by E. M. Morris, who gave it to the city for use as a school for disabled children.[25]

When Tippecanoe Place was threatened with demolition in the 1970s, after years of neglect, it was listed on the National Register of Historic Places and a concerted effort was made by local preservation organizations—the Southold Heritage Foundation, in particular—to find a new owner. Finally, in 1979, it was purchased by the Ralston Purina Corporation, of St. Louis, which converted it to a high-end restaurant while preserving and restoring its historic character.

At the time of its construction, Tippecanoe Place was a house that suggested authority, wealth, and opulence, recalling an old-world character befitting the European countryside. Its stone walls and castellar profile evoked a romantic sense of history, transcending mere domesticity and certainly outdoing any of South Bend's previous homes. Thomas Bonsall wrote: "It was a monstrous pile of limestone complete with vast lawns and luxuriant gardens—a veritable castle."[26] A reporter for the *South Bend Times* described it in 1889 as "A castle mansion that crowned the slope of Tippecanoe Place and loomed up majestically over our city. . . . It was a house fit for a prince; it was a residence South Benders contemplated with pride; an edifice that no stranger to our city would fail to look upon and justly admire."[27] Historian Wilbur Peat called Tippecanoe Place the extreme in Midwestern Romanesque expression, a house with an "air of indestructibility and proud defiance."[28] Men like Studebaker saw themselves as a new aristocracy, as "barons of industry." Cobb found in the Romanesque style of Richardson an architectural expression of the ambitions and achievements of a new breed of industrialists. The rusticated castle-like style was not only an alternative to the French châteaux style that Richard Morris Hunt was designing for wealthy clients like the Vanderbilts, but also a symbol of the rugged individualism that marked the Midwestern character of men such as Studebaker, men who overcame great obstacles and achieved unparalleled success.[29]

Richardsonian Romanesque and the Queen Anne

Other South Bend industrialists and businessmen sought to emulate Tippecanoe Place, and while none of their efforts rivaled it in size, they are notable for their stylistic invention, quality of materials, and construction details. One of these was the William L. Kizer House, built at 801 West Washington Street from 1887 to 1891.

A leading South Bend businessman and founder of Kizer and Woolverton, a firm specializing in real estate, insurance, and investments, Kizer moved to South Bend in 1865 from Ohio. He had been a representative of the Internal Revenue Service of the State of Indiana before becoming a real estate broker. He was an officer of the South Bend Malleable Range Company and invested in railroads, timber, and real estate. He served as a South Bend city commissioner from 1889 to 1894.[30] His house stood two stories high, with a raised basement and an attic story with dormers, crossing gables, and two corner turrets, following the Richardsonian Romanesque style of Tippecanoe Place. It features massive fieldstone construction, a round-arched front door, and a porte cochere, while inside there is elegant woodwork and a large entrance foyer with an open stairway.

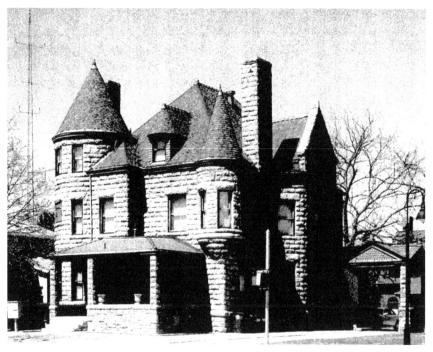

FIGURE 9.3
William L. Kizer
Residence,
801 W. Washington,
1890. (Photo by
author.)

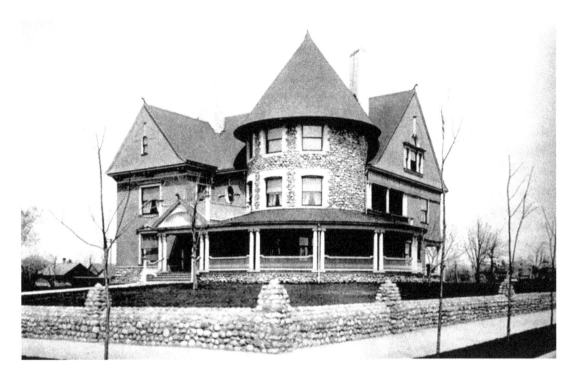

FIGURE 9.4
Alexis Coquillard
House,
825 E. Jefferson
Boulevard, ca. 1888.
(From *Art Work of
South Bend
and Vicinity*.)

Another mansion influenced by Tippecanoe Place was that of Alexis Coquillard at 825 East Jefferson Boulevard. Built circa 1888, it was a distinguished Queen Anne–style mansion with a large cylindrical turret built of fieldstone with a conical roof and a wraparound porch. It was beautifully sited, with a carriage house in the rear and a low stone wall around the perimeter.

John Mohler Studebaker built a second house, this one as a wedding gift to his daughter Grace and her husband Frederick S. Fish. Located just west of Sunnyside, it had a broad facade with a full-width veranda. Its front entrance was guarded by two Chinese dogs sculpted in stone, which were later donated to Chicago's Museum of Natural History.[31] The Fishes traveled extensively, and collectors' items from all over the world furnished their home. Inside was a grand staircase with an imported stained glass window at the first landing. Rooms were decorated with frescoes, elaborate fireplaces, Turkish carpets, and French and Florentine mirrors. The house was demolished in 1961 to make way for the construction of the First Christian Church.[32]

Other members of the Studebaker family built houses in Sunnyside during the 1890s. Ida Studebaker Kuhns, the daughter of the youngest of the five Studebaker brothers, Jacob, built an exemplary Queen Anne–style house, set in one of South Bend's most beautifully landscaped settings. This home, the

FIGURE 9.5
Louis Kuhns
Residence,
1243 E. Jefferson
Boulevard, 1895.
(Photo by author.)

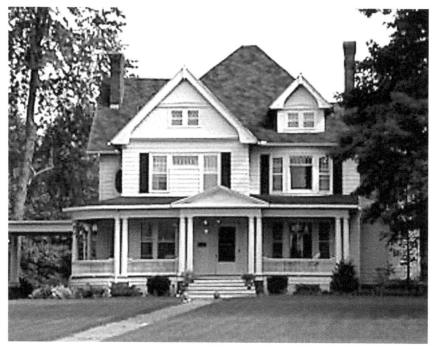

Louis Kuhns and Ida Studebaker Kuhns House, was constructed at 1243 East Jefferson Boulevard in 1895. Although it is clad today with aluminum siding, it retains its stylistic character and material texture. It features a wraparound porch with paired Doric columns and a roofline with intersecting gables, dormers, and tall chimneys. The driveway passes under a porte cochere and leads to a carefully preserved carriage house at the rear of the property.

Ida Studebaker Kuhns and her sister, Helen, with their husbands, went on to develop the remaining Studebaker property along the north side of Jefferson Boulevard for residential use, selling the lots to prominent and wealthy businessmen.

Yet another of the Studebaker brothers, Peter, the second youngest, built a magnificent mansion at 627 West Washington Street in 1895. A Queen Anne or Neo-Jacobean house, it is built of red brick with limestone trim, two projecting dormers, a classically detailed porch, and prominent gabled parapets. Its site includes a large carriage house and an original wrought-iron fence.

All of these houses, whether on the west side or the east, represented the industrial and financial success of a particular class of South Bend society—members of the extended Studebaker family, owners and managers of growing companies—influenced by the standard set by Clement Studebaker and his ar-

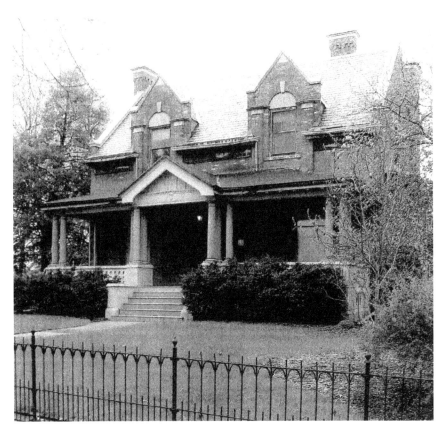

FIGURE 9.6
Peter Studebaker
Residence,
627 W. Washington
Street, 1895.
(Photo
by author.)

chitect Henry Ives Cobb. The only other house in South Bend from the late nineteenth century that would equal or perhaps surpass Tippecanoe Place was that of Joseph D. Oliver.

Copshaholm: The Joseph D. Oliver Residence

Rugged individualism was likewise an appropriate descriptor of Joseph D. Oliver, son of James Oliver, founder of the Oliver Chilled Plow Company. He grew up in the house of his parents at 325 West Washington Street, which had been remodeled by Richard Waite in 1881. In 1885 he and his wife, Anna Gertrude Wells, moved into the corner house of Oliver Row, living there until 1897.[33] It was here that their four children were born. By the early 1890s the family had outgrown Oliver Row, and in anticipation of building a new house, they purchased a lot at the corner of Chapin and Washington Streets in 1891. They hoped to build their own magnificent mansion, one large enough to rival

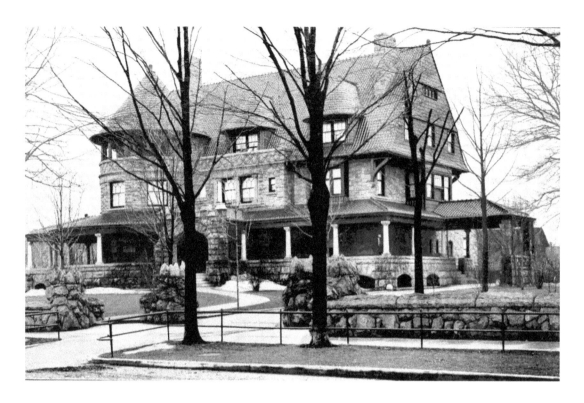

Tippecanoe Place. James Oliver and the Studebaker family had already demonstrated that tree-lined West Washington Street was an ideal place to build a mansion, even though it was right among workers' houses and near the industrial plants. It was a wide street, conveniently close to downtown and to the factories—reasons that, in J. D. Oliver's mind, more than made up for its proximity to workers' housing.[34]

By 1894 Oliver had purchased several more lots adjoining his West Washington Street property, and the site now covered over two and a half acres. That same year, he and Anna made a trip to New York City, where they explored recently built neighborhoods and suburban developments in search of inspiration for the design of their house. They discovered that several recent houses they admired had been designed by the architectural firm of Lamb and Rich, whose office was in New York City. They were especially impressed by the home of Teddy Roosevelt, Sagamore Hill, located in Oyster Bay, Long Island. Completed in 1893, it featured a combination of Richardsonian Romanesque and Queen Anne stylistic details.[35]

Charles Alonzo Rich, born in Beverley, Massachusetts, in 1855, had studied engineering at Dartmouth College. After graduating in 1875, he made the

grand tour of Europe for three years to learn firsthand from its great monuments. In 1882 he formed a partnership with Hugh Lamb, also of New York, and for the next twenty years the two maintained a practice that specialized in residential and institutional design. They designed college buildings for Dartmouth, Smith, Williams, Amherst, and Colgate, as well as several office buildings and theaters in New York.[36]

Collaborating with Lamb and Rich as local supervising architects for the Oliver House were Wilson B. Parker and Ennis Austin.[37] Parker graduated from MIT and then worked as an apprentice with the New York firm of McKim, Mead and White. He then worked for two years for the Tiffany Glass and Decorating Company, where he gained experience in the decorative arts. He moved to South Bend in 1892 and established a partnership with Ennis R. Austin, whom he had met in New York and who had also worked at Tiffany's.[38] Austin would later form a partnership with N. Roy Shambleau, and both would become leaders of the Prairie School movement in South Bend (see chapter 13).

Construction of the Oliver mansion, which the family named Copshaholm, was carried out from 1894 to 1896. The name derived from the Scottish village from which the Olivers had hailed before immigrating to the United States in the mid-1830s. As with Tippecanoe Place, fieldstone from St. Joseph County farms was used for the exterior masonry. Stone carvers were hired to shape the fieldstones into rectangular blocks for the coursing of Copshaholm's walls. By regulating the average size and shape of the stones to a carefully considered scale, the design formed a strong contrast to Tippecanoe Place, which now appeared crude and excessively bold. The only stone not from St. Joseph County was the columns of the front porch, which were granite brought to the site from Vermont to be cut and placed by European stonemasons.[39]

Among the other Richardsonian Romanesque features in Lamb and Rich's design are its picturesque profile, turrets, and round-arched windows and doors. There are also Queen Anne influences, as seen in the broad veranda across the front, the gambrel roof profile, and the mixture of materials: stone, shingle, and tile. Its combination of roof profiles and wide verandas most closely resembles Roosevelt's Sagamore Hill. Its semicircular music room and mezzanine-level seating alcove are expressed on the rear facade with bands of window, red tiles, and a balustrade.

Lamb and Rich devised many additional decorative effects, including a rosette in the east facade carved from pink and gray granite, diamond-shaped

FIGURE 9.8
J. D. Oliver Residence,
view of the entrance
with the turret in the
background. (Photo
by author.)

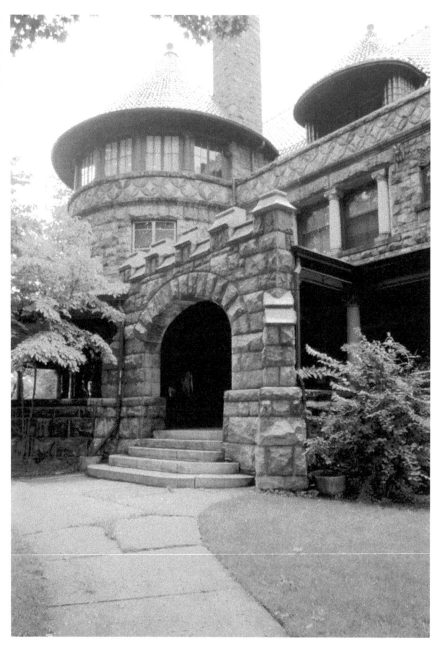

panes placed below the main windows, a band of quatrefoils below the third floor, a second-floor window framed by Corinthian columns, decorative windows topped with a shell motif, and dentils along the eaves.

The carriage house is itself a remarkable work of architecture, featuring the same massive masonry walls as the main house, a second-story butler's

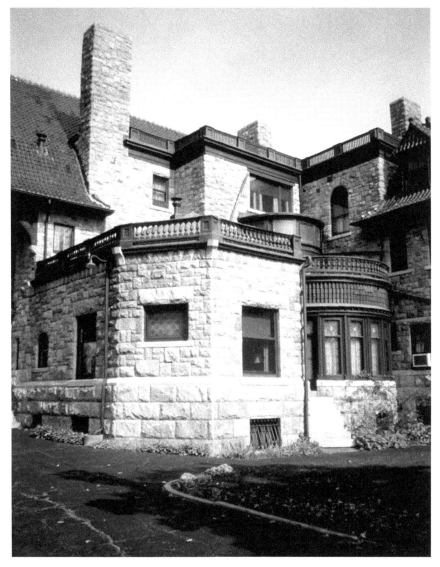

FIGURE 9.9
J. D. Oliver Residence,
view from the rear.
(Photo by author.)

apartment, and two turrets framing the main garage door. It currently serves as an office of The History Museum.

For the Olivers, the wide veranda on the mansion's north and west sides served as an outdoor living room in the summer. Bamboo furniture was brought out for the family to enjoy the cool summer breezes. It not only provided a cool outdoor place but also shaded the interior rooms from the summer sunlight. The veranda's floor is multicolored stone mosaic with squares of granite, marble, and limestone.[40]

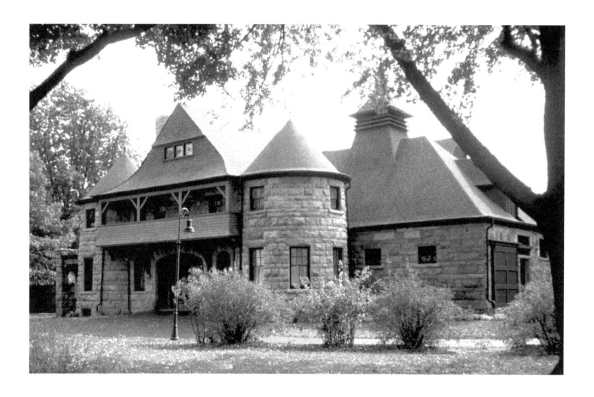

FIGURE 9.10
J. D. Oliver Residence
carriage house,
Lamb and Rich,
architects. (Photo
by author.)

The combined styles of Richardsonian Romanesque and Queen Anne are also reflected in the mansion's interior, which encompasses 12,000 square feet on three floors, plus an attic and basement. It has a total of thirty-eight rooms, including a ballroom, six full bathrooms, three half bathrooms, and fourteen fireplaces.[41]

The main hall, impressive in size and detailing, provides access to all of the principal first-floor rooms, reflecting in part the open-plan concept that was becoming popular at the time and which Lamb and Rich, like Richardson, used in all of their houses to great effect. The woodwork is oak, cherry, and mahogany. Specially crafted by the Matthews Brothers Manufacturing Company of Milwaukee, Wisconsin, it features classical paneling and beamed ceilings, finely carved grills in the stair railings, and carved urns, capitals, and brackets. In the library, carved figures dramatically frame the fireplace.[42]

Copshaholm was, above all, a house of the modern industrial city. While its exterior appearance and interior detailing were traditional in character, it nevertheless had a steel-frame structure and it incorporated the latest in plumbing, heating, and electrical conveniences. It had a modern kitchen, an elevator, and a secured storage vault, as well as steam heating controlled by

thermostats and forced warm air systems. Running water was provided by two wells on the property which supplied a holding tank in the attic.[43] It was piped for gas and wired for electricity. Electrical power was provided first by the turbines at the Oliver factory, then from the Oliver Hotel, and later from Oliver's own generating plant on the West Race.[44]

An essential aspect of Copshaholm's beauty is the quality of its landscaped setting. The gardens of the two-and-a-half-acre estate were designed in 1906 by Alice E. Neale, an employee of Shepley, Rutan and Coolidge who had worked on the interiors of the Oliver Hotel. Her plans included a sunken garden laid out along rigid formal lines with the classical design elements of a fountain, sundial, and pergola. The garden was altered in 1927 by Louisa King, a nationally known horticulturalist.[45] As at Tippecanoe Place, the perimeter of the site is marked by a low fieldstone wall.

The Birdsells

The influence of Tippecanoe Place and Copshaholm and the synthesis of the Richardsonian Romanesque and Queen Anne styles continued at least until the first years of the twentieth century. Descendants of prominent businessman John C. Birdsell built what were probably South Bend's last two examples of this bold style. The farm implement company founded by Birdsell in 1864 had become the city's fourth-largest employer, producing farm wagons and steam powered machinery. While Birdsell died in 1894, by the end of the decade five of his sons and grandsons were running the company.[46]

The combined Richardsonian Romanesque and Queen Anne styles are evident in the house of Joseph B. Birdsell, one of the founder's sons. Built in 1898 at 511 West Colfax Street, it features a fieldstone porch, brick and stucco, and half-timbers. Designed by the South Bend firm of Parker and Austin, which had served as the supervising architects of Copshaholm, its interior features detailed woodwork and marble fireplaces, a third-floor ballroom, a front parlor, and a library. The mahogany-paneled dining room has double glass-paned, pocket panel doors.[47]

John C. Birdsell, the last son to serve as president of the Birdsell Manufacturing Company, built an equally magnificent mansion at the northwest corner of Jefferson and Sunnyside Avenue in 1902. Also designed by Parker and Austin, it combined the Queen Anne and Richardsonian Romanesque styles

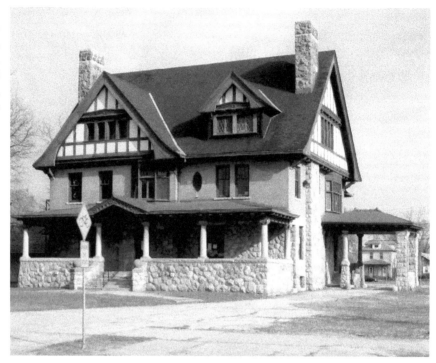

FIGURE 9.11
Joseph Birdsell
Residence,
511 W. Colfax Street,
1898, Parker and
Austin, architects.
(Photo by author.)

in a manner similar to the Oliver Mansion, its most striking feature being a large cylindrical corner tower built of fieldstone. The tower, with its conical roof, is balanced against a steeply pitched front gable with a porch below.

Tippecanoe Place, Copshaholm, and their imitators were romantic idealizations of their builders' concept of the Old World. They were mock fortresses with towers and turrets, built of huge blocks of stone, recalling the Cyclopean masonry of the ancient Mycenaeans. The industrial barons who built these houses were pillars of corporate genius and civic magnanimity. They built their great houses both as monuments to themselves and as landmarks in their communities.

It is important to consider the continuing role of these great mansions in the history of South Bend. Are they simply relics of a past era never to be repeated, or are they essential to South Bend's identity and future aspirations? We can study them in terms of their style and the causal relations between social and economic forces that produced them, and we can analyze their role in defining South Bend's urban image. Most importantly, what continuing influence will these mansions have in defining South Bend's residential culture in the twenty-first century?

Turn-of-the-Century Churches and Institutions

As South Bend grew, the need for places of worship was met by the construction of churches both in residential neighborhoods and downtown. In the 1880s and 1890s, a church was as important a part of the infrastructure of a new residential area as were streets and sidewalks. Many churches, both Catholic and Protestant, were in fact built before the houses. Downtown likewise benefited from the construction of churches, adding a further architectural complement to the blocks of commercial buildings. For Notre Dame and Saint Mary's, the 1890s was a decade of cautious growth, in contrast to a handful of selective universities like Stanford and Chicago that transformed into major research universities after receiving unprecedented endowments. While those institutions built expansive new campuses designed by leading architects of the day, Notre Dame and Saint Mary's, with a smaller base of donors and fewer financial resources, added only a few buildings, designed in a Midwestern vernacular style focused more on function than high style.

Churches and the Richardsonian Romanesque

During the 1880s and 1890s, many of the Richardsonian Romanesque features evident in the Studebaker and Oliver mansions carried over into the design of some of South Bend's most distinguished churches and institutional buildings. The availability of local fieldstone made it a popular building material not only for structures in the Richardsonian Romanesque style but also in the Gothic

Revival, Neo-Jacobean, Classical Revival, and other styles. Critical to the stylistic changes evident during this period were the Studebaker and Oliver families, who commissioned and paid for many of the city's important civic and religious buildings and had access to the architects who were most in step with the changing trends of the time.

Religious upheaval within the Studebaker family during the Civil War had a profound effect on several of South Bend's churches many years later. It had to do with the Dunkard Brethren Church, a reformist religion that originated in Germany, to which the Studebaker brothers and their father all belonged. Because the Dunkard Brethren opposed war and any support for it through the manufacture of munitions or equipment, the brothers were forced to decide between making wagons for the Union army (which they initially did as subcontractors for the Milburn Wagon Company) or deferring to their family's faith by giving up their military contracts.[1] The eldest brother, Henry, had already left the company to take up farming in 1858, after he was bought out by John Mohler. Clement, John Mohler, and eventually the two younger brothers, Peter and Jacob, all chose to stay with the company and, as a consequence, left the Dunkard Brethren Church and joined other Protestant denominations: Jacob, the First Baptist Church; Clement, St. Paul's Methodist Church; John Mohler, the First Presbyterian Church; and Peter, the St. James Episcopal Church. They all donated generously to their chosen institutions over the years. Thus, by the 1880s, it was possible for them to construct architecturally distinguished church buildings.

The First Baptist Church, located at the northwest corner of South Main and West Wayne Streets, was the first example of Richardsonian Romanesque style in South Bend's religious architecture. Built in 1886 (and thus a direct contemporary of Tippecanoe Place), its principal patron was board member Jacob F. Studebaker.[2] As we saw in the previous chapter, he took charge of the company's carriage department and had been largely responsible for the construction of its Chicago headquarters two years earlier.[3]

The architect of the Chicago headquarters, Solon S. Beman, designed the new First Baptist Church. He had established his reputation as the designer of industrial and office buildings with his commission from the Studebakers and with his projects for George M. Pullman. However, he also had a strong interest in religious architecture, which he developed while working in the New York office of Richard Upjohn. Upjohn had introduced to the American architectural scene an authentic example of the Gothic Revival style with his design

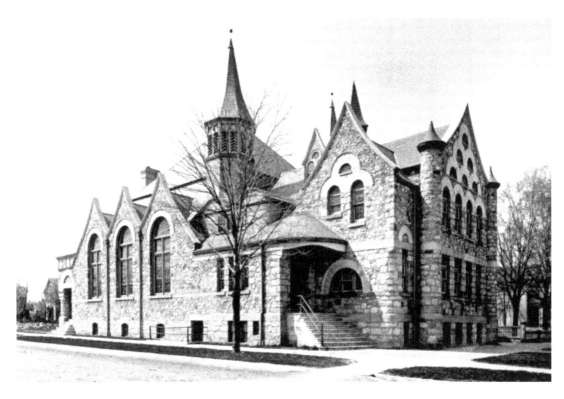

FIGURE 10.1
First Baptist Church,
northwest corner of
Main and Wayne
Streets, 1886,
demolished 1960s,
Solon Beman,
architect. (From *Art
Work of South Bend
and Vicinity*.)

of Trinity Church, which featured high vaults, pinnacled buttresses, a soaring spire, and tracery windows.[4] Upjohn and his son, Richard Mitchell Upjohn, were leading proponents of the Ecclesiological movement in the United States, which promoted the Gothic Revival style for church design. Working in their office during the 1870s, Beman was instrumental in carrying out their Gothic Revival design of the Connecticut State Capitol.[5]

As recounted in chapter 5, Beman moved to Chicago after leaving Upjohn's office to carry out the commission for the design of the model town of Pullman, Illinois. He was then commissioned by Jacob Studebaker to design the Studebaker showroom. His interest in the Richardsonian Romanesque style marked a natural progression from his early training in the Gothic mode to the Romanesque Revival. While Beman was working in Upjohn's office, H. H. Richardson's Trinity Church was under construction in Boston, something that no doubt attracted his attention through publications and visits to the city. It had a profound influence on him just as it did hundreds of other American architects at the time.

This would not be the last transformation of Beman's aesthetic taste, however, as by the early 1890s, like the majority of his contemporaries, he

embraced the Neoclassical style. He had a compelling reason to do so, as in 1893 he was invited to join a group of classically inspired architects from the East Coast to design one of the principal buildings surrounding the Court of Honor at Chicago's Columbian Exposition (see chapter 11). He truly came into his own as a designer of churches when he was named the principal architect for the Christian Science denomination, based in Boston, for which he eventually designed dozens of churches across the United States in the Neoclassical style.[6]

Though Richardson's influence is evident in the design of the First Baptist Church, it had a unique quality that represented Beman's inventive and transformative approach to the Richardsonian Romanesque style. Its most characteristic Romanesque feature was masonry walls of rough-faced or undressed fieldstone collected from farms in the county.[7] Its main facade, fronting on Main Street, was framed at the corners by slender cylindrical turrets, and it was topped by a gable roof that flared out at the corners in the manner of a Chinese gable. In the center, a group of round-arched windows above rows of rectangular ones crowded up under the gable, creating a crescendo effect. While the turrets were nearly identical to those of the central tower of Richardson's Trinity Church in Boston, the composition of the windows and the curved profile of the gable were Beman's unique inventions.

The sanctuary was lined on each side by three window bays, each with a round-arched stained glass window and topped by a steep gabled parapet. A reporter for the *South Bend Tribune* wrote of the First Baptist Church in 1936, "In exterior beauty and interior arrangements, we doubt if there was a church building in the state which will equal it."[8] True, there was no other church like it anywhere. Built by an industrialist for himself and his family, and the workers in his factory who followed the Baptist faith, it had a sense of rugged individualism about it, a Protestant church that followed no conventional rules.

The First Baptist Church of South Bend was an important early work by Beman, coming some seven years before the Columbian Exposition and his switch to the Neoclassical style. Always attuned to the latest architectural trends, he, like many of his peers, worked hard to stay abreast of the fast-paced changes of the period. This building, unique among its Romanesque Revival contemporaries, was demolished in 1965. In January of that year, the *South Bend Tribune* reported, "Another of South Bend's landmarks . . . soon will be removed from the downtown scene."[9] The significance of this church is

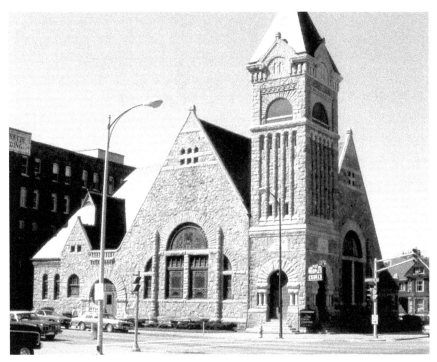

FIGURE 10.2
First Presbyterian
Church,
302 W. Washington
Street, 1888–1889.
(Photo by author.)

remarkable, and its destruction, despite the building's eccentricities, is un-fathomable.

The second example of South Bend's religious architecture designed in the Richardsonian Romanesque style—an accomplished design with all of the finesse of Richardson himself—is the First Presbyterian Church (1887–1888). Located at 101 South Lafayette Boulevard, it was built under the pastorate of Reverend George T. Keller, a popular minister who was at the center of much of South Bend's social scene, presiding over the weddings, baptisms, and funerals of many of the city's leading citizens.[10]

The Presbyterian Church in South Bend began in 1831, when Horatio Chapin and William Stanfield organized the first Sunday school, and in 1836 a small frame church was erected at the corner of Lafayette and Water (LaSalle) Streets. Three years later a new church was built in the Gothic Revival style on the southwest corner of Lafayette and Washington. It was replaced in 1866 by a new church constructed of brick and featuring a spire 145 feet tall. Its nave was lined with round-arched windows in the Romanesque style, though its bell tower was decidedly Gothic. The steeple bell used in all three churches was manufactured in 1832 and was transferred to the new church, where it remains today.[11]

Again, the Studebaker family figured prominently in the construction of the new church. John Mohler Studebaker and his wife, Mary, had recently come to the Presbyterian church from the Dunkard movement.[12] It was not just the Studebakers, however, who claimed the First Presbyterian Church as their religious home, but James and Joseph Oliver and Schuyler Colfax as well. The old Romanesque/Gothic church from the 1860s suffered from ills that apparently faced a number of local churches at the time. According to reports, it was poorly ventilated and lacked sufficient heat. The space was hot in the summer and smoky and cold in the winter. Reverend Keller threatened to quit if something was not done. One reporter in the *South Bend Tribune* wrote of the conditions of South Bend's churches in the 1930s, an indictment that likely reflected the 1880s as well:

> There is not a properly heated or ventilated public building in South Bend and it must be admitted that the churches are the worst of all. With chimneys of narrow flues, small furnaces, or old cracked stoves, no means of ventilation except through open doors and windows, it is no wonder that these places are so uncomfortable.
>
> It was either too hot or too cold in the churches; in some that did have a working furnace, it leaked a toxic smoke permeating the whole room. . . . There was scarcely a minister or choir member that wasn't troubled with some bronchial affliction that can be directly traceable to the foul and varying atmosphere of our city churches.[13]

Since Reverend Keller was a popular and outspoken minister, his admonitions led to the decision to build a new church, with the Studebaker and Oliver families leading the charge. Studebaker and Oliver each paid one-third of the cost of the new church, which reached just over $65,000.[14] The church features a prominent corner tower, large round-arched stained glass windows and doors with heavy stone voussoirs, and massive fieldstone walls. It has a compact square plan rather than a basilican plan, which provides a more centralized focus. Its architect is unknown; however, the contractor was Christopher Fassnacht, who also built the Clement Studebaker house. George Freyermuth, who later became an accomplished architect and served as the city's mayor, was a carpenter on the job.[15] Its architect might have been Henry Ives Cobb or Solon Beman, though it could as easily have been designed by a local architect imitating the Richardsonian Romanesque style.

James and Joseph Oliver also paid for the construction of a new manse for the church, a frame Colonial Revival house with a broad, welcoming front porch located at 502 West Washington.[16] Unfortunately, Reverend Keller died shortly after the new church was completed. It stands today as a monument to his perseverance and to the philanthropy of the Studebaker and Oliver families. Although the church is not the center of South Bend's social and religious life that it once was, it has had an important history throughout much of its existence.[17] In 1912 legendary evangelist Billy Sunday led a revival campaign in the church, preaching against vice, gambling, and drinking.[18] On a lighter note, in 1916 James Oliver's daughter Gertrude wed Charles Frederick Cunningham in the church, an event that was the highlight of the social season.[19]

Romanesque Revival in the Civic Realm

The 1890s and the early 1900s were one of the most important eras in South Bend's history for the construction of civic buildings—libraries, schools, a post office, fire stations, a hospital, and theaters. The Romanesque Revival and Richardsonian Romanesque styles proved to be the most popular in this area of South Bend's civic development.

In 1895 construction began on the new South Bend Public Library, located at the southeast corner of South Main and West Wayne Streets. It was built to provide new quarters for the institution initially housed on the fourth floor of the Oliver Building.[20] Commissioned by the South Bend Board of Education, it was designed by the office of Wing and Mahurin of Fort Wayne, which had designed numerous courthouses and libraries across the state. Local architects Parker and Austin supervised the construction, and George Freyermuth was the contractor.[21]

A red sandstone building with a copper roof, the new library had the appearance of a Romanesque castle, with turrets, pinnacles, gables, and large windows. It featured rusticated masonry walls with picturesque twin towers framing a recessed gable on the second floor. It sat on a raised basement, with ten limestone steps leading up to the front entrance. It was described at the time as French Gothic, though its rough-cut masonry walls related it more to the Richardsonian Romanesque tradition.

While it was large in stature, its plan measured only seventy-seven feet wide by fifty-eight feet deep. The main floor included a vestibule, catalog

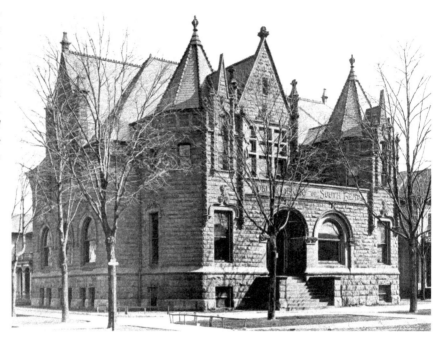

room, main reading room, and stacks. The stacks continued to the second floor, with large round-arched windows on the building's south side providing ample natural light. The second floor also contained a large meeting room and a balcony overlooking the street. It housed sixty thousand volumes and included lecture halls and society rooms in the basement. The entire upper floor was occupied by the Historical Society of South Bend.[22]

At its opening in 1896, the total cost of the library was $40,000. Its construction reflected a nationwide trend. Between 1885 and 1895, some 225 new library buildings were constructed in cities across the country, 32 of them opening in 1894 alone.[23] Despite the seeming permanence of the library's stone walls and copper tiled roof, it did not weather well and was soon overcrowded. Proposals for a new library began to circulate as early as the mid-1920s, with a site near Central High School being considered. There was even a proposal to repurpose Tippecanoe Place, which was vacant at the time, as the library. By 1930 the original structure housed ninety thousand volumes, one-third more than it was designed for. Plans were drawn up, though not executed, for a new building, the design based on the study of recently built Carnegie Libraries.[24] The *South Bend Tribune* reported in 1937 that stones in the front gable were starting to break and fall out, but it was only in 1958 that the library was demolished and replaced.[25]

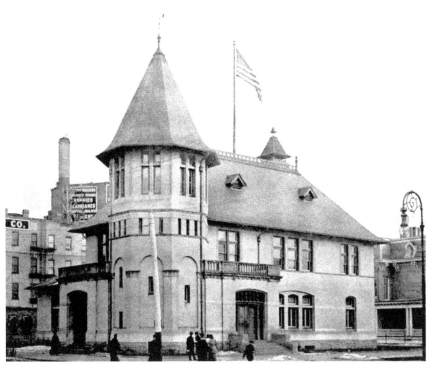

FIGURE 10.4
Post office, southeast
corner of S. Main and
Jefferson Streets, 1898.
(From *Art Work of
South Bend and
Vicinity*.)

Following closely upon the construction of the library was a new post office, completed in 1898 at the southeast corner of South Main and Jefferson Streets. Built at a cost of $75,000, it was a two-story brick building with a steeply pitched hipped roof and a prominent corner turret. It featured large, segmentally arched windows and, in the turret, a combination of round-arched and rectangular windows, creating a Romanesque/Victorian appearance.[26]

South Bend's institutional realm extended to its schools, built near downtown and in the growing neighborhoods. The construction of Central High School in 1872 marked a major advance in the civic character of school architecture in South Bend. The city's earliest schools had been simple frame structures with clapboard siding and gable roofs. Soon, however, for reasons of fireproofing, they were constructed of brick. While earlier school buildings had been considered purely utilitarian structures with little pretense to high style, from the 1870s on they came to represent European architectural traditions, which in turn reflected the higher priority placed on education within the community. This change from the vernacular to European influences in South Bend was a sign of progress and growing links to the rest of the world. Central High School remained standing until 1910, by which time it was completely

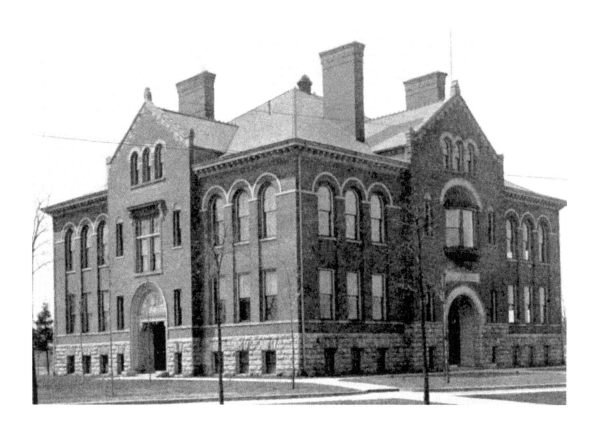

FIGURE 10.5
Colfax School,
914 Lincolnway West,
1898, Dirham and
Schneider, architects.
(Photo by author.)

outdated. It was replaced by a new building that would again be a model for school design and, further, an important component of South Bend's beautification efforts.

The Colfax School is one of the most characteristic of the schools from the period, built in 1898 on Lincolnway West between Harrison and Cottage Grove Streets. Designed by Dirham and Schneider, its plan measures ninety-six by ninety-four feet, composed of a cross-axial plan with entrances on three of its four sides. The main entrance, on the north, features a copper-clad bay window on the second floor embedded in a round-arched opening. It has two main floors plus a basement and attic, and its picturesque roofline is marked by tall chimneys and gabled parapets. It contained ten classrooms, a principal's room, playrooms, a bicycle storage room, and a third-floor assembly room. Its construction is of brick with Berea sandstone trim and a rusticated granite base. Its cornice is galvanized iron, and the roof is slate.[27] The school is still used today as a cultural arts center for South Bend's Near Northwest neighborhood.

Gothic Revival Departures

The popularity of the Richardsonian Romanesque style faded by the turn of the century as various forms of the Gothic Revival and Neo-Jacobean styles regained favor for churches and schools. One example is St. James Episcopal Church, in the heart of downtown at 117 North Lafayette Boulevard. Designed in 1888 by Parker and Austin, its construction was completed in 1894, the year Parker and Austin collaborated with Lamb and Rich on the construction of Copshaholm as well as with Wing and Mahurin for the public library. A Gothic Revival design, St. James features a rectangular plan with a narthex, shallow transept arms, walls of reddish-orange brick, and engaged buttresses. A stained glass rose window in the front gable depicts an angel, representing the church, reverently holding chalices and the host. Above the angel is the

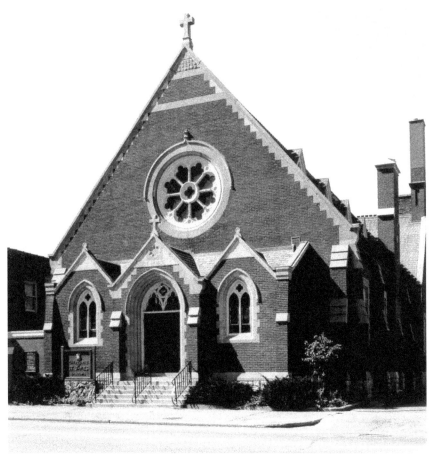

FIGURE 10.6
St. James Episcopal Church (now Cathedral), 117 N. Lafayette Street, 1894–1895, Parker and Austin, architects. (Photo by author.)

figure of a dove symbolizing the Holy Spirit. Designed by Thomas A. O'Shaughnessy of Chicago and made in Kokomo, Indiana, the window was composed of two thousand pieces of glass.[28]

Above the high altar is a second stained glass rose window, in this case by Tiffany, which had been exhibited at the Columbian Exposition in Chicago. It was purchased by Peter Studebaker and his wife and presented to the church at the time of its construction. It represents the Holy Spirit and the Passion Flower, and includes symbols of St. John, St. Peter, St. Paul, and St. James.[29] Other donors to the church's construction included prominent women, including Mary Studebaker, Emma Birdsell, and Ellen Maria Colfax, the wife of Schuyler Colfax Jr.[30]

The Gothic Revival style was also manifested in the construction in 1888 of the Zion Evangelical Church, located at the corner of South St. Peter and East Wayne Streets. It hosted the largest German congregation in South Bend, and the building was thus designed in a vernacular version of the German Gothic Revival style, with large lancet stained glass windows, a corner bell tower, and corbelled brick eaves. The use of yellow common brick was typical of many houses in the Near East neighborhood. The building campaign was directed by Father Waldemar Goffeney with the assistance of fifty-four charter members. It was constructed by church member H. G. Christman.[31]

Also in a Gothic Revival style is St. Paul's Memorial Methodist Church at 933 West Colfax Avenue, built from 1898 to 1901. Its asymmetrical Gothic Revival facade has a broad gable with an arched leaded glass window above two portals, all balanced by a single square bell tower. It was designed by Sydney Rose Badgley, an architect who was active in Cleveland, Ohio, from 1887 to 1916. He was noted nationally for his design of churches and college buildings, including the Epworth Memorial Methodist Church (1893) and Pilgrim Congregational Church (1894) in Cleveland.[32]

St. Paul's was founded by Clement Studebaker's wife, Ann, and was originally to be dedicated to her father, George Milburn. Ann's family was Methodist, and Clement had converted to the Methodist faith in 1868.[33] Clement Studebaker laid the cornerstone in 1902. He died, however, before the church was completed. Other members of the Studebaker family involved with the church included John Mohler Studebaker, Colonel George M. Studebaker, Clement Studebaker Jr., and Colonel Charles A. Carlisle.[34]

St. Paul's large stained glass window, made in Munich, Germany, by Mayer and Company, depicts the Apostle Paul addressing the Men of Athens from

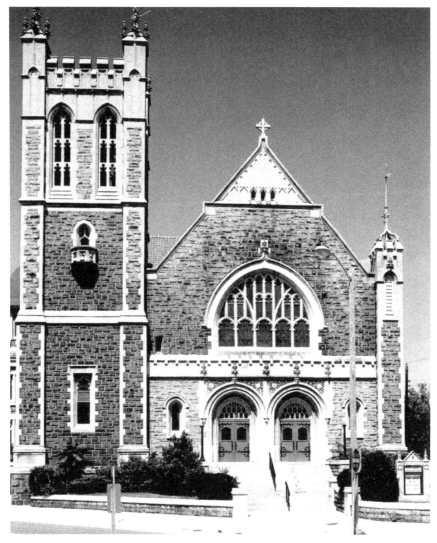

FIGURE 10.7
St. Paul's Memorial
Methodist Church,
corner of W. Colfax
Street and LaPorte
Avenue, 1901,
Sydney Rose Badgley,
architect. (Photo by
author.)

Mars Hill. Studebaker purchased it in Germany, decided to install it in the new church, and changed the church's dedication to St. Paul. John Mohler Studebaker gave to the church a Byzantine-style baptismal font that had originally been located in a chapel in the crypt of the Church of Santa Cecilia in Rome from AD 821.[35] The interior of the church is one of the most interesting in South Bend: a lofty square space in which the auditorium and Sunday schoolroom can be opened into one space by collapsing a large partition.

Many of the features found in St. Paul's Church were again employed in the design of the First Christian Church, built from 1909 to 1910 and located

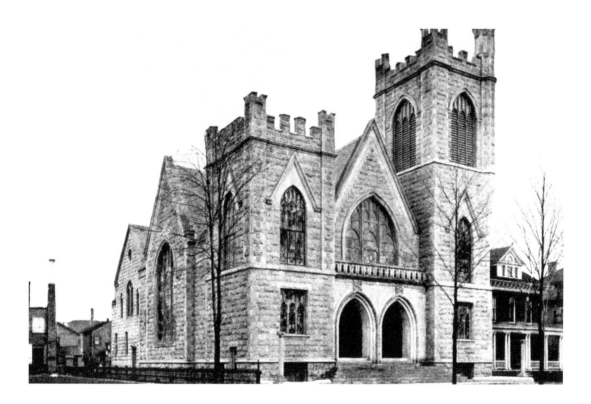

FIGURE 10.8
First Christian
Church, 316 S. Main
Street, 1910,
Acmegraph Co.
postcard, 1915.
(Author's collection.)

at 316 South Main Street. Its Gothic Revival style was reflected in its large lancet stained glass windows, rough-faced masonry walls, steeply pitched roofs, and crenellations along the rooflines. Its wide facade was composed of two square towers flanking a central bay that included a pair of entrance doors and a large stained glass window above. The north tower was two stories high, while the south tower was three stories and housed the bells behind lofty wooden louvers in lancet openings. Like St. Paul's, its asymmetrical composition provided a picturesque silhouette on the exterior and its auditorium, with a seating capacity of 500, could be opened up into the classroom and balcony areas to seat a total of 1,200 people.[36] Although its architect is unknown, Badgley's influence is unmistakable. The nave featured stained glass windows on the north and south sides and crossing Gothic vaults overhead. The church was demolished in the city's urban-renewal efforts in 1970, when the congregation moved to a new site on the Near East side.[37]

Finally, the Gothic Revival style marked the design of the First Methodist Episcopal Church at the corner of North Main and Madison Streets, built from 1913 to 1914.[38] It is clad with dark brown brick with limestone trim. Its facade features a large square bell tower on the north side and a large lancet stained

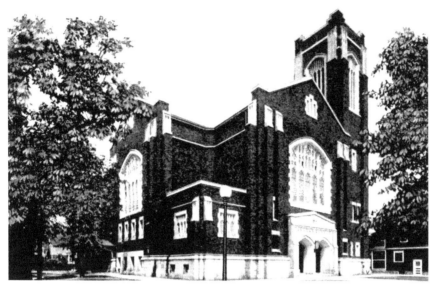

FIGURE 10.9
First Methodist
Episcopal Church,
corner of N. Main
and Madison Streets,
1913–1914.
(Author's collection.)

glass window above a pair of entrance doors. In contrast to the Gothic Revival churches discussed here, the lancet arches employed in the First Methodist Church are the very flat four-centered arches associated with the English Perpendicular Gothic style.

Building Black Churches in South Bend

The Studebakers were also instrumental supporters of one of the earliest African American churches in South Bend. As mentioned in chapter 4, the first African American congregation in South Bend was Olivet African Methodist Episcopal Church, founded in the early 1870s. Through the late 1880s, both Methodists and Baptists from South Bend's Black community worshipped in the building, but in 1890 the Baptists struck out on their own, under the leadership of Reverend W. M. Ridley, and established the Mount Zion Missionary Baptist Church (now Pilgrim Missionary Baptist Church) at the corner of Main Street and Jefferson Street, just south of downtown. The Studebakers donated the funds to construct a comparatively modest yet stately wood-framed church on the site. The front featured two arched doorways with a low-sloped roof and a bell tower. A year after its construction, in 1891, the congregation purchased land at 116 North Birdsell Street and paid to move the church to that location.[39]

The connection between the Studebakers and Mount Zion Missionary Baptist Church remains unclear. The 1890 census, conducted the year of the church's founding, registered 340 African American residents of South Bend, about 1 percent of the city's total population. Some of them, it seems, worked in South Bend's factories, including for the Studebakers, and perhaps this is where the connection between the congregation and their White benefactors emerged. It should be noted that although the formation of Mount Zion Missionary Baptist Church suggested a degree of racial segregation in South Bend church life at the time, this separation did not extend to other aspects of daily life. Local African American pastor and historian Buford F. Gordon recalled in 1922 that through the mid-1910s, "There was no particular Negro community in South Bend. There were no special places for the Negroes to eat. If he proved his worth and was able he could go where he chose."[40] Rather, most African Americans lived and worked alongside the influx of Eastern European immigrants who labored in South Bend's booming industrial sector.[41] The Studebakers' sponsorship of the construction of Mount Zion Missionary Baptist Church suggests a degree of racial paternalism, but it also indicates that churches were among the earliest forms of Black communal life to develop within South Bend's then-minuscule, and at the time largely integrated, African American minority.[42]

This situation would not last, however, and the church the Studebakers helped form would play a key role in advocating for South Bend's African American community amid worsening racial discrimination. South Bend's Black population grew from 340 in 1890 to 1,269 in 1920. Over those three decades, Mount Zion Missionary Baptist Church enlarged significantly, in particular by welcoming Black workers who moved from the American South to South Bend's western neighborhoods near the relocated church in search of steady factory jobs.[43] Congregational growing pains ("Their church is too small and uncomfortable in winter," Gordon remarked) meant the wood-framed structure was replaced by churchgoers with a better-insulated brick sanctuary in the 1920s.[44] The growth in the African American community in South Bend also engendered increasing discrimination and segregation. "There is an entirely new atmosphere," Gordon wrote of South Bend race relations in 1922, "from that as pictured to me as existing several years ago."[45] Reflecting this sea change, James R. Smartt, then pastor of Mount Zion, founded South Bend's first NAACP chapter in 1919; it would lead the local fight against racial discrimination throughout the twentieth century.[46] In aiding in the for-

mation of Mount Zion, the Studebakers may not have funded as ostentatious or long-lasting a building as the churches they built to serve White residents, but they contributed to the foundation of a congregation that played a central role in the future of South Bend's African American community.

While each of the churches built in South Bend during this era represents the specific character of its religious use, they all likewise express the individual character of their patrons—notably members of the Studebaker and Oliver families and their circles of friends and business associates. Four of the Studebaker brothers, along with James and J. D. Oliver, the Birdsells, Schuyler Colfax, and Charles Carlisle, all contributed to this important architectural legacy, which reached across denominational and racial lines.

Notre Dame in the 1890s

Most of the buildings added to the Notre Dame campus during the 1890s and early 1900s were designed by in-house architects in a vernacular version of Second Empire, Victorian Gothic, or Romanesque Revival. One example, constructed during the lifetime of Father Sorin, was St. Edward's Hall, located to the north and east of the Main Building, and housing the University's Minim Department, or grade school. Designed by Brother Harding with some assistance from Father Sorin—both of whom had been the major voices behind the design of Sacred Heart Basilica some twenty years earlier—it was in line with the Second Empire style that had first been introduced to the campus by William Thomas with the remodeling of the Main Building.[47] It featured a raised basement plus two stories and an attic story contained within a mansard roof. Its most distinctive feature was a tall parapet wall in the profile of a round arch rising above the central bay, its face adorned with a mural of St. Edward. As with the second Main Building, this arched profile was common with the French mansard roof and may have been influenced by Father Sorin's childhood in La Roche, Ahuillé. An addition was added to St. Edward's east side a few years later, repeating the motif of a central bay with a tall round-arched parapet. Fondly known as St. Ed's, it suffered severe fire damage in the 1990s that resulted in the loss of its round-arched parapets.

In 1893, Father Sorin, the university's most creative, influential, and inspirational leader since its founding in 1842, died. His legacy was unrivaled throughout the nineteenth century. Under his leadership, both as president

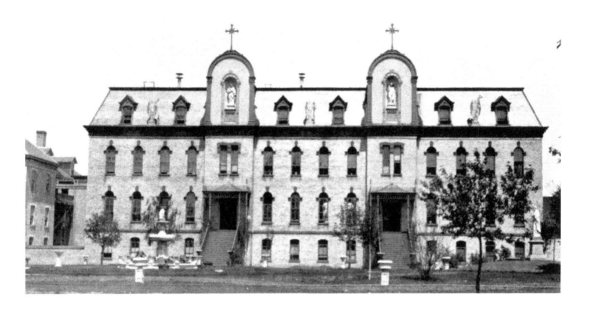

FIGURE 10.10
St. Edward's Hall,
1892, Father Edward
Sorin and Charles
Harding, designers.
(Author's collection.)

and as superior general of the congregation, the university had constructed some 24 buildings, on property that encompassed nearly 1,300 acres, for the use of 542 students and 52 faculty.[48] At the same time, he did more than anyone else in the congregation to aid in the development of Saint Mary's College. One author wrote laudatorily in 1894, "Father Sorin lived to perfect all his plans, to see his fondest hopes realized. Disaster was plentifully mingled with his successes . . . but while others gave up in despair, the stout-hearted, trusting Christian founder never for once lost hope or courage."[49]

That year was a time to mourn the death not only of Father Sorin, but also of the current president, Father Thomas Walsh, and early university architect and pastor Alexis Granger, who had worked with Brother Harding on the design of Sacred Heart Basilica.[50] Building construction on campus continued afterward at a slower rate, primarily during the presidency of Father Andrew Morrissey (1893–1906), but it would be several years before it would rise to the level of architectural distinction equal to the legacy of Willoughby J. Edbrooke.

The university's leadership was soon embroiled in an intense debate over its future direction. Despite the urging of progressive faculty members such as Father John Zahm to increase faculty and student populations in order to make it one of the country's leading universities in teaching and research, Father Morrissey shared no such ambitions. He favored the idea of a prep school, stating, "Our very existence depends on giving Catholic boys a good preparatory foundation!" A frugal man, he did not believe the institution

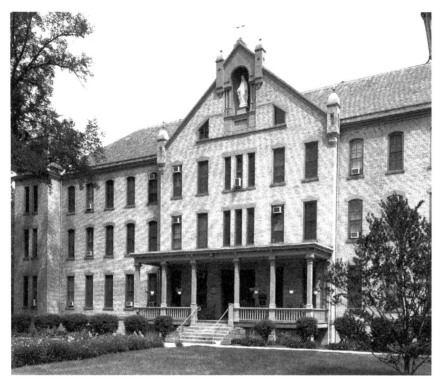

FIGURE 10.11
Corby Hall, 1893,
demolished 2018,
Brother Francis
Harding, architect.
(Photo by author.)

should incur unnecessary debt, and he was not the university's most successful fundraiser.[51]

As Thomas Schlereth has written, Father Morrissey was averse to competing with recently established institutions with substantial endowments.[52] He was no doubt thinking of John D. Rockefeller's $30 million gift to build the University of Chicago's new campus in Chicago's Hyde Park and Leland Stanford's gift of $20 million to establish Stanford University in Palo Alto, California.[53] Father Morrissey believed Notre Dame should strive to maintain its reputation as a small Catholic college and prep school, and nothing more.[54] He was acutely aware that Notre Dame didn't yet have a devoted philanthropic benefactor on the order of a Rockefeller, Stanford, Cornell, Vanderbilt, or Duke. With that in mind, his contribution to Notre Dame's physical plant was modest, though it did keep up with most of the university's growing needs.

Two buildings were constructed during Father Morrissey's first year as president, though both had been planned the previous year during Father Walsh's tenure: Corby Hall and Hoynes (Crowley) Hall. Both were designed by Brother Harding. Corby Hall was built to house dormitory rooms, classrooms, and offices, as a sort of annex to the Main Building. A subdued building located

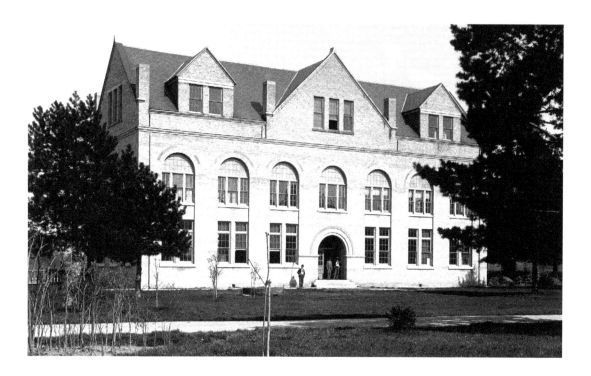

FIGURE 10.12
Hoynes (Crowley)
Hall, 1893, Brother
Francis Harding,
architect. (Courtesy of
Notre Dame Libraries
Special Collections.)

west of Sacred Heart Basilica, it rises three stories and features a central pavilion with a prominent gable. In the center of the gable is a tall round-arched niche containing a statue of the Virgin Mary. For years it served as the primary residence for members of the Congregation of Holy Cross; however, it was demolished and replaced with a near replica in 2020.

Hoynes Hall, built on the east side of the Latin Quad, just south of the Science Building, was designed by Brother Harding at the request of Father Zahm, the university's most influential scientist and head of the science department. Always one to think big, in 1893 he attempted to purchase the Columbian Exposition's Machinery Hall, planning to have it dismantled and reassembled on the Notre Dame campus to be used by the Engineering College.[55] Failing in this (a plan that was clearly too grandiose for the university administration), he nevertheless succeeded in building Hoynes Hall to house what was then called the Institute of Technology.[56]

The building was three stories high, the third floor being a prominent attic story with two large dormers.[57] Its upper two floors were devoted to lecture, recitation, and drawing rooms, while the first floor contained a wood shop, machine shop, and blacksmith shop.[58] A likely precedent for the design of Hoynes Hall was a building in Springfield, Massachusetts, designed by

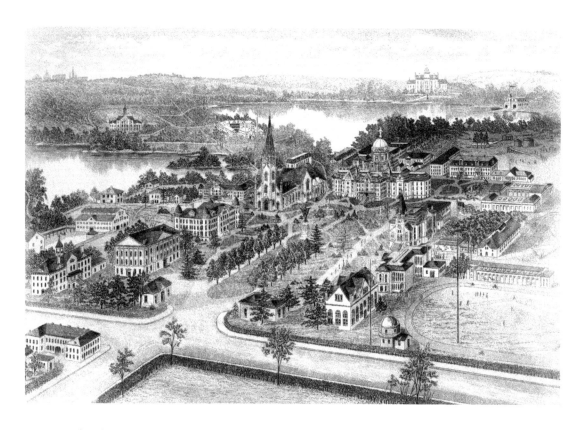

H. H. Richardson: the Hampden County Courthouse of 1871. It had similar dormers, a steeply pitched roof, and an arched entrance. We can discern this comparison only from photographs, as the Springfield Courthouse was altered in 1912 when its roof and dormers were removed and replaced with a flat roof in a major remodeling. Hoynes Hall's roof and third-floor dormers were destroyed by a fire that ravaged the building in 1918. While Hoynes Hall was much less distinguished than the Springfield courthouse, its yellow-brick walls being no match for Richardson's characteristic rough-faced ashlar masonry, the similarities between the two buildings' picturesque rooflines and the shape and size of their arched entranceways nevertheless draw a clear comparison.[59]

By the mid-1890s Notre Dame had what could definitively be called a campus, an institutional image that was quite different from Father Sorin's initial focus on a single main building that housed everything from classrooms and offices to the library and dormitory rooms. The buildings designed by Edbrooke, Brady, and Brother Harding, plus several additional ancillary structures, formed the campus's main quadrangle, which now opened onto a broad, landscaped lawn to the south, an area that in time would become a second

FIGURE 10.13
Aerial view of Notre
Dame, ca. 1893.
(Courtesy of
University of Notre
Dame Special
Collections.)

Turn-of-the-Century Churches and Institutions

formally planned quad. Timothy Howard described the campus this way in 1907:

> The buildings . . . are arranged so as to form a harmonious front. The main building, with its noble dome, occupied the central space; to the right is the Church of the Sacred Heart, and to the right front of the Church is Sorin Hall; to the left front of the main building stands the Music Hall, to the left front of Music Hall is Science Hall, and to the left front of this is the Institute of Technology, and the front of the Astronomical Observatory. All these buildings, therefore, present a unified grand front to the south, extending to the east and west with a combined width of nearly one thousand feet. Within this space, in the embrace as it were of these noble edifices, is enclosed a beautiful courtyard, a garden of green and shade and pleasant walks.[60]

The isolated site overlooking St. Mary's and St. Joseph's Lakes on which Father Sorin had been asked to build a college in 1842 was now seen in a new light. As South Bend developed into a major industrial powerhouse, this once forbidding rural area seemed like the best place to avoid the evil influence of city life. As Leo Marx stated, this way of thinking saw nature as more spiritually uplifting and intellectually stimulating than the city, "a retreat to an oasis of harmony and joy."[61] Such concerns dominated the thinking of many nineteenth-century college administrators, who often cited the aesthetic and moral advantages of nature together.[62] The psychic root of such pastoralism was a yearning for a simpler, more harmonious style of life, free from distraction and conducive to learning and contemplation.[63]

Historian Paul Venable Turner pointed out, in contrast, that many Catholic universities in the United States that were contemporaries of Notre Dame preferred urban locations over rural ones: Georgetown, Saint Louis University, and St. Xavier's College in Cincinnati, for example. They tended to construct buildings in closely spaced groups on standard city blocks, reflecting an urban European tradition. Turner suggests that Notre Dame, despite its rural setting, had an increasingly urban character, as its buildings were densely grouped around the Main Building and down the sides of the original quad. The character of the Main Building itself was very cosmopolitan, with its tall profile and grouping of many wings and towers. It was similar to such urban college buildings as the massive Healy Hall at Georgetown, constructed in

1877, and the Main Building at Vassar College, designed in 1861 by James Renwick Jr.[64]

As the university approached the next century, several additional buildings were constructed beyond the Latin Quad. Two dormitories were built as residence halls for the Brothers of the Holy Cross: Columba Hall in 1895 and Carroll Hall in 1906. Columba Hall, located on a spit of land between St. Mary's and St. Joseph's Lakes, was designed by A. O. Herbulis, about whom little is known today. Carroll (Dujarie) Hall, located at the far western edge of the campus, overlooking St. Mary's Lake, was designed by Brother Harding. Both occupied pristine sites with superb views, though they were purely utilitarian structures of yellow and buff brick, with rectangular windows and steeply pitched hipped roofs.[65]

One of the campus's most sacred shrines, the Grotto, was built in 1896, during Father Morrissey's presidency. The university's Council of Administration had voted as early as 1872 to build a replica of the Grotto at Lourdes, France, the site made famous by Bernadette Soubirous. In 1878 the university received a pledge from a former Holy Cross priest, Father Thomas Carroll, to finance most of the cost. Huge Indiana fieldstone boulders were hauled to the site facing St. Mary's Lake and placed in a large mound, with a broad stone arch forming the entrance. It was made at one-seventh the scale of the original.[66] A statue of Our Lady of Lourdes was placed in a niche at the right. From the time it was built, the Grotto became one of the most sacred spots on campus, drawing a daily round of students and faculty and thousands of visitors a year.[67]

The year 1897 saw the construction of St. Joseph's Industrial School, now Badin Hall, designed by Brother Columkille Fitzgerald. Designed to house a manual-labor program, it had a plain vernacular facade with a single central gable. As with Corby Hall, the central gable featured a tall round-arched niche with a religious statue. This motif of a featured religious figure represented by a statue or a mural in or on the upper surface of a tall central gable was something of a common feature during the 1890s. Now appearing on three buildings—Corby, St. Edward's, and the Industrial School—it can be identified as a signature element of Brother Harding's late work.[68]

A large fieldhouse was constructed at the campus's eastern edge in 1898 by local builder Christopher Fassnacht. One of Father Morrissey's most favored campus buildings because of its accommodation of physical fitness equipment and athletic events, it was destroyed by fire the following year and immediately rebuilt. In its initial form it had a broad, gabled facade, reflecting the profile of

its long-span iron-truss roof structure. When it was rebuilt, however, a castellated facade with square corner towers was added, substantially changing its character from nineteenth-century train shed to a Gothic Revival library.[69] It was demolished in 1983, and the Clarke Memorial Fountain now marks the site.[70]

Walsh Hall (1909), designed by William Brinkmann, was the final building of the Latin Quad, finishing off its southwest corner. Vonada praises it for being more luxurious than the older Sorin Hall, as it offered individual closets for students, suites with private baths, and amenities on the basement level including billiards and bowling. It was named for Father Thomas Walsh, who served as the university's president from 1881 until his death in 1893.[71]

Although this group of buildings from the 1890s and early 1900s provided much-needed dormitory, classroom, and athletic accommodations, they reflected a distinctly utilitarian character that was far from the visionary plans and architecturally distinctive buildings added to the campuses of Stanford, Chicago, and Columbia during the same years. At Stanford, the firm of Shepley, Rutan and Coolidge and landscape architect Frederick Law Olmsted designed a series of Romanesque buildings linked by arcades and centered around a monumental arch standing at the head of a mile-long tree-lined boulevard. At the University of Chicago, Henry Ives Cobb designed a series of quadrangles framed by elegant Collegiate Gothic structures built of Bedford limestone and based on the architectures of Oxford and Cambridge in England. At Columbia University, McKim, Mead and White produced a Beaux-Arts master plan that featured the monumental Low Library on the main axis flanked by classroom buildings, which Charles McKim compared to the Sorbonne in Paris.[72] The Beaux-Arts principles of design and the European campus traditions represented by these master plans and their buildings reflected the influence of the Columbian Exposition of 1893, a profoundly important event in the history of American architecture that is addressed in chapters 11 and 12.

A final note to consider is a moment in the first decade of the twentieth century that threatened the tranquility and order of the university's pastoral landscape. A boiler house had existed a few hundred yards straight north of St. Edward's Hall since 1844. It was rebuilt and expanded several times, eventually including a tall brick chimney.[73] In 1902 Father Zahm convinced the university to allow the Michigan Central to build a railroad line to circle around the north side of St. Joseph's Lake from Niles Road and extend to the

boiler house.[74] The track was to be used for delivering supplies and to accommodate a special railroad car commissioned by Father Zahm for the use of students, parents, and visitors from the West Coast.[75]

The imposition of a train line, in Leo Marx's words, introduced "a contrast of two worlds, one identified with peace and simplicity, the other with urban power and sophistication."[76] The university's pastoral setting was interrupted by the whistle of the locomotive, creating a vivid contrast and introducing tension in a place of repose, the train instilling a sense of dislocation, conflict, and anxiety.[77]

Fortunately for the campus, the train line lasted only a few years and the boiler house was turned into a natatorium when a new boiler house was built farther north at the edge of St. Joseph's Lake. Thanks to its vast open spaces, quadrangles, and picturesque buildings, the campus managed to retain its pastoral setting.

Beaux-Arts Classicism and the Civic Ideal, 1893–1918

By the 1890s, South Bend's national identity was that of a flourishing industrial city known for making Conestoga wagons, the Oliver Chilled Plow, and cabinets for the Singer Sewing Machine Company. Notre Dame University was gaining recognition on a national level, but it was industrial production that put the city on the map. South Bend's products were carried across the western plains by the Grand Trunk Railroad and shipped eastward on the Lake Shore and Michigan Southern Railroad. The city was an integral player in the country's industrial expansion, and as such it reaped a significant financial reward, one that was manifested in its urban development.

During the height of South Bend's growth in the second half of the nineteenth century, its downtown commercial district saw a significant increase in building activity. Larger, more substantial buildings replaced those of the earliest settlers. Big St. Joseph's Station, other trading posts, and most of the early houses were demolished and new buildings constructed in their place. Many of the more distinctive buildings erected during and after the Civil War were commissioned by the same industrialists who built the city's factories, especially the Studebakers and the Olivers. These included important civic buildings such as the opera house and public library, a new courthouse, city hall, an auditorium, schools, and a YMCA and YWCA. These buildings were all necessary to accommodate the city's growing cultural aspirations, and it was the city's thriving industries that provided the financial resources to build them, through either taxation or direct private donations.

The construction of buildings for these newly established cultural institutions changed the city's civic face. The larger, taller commercial buildings filling out each downtown block created a density and character that rivaled many midsize European cities. The Italianate, Second Empire, and Romanesque Revival styles that dominated the later decades of the nineteenth century had provided a rich texture to the urban fabric. These styles were joined in the 1890s by Beaux-Arts Classicism, Neo-Renaissance, and Châteauesque styles, which were common motifs in the curricula of the École des Beaux-Arts in Paris and favored by nationally known architects such as Richard Morris Hunt and McKim, Mead and White.[1] They gave it a new image of civic virtue combined with commercial vitality.

The Columbian Exposition and Its Influence

The character of South Bend's civic and commercial architecture in the 1890s was influenced by a singular event that brought about a change in the way cities across the country were planned and developed: the World's Columbian Exposition of 1893. Located in Jackson Park on Chicago's south side, it was only about one hundred miles west of South Bend and easily reachable by train. An event attended by many from South Bend, it was a memorable spectacle that left a deep impression. The exposition's monumental Neoclassical buildings, formal courts, water basins, and landscaped gardens gave builders, architects, and city officials alike impetus to beautify their cities by adding new boulevards, landscaped parks, and groups of Neoclassical, Beaux-Arts, and Neo-Renaissance civic buildings.

The Columbian Exposition was one of the most significant examples in the United States of a form of planning and architecture that featured major formalized urban spaces conceived in terms of the large outdoor spaces prevalent in Europe. The opportunity to promenade down long, broad walkways, the ritual of public display among classical buildings and colonnades, the viewing of classical sculpture and picturesque fountains, all added up to an idealized urban experience, something new to America, and this proved to be the major impetus for the City Beautiful movement.

The Columbian Exposition was planned at a time of unprecedented urban development in the American Midwest. Many towns that had been home to only a few hundred people in the 1820s and 1830s now had hundreds of thou-

sands of residents. Chicago, in the early 1890s, exceeded one million, surpassing both Philadelphia and Brooklyn and making it the second-largest city in the country. Though it was not on par with Paris or Vienna, with their great civic buildings, luxurious apartment blocks, and broad tree-lined boulevards, Chicago was quickly becoming so. After the fire of 1871, it was rebuilt with rows of brick townhouses, commercial buildings in the Loop with stone and cast-iron facades, and an expanding lakefront park. In 1890 the city encompassed over 180 square miles and, most importantly, extended some 24 miles along the lakefront.[2]

The initial plans for the exposition, which were produced by Chicago's own Daniel Burnham and John Wellborn Root with the landscape architects Frederick Law Olmsted and Henry Sargent Codman, represented both Romanesque and Neoclassical building forms. Burnham, a descendant of an old New England family, moved with his parents to Chicago in 1854 and began his career in 1868 as an apprentice to William Le Baron Jenney. He later worked for John Mills Van Osdel, designer of South Bend's second county courthouse.[3] He then worked for a brief time in the office of Carter, Drake and Wight, and in 1873 he formed a partnership with Root, a gifted designer who had studied for two years in England and then apprenticed to James Renwick in New York. Root moved to Chicago after the fire and had also found employment with Carter, Drake and Wight.[4] The Burnham and Root partnership produced many of Chicago's most legendary buildings, from the Rookery and the Monadnock Block to the Great Northern Hotel and the Women's Temple.[5]

The plans for the Columbian Exposition manifested a transitional stage in the design direction of Burnham and Root, if not a serious conflict beginning to appear in their professional relationship. While Root was a talented designer in the Romanesque Revival style, Burnham grew increasingly attached to Neoclassicism as the planning of the Exposition progressed. Root died in January 1891, and in the end, Neoclassicism was the dominant style embraced by all of the principal architects involved, including Hunt, McKim, Mead and White, Louis Sullivan, and George B. Post. Nearly all were from the East Coast and experienced in Neoclassical and Renaissance Revival architecture. The only exception was Sullivan, whose Transportation Building would be more akin to an abstractly ornamented Romanesque Revival building and was highly polychromatic rather than white like the rest of the exposition's buildings.

Solon Beman was the lone Chicago architect assigned to design a building on the Court of Honor: the Mines and Mining Building. He used a consistent

facade bay width and a set cornice height that all of the Court of Honor archi-tects agreed to follow.[6] The details of his design were based in the Italian Re-naissance, with two-story round-arched openings, piers ornamented with decorative shields, tympana with bas-reliefs, and a pediment with a bas-relief representing Mining and its allied industries.[7]

Historian Thomas Tallmadge wrote that American taste was on the verge of change when planning for the exposition began in the early 1890s. Even without the fair, national restlessness was about to toss aside the Romanesque Revival style of Richardson, Sullivan, Jenney, and Burnham and Root and turn to something more fashionable.[8] In South Bend that transition can be seen in the difference between the Oliver Opera House and the third county court-house, built twelve years apart.

An important question to consider is the following: To what extent did Burnham and the designers of the Court of Honor buildings consciously in-tend to influence the course of American architecture in the direction of Neo-classicism? These architects believed strongly in this new design mode and, as Burnham stated after the fair, they wanted to see its proliferation through-out the country because they were convinced that it was the most appropriate style for the young and growing United States. He felt it struck a chord in the American psyche and enlivened the country's sense of destiny while making direct associations with the historical past.

Third County Courthouse:
Beaux-Arts Classicism in the City's Civic Center

The Columbian Exposition manifested its most direct influence in South Bend in the third county courthouse, built from 1896 to 1898. This stately Beaux-Arts style building, called "Roman classic" at the time, was constructed at the corner of Main and Washington Streets in the place of John Mills Van Osdel's county courthouse of 1855, which was preserved and moved to another spot on the same block.[9] The new courthouse was designed by Shepley, Rutan and Coolidge, a Boston firm that was designing at the same time two monumental buildings in the Beaux-Arts style in Chicago: the Art Institute of Chicago (1895) and the Chicago Public Library (1897), both located on Michigan Ave-nue in proximity to Grant Park.[10]

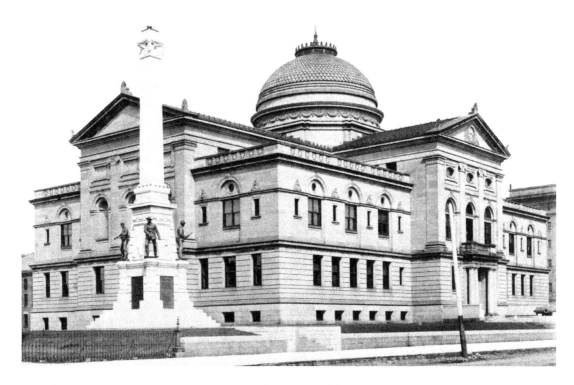

FIGURE 11.1
Third St. Joseph
County Courthouse,
corner of Main and
Washington Streets,
1896, Shepley, Rutan
and Coolidge, with
George Selby,
architects. (From
*Souvenir of
South Bend.*)

The Beaux-Arts style represents a particular subset of the larger Neoclassical movement that swept the country after the Columbian Exposition. Its buildings have many of the same details and formal qualities as other classically inspired styles, but they are characterized by more exuberant surface ornamentation, larger and more monumental scale, and use of expensive materials such as marble, limestone, and granite. Masonry walls are typically rusticated on the first story, with smooth, light-colored stone above. Entry porches with classical columns are common; cornices are elaborated with moldings, dentils, modillions, and balustrades. Decorative window and door surrounds, corner quoins, pilasters, and columns are almost universal.[11]

Historian Jon Dilts, in his study of Indiana courthouses, wrote that many communities believed that with cash in hand or adequate means of financing, it was acceptable for new courthouses to be expensive. Prominent public buildings were believed to advertise a community's success and attract new businesses. Cities competed with one another to build the most attractive courthouse possible. One country lawyer in northern Indiana exclaimed that "a courthouse should be like justice itself, simple and unostentatious, but since it is the fashion to build expensive public buildings, I'll do my part."[12]

Beaux-Arts Classicism and the Civic Ideal, 1893–1918

Charles A. Coolidge, a Boston native who studied at both Harvard and MIT, had started his career in the office of H. H. Richardson. In 1886 he formed a partnership with George Shepley and Frank Rutan to carry on Richardson's practice after his death. Important early commissions of the firm included designs for Stanford University and the Ames Building in Boston, projects that followed Richardson's famous brand of the Romanesque style.

The firm's continuation of Richardson's practice received wide attention in the architectural press. Between the time of its founding in 1886 and the opening of the Columbian Exposition, the work of Shepley, Rutan and Coolidge was published in *American Architect and Building News* almost as frequently as Richardson's work had been in previous years. The architects' ability to practice successfully in the Richardsonian mode helped in the continued dissemination of the popular style across the country.[13] However, this popularity proved to be short-lived when, like Burnham before them, the firm began to embrace the Neoclassical style.

Coolidge moved to Chicago in 1893 to execute the commissions for the Art Institute and the Public Library, purely Neoclassical designs that represented a significant transformation of the firm's design philosophy. Gone was any trace of the Romanesque vocabulary that had made Richardson so famous and which Shepley, Rutan and Coolidge had until now so effectively promoted.

Coolidge maintained an office in Chicago until 1897. During this time he designed the St. Joseph County Courthouse along with other commissions in South Bend and numerous other Midwestern cities. After he returned to Boston, the firm maintained its prolific practice, designing university, institutional, and religious buildings across the country, now mostly in the Neoclassical or Beaux-Arts style, with some less-convincing experiments with the Gothic Revival.[14] Architectural historian Alan Gowans referred to their new mode as the "Imperial Roman" style: "In this style they built the Public Library and the Art Institute in Chicago; henceforth they and their successor firms used the Imperial Roman style for courthouses, banks, office buildings, and hospitals all over the country, well into the 1920s."[15]

The project architect for South Bend's courthouse was George Selby, who joined Shepley, Rutan and Coolidge in 1897. A native of Utica, New York, Selby had moved to Chicago in 1889 to work in the office of Burnham and Root, where he remained for six years, working on such projects as the Monadnock Block, Great Northern Hotel, Women's Temple, and Marshall Field

Annex.[16] In 1895 he formed a partnership with Dwight H. Perkins under the firm name Perkins and Selby, but two years later he joined Shepley, Rutan and Coolidge and moved to South Bend in order to supervise construction of the courthouse.[17] He decided to remain in South Bend and eventually started his own firm.

As the new courthouse was planned for the same site as the second county courthouse of 1855, the county commissioners decided to retain the older building rather than demolish it. They had it jacked up from its foundation, put on rollers, moved a few hundred feet to the west, and turned 180 degrees to face Lafayette Street. While it was admirable that the city's leaders saved this building so important to the city's history, moving it to a different location on the same block had the effect of constricting the site of the new courthouse, much to its disadvantage. The new building would have been better located if the entire block had been available in the manner of a courthouse square, a tradition that was more or less indigenous to city planning in the state and much of the country throughout the nineteenth century. Of the ninety-two counties in Indiana, each with their own county seat and county courthouse, at least three-fourths of them have a full city block in the center of town with their noble courthouse in a parklike setting. Such an arrangement dignified city and county governmental functions, making them a significant focus for the community. It raised them to a higher level, lending a semisacred quality to the role of government.

Relocating the original courthouse also closed off the approach to the new building from the west side. An existing church and a site for commercial development blocked the approach from the south side. What should have been a noble building in the center of the block, with axial approaches from all four directions, ended up on a tightly constrained site with formal approaches from only two directions, the east and the north. Its symbolic role as the center of the county's civic government was thus not as strong as it could have been.

As of this writing, over a hundred years later, the downtown governmental core remains a highly compromised civic space, the courthouse being jostled by too many adjacent buildings. The traditional courthouse square was meant to reflect the alliance between government, business, and the people, the iconography of governmental authority linked symbolically to the dome of the U.S. Capitol in Washington, DC. The city square in turn had a relationship with the surrounding urban fabric that was both axial and hierarchical. Both are lacking in South Bend's case.

FIGURE 11.2
Initial design for third
St. Joseph County
Courthouse, 1896,
A. W. Rush and Son,
architects. (*South
Bend Tribune*, 1896.)

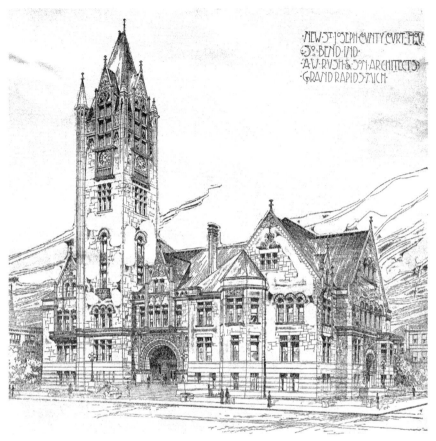

The process of designing the courthouse building was not without compli-
cations. The county commissioners had initially hired A. W. Rush and Son, an
architectural firm from Grand Rapids, Michigan. They were impressed by the
firm's success in designing and building new courthouses in other cities in In-
diana—Winamac, Rochester, and Rushville—all in the Richardsonian Roman-
esque style. Rush's design called for a massive stone structure, asymmetrical in
plan, with a round-arched entrance and a clock tower rising 180 feet high.[18]
However, largely because of the influence of the Columbian Exposition, the
commissioners soon realized it was a fashion that was falling out of favor.[19]
Concerned that the building should not look outdated before it was even built,
they canceled their contract with Rush and invited six new firms to submit
plans. They chose the Beaux-Arts design by Shepley, Rutan and Coolidge, with
its clear link to the exposition.[20]

The resulting design was of such exceptional quality that it largely made
up for the difficult site. It was directly influenced by the Beaux-Arts Classicism

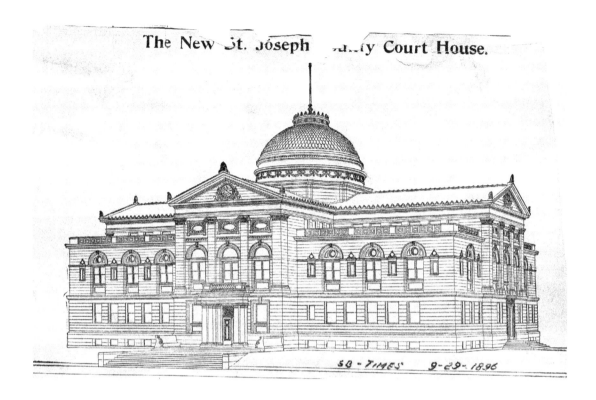

The New St. Joseph ...ty Court House.

SB - TIMES 9-29-1896

of the Columbian Exposition, especially the Fine Arts Palace designed by Charles Atwood. Like that building, the courthouse has a rectangular plan measuring 176 feet on Main Street and 106 feet on Washington, with a projecting pavilion in the center of each facade, indicating a cross-axial composition. Each pavilion is topped by a Greek pediment, while a prominent dome in the center marks the crossing of the two axes. It has Indiana limestone walls and a red-tiled roof, and the dome, once sheathed in terra-cotta tiles, is now covered by glass-fiber reinforced concrete panels rendered in a fishscale motif that matches the original pattern.[21] Renaissance influences are seen in the heavily rusticated base, arched window frames, and engaged pilasters. A striking feature is the placement of three oval windows in rectangular frames in the third level of the main facade.

The building's interior features an octagonal rotunda topped by a dome that rises to a height of fifty-six feet. It is supported on pendentives and lit from a glazed oculus in the center.[22] Two lunettes under the dome, measuring sixteen by eight feet, contain paintings representing scenes from the history of South Bend: "LaSalle at the Portage, December 5, 1697" and "LaSalle at the Miami Treaty, May 1681," both by Conrad Arthur Thomas of the studio of

FIGURE 11.3
Design drawing for third St. Joseph County Courthouse, 1896, Shepley, Rutan and Coolidge, with George Selby, architects. (*South Bend Tribune*, 1896.)

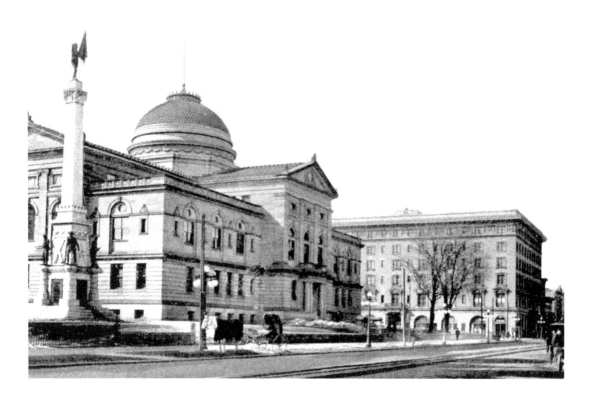

H. F. Huber and Company, New York. A newspaper article indicated that "the paintings met the approval of the building's architects Shepley, Rutan and Coolidge."[23]

Two large courtrooms are located on the second floor, both with clerestory windows on two sides. A reporter for the *South Bend Times* wrote that the arrangement of the windows was "similar to that of the new 'Cour d'Appel' of the Palais de Justice in Paris" and that "their height from the floor ensures quiet and immunity from the distractions of the street."[24] Below the windows, the walls were clad with a high wainscoting of white oak, marked at one end by the judges' rostrum and at the other by double doors leading to the central rotunda. Corridors had mosaic floors and marble wainscoting, much of which has been replaced over the years in the course of remodeling projects.

The building's form represented its multiple functions in a vertical hierarchy. The first floor contained government offices for the county assessor, tax collector, and auditor, among others. The upper floor contained the courtrooms, the judges' chambers, and the law library. Windows and clerestories allowed light into the courtrooms, and the dome's oculus filtered light into the rotunda. The building's cross-axial form created order and hierarchy, a spatial

pattern that was repeated numerous times in courthouses across the Midwest. The Beaux-Arts forms employed by Shepley, Rutan and Coolidge were in step with the national infatuation with the Court of Honor buildings in Chicago.

More than ten thousand people passed through the building during an open house shortly after it was completed in November 1898. Praise for the new building was nearly universal, much of it similar to this statement reported in the *South Bend Tribune*: "The people now have a courthouse of which they may well feel proud." Taxpayers, it reported, "had, indeed, received full value for every dollar expended."[25] One local resident stated, "I feel prouder tonight of St. Joseph County than at any time during the 60 years I have lived here. I think the new courthouse is magnificent." Another said, "I have been in fine buildings in Europe but this courthouse is simply magnificent." Former congressman George Ford said, "The more one looks at the Courthouse the better it appears. It is of the style of architecture that grows upon you."[26] There was satisfaction with the building's design and workmanship, as well as praise for the professionalism of the county commissioners who saw the project through and for the fact that, at $240,000, the project came in under budget. The willingness to build grandly, to build classically, marked South Bend's ascendency.

The Oliver Hotel

One of the most significant buildings constructed in South Bend after the third county courthouse was the Oliver Hotel, constructed from 1898 to 1899. Built on a site directly across the street from the courthouse square, it would be James and Joseph Oliver's most important architectural contribution to downtown South Bend.[27] The site was originally home to the St. Joseph Hotel, which dated to 1856. It was destroyed by fire twice, first in 1865 and then in 1878, and rebuilt both times. The Olivers acquired the site in 1879 and built a three-story Italianate hotel that was the first to carry the name "The Oliver."

By the late 1890s this building had become outdated, and the Olivers decided to replace it with a new and larger hotel, one that would be a major architectural landmark in the city. To design it, they commissioned the same group of architects that had designed the third county courthouse: Shepley, Rutan and Coolidge, with George Selby as the supervising architect.

The new Oliver Hotel would be grand and magnificent. Its style was a

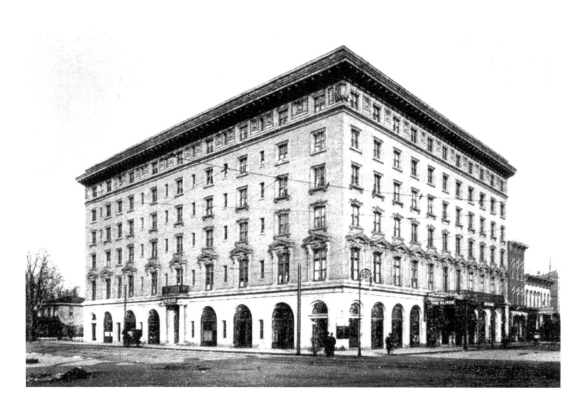

FIGURE 11.5
Oliver Hotel, corner of
Main and Washington
Streets, 1898, Shepley,
Rutan and Coolidge,
with George Selby,
architects. (Courtesy
of The History
Museum, South Bend,
Indiana.)

combination of Italian Renaissance and Baroque, a six-story block with refined proportions, perfectly scaled, with decorative windows on the second floor and an elaborate cornice at the top. The closest analogy to this building would be Chicago's Drake Hotel, designed in 1920 by the socially prominent firm of Marshall and Fox.[28]

A reporter for the *South Bend Times* wrote of the Oliver Hotel, "It was evident that money had not been spared; while the best workmanship, the richest furnishings, the most modern conveniences, the acme of artistic taste and architectural talent had been employed in rearing this hostelry unsurpassed in the United States except in size."[29] It was clad in yellow-orange Roman brick, with Bedford limestone on the first floor and terra-cotta trim above. The second floor featured the most ornate architectural treatment, with Renaissance window frames and terra-cotta pediments. The sixth floor was set off by a belt course and was faced with decorative terra-cotta panels between the windows. The main cornice, with brackets and lions' heads, projected five feet beyond the plane of the facade. At the corner of Main and Washington Streets—soon to become the city's most prestigious address—the frieze was accented with a shield in the form of a cartouche surrounded by a laurel wreath. Porticos with

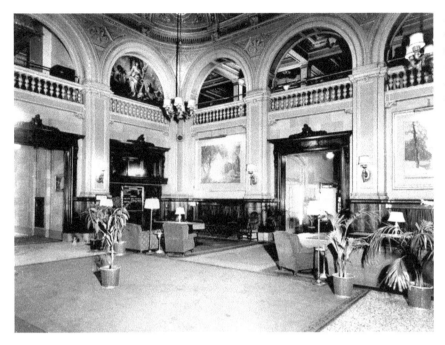

FIGURE 11.6
Oliver Hotel, lobby
and waiting room.
(Courtesy of The
History Museum,
South Bend, Indiana.)

Doric columns marked the two entrances, and, in addition, the Main Street entrance had a cast-iron porte cochere.[30]

The building occupied a full quarter block. It included a two-story central lobby space, measuring forty-four feet square, that was lavishly decorated with arches and balustrades, embellished in gold, yellow, and green, and topped by a stained glass skylight. The ceiling's coved edges were decorated with sixteen painted life-size female figures, done under the direction of Gustave Brand of Marshall Field and Company, who served as decorator for the hotel. Four figures on the room's west side depicted the four seasons; those on the north depicted the fine arts: poetry, architecture, sculpture, and painting; those on the east portrayed the elements: water, earth, fire, and air; and those on the south, music, song, grammar, and dance.[31] A monogram of *TO*, for "The Oliver," was repeated throughout. The three hundred guest rooms were beautifully appointed, with those on the second floor being the largest and most luxuriously decorated and furnished. Those on the south had splendid views of the courthouse, to which it provided a stately, palazzo-type facade well suited to its urban context.

The hotel's grand opening, held in December 1899, was eloquently described in the *South Bend Times* in terms of the link between the Oliver Company and the city of South Bend:

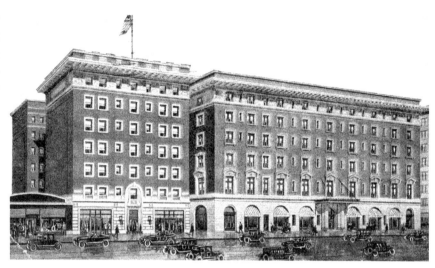

The Oliver name has been linked with South Bend to the city's world-wide renown for these many years as manufacturers on a scale eclipsing any other industry of the same kind on earth. It then became closely associated with the city of their pride in the splendid Opera House that is excelled by none in the United States. Their palatial homes then became a joy to our city architecturally, but the crowning triumph of their career as citizens of the metropolis of the St. Joseph Valley . . . unfolded its conveniences, completeness, massiveness, beauty, and magnificence to thousands of enraptured people at the reception.[32]

The Oliver Hotel was also notable for being one of the first major buildings in the city to have electric lights. In 1903 James Oliver had undertaken an enterprise to produce his own electrical power for his factory and downtown buildings by purchasing property along the West Race of the St. Joseph River. He demolished the old industrial buildings, dredged the race, built a dam, and by 1905 had constructed a new hydroelectric power plant, which provided electricity for both the Oliver Hotel and the Oliver factory.[33]

Joseph D. Oliver sold the hotel in 1914 to Leo Strauss of Chicago for $400,000, some $200,000 less than it cost to build.[34] In 1921 Strauss expanded it to the west, adding another two hundred rooms. Designed by Herbert H. Green of Chicago, the addition was compatible with the original building in terms of style and details. In the 1950s its name was changed to the Pick-Oliver Hotel, and in 1957 it underwent a $250,000 renovation. Ten years later, in one of the great tragedies in South Bend's history, the Oliver Hotel was demol-

FIGURE 11.8
Dean Building
(Lafayette Building),
N. Lafayette
Boulevard, 1901,
George Selby,
architect.
(Photo by author.)

ished to make way for a twenty-three-story tower housing a bank, motor inn, and offices.[35]

The construction of the third county courthouse and the Oliver Hotel established George Selby as one of the city's leading architects. He went on to design several other buildings downtown, each in a variant of the Neoclassical or Neo-Renaissance style. His first independent commission after leaving the employ of Shepley, Rutan and Coolidge was the design in 1901 of the Dean Building, now the Lafayette Building, at 115 South Lafayette Street. Originally designed to be two stories high, the top three floors were added in 1903. Its facade is noted for both its Renaissance order and its simplicity, characteristics of the Chicago tradition of Jenney and Sullivan. Its interior contains a unique five-story atrium ringed with open balconies and topped by a skylight. For

many years this was the most prestigious office building in downtown South Bend.[36] Before the insertion of an elevator shaft, this atrium was one of the most unique and inviting interior spaces in the city.

The Studebaker Auditorium

Just as the Oliver family built its great Oliver Hotel in the Renaissance style on the courthouse square, the Studebaker family built its own Renaissance palace, the Studebaker Auditorium, on South Michigan Avenue, just south of their original headquarters building. It opened in 1898 with the comedy *American Citizen*, starring Nat Goodwin and Maxine Elliot.[37]

To design this landmark building they chose the Chicago architect they were most familiar with: Solon S. Beman. As we have seen in previous chapters, Beman began the ten-year project of designing Pullman, Illinois, in 1879. He carried out the commission of Jacob Studebaker to design the Studebaker headquarters in Chicago in 1884, and he designed the First Baptist Church in South Bend in 1886.[38] Now, some twelve years later, the Studebakers brought him to South Bend again to design a large civic building in the middle of the city.

The Studebaker Auditorium stood four stories tall, featuring a brick facade with commercial shop fronts on the first floor, oculus windows on the third floor, and a prominent cornice, all following the Renaissance style. The *South Bend Times* reported that it "combines architectural novelty and attractiveness to a high degree, and no conveniences or comfort or appliances for safety have been omitted from its make-up."[39]

The Renaissance facade extended 120 feet on Michigan Street. Its entrance, which served as a connection to the Studebaker headquarters, was marked by an iron-frame porte cochere similar to that marking the entrance to the Oliver Hotel. The entrance vestibule was lined with porphyry and plate glass doors set in oak frames, and a twelve-foot-wide marble stairway with red Turkish carpet and bronze balusters led to a second-floor lobby and entrance into the auditorium. The main floor held 840 seats and standing room for 100, while the balcony held 200 seats. The stage was 84 feet wide and 38 feet deep. The auditorium interior was in the Empire style with red walls and a yellow ceiling.[40]

Given that the Studebaker Auditorium was built as a direct competitor of the Oliver Opera House, the *South Bend Times* went on to say, "South Bend now has two of the finest playhouses in the country. . . . In everyone's

FIGURE 11.9
Studebaker Auditorium,
S. Michigan Street,
1897–1898, Solon
Beman, architect,
Souvenir Post Card Co.,
New York. (Author's
collection.)

heart of hearts, there should be a sincere sense of gratitude for the public spir-
ited citizens who have given to northern Indiana's Queen such splendid opera
houses as the city now enjoys. It means much to the city and its people."[41] It
was fine praise, but of course there were other elegant playhouses in cities ac-
ross the country, many of them larger and more lavishly appointed, especially
in cities such as New York, Boston, and Chicago. Nevertheless, the Studebaker
Auditorium was an important manifestation of South Bend's aspirations for
cultural attainment.

These turn-of-the-century downtown building projects by the Olivers
and Studebakers paralleled Beman's work to develop George A. Pullman's ideal

industrial town south of Chicago. There he had laid out streets, designed rows of houses for workers, and created plans for factory buildings, an administration building, a hotel, a church, a library, and commercial buildings. It was one of America's largest industrial communities to be planned and built in its entirety by just one architect and one industrialist. The intention was to take workers away from the grime and pollution of the city and locate them in a healthy country atmosphere.[42]

When it was completed, Pullman accommodated nearly nine thousand residents, all of them Pullman employees and their families. It included a three-acre lake with landscaped banks, a town center, and a combination of apartment blocks, row houses, and single-family dwellings. The Pullman Palace Car Administration Building, crowned with a tall clock tower, dominated the town's skyline. A reporter for the *Inter Ocean* wrote in 1885 that the town "is already famous as one of the wonders of the west." He went on to say, "More completely and on a larger scale than was ever before attempted, there is seen here a sympathetic blending of the useful and beautiful."[43] Architect John Garner wrote, "The company town—built, owned, and managed by a single enterprise—served as a kind of paradigm for industrialism in urban design."[44]

The parallel between Pullman and the civic development of South Bend carried out by the Studebakers and Olivers is striking. In each case the intention was to make a comfortable and healthy environment with beautiful buildings where factory laborers could live and work. As Garner pointed out, there was a paternalistic side to such intentions, a concern for the social conditions of the working class. Industrialists were convinced that by improving the environment of their workers, they were also improving their own condition. Contented workers living in an attractive city made it easier to hire and retain labor, helped avoid labor strikes, and led to greater efficiency. As Garner stated, they viewed paternalism "as a pragmatic means of securing order and improvement for an industrial society."[45]

The South Bend City Hall

In 1900, at a time when the city's population had exceeded thirty-five thousand, South Bend was in need of a new city hall—one that it could not afford to build. James Oliver's unfailing interest in South Bend's civic architecture led him to step in with an offer to build one himself and lease it back to the city. He

FIGURE 11.10
City Hall,
214–18 N. Main
Street, 1901–1902,
Freyermuth and
Maurer, architects,
demolished 1970.
(From *South Bend
and the Men Who
Have Made It.*)

held a closed competition between four architects and in the end offered it to Freyermuth and Maurer, who were already engaged with designing St. Joseph Hospital. Constructed at a cost of $75,000 by the contractor Henry G. Christman, City Hall was dedicated in 1902.[46]

The new city hall was located on the east side of Main Street, just north of Colfax Avenue. It was a three-story building in a combination of French Renaissance and Châteauesque style, with a high sloping tile roof and an ornamental tower that rose to a height of 115 feet. The facade was built of Bedford limestone with ornamental carvings and yellow pressed-brick panels. This eclectic design featured a round-arched, recessed entrance with limestone trim, a third-floor balcony, a circular window, and a clock face in the tower. The front windows were grouped in threes, and each floor had a different architectural treatment, the first with smooth-faced limestone, the second with brick and corner quoins, the third with fluted Ionic pilasters at the corners, and the attic with Jacobean-style dormers.

The lobby featured white oak woodwork, Tennessee marble wainscoting, and a floor of Venetian mosaic tile. A massive open stairway with artistically wrought-iron railings and marble steps led to the second floor. The building had modern conveniences of electric lighting and steam heating. It was demolished in 1970. As the *South Bend Tribune* reported at the time, "In the name of progress, the old City Hall is doomed to the wrecker's ball."[47]

St. Joseph's Hospital and the Châteauesque Style

One of South Bend's most noble institutional buildings outside of downtown, significant for both its site and its architecture, was the former St. Joseph Hospital, located on a high bluff on the Near East side between Notre Dame Avenue and St. Louis Street. The site had originally been occupied by the Church on the Hill of St. Joseph's Parish, built in 1873 when the St. Alexis Church burned down. Designed by Father Edward Sorin, it was later called the Church of the Assumption. Its connection to healthcare came nine years later, when the parish built St. Joseph's Church and the Holy Cross Sisters bought the building to house their health services.[48]

The new hospital was designed by the relatively young firm of Freyermuth and Maurer. George Freyermuth was a native of Philadelphia who moved to South Bend with his family as a child. He learned architecture from his father, who was a building contractor, and in 1897, he joined R. Vernon Maurer to form Freyermuth and Maurer. Freyermuth was later appointed a member of the City Planning Commission, and he served as mayor of South Bend from 1935 to 1939.[49] Maurer was a native of South Bend and had studied art at the Chicago Art Institute. He apprenticed in a Chicago firm until returning to South Bend in 1895.[50]

The Châteauesque features of St. Joseph Hospital included a round-arched central doorway framed by two cylindrical stair turrets connected above by a wide gabled parapet. Its walls were reddish-orange brick with stone trim. Its distinctive facade measured 156 feet wide, with two wings extending 100 feet at the rear. On its west side was a two-story wooden porch, from which patients and visitors had a spectacular panoramic view of the city.[51] It had tiled fireplaces in every room, stained glass windows, and turrets. At the top of the gable was a 9-foot-high copper Celtic cross.[52]

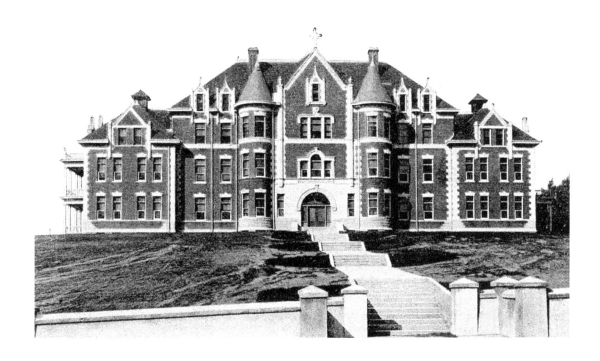

Work on the new hospital began in 1902 and was completed two years later. Over the years, numerous wings were added to the original building, but its main facade was never hidden or altered, thus maintaining its prominence on the bluff. Sadly, the hospital was demolished in 1979, the site now being occupied by St. Joseph's High School.

FIGURE 11.11
St. Joseph's Hospital,
E. LaSalle Street,
1902, Freyermuth
and Maurer,
architects.
(Author's collection.)

Collegiate Hall, St. Mary's

One of the most beautiful features of the Saint Mary's campus is the tree-lined Saint Mary's Avenue that serves as its main entrance, leading from State Road 933 westward into the heart of the campus and terminating in a circular drive in front of Holy Cross Hall. It is lined with sidewalks and sycamore, oak, and maple trees. A monumental gateway, located at the intersection with 933, was designed for the avenue in 1897. This fieldstone entrance is composed of two low walls with pedestals at either end flanking the drive. Lake Marion and its island were constructed just north of the avenue in an area that had long been an orchard.

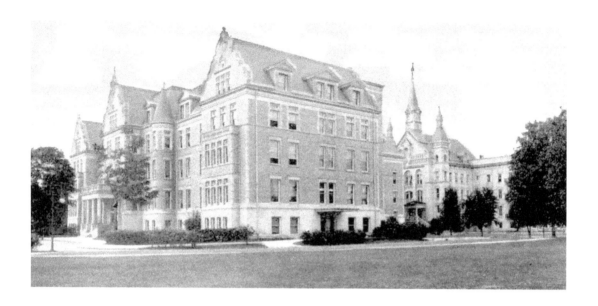

FIGURE 11.12
Collegiate Hall
(now Holy Cross),
Saint Mary's College,
1903, Egan and
Prindeville,
architects. (Author's
collection.)

Holy Cross Hall is one of the most prominent buildings on the campus because of its location at the head of Saint Mary's Avenue. Built in 1903, it was designed by the firm of Egan and Prindeville. Originally called Collegiate Hall, it was a new all-purpose facility meant to house the entire student body in addition to the library, dining hall, bookstore, post office, classrooms, guest rooms, health center, and chapel. It was turned into a freshman dormitory in 1925 and its name was changed to Holy Cross Hall in 1945.

Egan and Prindeville was known in the Midwest for its civic and ecclesiastical architecture. James J. Egan moved to Chicago from New York in 1871; like Beman, he had worked with Richard Upjohn. He gained recognition after the fire of 1871 with his design of the Cook County Courthouse and City Hall (1871–1875).[53] In 1897 Egan formed his partnership with Charles Prindeville, and the firm became known for the numerous churches it designed for the Catholic Diocese of Chicago, including St. Elizabeth's Church and St. Vincent's College.[54]

What makes Holy Cross Hall so important to the overall campus plan is its location at the head of Saint Mary's Avenue, in a manner similar to Notre Dame Avenue and the university's Main Building. Unfortunately, it was placed squarely in front of Willoughby J. Edbrooke's Tower Building, thus hiding from view the elegant Romanesque Revival facade built in 1889.

The plan of Holy Cross Hall is symmetrical, with a central pavilion on the main axis. Wings with turrets and end pavilions extend from either side. It fea-

tures distinctive shaped parapets topping the central roofline and that of the two end pavilions. It has a raised limestone basement story, with brick above.

The Saint Mary's campus is also notable for the shrines placed at strategic locations to commemorate important religious figures. In 1905 St. Michael's Shrine, made of white marble, was erected north of Holy Cross Hall. It commemorates the first fifty years of the Sisters of Saint Mary's. The Sacred Heart Shrine was built in 1918 in the Gothic Revival style. This outdoor devotion was a gift of the Sisters of Holy Cross to Mother Perpetua, the Superior General, on the occasion of the fiftieth year of her profession. A series of Tudor arches topped by trefoils, the octagonal stone gazebo was moved from the front of Le Mans Hall when the Moreau Center and O'Laughlin Auditorium were built.

Collegiate Hall joined an increasingly rich built environment in the South Bend area marked by the influence of architectural styles that emanated from Chicago and the World's Columbian Exposition of 1893. As noted earlier, the civic architecture funded by South Bend's leading industrialists during this era also resembled in many ways the planning and architecture featured in Pullman, Illinois. The difference, however, was that the Studebakers and Olivers in South Bend did not have the opportunity to create an entirely new city. They envisioned making South Bend a utopian workers' city similar to Pullman's ideal town outside of Chicago, but they had to work with an already existing urban fabric. They added civic buildings, offices, and houses where they could and to the extent that their financial resources allowed, but they were unable to transform the city in its entirety into a utopian town that was a beautiful and comfortable place to live, complete with all the amenities needed for the workers' livelihood and happiness and governed by a single entrepreneurial entity. Instead, they had to deal with an already existing infrastructure, diverse property ownership, competing enterprises, and local political interests. The buildings they created were noble and monumental, but the overall character of the city never attained the unified appearance of Pullman, nor the singular political and economic authority that George Pullman wielded over it.

South Bend and the City Beautiful Movement

The turn of the century was a time of great prosperity for South Bend, with the industrial giants reaping the benefits of their economic prowess by expanding their production and at the same time branching out into real estate development in downtown and in the neighborhoods. The South Bend of the Studebakers and the Olivers was a vibrant and interesting city, a thriving metropolis in an age of expansion, industrial growth, and economic riches.

The Columbian Exposition was important not only for bringing the Neoclassical style to the forefront of architectural design, but also for its influence on city planning. This was especially the case with the City Beautiful Movement, the nation's first concerted attempt at planned urban beautification, second in importance only to the many park systems designed by Frederick Law Olmsted in cities across the country. More than any other single factor of the nineteenth century, the exposition encouraged aesthetic efforts in municipal life throughout the country, giving tangible shape to a desire arising out of the era's greater wealth, increased travel, and improving provision for the essentials of life.[1]

The number of comprehensive city-planning projects mushroomed across the country, calling for the regularity and monumentality of building design and the fusion of naturalistic park systems with formal Neoclassical-style civic centers.[2] Included among them was a design for Copley Square in Boston, public building groups in Cleveland and San Francisco, the McMillan Plan for Washington, DC, and Philadelphia's Benjamin Franklin Parkway. Most important to Chicago, of course, was Daniel Burnham's 1909 *Plan of Chicago*, in

which he proposed rebuilding the city on a massive scale with a new Baroque street pattern, a lakeshore park, grand civic buildings in the Neoclassical style, and a giant domed city administration building in the center on axis with Congress Avenue.

The grand boulevard and the axial pattern of urban streets with squares and circles evident in the Chicago Plan expressed a sense of rationalism and of man's power to control the built environment, which was analogous to that disposition found in industry, business, science, and technology. The architectural vocabulary that distinguished the City Beautiful movement—the Classical tradition derived from Roman, Parisian, and Viennese precedents—was easily understood or recognized by most people, and it suggested that there was a universal truth or ideal to which designers and builders could strive.[3]

Architectural historian Richard Guy Wilson pointed out that the early large-scale City Beautiful projects carried out by Burnham and McKim, Mead and White were formal ensembles placed in the city and set in contrast to the urban fabric around them. Whether the campus of Columbia University or the mall in Cleveland, they were "to be seen against the surrounding context of disunity which made them stand apart."[4]

There were, of course, detractors who argued against the idea of concentrating all of the city's civic buildings in one area, isolating them from the city's commercial and residential districts. Jane Jacobs wrote one of the most succinct criticisms of the City Beautiful movement in her book *The Death and Life of Great American Cities*, arguing that the primary result was the "Center Monumental," modeled on the Columbian Exposition's Court of Honor. She noted that the monument and boulevard projects were typically "sorted out from the rest of the city, and assembled into the grandest effect possible, the whole being treated as a complete unity, in a separate and well-defined way."[5] The problem was, this separation from the city's vital commercial core left them without life, without the activity essential to city living. Instead of being uplifted, the areas around them "invariably" became run-down, she stated, turning into "an incongruous rim of ratty tattoo parlors and second-hand-clothing stores, or else just nondescript, dispirited decay."[6]

Perhaps this is true in its purest and most grandiose form, as found, for instance, in the Washington Mall or San Francisco's Civic Center. If we consider a city the size of South Bend, perhaps it could have benefited from a little more hierarchy in the planning of its downtown, perhaps one or two small Neoclassical buildings facing an urban square or secondary town green across from

the courthouse? Likewise, who does not enjoy a boulevard meandering its way through a city park or along the landscaped bank of a river?

Indeed, the development of parks and the construction of civic buildings in the Neoclassical or Beaux-Arts style in South Bend in the first decade or so of the twentieth century helped to create a nobler, more rational, and more beautiful city than before. In writing about the influence of the Columbian Exposition on South Bend's development, however, care is needed to distinguish between the vision that could have been and the actual outcome. In South Bend, as in many cities, the potential for developing a system of formal boulevards and parks punctuated by civic buildings and monuments, as promoted by the City Beautiful movement, was only partially fulfilled. Great schemes were drawn up in city after city but, in Jacobs's words, these proposals "mainly came to nothing."[7] British urban designer David Gosling wrote, "often the most imaginative of urban design proposals are never built. Many major US cities demonstrate a woeful lack of any coherent urban design policy except, predictably, in historic districts and neighborhoods. Rather, it seems, both the public and private sectors employ urban designers for reasons of political expediency or public relations. Unless urban designers are also the architects of the ultimate built form, it is unlikely that their plans will be implemented."[8]

In South Bend's case, turn-of-the-century urban improvement efforts came in the form of newly developed parks, riverfront boulevards and a dozen or so Neoclassical, Beaux-Arts, and Renaissance Revival buildings, as well as a comprehensive City Beautiful master-plan project, all of which went a long way toward beautifying the city, though not necessarily in the unified, comprehensive way envisioned by the promoters of the City Beautiful movement or feared by Jacobs.

The period from the late 1890s to the 1910s was an important time of stylistic transition in South Bend, as in other American cities, as the once-favored Romanesque and Gothic styles were superseded by a near total embrace of Classicism. The Columbian Exposition and the City Beautiful movement had a significant influence across the country, which manifested itself in South Bend with great Classical Revival buildings such as the third county courthouse and the Renaissance Revival Oliver Hotel. These two buildings and those that followed in the Neoclassical or Beaux-Arts styles were at the time of their construction the city's most important civic and commercial architectural landmarks, beacons of the period's Classical dream.

In a broader context, the civic buildings constructed in South Bend at the turn of the century reflected a nationwide trend. Across the country there were countless individual buildings designed in the Neoclassical style, beginning in the mid-1890s with the Boston Public Library and the Art Institute and Public Library of Chicago, for instance. At the same time, there began a reform of federal and regional architecture throughout the country, with Neoclassical customs houses, courthouses, and post offices being constructed in such cities as New York, Indianapolis, San Francisco, and Cleveland, and new Senate and House offices constructed in Washington. All of this, in the words of architectural historian A. D. F. Hamlin, "lifted our National official architecture from pretentious inferiority to a level of high artistic merit."[9] Making further contributions were the railway terminals built in Washington, New York, Chicago, Pittsburgh, Kansas City, and Baltimore, along with innumerable university buildings, campus beautification plans, school buildings, fire stations, libraries, and hospitals. Such a wide-ranging influence of the Neoclassical style suggested to Hamlin an even better future for architecture, "an architecture far nobler, purer, more serious and more beautiful than that of today, offering to the whole world models of good taste and sound construction, and making our cities and villages fairer and happier places to live in."[10]

The First Parks and Bridges

The earliest official attempt by the city of South Bend to develop a park in the area of downtown occurred in 1878, long before the advent of the City Beautiful movement. Judge Timothy Howard, then a member of the city council, drafted a bill to allow the city to consider purchasing property on the east side of the St. Joseph River south of Jefferson Boulevard.[11] The city established a park there the following year, and in 1880 it took steps toward a basic landscape plan by planting fifty trees in random patterns. In the words of park board member Richard Elbel, writing in 1922, the site was "nothing but a villainous looking hole and dumping ground . . . and three or four holes where water would stand at most seasons of the year."[12]

It was not until 1894, just after the close of the Columbian Exposition, that the city hired landscape designer John G. Barker to fill in the marshy areas and develop it further as a "pleasure park." Additional property was acquired

through both purchase and donation as the park was extended eastward from the river to St. Louis Street. At the same time, the park board took the important step of erecting a decorative seawall along the river to protect the water's edge and control flooding. It was named Howard Park after Judge Howard, who by then had become an important civic leader and one-time member of the Indiana Supreme Court.[13]

Howard Park was further enhanced in 1906, when John Mohler Studebaker donated a large ornamental electric fountain, cast in bronze, to be placed near the center of the park. It stood in a circular basin that was populated with cast-concrete statues. Its cascading water sprays were illuminated at night by a series of electric spotlights.[14] After years of being in storage, this fountain has been recently restored and reinstalled, not in its original location, but in a newly redesigned portion of Leeper Park, the second park in South Bend's history to be developed.

Leeper Park, located just north of downtown, at the so-called southern bend of the St. Joseph River, was equally important to the early development of South Bend's urban park system. The city began acquiring property in the area in the 1890s, initially for the purpose of building a waterworks pumping station. The site extended from the river on the east and across Michigan Street to as far as Lafayette Street on the west. In 1901 the South Bend Engineering Department, headed by Chief Engineer Alonzo J. Hammond and assistant engineers William S. Moore and W. E. Graves, all advocates of the City Beautiful movement, began drawing up plans for the North Pumping Station grounds and the surrounding park.[15] It was named Leeper Park in honor of David R. Leeper, former state senator and mayor of South Bend.[16]

Improvements to the park soon followed as roadways and sidewalks were graded, trees were planted, and a lily pond was installed as a landscaping centerpiece.[17] In 1903 the Board of Public Works hired Herman H. Beyer to serve as the Park Department's landscape designer, engineer, and superintendent. A former landscape gardener for James Oliver, Beyer produced a design for Leeper Park that suggested the influence of both Frederick Law Olmsted and the City Beautiful movement.[18]

The park took on a new appearance with the construction of a building to serve as the pumping station, as thirty artesian wells were dug for the city's water supply system. The park took on an added historical dimension when, in 1904, the Navarre Log House was moved from its original site north of the

river to a spot southeast of the pumping station.[19] It has been visited for decades in that location by tourists and grade-school groups, but as of 2022, plans were pending to move it to a site on West Washington Street.

Bridges were an equally important component of South Bend's urban image during its development in the late nineteenth and early twentieth centuries. The city's principal east–west streets—LaSalle, Colfax, and Jefferson—had been served since the 1830s by ferries that connected the river's west bank to the town of Lowell. Over the years, these streets, as well as Michigan Street north of downtown, were connected by covered wooden bridges, which were in turn replaced by iron-truss bridges resting on masonry piers in the 1870s.[20]

Concepts of bridge design took a dramatic turn after that toward both elegance and durability. In the words of one *South Bend Tribune* reporter, "Finally, public opinion was so distinctly expressed that the county commissioners took the ultimate step in bridge building and adopted the Melan, or concrete-arch, bridge. The arches of these bridges are reinforced with ribs of steel buried in the concrete."[21] The Melan arch was developed in the 1890s by the Viennese engineer Josef Melan, who used scientific analysis to perfect a hybrid system of construction that combined concrete with iron reinforcing, soon replaced by steel. Joseph Monier had experimented with the system in France as early as the 1870s, and after his son Jean patented it in 1873, it was used extensively in Germany during the 1880s. Tests conducted by the Austrian Society of Engineers revealed that the Melan arch, because of the way the reinforcing bars were placed, was four times stronger than any of its predecessors.[22] This system resulted in the spanning of the St. Joseph River with "indestructible" concrete arches on which were built ample and durable roads and walks that immeasurably enhanced the city's transportation and beautification efforts.

The first of these Melan-arch bridges was built in 1906 and 1907 at Jefferson Boulevard, its eastern approach bordering the southern edge of Howard Park. Designed by city engineers Hammond and Moore, it was composed of four graceful concrete spans with a total length of 490 feet. Designed to harmonize with Howard Park, it featured classical balustrades and a winding staircase leading down to the park.[23] Each decoratively molded engaged pier column took the form of a classical goblet. The bridge deck originally included ornate lighting fixtures and recessed areas along its sidewalks where pedestrians could pause and take in the view. *South Bend Tribune* reporter Margaret Fosmoe wrote of the Jefferson Boulevard Bridge in 1997, "Its graceful white

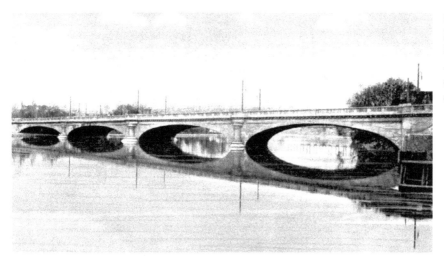

FIGURE 12.1
Jefferson Boulevard
Bridge, 1906–1907,
A. J. Hammond,
engineer. (Author's
collection.)

arches represent an era in area history when bridges, many constructed of or-
nate concrete, did more than bear traffic over the St. Joseph River. The bridges
served as public art and points of community pride."[24]

The opening ceremony of the new Jefferson Avenue Bridge coincided with
the unveiling of John Mohler Studebaker's fountain in Howard Park. Fifteen
thousand people attended for the dedication on July 21, 1906. The *South Bend
Tribune* reported that speakers on the platform "hailed the fountain and the
new bridge as milestones in the progress of the city" and said that "the public
spirit of the city's citizens as manifested by the gift of the fountain and the pro-
gressiveness of public officials as reflected in the new bridge would make South
Bend the ideal city in all of Indiana."[25]

Other bridges followed, beginning with the LaSalle Street Bridge in 1907,
again designed by Hammond and Moore. It replaced a 330-foot-long iron-
truss bridge that was unhooked from its moorings and floated down the river
to Darden Road, where it serves today as a pedestrian bridge.[26] It was followed
in 1913 by the Logan Street Bridge, located east of downtown at the city limits
shared with Mishawaka. A four-span concrete-steel Melan-arch bridge, it was
467 feet long and featured open-panel rails, light standards, and classical em-
blems on its piers. It was designed by William Moore, who had replaced
Alonzo Hammond as city engineer in 1912. A civil engineering graduate of
Purdue University, Moore would go on to serve as the first chief engineer for
the Indiana State Highway Commission from 1917 to 1922 before starting his
own civil engineering practice specializing in surveying, subdivision design,
sewers, and bridges.[27]

FIGURE 12.2
LaSalle Street Bridge,
1907, Hammond and
Moore, engineers,
C. T. American
Art postcard.
(Author's collection.)

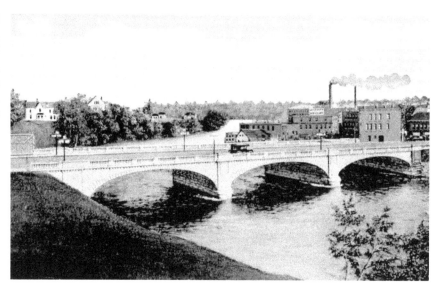

The most elegant of South Bend's City Beautiful bridges was the new Michigan Street Bridge, built from 1914 to 1915.[28] Its south approach passed through Leeper Park, while at the north it connected to the picturesque North Shore Boulevard, adding a new element of beauty to both.[29] A three-span bridge of reinforced concrete, its two end arches span 80 feet while the center arch spans 116 feet. What makes this bridge so distinctive is that its designer, Charles W. Cole, faced its concrete surfaces with smooth-cut Bedford lime-

FIGURE 12.3
Michigan Street
Bridge, 1914–1915,
Charles W. Cole,
engineer, postcard by
Louis V. Bruggner,
South Bend, ca. 1915.
(Author's collection.)

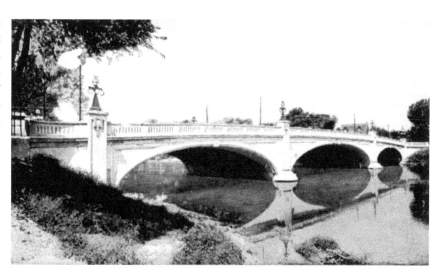

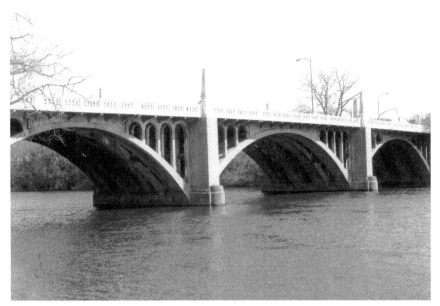

FIGURE 12.4
Twyckenham Drive
Bridge, 1929–1930,
William Moore,
engineer. (Photo by
author.)

stone decorated with paneled spandrel walls, carved scrolls, and raised emblems. Its deck carried wide sidewalks and ornamental light standards between open-arched balustrades.[30] The bridge was extensively restored in 2010.

The last of South Bend's City Beautiful bridges was Moore's Twyckenham Drive Bridge, built in 1929. Again composed of open spandrel arches, it extends 432 feet in length. Called by a reporter for the *South Bend Tribune* "a model of stately elegance," it included sidewalks carried on brackets, lights with cast bronze figures, and commemorative obelisks as a tribute to soldiers who died in World War I.[31] Historian James L. Cooper wrote of the consulting engineers practicing in Indiana during the 1920s and 1930s that "none seems to have worked as widely and creatively as William S. Moore. . . . [He] contributed something to every major design phase in concrete within Indiana before the Second World War, and closed the period with the most significant private-designed achievements in the state during the thirties."[32]

South Bend's concrete-steel Melan-arch bridges were as much pieces of sculpture as they were functional transportation structures. They transcended timber and iron-truss bridges, providing a material with which engineers and architects could create soaring repetitive spans and mold into decorative forms in a way that evoked the architectural legacy of the ancient Romans. Yet their forms were lighter, more elegant, and more suggestive of a modern era in the twentieth century.

George Kessler's Master Plan for South Bend

The influence of the Columbian Exposition and the City Beautiful movement led South Bend's local architects and city officials alike to take action. Some dreamed of a plan for the city similar to those produced by Burnham for Chicago and other cities. An anonymous writer in *The Ohio Architect and Builder*, for instance, wrote in 1910:

> South Bend can be opened up as Burnham is opening up Chicago and as Haussmann opened up Paris. Quarter can be connected with quarter in the shortest direct lines. Car-lines can be rearranged to give quicker communication. Plazas and star-places can break up the monotony of rectangular streets. The riverbanks can be converted into boulevards and the stream crossed by monumental bridges. Parks can be created and joined together by tree-lined drives. Breathing spots and playgrounds can be created where most needed. Streets can be properly paved. The city can be beautifully lighted. The public and semi-public buildings can be monumentally grouped.
>
> All this will take time—years—fifty, perhaps—but it can never be done until a beginning is made; it can never be done haphazardly; but it must all be in accordance with a definite plan, well-thought out and considered, and then made the goal for all future striving. Then, for beauty as well as for progressiveness and push, South Bend will be justly "World Famed."[33]

This was a bold vision to be sure, perhaps more than South Bend could achieve. Nevertheless, South Bend's city officials made the decision to produce a master plan for the city in 1912. They turned to the German-trained planner and landscape architect George Kessler, who had gained a reputation for the planning proposals he had created for Kansas City, Indianapolis, Fort Wayne, and the St. Louis World's Fair of 1904.[34] Kessler's plan for Kansas City's park and boulevard system had been published in 1893, and work began on that project two years later, continuing until the 1910s. Historian George Ehrlich called that plan "a bold and effective demonstration of the concept of the City Beautiful," a plan "to be emulated by others."[35]

The city of South Bend commissioned Kessler to produce a plan for a park and boulevard system that would be in keeping with the principles of the City

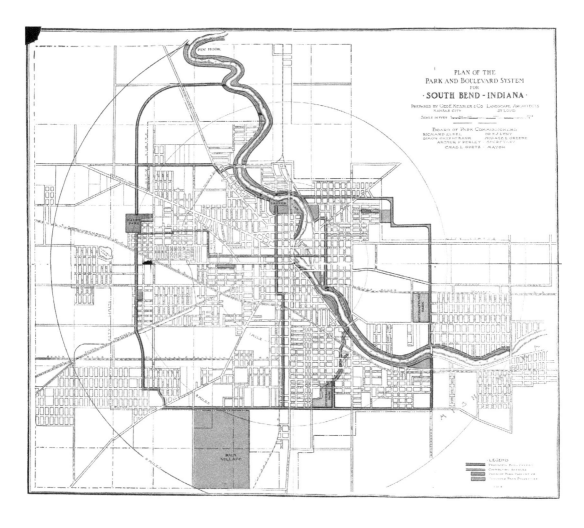

Beautiful movement. The main features he proposed were a series of tree-lined boulevards along both sides of the St. Joseph River, combined with a loop boulevard system encircling the city, an expanded layout of Leeper Park on the city's near north side, and the development of the Rum Village Park on the city's south side. It is telling that local residents and city officials alike, inspired by the potential of municipal beautification, looked past the city's largely industrial character to envision riverfront boulevards and extensive new parks. Initially, two portions of Kessler's proposal for new boulevards were carried out: Northside Boulevard along the river on the east side, and North Shore Drive, also along the river, on the near northwest. His influence would continue to shape the next two decades in the development of South Bend's street planning, bridge design, and parks.

FIGURE 12.5
Master plan for South Bend, 1912, George Kessler, urban planner. (Courtesy of St. Joseph County Public Library, Local and Family History Services Archival Collection.)

Leeper Park was significantly impacted by Kessler's plan. With the advent of the automobile, many of the pathways and roadways that had been part of its original plan barely ten years earlier had been abandoned and turned into lawns and flower beds, most of which have since disappeared.[36] Its new transformation made it more inviting to a range of age groups from youth to the elderly.

In addition to the city's master-planning efforts, a building boom in the 1910s led to the need for a building code, which the city council worked on for many years. Approved in 1915, it covered modern electrical wiring, plumbing, and construction techniques to ensure the health and safety of the city's residents.[37]

Likewise, much of the city's commercial, civic, and residential development was influenced by the lessons of the City Beautiful movement until well into the 1920s. The aesthetics of the buildings and their settings were foremost in the minds of architects and their clients, individual developers and city officials alike. The remainder of this chapter will analyze areas in South Bend where this influence is evident, including the building projects of John Mohler Studebaker, who played a prominent role in furthering the movement. Included also are the new U.S. Post Office and the new Central High School, plus a group of civic and club buildings in and around Leeper Park.

Civic and Commercial Architecture of the John Mohler Studebaker Era

Between roughly 1910 and 1920, South Bend's image as an industrial city entered a new phase, one especially affected by the Studebaker Brothers Manufacturing Company. During this time the company passed into the hands of a second generation of ownership. Of the five original brothers who had been active in the company, Jacob, the youngest, died in 1887, Henry died in 1895, Peter in 1897, and Clement in 1901. John Mohler Studebaker, now the sole surviving brother, replaced Clement as president of the company and later became chairman of the board.[38]

Through this transition at the turn of the century, the Studebaker Brothers Manufacturing Company continued to thrive in large part because it was the only wagon manufacturer to make a successful transition from wagon and carriage production to motorized vehicles. By 1900 the horse-drawn carriage was

being phased out. Under the direction of Studebaker and his son-in-law, Frederick S. Fish, the company began experimenting with both electric and gasoline-powered cars. Fish attended an important trade fair in New York for horseless carriages, demonstrating some of the company's earliest prototypes, and in 1901 the company produced its first electric car; three years later, it made its first gasoline-powered car.[39]

Factories in Europe, especially in France and Germany, had already been producing gasoline-powered cars since the early 1890s. Credit for the first successfully made car went to Gottlieb Daimler and Karl Benz in Germany in 1886, while it was France's commercial production of cars that gave us words such as *automobile*, *chauffeur*, and *garage*. The first gasoline-powered car made in the United States came from a small company in Springfield, Massachusetts, in 1893, headed by Charles and J. Frank Duryea.[40]

In 1895 Henry Ford, working out of a small shop housed at Detroit's Edison Illuminating Company, where he was employed, built his first rudimentary gasoline-powered engine out of scrap parts. The following year he and a small team of coworkers assembled and tested his first automobile, more properly called a quadricycle.[41] Others experimented with gasoline-powered vehicles as well, including Charles B. King, also in Detroit, Ransom E. Olds in Lansing, Elwood Haynes in Kokomo, Indiana, and many others. In 1903 Ford put out his first Model A, a four-person open carriage powered by a two-cylinder engine. By 1904, Buicks, Oldsmobiles, Franklins, Pierce-Arrows, and others were being produced at a rapid clip, and Ford began making the Model B, a four-cylinder model.[42]

Studebaker's first gasoline-powered car was called the Studebaker-Garford. Its chassis was built at a plant in Elyria, Ohio, and its body and drivetrains were produced and assembled in South Bend.[43] In 1908, with nearly 8,000 units sold, Studebaker ranked third in the country behind Ford and Buick for the number of cars produced. By 1911, the year it was reorganized as the Studebaker Corporation and listed on the New York Stock Exchange, it was second only to Ford. Its increased capacity was made possible largely by the purchase of several smaller car and supplier companies in Detroit and Ontario, Canada.[44] Studebaker ceased production of the electric car in 1912, after selling only 1,841 of them in eleven years, and focused all of its attention on gasoline-powered vehicles.[45]

One of the smaller companies that it purchased in 1909 was the Everitt-Metzger-Flanders Company, known as EMF. Based in Detroit and Port Huron,

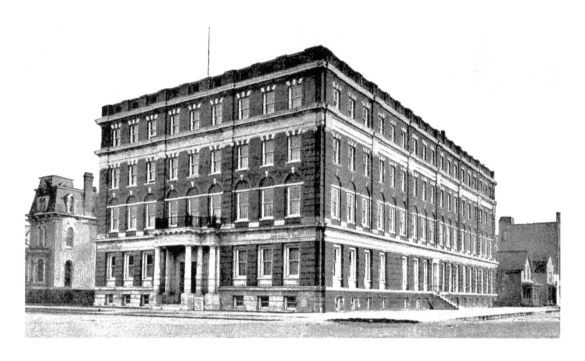

FIGURE 12.6
Young Men's Christian
Association, corner
of Wayne and Main
Streets, 1908, Solon
Beman, architect.
(Author's collection.)

Michigan, the company manufactured and marketed large numbers of a low-priced, four-cylinder car called the EMF-30. With its national and growing worldwide sales distribution network, the Studebaker Corporation made it a popular and successful automobile around the world, selling 7,500 vehicles.[46]

As Studebaker was proving to be a worthy successor of his late brother as a corporate president, he was equally becoming a prodigious builder in South Bend, equal to his brother Jacob, funding and building several civic and commercial structures in the downtown area. A new YMCA was the first important civic building paid for by John Mohler as head of the company. The YMCA was one of the most important social institutions in most American cities at the turn of the century. South Bend's YMCA had been founded in 1882, with Clement Studebaker serving as its first president and Schuyler Colfax its vice president. It occupied a series of temporary quarters, beginning in 1885 with the purchase of the Bristol Hotel, at 122–24 South Main Street. In 1905 it moved into a Second Empire–style house owned by the Studebaker Manufacturing Company at 222 South Main Street.[47]

The new YMCA was built from 1906 to 1908 under very unusual circumstances of public philanthropy, a case in which the Studebaker and the Oliver families competed for the same project. In December 1903, both James Oliver and John Mohler Studebaker offered to donate land, a building, and

equipment for a permanent YMCA. However, when they found out that they had made similar offers, each deferred to the other and withdrew his proposal.

A few weeks after the dual proposals, Studebaker made a second offer to build the YMCA for "the up-building of Christian character in the young manhood of South Bend." His gift totaled $300,000, which was the largest single gift ever made to the YMCA up until that time anywhere in the United States.[48] A building committee was formed, with Frederick S. Fish as president, plus Scott Brown and Christopher Fassnacht, who was president of the YMCA board of directors. To design the building, Studebaker commissioned Solon Beman, who had by this time designed the First Baptist Church for Jacob Studebaker, the Studebaker Auditorium for Clement, and the Studebaker Building in Chicago.

Located at the northeast corner of South Main and Wayne Streets, across from the public library, it was four stories high, with a raised basement. The basement level and first floor were rusticated, while the upper floors were smooth-faced brick. The facade was elaborated in the Renaissance manner with an intermediate cornice between the third and fourth floors, and there was an upper cornice with a parapet. The windows were all rectangular, though those of the second floor were recessed within a blind arch.

The building contained two gymnasiums, with 1,800 bleacher seats, a swimming pool, running track, classrooms, commercial spaces, and a pool room, exhibition room, meeting rooms, and dormitory rooms. The building was dedicated in 1908 as a "memorial to the five Studebaker brothers as a great center of Christian service and activity, and as a landmark in the building of Young Men's Christian Associations." An oil portrait of the five Studebaker brothers together was hung over the fireplace in the main lounge.[49]

In 1912, to accommodate more activities and to further memorialize the Studebaker name, it was expanded with the additions of a Boys' Building. Extending to the north from the main building, it was to be used by children under ten years of age. A tribute written by the directors of the Studebaker Corporation for the opening of the new YMCA states that it was "a perpetual monument" to the memory of the five brothers, "whose business activity and industry, covering a period of more than half a century, contributed to the up-building of their community and the possibility for the Studebaker Brothers Manufacturing Company to make this contribution for the well-being and usefulness of young men."[50]

FIGURE 12.7
Studebaker
Manufacturing Company
Headquarters,
635 S. Main Street, 1910,
Solon Beman, architect.
(Author's collection.)

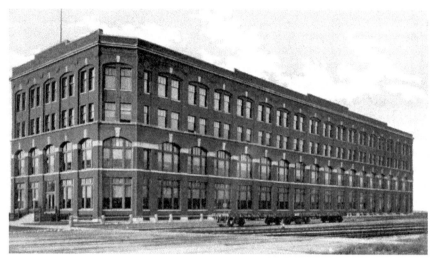

In 1910 John Mohler Studebaker commissioned two large commercial buildings, one a new administrative headquarters in the midst of the Studebaker Company's factory complex on the city's south side, and the other the JMS Building in the heart of downtown, both designed by Beman.

The Studebaker Administration Building was located at 635 South Main Street, just south of the railroad lines that were so vital to the company's success. Similar in scale to the YMCA, it is a dignified building with classical rustication on the first level, a horizontal stringcourse, and segmental arches with prominent keystones above. The interior features a large central atrium with balconies and skylights, its offices and boardroom facing onto the central space. For many years, after the closing of the Studebaker Corporation, it served as the headquarters of the South Bend Community School Corporation.

The JMS Building, commissioned the same year, was located at 108 North Main Street. It manifested the influence of Chicago architecture, both the Classical style of the Columbian Exposition and the functional and technological influences of William Le Baron Jenney and Louis Sullivan. Standing eight stories tall, the JMS Building perfectly balanced the Oliver Hotel located just across the street, and it fit well with its neighbor to the north, the Oliver Opera House. The use of white terra-cotta cladding was influenced by Burnham and Root's Reliance Building (1896) in Chicago, which had classically detailed terra-cotta spandrels and prominent Chicago bay windows. The JMS Building was given a similar Chicago School appearance, though without bay windows, which were never adopted in South Bend's commercial high-rise architecture.

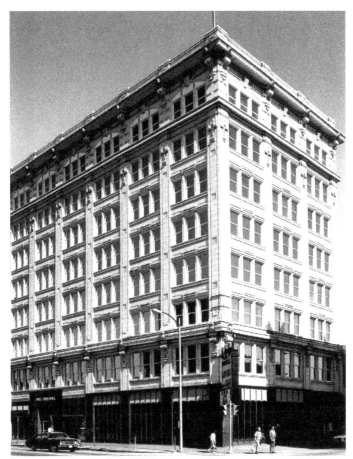

FIGURE 12.8
JMS Building,
108 N. Main Street,
1910, Solon S. Beman,
architect. (Photo by
author.)

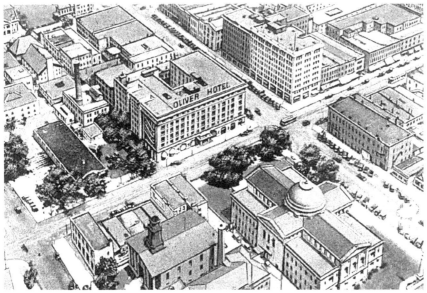

FIGURE 12.9
Aerial view of
downtown South Bend
showing the third
St. Joseph County
Courthouse on left,
Oliver Hotel in the
center, and the JMS
Building on the right.
(Courtesy of The
History Museum,
South Bend, Indiana.)

Here Beman designed groupings of three double-hung windows framed by terra-cotta pilasters. He distinguished the top floor by placing segmental arches under a prominent cornice ornamented with egg-and-dart moldings and elaborate brackets.

Also influenced by tall buildings in Chicago was the compositional motif of a base, shaft, and capital. The structural piers at the base frame the store-fronts of retail spaces, and they are set off from the upper-level office stories by a strong horizontal cornice. The repetitive vertical framing members of the shaft create the effect of a fluted column. The capital is marked by a more decorative treatment of the upper-level windows and the prominent cornice.[51]

As handsome as the building's main facades on Main and Washington Streets are, it has one negative aspect, namely its rear facade, which faces adjacent buildings and a service alley. Left completely unadorned, its austere brick surface was purely utilitarian. This in itself would not have been a problem if other buildings had been constructed behind it to a similar height. Beman designed the building to be one component of an entire block of eight-story buildings. In this scenario, only the street fronts needed to be articulated with decorative surfaces. This was common in large cities like Chicago, where densely packed blocks of eight, ten, and more stories were developed, but not so much in smaller communities. As it turned out, no structures of more than two stories were built to the east of the JMS Building, leaving its utilitarian rear facade exposed and visible from blocks away. This and other buildings like it constructed throughout the 1920s would create a fragmented urban image for downtown South Bend, with a jagged juxtaposition of architecturally refined facades—tall and short—set against bare brick walls with not even so much as a belt course or window adornment to lend a sense of composition or dignity. The high-rise buildings of the 1910s and 1920s in South Bend created a front facade/back facade dichotomy that would characterize the city's urban image for several decades, one that would not change until the next surge in high-rise construction in the 1960s and 1970s.

With the construction of these two office buildings in South Bend, the Studebaker family, in particular John Mohler, proved to be consistent leaders in architectural design. The standard set by the company's first headquarters building of 1874 at the corner of Michigan and Jefferson Streets was matched in both its beauty and technology. With the exception of the JMS Building's unadorned rear facade, all three of these buildings added a new dimension to the quality of South Bend's office and commercial architecture. Studebaker

continued to prove that he was as innovative and quality-conscious in the design of buildings as his company was in the design and craftsmanship of its automobiles.

Central High School

The South Bend school board's decision to build a new Central High School was directly in step with the goals of the City Beautiful movement. However, the resolution of its site, in the end, was badly flawed. Central High School had been one of South Bend's most venerable educational institutions, notable for its long-standing and consistent policy of racial integration and the focus of much community spirit and athletic pride. The 1870s Second Empire–style building on the city's near west side had been outgrown by the turn of the century, and planning was initiated by the school board's trustees to build a new one in 1910. For many years alternative sites were considered, but it was ultimately decided to build adjacent to the old high school on an expanded site that lay between West Colfax Street on the north and West Washington Street on the south.

In 1911 the school board purchased several lots fronting on West Washington Street, including the James Oliver estate. The board paid $60,000 for the forty-year-old Oliver house, then owned by J. D. Oliver. It demolished both the house and its carriage house the following year, along with those on the adjacent properties.[52]

To design the new building the school board commissioned William B. Ittner, a recognized school architect from St. Louis whose work, widely published in architectural journals, was influential across the country.[53] He had studied at Washington University and Cornell before traveling extensively in Europe in the mid-1880s. He served as commissioner of school buildings for the City of St. Louis from 1897 to 1910 and as architect for the board of education until 1916, during which time he designed five high schools and seventy-five elementary schools. In all, he carried out more than five hundred architectural commissions over the course of his career, building schools in one hundred and fifteen communities and twenty-nine states.

Ittner's design for Central High School is an eclectic but unified combination of Classical Revival, Prairie School, and Collegiate Gothic styles. A three-story brick building, it has brown-brick walls on a rusticated limestone

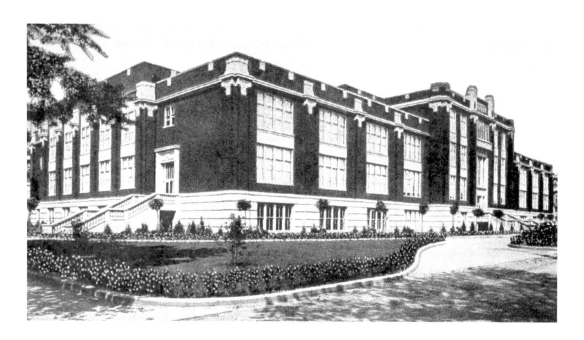

FIGURE 12.10
Central High School,
1911, William B.
Ittner, architect,
Gardner News Agency
postcard, ca. 1915.
(Author's collection.)

base, with terra-cotta trim. Its rectangular windows are set in varying groups of threes and fours, and it features a large stained glass window above the main entrance doors on the east side. Wide cascading stairs are located at the north and south entrances. It served 1,500 students, with 50 classrooms, a gymnasium, an auditorium, and a swimming pool. The building's scale, massing, and details are indicative of a quality of design meant to transcend purely functional needs to display an iconography of educational values.

The building is oddly sited, however, for the main entrance, marked by a projecting pavilion and the stained glass window, faces neither Washington Street nor Colfax, but rather an alley on the east, with virtually no setback or front yard. At the time, the board determined it would widen the alley to make it into a street in order "to have a proper approach." This decision was made with the goal of not disturbing the existing high school during construction, and also to avoid the noise on Washington Street associated with trolley cars that ran down its center lane at the time.[54]

Although the alley was widened, it was never turned into a proper street. Worse, located directly across the alley is the back of St. James Church and its adjoining classroom building, thus obstructing any possible distant view. The magnificent stained glass window in the entrance pavilion is never seen to its full advantage, and the main entrances have always been the "side entrances" facing Colfax and Washington Streets. It is apparent that the board members

had to make a painful compromise in siting the building, and in the end it greatly diminished the school's urban setting.[55]

Civic Buildings in Leeper Park

Adding to South Bend's urban image in step with the City Beautiful movement was the construction of three monumental Classical Revival buildings on the near north side, in and around Leeper Park and Memorial Hospital. The first was the pumping station for the South Bend Water Works, built from 1910 to 1912 to replace the original building of 1902 to 1903. Located on North Michigan Street, in the park's eastern half, it was designed by South Bend architects George Freyermuth and R. V. Maurer. Its symmetrical facade features large round-arched windows and a projecting portico of six finely carved limestone columns with Ionic capitals. The building remains today as a symbol of an important era of civic responsibility in South Bend's downtown development.

The second building on the city's immediate north side is the former Christian Science Church, located at 405 North Main Street. Built in 1916 to 1918 with funding provided by John Mohler Studebaker Jr., it features a dome and a Classical portico with six Ionic columns supporting an entablature and pediment.[56] The church started meeting in 1898, using space in the Progressive

FIGURE 12.11
South Bend
Pumping Station,
N. Michigan Street,
1914, Freyermuth and
Maurer, architects.
(Photo by author.)

South Bend and the City Beautiful Movement 245

Club at first and then the public library. In 1906 it purchased the lot at the northwest corner of Main and Madison Streets and built a small church in the Arts and Crafts style after a design by Beman. However, this building only served the congregation until 1916, when it was demolished and the new one was constructed.

Because Beman had died in New York in 1914, the congregation chose Chicago architect Leon E. Stanhope to design their new building.[57] Built of

Bedford limestone, it is a square blocklike building with a prominent Ionic portico. The building's dome was modeled after that of the First Christian Science Church in Boston, considered one of the best examples of Classical Revival in the United States.[58] Inside, the space is cross-shaped in plan with the great dome rising to a height of forty feet. Vaults supporting the dome are reminiscent of those in John Soane's Bank of England. An organ made by Ernest M. Skinner of Boston was donated by Mary Jane Studebaker, wife of John Mohler Sr., as a memorial to her daughter Lillie Elgin Studebaker Johnson, a charter member of the church, who had died in 1901.[59]

For many years the church sponsored a lecture series that drew speakers from all over the country. It was patronized by many leading citizens of the community, including Frederick Fish, at that time a state senator; Clarence A. Buskirk, a former state attorney general; Charles H. Bartlett, the principal of Central High School; and numerous members of the Studebaker family.[60] From 1982 to 2004 the building served as the home of the Scottish Rite Masonic Temple, and it is currently home of the South Bend Civic Theater.[61]

The third Classical Revival building in the area of Leeper Park is the Masonic Temple on North Main Street immediately north of the Christian Science Church. A noble five-story building that features a colonnade across the front composed of tall Ionic columns standing above a first-floor base, its design is somewhat akin to the two columnar buildings fronting onto the Place de la Concorde in Paris. Built from 1924 to 1926, it was designed by the firm of Osgood and Osgood of Grand Rapids, Michigan. The head of the firm, Eugene

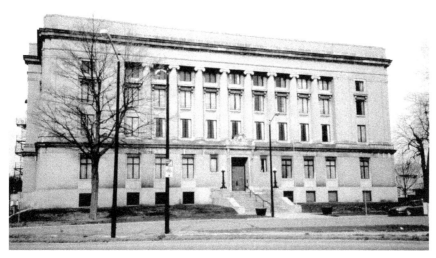

FIGURE 12.13
Masonic Temple,
427 N. Main Street,
1925, Osgood and
Osgood, architects.
(Photo by author.)

South Bend and the City Beautiful Movement

FIGURE 12.14
Masonic Temple,
detail of entrance
door. (Photo by
author.)

Osgood, was himself a grand master Mason and architect of several other Masonic temples in the United States.[62]

Built at a cost of nearly $1 million, the temple fronts 160 feet on Main Street and extends back 140 feet. Built of concrete and brick, the building is in the shape of a cube, a symbolic form evident to the Masons. The number of steps approaching the front entrance is three, five, and seven, again a symbolic combination. Over the entrance is the square and compass, known throughout the world as the symbol of Masonry. The ground floor included club rooms, billiard rooms, and a banquet hall to seat 650 people. The main floor includes an entrance lobby, offices, and the Blue Lodge room, which measures 46 by 66 feet with a 22-foot-high ceiling, and the Scottish Rite Lodge room, measuring

60 by 80 feet with a 32-foot-high ceiling. The latter's style is meant to suggest a Gothic cathedral, with a timber ceiling, massive hanging lamps, a lancet arch over the stage, and tiered seating on either side. Upper floors include more offices, parlors, meeting rooms, the Cryptic Lodge room, an armory, and a suite of rooms for the ladies' auxiliary. Other rooms' styles range from French Renaissance to Persian, Italian Renaissance, and Moorish.[63]

The social importance of the Masonic Temple in the 1920s in South Bend can be inferred from articles in the *South Bend Tribune* and *News-Times* from the day of its dedication on June 26, 1926. Before the dedication, fifteen hundred master Masons, clad in white leather aprons and escorted by several hundred white-plumed Knights Templar, marched through the business district to the music of five bands and a drum corps, the parade being one of the most imposing and picturesque ever seen in the city.[64] The *News-Times* reported,

> Today, thousands strong, the various Masonic organizations of South Bend, headed by the Grand Lodge of Indiana, have dedicated a new temple, beautifully housing their activities and providing as well a monument to the work of the order—past and present.
>
> We congratulate them on their new building. We congratulate them upon the spirit and sincerity that has made such an edifice, a temple in every sense of the word, possible.
>
> For this, says a learned writer on Masonry, is "founded upon belief in a Divinity. As a fraternity it inculcates a system of pure morality by forms, ceremonials, and symbolism in which the relief of suffering, the cultivation of virtue and the search for truth are emphasized."[65]

The publicity gleaned by the Masons upon the dedication of their new building was a model of public relations. The *News-Times* went on to report,

> As one reads the roles of those men of South Bend who are prominent in the movement, he cannot but be impressed with their high standing in the community and their good citizenship. They are all men who have won the respect and esteem of their neighbors. They are men known not alone in Masonic circles, but in the broader field of civic and state activity.
>
> The new Masonic temple is therefore a heartily welcome addition to the architecture of South Bend. In itself it stands as a beautiful home, attractive to the eye and adding materially to the beauty of the city.

Spiritually it stands for what is highest and best in the laws of humanity, in social conduct, in good fellowship.[66]

The *South Bend Tribune* reported on the dedication with equal approval. Praise was lavished on the building and its interior rooms. The Symbolic Hall, where the ceremonies began was, according to the grand master presiding over the ceremony, "one of the most beautiful in the United States." In the Cathedral room he paid tribute to "the courage of the South Bend craft in undertaking the stupendous project which has developed a temple unsurpassed in any city equal in size with South Bend."[67]

Beyond South Bend, thanks to the impetus of the City Beautiful movement, the Indiana State Legislature enacted legislation in 1921 enabling municipalities to establish planning commissions to "promote the orderly and economic development of the urban area." The South Bend Common Council established the South Bend City Planning Commission to develop the basic institutional framework for planning in the city, establishing rules for platting subdivisions, a plan for streets and thoroughfares, and in 1923, the first city zoning ordinance.[68]

Churches

Several South Bend churches were designed in the Classical Revival style, two of these being St. Andrew Greek Orthodox Church and the Broadway United Methodist Church. St. Andrew, at 760 South Michigan Street, has dark brown brick walls, a projecting bracketed cornice, and a front portico with Doric limestone columns supporting an entablature and pediment. Broadway Methodist Church, at 302 East Broadway, was built in 1919 and is similar in size and use of materials, but differs in its window and portico treatment.

Also on the city's south side was the First United Brethren Church at 606 South St. Joseph Street, built in 1910 and enlarged in 1927. It included a large sanctuary seating five hundred people, as well as an auditorium, gymnasium, and twelve classrooms.[69]

The Sunnyside Presbyterian Church is perhaps the best among these churches in the Classical Revival style. Located on Francis Street, its entrance portico has stone Ionic columns supporting a pediment. The design is a replica of the First Covenant Church in Boston, and the interior is patterned in the

FIGURE 12.15
St. Andrew Greek
Orthodox Church
(originally Grace
United Methodist
Church),
760 S. Michigan
Street, 1915.
(Photo by author.)

FIGURE 12.16
Central Evangelical
United Brethren
Church, 602 S. St.
Joseph Street, ca.
1920. (Photo by
author.)

FIGURE 12.17
Sunnyside
Presbyterian Church.
(Photo by author.)

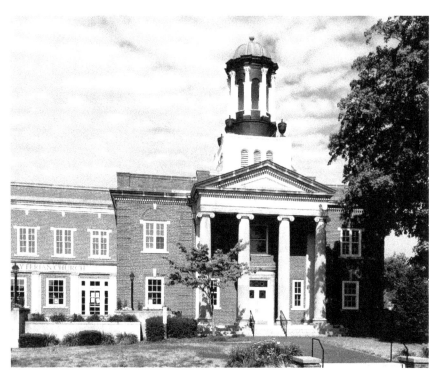

Colonial Revival style after the Christ Episcopal Church in Alexandria, Virginia. Its bell tower is composed of a copper-domed lantern placed on a square base with three arched vents and engaged Corinthian columns. Construction of the church was paid for by John Mohler Studebaker.

Classicism at Notre Dame

The establishment of an architecture school at Notre Dame University in 1898 coincided with South Bend's assimilation of Classical Revival architecture and the City Beautiful movement. Notre Dame was the first Catholic university in the United States to establish a program and award a degree in architecture.[70] Courses in drawing and design had been offered as early as 1869, but it was not until 1898, five years after the Columbian Exposition, that the degree-granting program was formally initiated. Its first chairman was the Chicago architect and noted church designer Henry Schlacks. In the intervals between Schlacks' weekly visits, the work was directed by Francis X. Ackermann, head of the De-

partment of Mechanical Drawing. During its earliest years, the department occupied half of the Main Building's fifth floor, a double-height space topped by skylights.[71]

In 1905 Schlacks was succeeded by Rolland Adelsperger, who was himself a student in the program and graduated only in 1908.[72] He was an active local architect and served as the president of the South Bend Architecture Club. Under Schlacks's leadership, Notre Dame's architecture program became the university's College of Architecture in 1906; it offered the degree programs of Bachelor and Master of Science in architecture and in architectural engineering. It later became a department in the College of Engineering, and its undergraduate program, like most others in the country, was expanded to five years.

At the time of the founding of Notre Dame's architecture program, the city of South Bend had a population of about fifty thousand; however, the campus was in an isolated location for the study of architecture in comparison to the dense urban settings of schools such as MIT in Cambridge and Columbia in New York. A trolley line running from South Bend to Niles, Michigan, passed through the campus, although visits to the city were not favored by the university administration because of the desire to "guard against loss of time and possible exposure to 'temptations.'"[73] While the policy had clear advantages for the students' safety and moral development, it allowed architecture students little urban involvement. The pastoral quality of the landscaped campus was more akin to a nineteenth-century suburban setting or the quad of the University of Virginia and perfectly suited to the influences of the City Beautiful movement.

Virtually all of the students attending Notre Dame at the time resided on campus, and they traditionally developed a great comradery, an enduring quality of the Notre Dame experience and one that was reinforced even further for students in architecture with the advent of the yearlong Rome Studies Program. The student population at the university in the 1890s numbered about seven hundred a year, all males, and all but 20 percent of them Catholic.[74] While the geographical distribution of the students was relatively limited in the early years, it has since become among the most widely diverse of any private university in the country.

In 1909 a new member of the College of Architecture's faculty, Francis Wynn Kervick, brought new impetus to the school's Beaux-Arts curriculum

and would have a significant influence on campus architecture and planning in the years to come. A graduate of the University of Pennsylvania—which, like MIT, Columbia, and Harvard, was an ardent proponent of the French system—he had such a great interest in France that he soon took a year's leave to work in Paris, where he absorbed firsthand the Beaux-Arts method of design and education. When he returned to South Bend in 1914, he became chairman of the Architecture College, a position he held until 1950.[75] He maintained the Beaux-Arts system for the next two decades, with coursework centered around the studio and all instruction in planning and composition based on what were described in the university *Bulletin* as "accepted principles of design," namely European and classical.[76]

The wave of Classicism that predominated in the profession during the first years of the twentieth century manifested itself architecturally on the Notre Dame campus from 1917 to 1919 with the construction of Lemonnier Library, later known as Bond Hall and home of the School of Architecture. The Reverend Augustus Lemonnier had served from 1866 as vice president and director of studies at the university and succeeded Father William Corby as president until 1874. The university hired the New York architects William Boring and Edward L. Tilton to design the new library building in 1915 for a site at the campus's western edge, overlooking St. Mary's Lake.[77] Its Italian Renaissance style in Bedford limestone was modeled after the Boston Public Library, the most prominent library building of the day, which had been designed by Tilton's mentors, McKim, Mead and White.

Lemonnier Library was the only building to be constructed on the campus in such an overtly Classical style. Further, it was built with walls of Bedford limestone rather than the yellow brick that was common to the campus at the time. It featured a classical entrance porch with Ionic columns and rows of round-arched windows that illuminated high-ceilinged reading rooms in a manner similar to the Boston Public Library and the Bibliothèque Sainte-Geneviève in Paris.

The library was designed to house some 618,000 volumes, at a time when the university's collection numbered only about 100,000, and accommodated 360 readers in several large reading rooms on four floors. It had an impressive skylit central space for the card catalog surrounded by multitiered floors of stacks composed of efficient iron shelving and marble floor slabs. The top story housed the special collections, a history museum, and the art collection.[78]

Bond Hall appropriately became the home of Notre Dame's School of Ar-

FIGURE 12.18
Lemonnier Library
(now Bond Hall),
University of Notre
Dame, 1917, Boring
and Tilton, architects.
(Photo by author.)

chitecture in 1967 after the construction of a new library. The School of Archi-
tecture moved to its current location in Walsh Family Hall upon that building's
construction in 2018, but Bond Hall continues to serve as an important model
for classical order, rationality, and grandeur, recalling an important time in the
architectural history of South Bend and Notre Dame.

Residential Architecture in the New Century

From Neoclassicism to the Prairie School and Arts and Crafts

The first decade of the twentieth century was one of the most innovative and prolific periods in South Bend's residential architecture, involving three seminal movements, the Neoclassical style and its opposites, the Prairie School, and the Arts and Crafts movement. The influence of the Neoclassical style in South Bend's residential architecture lasted for a brief period of time, but it resulted in some of the city's most distinguished residences. Then a talented group of South Bend architects, all of whom began their careers around the turn of the century, were caught up in the highly influential movement created by Louis Sullivan and Frank Lloyd Wright in Chicago and Oak Park. South Bend is fortunate to possess two houses designed by Wright himself, one from 1906, at the height of his Prairie School phase, and the other from 1948, corresponding to his later Usonian phase. The influence of the Prairie School is found throughout South Bend's residential neighborhoods, making a significant contribution to the Midwestern regional character of the city's architectural heritage. Equally important was the influence of the Arts and Crafts movement, or Craftsman style, and its leader, Gustav Stickley, as manifested in the bungalow-style houses built by the hundreds in middle-class neighborhoods across the city.

Given the number of architects practicing in South Bend at this time, this chapter is as much about their biographies as it is about architectural developments. Many who began their careers during this period formed the core of the city's architectural profession for years to come, well into the boom years

of the 1920s. It is especially interesting to trace the paths of these architects as they embraced the Prairie School early in their careers and then adapted over time to changing currents in architectural styles—Tudor Revival, Colonial Revival, Italian Palazzo, and Georgian Revival. These new trends significantly altered the character of these architects' work and dramatically changed the character of many of South Bend's neighborhoods.

North Shore Boulevard's Residential Classicism

During the time of the City Beautiful movement and its influence on civic, educational, and commercial architecture, a coinciding trend toward the Neoclassical style emerged in South Bend's residential development, at least until about 1910. The most significant examples, with prominent porticos and expansive lawns with an axial approach from the street, were built in the early 1900s on North Shore Drive, Riverside Drive, and East Jefferson Boulevard.

The most prominent group of Neoclassical houses in South Bend is that located on North Shore Drive. They can be seen in a dramatic panoramic view from North Michigan Avenue and from across the St. Joseph River in Leeper Park. They are distinguished by full-height front porches, with their roofs supported by tall classical columns with either Ionic or Corinthian capitals, and by their symmetrical facades with paired windows and a classically detailed central door.

As historians Virginia and Lee McAlester pointed out, the interest in Neoclassical houses was nurtured nationwide in publications such as *The Ameri-*

FIGURE 13.1
North Shore Boulevard, looking west from Michigan Avenue ca. 1920. (From *Souvenir of South Bend*.)

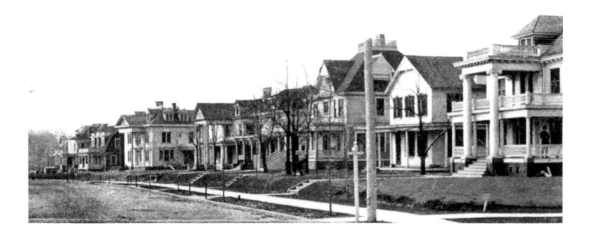

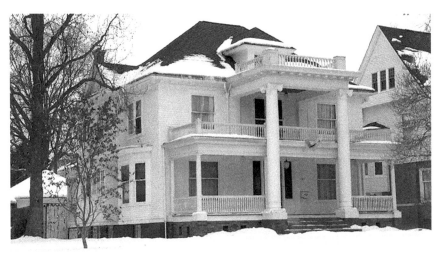

FIGURE 13.2
Dr. Edwin Lent House,
107 W. North Shore
Drive, 1905. (Photo by
author.)

can Architect and Building News, *Architectural Record*, and *The White Pine Series of Architectural Monographs*, which brought to the American public photographs and etched views of Classical Revival, Colonial Revival, and Georgian-style houses.[1]

The basis of the Neoclassical style in residential architecture came about not only because of the Columbian Exposition, but also because of an increasing interest in the history, culture, and architecture of America's colonial period. *The American Architect and Building News* was one of the most important sources, providing illustrations of buildings from this period in America's past. Its first issue, published in 1876, included a plate of Old South Church in Boston, and in the following year it featured articles on Georgian houses in New England and Dutch farmhouses in New Jersey. By 1879 articles about colonial buildings appeared regularly and in great quantities, feeding the widespread interest in the aesthetic and historical background of colonial buildings. One author wrote in 1879, in *The American Architect*, that what the profession needed was "architects, draftsmen, or amateurs who will take the trouble" to make "accurate measures" and "a useful record" of the colonial work that was left.[2] Historian Daniel Reiff points out that between 1876 and 1900, *The American Architect* published more than 350 articles, plates, letters, and notices on colonial architecture, covering the field from Massachusetts and Rhode Island to New York and Virginia, as well as Florida and New Mexico.[3]

The location on the city's north side, facing the river along North Shore Boulevard, creates one of the city's most historic and picturesque settings for

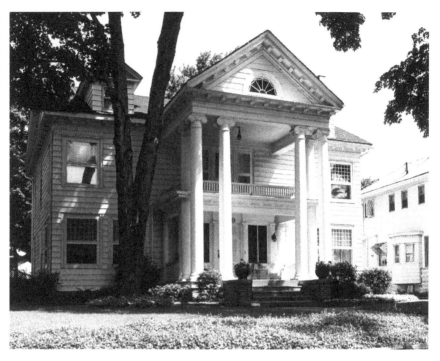

stately Neoclassical houses. The first was the Dr. Edwin Lent House, built at 107 West North Shore Drive in 1905. Two stories high, with a square plan, clapboard siding, and a hip roof with bracketed eaves, its principal feature, which lends it a high degree of monumentality, is its two-story columnar portico topped by a cornice and balustrade. The second is the 1905 Eugene Miller House, at 129 West North Shore Drive, which is similar but with a gable roof and a gabled portico with paired Ionic columns.

The third and largest of the group is the Solon Rider House at 201 West North Shore Drive, built in 1906. Designed by George Selby, supervising architect of the third county courthouse, it has an imposing entrance portico with paired Corinthian columns. The entrance consists of a pair of wood-paneled doors with sidelights and transom, and a bracketed balcony above. The cornice features impressive modillions, and the hipped roof has multiple dormers.

Precedents for these designs could be found in issues of *The American Architect and Building News* from the previous decade. Reiff has pointed out three hipped-roof mansions in the colonial style, published in 1896 and 1897, that had features similar to these North Shore Drive houses.[4]

Versions of the Neoclassical style that were aimed more at the middle class could be found in publications such as *The Radford American Homes*. The 1903

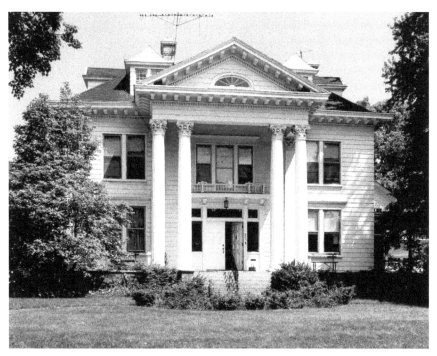

FIGURE 13.4
Solon Rider House,
201 W. North Shore
Drive, 1906, George
Selby, architect.
(Photo by author.)

edition, for example, featured Colonial Revival designs with only modest architectural detailing to suggest a link to their high-style counterparts. These included corner piers supporting a classical entablature, an Ionic porch with a latticework balustrade, a hipped roof—an eighteenth-century Georgian motif—and pedimented dormers, all suggesting colonial antecedents found in Williamsburg from the early eighteenth century.[5]

A lesser version of the Colonial Revival, often referred to as the American Foursquare, was one of the most common house types in South Bend around the turn of the century. Appealing to the working class and tradesmen, it represented a new vernacular type, square in plan, two stories high, with a hipped roof, full-width front porch, and clapboard siding.

Plan sets and specifications for American Foursquare houses could be purchased from *Radford American Homes*. Looking again at the 1903 edition, we find an example based on a compact square plan with geometric clarity that suggests, according to Reiff, "a foursquare or forthright quality." It is distinguished by its cubic form, prominent hipped roof with compact dormers, wide eaves, and one-story front porch.[6] Reiff identified the first pure example of an American Foursquare as the Frank E. Kidder House in Denver, Colorado, showcased in the January 1891 issue of *Architecture and Building*. The first

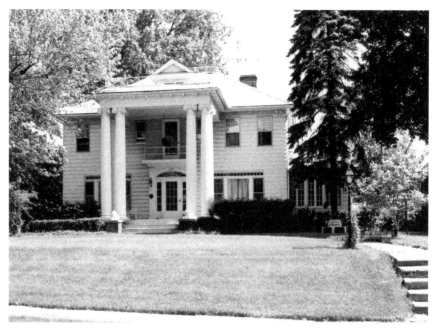

example published in the more widely read *American Architect and Building News* appeared in 1896.[7] Entire house kits could be purchased from Sears, Roebuck and Company catalogs between 1908 and 1933.[8] These could be erected in a few weeks by a small crew of laborers. These working-class houses proliferated in several neighborhoods across South Bend. The Sears catalogs also included larger examples of Neoclassical houses for the wealthy class, similar to its earlier neighbors on North Shore Drive; however, these only appeared later, between 1918 and 1921. The Sears architects were producing designs in line with a movement that had been popular in American architecture for some time.[9]

An example of a Sears, Roebuck catalog house showing the continuing influence of the Neoclassical style in residential construction is the Stryker House of 1926, at 325 West North Shore Drive. This stately home features a front portico with paired Ionic columns, a bracketed cornice, and a segmental transom over the front door.

From the third county courthouse to the stately houses of North Shore Drive, South Bend's flourishing as an industrial city in the 1880s and 1890s, combined with the influence of the Columbian Exposition, resulted in an urban image of civic virtue and nobility in the midst of economic success. As the popularity of the Neoclassical style swept across the country, South Bend

was quick to embrace the movement, as indicated by the county commissioners' decision to hire a new architectural firm practicing in the most avant-garde style of the day to build their new courthouse, even though they were already under contract with a firm to build in the now discredited Romanesque Revival style. The Neoclassical style was at that moment the unrivaled mode for civic, commercial, and residential architecture alike.

South Bend's Prairie School

The Prairie School of Frank Lloyd Wright became equally significant in the history of South Bend's domestic architecture in the first decade of the twentieth century, and theoretically speaking, it was at the opposite end of the spectrum from the Neoclassical style. Wright influenced an entire group of architects across the Midwest from about 1900 until the advent of World War I, initiating what Leonard K. Eaton described as a revolution in architecture.[10] It was a time when architects sought to achieve a fresh and original expression that was "personal" and "American," for which they found inspiration and guidance in the buildings and writings of Wright.[11] In South Bend, several young architects began their practices when economic conditions in the city were favorable to a boom in housing construction and just when the pioneering works of Wright were starting to be published in architectural journals. It was in 1907 that the legendary architect from Oak Park, Illinois, built his first Prairie School house in South Bend. This revolutionary design, along with the considerable publicity Wright received in architectural journals and popular magazines such as *Ladies' Home Journal*, captured the attention of many young local architects, initiating the city's own version of the Prairie School.

Frank Lloyd Wright was born in Spring Green, Wisconsin, and studied engineering at the University of Wisconsin–Madison for little more than two years. He moved to Chicago in 1887 to begin his architectural career, working first for Joseph Lyman Silsbee and then for Louis Sullivan, with whom he was employed until 1893, the year of the Columbian Exposition. He began his own practice with an office in Chicago, although he soon moved to a studio attached to his home in suburban Oak Park. He later established the Taliesin studios in Spring Green, Wisconsin, and Scottsdale, Arizona.[12]

Wright's most important design mentor was Sullivan, the architect, philosopher, artist, and teacher who inspired a generation of Chicago architects to

invent new and creative forms of expression within the highly structured manner he had introduced.[13] Biographer Hugh Morrison wrote, "Sullivan was probably the first man of his times to set forth both by precept and by example the clear outlines of a new philosophy and a new art of building."[14] His influence was legendary: "His genuine influence on the practice of architecture in this country . . . was far more extensive than generally supposed. Acting first through his disciples of the 'Chicago School,' it later spread so widely as almost to establish a new vernacular style in the cities and small towns of the Middle West. Traveling through the suburbs of Chicago and in towns and cities from Buffalo to western Iowa, one frequently sees a 'Sullivanesque' or else a 'prairie style' building, done perhaps by a local architect of no distinction but bearing unmistakable evidence of influence from the source."[15] Sullivan and Wright together inspired such remarkable leaders of the Prairie School movement as Walter Burley Griffin, Marion Mahony Griffin, Hugh M. G. Garden, Richard E. Schmidt, Robert C. Spencer Jr., William E. Drummond, George Maher, Thomas E. Tallmadge, Dwight H. Perkins, John S. Van Bergen, and Barry Byrne, to name only a few.[16]

Many of these designers had offices in Steinway Hall, then located at 64 East Van Buren Street, a seventeen-story office building designed by Perkins. Most were members of the Chicago Architectural Club, founded in 1897, which held meetings in the club rooms of the Art Institute of Chicago. The club sponsored numerous lectures, exhibitions, and design competitions while publishing its members' work in elaborate, illustrated catalogs.[17] Its activities were important for not only promoting the work of its members but also promulgating a set of shared design principles that fostered the Prairie School as a stylistic movement.

Over the course of his career Wright designed a total of five houses in Indiana. So revolutionary were their forms that they had a profound influence on many of the younger architects just starting their careers in South Bend, Mishawaka, and Elkhart. Wright introduced the Prairie School in South Bend in 1906 with his design of the K. C. DeRhodes House on West Washington Street. Even today this house stands out from its neighbors for its wood-trimmed, plaster-surfaced walls, its low-pitched hip roof with widely overhanging eaves, and its bands of leaded glass windows. It has a cross-shaped plan with the entrance leading from one of the side wings and a massive chimney anchoring the other. Wright had already built dozens of houses based on the same design principles, most of them located in Oak Park, Highland Park,

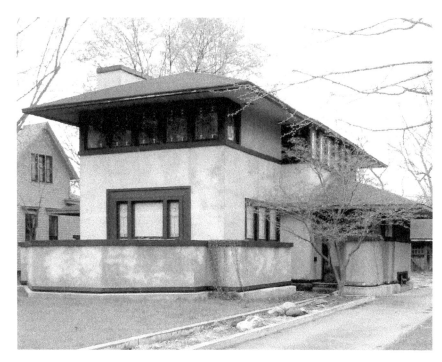

FIGURE 13.6
Kersey DeRhodes
House, 709 W.
Washington Street,
1906, Frank Lloyd
Wright, architect.
(Photo by author.)

or Kankakee, Illinois, and others as far away as Buffalo, New York, and Racine, Wisconsin. The DeRhodes House can be most closely compared to his J. J. Walser House (1903) in Chicago and to the much larger Ward Willits House (1901) in Highland Park.[18]

In the words of Irving K. Pond, the characteristic horizontal lines, planes, and volumes of Prairie School houses echoed "the spirit of the prairies of the great Middle West," which these architects believed embodied the essence of democracy. Low, long hipped or gabled roofs juxtaposed against wide supporting piers, the horizontal banding of windows, an emphatic banding or belt course between floors, and a broad, projecting foundation securely holding the building to the ground were all characteristic features of the style. There were influences of both Shingle-style and Classical architecture, but above all a continuity of line, edge, and surface was emphasized. H. Allen Brooks, the author of *The Prairie School: Frank Lloyd Wright and His Midwest Contemporaries*, wrote, "Every feature of the building—from the basic mass to the smallest detail—was clear, precise, and angular. Ornament, per se, was a rarity; enrichment was dependent on the textural expression of materials and the often lively juxtaposition of various shapes and forms. Only in the stylized or abstract patterns of the leaded glass (or zinc strip) windows did one find

consistent ornament. The historical styles, as commonly known, were rejected."[19] Above all, the manipulation of space for the enrichment of the living experience through varying ceiling heights, vertically interpenetrating levels, and diffuse top lighting helped the style become popular among its many patrons.

The rejection of the "commonly known historical styles"—Colonial Revival, Neoclassical, Queen Anne, and Richardsonian Romanesque—was the most radical aspect of the movement. There was a conscious attempt to alter the traditional language of architecture in terms of scale, proportion, materials, plan types, and landscape settings. The Prairie School architects introduced new concepts related to the use of basements, attics, roof profiles, and window types and compositions, as well as the locations of doors, fireplaces, and stairways.

Historians Richard Guy Wilson and Sidney K. Robinson referred to Wright's houses as "abstractions of Midwestern landforms and nature, simple geometrical forms enlivened by special ornament." They point out that his buildings were environmentally appropriate, their elevations oriented for natural ventilation and heat and their deep roof overhangs shielding against sun and snow. Materials ranging from brick and wood to terra-cotta and stucco to concrete and steel were employed in their natural colors and textures, while the highly polished marble or fine-cut ashlar masonry as favored in Neoclassical buildings were avoided. As Wilson and Robinson suggested, "The Prairie School architects broke away from the established canons of architectural style and created a different expression of architectural form and spatial experience."[20]

Numerous Prairie School houses followed the DeRhodes House, all variants on its design principles, including Wright's F. F. Tomek House in Riverside, Illinois (1907); the design for the Harold McCormick House in Lake Forest, Illinois (1907); the L. K. Horner House in Chicago (1908); and the much admired Avery Coonley House in Riverside, Illinois (1908).[21] These are among dozens of houses Wright designed in this, the most prolific decade of his career. The majority of these revolutionary designs, including the DeRhodes House, were published in 1910 in the highly influential Wasmuth publication *Ausgeführte Bauten und Entwürfe von Frank Lloyd Wright*, which began circulating among American architects and their clients by 1911. All of these houses, in the words of Lewis Mumford, reflected two qualities that left a per-

manent mark on American architecture: a sense of place and a rich feeling for materials.[22]

The appeal of the Prairie School style to architects and their clients across the Midwest lay not just in its forms but in the conservative, family-oriented social model espoused by Wright. Family life was always paramount in his designs, with his emphasis on the central fireplace, intimate seating alcoves, dining room, and areas combined for family activities. Open planning, the combination of different interior spaces, and the ennobling of certain family activities were common features of all Prairie School houses. Most clients of these architects were businesspeople and professionals from the upper middle class who aspired to close family relations nurtured by their success. Many were bankers or business leaders in their communities in search of an image of respectability and social status.[23] Eaton described the typical clients of Prairie School architecture: "Outwardly conventional, they nonetheless tended to possess a streak of artistic or technological interest which predisposed them to accept new and radical solutions to the architectural problem of the dwelling house. The programs for their residences, however, tended to be conventional, as the men and women themselves were conventional. The average family was small, consisting of husband, wife and two or three children. . . . A program including three or four bedrooms, living room, dining room, kitchen, and bath was therefore usual. If a family had special interests, a music room or library would be added."[24]

The spread of the Prairie School across the Midwest also spoke to the influence of Chicago itself. Citizens of Midwestern cities in northern Indiana, as in Illinois, Wisconsin, and Iowa, were culturally and economically oriented more toward Chicago than any other city of the region. The Prairie School was seen as a regional expression emanating from Chicago and its suburbs, one that, in the words of Wilson and Robinson, "asserted the traditional elements of status, shelter, security against the outside world, and family solidarity in the face of a rapidly changing world."[25]

South Bend's Prairie School Followers

At least three young architects practicing in South Bend in the early years of the twentieth century were especially attracted to Wright's work and watched

closely the construction of the DeRhodes House. Ernest Young, Ennis R. Austin, and N. Roy Shambleau would design many of the city's most distinctive and innovative houses, schools, commercial buildings, and churches from about 1907 into the 1920s, many in the style of the Prairie School. They were among a group who migrated to South Bend largely because of the opportunities for residential construction made possible by the economic success of the Studebaker and Oliver companies.

Ernest William Young was among the most gifted of this group. He was born in 1883 in Kansas City, Missouri, and in 1889 his family moved to Princeton, Illinois, where he attended school. He went to high school in Chicago while taking evening courses at the Chicago Art Institute, and in 1900 he began working as a draftsman in the Chicago office of Richard E. Schmidt and Hugh M. G. Garden.[26] The projects Young would have worked on include the Madlener House of 1902 (now the Graham Foundation) and the Grommes and Ullrich Building of 1901.[27] The design influence of Garden was strong in Young's work, as was the influence of Wright and of Walter Burley Griffin.

In 1904 Young moved to South Bend to work on the design of a building for the Singer Sewing Machine Company. He decided to stay and worked for short periods of time with Walter W. Schneider and with Rolland Adelsperger while he was teaching in Notre Dame's College of Architecture. In 1907 Young entered into a partnership with George Selby, who had been the supervising architect of the third county courthouse. The two remained in partnership until Selby died in 1912. While Selby's work was characterized by the Neoclassical style, Young's work was closely in step with the Prairie School.

In 1908 Young built his own residence at 1216 Hillcrest Road, a small Prairie School house on the crest of a hill overlooking the North Shore Triangle neighborhood. This was one of the first houses designed by a local architect to be modeled after Wright's DeRhodes House. A small two-story stucco-clad design, it features a low-pitched gable roof with wide overhangs and large windows overlooking the St. Joseph River and the city below.[28]

Young's work received wide attention in South Bend, and in contests held by the South Bend Architects' Club, he twice won the bronze tablet awarded for superior work.[29] Over the course of his career Young held several public posts, including helping to write South Bend's first building code and serving as a member of the city's first planning commission, which was in

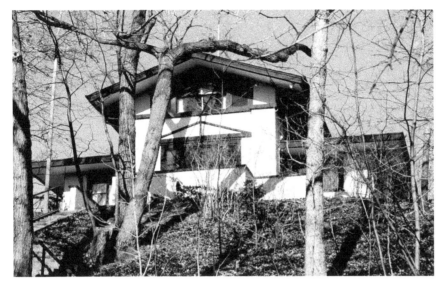

FIGURE 13.7
Ernest Young House,
1216 Hillcrest Road,
1908, Ernest Young,
architect. (Photo by
author.)

charge of implementing the Kessler Plan. In 1920 he was appointed by Governor James P. Goodrich to Indiana's first Memorial Art Commission, a position he held for four years.[30]

Young's most exemplary Prairie School house was that built in 1909 for Thaddeus Talcott, located on West Riverside Drive. Featuring a cross-shaped plan, stucco and horizontal board-and-batten siding, and wide overhanging eaves, it reflected Wright's influence, though rendered at a slightly larger scale.[31] Young also designed several Prairie School houses in the North Shore Triangle, including the Judge Thomas Slick House (1908) on Marquette Avenue and several other simple two-story, square-plan, stucco-clad houses across the city. On Hillcrest Road, next to his own house, he designed the Enoch Blose House (1910) and the Samuel Bunker House (1922).

The firm of Austin and Shambleau designed an even greater number of Prairie School houses in South Bend, in addition to numerous commercial buildings downtown. Ennis R. Austin was born in Owasco, New York, and enrolled at Cornell University in 1882, graduating with a degree in architecture in 1886. His early experience was gained in the office of LeBrun and Sons in New York, and he later worked for the Tiffany Glass and Decorating Company.

Coming to South Bend in 1892, he at first formed a partnership with Wilson B. Parker under the name of Parker and Austin. In 1900 he became superintendent of construction for the U.S. Treasury Department, for which he directed the construction of post office buildings in Indiana, Illinois, and

FIGURE 13.8
George Zinky House,
308 LaMonte Terrace,
1912, Austin and
Shambleau, architects.
(Photo by author.)

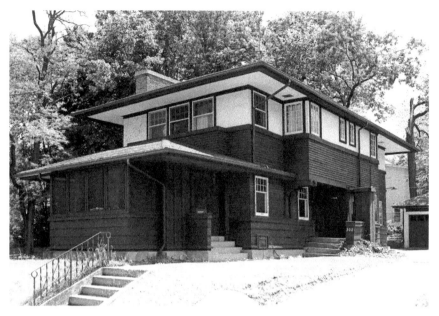

Michigan. Resigning his commission in 1906, he formed a partnership with Walter Schneider, which lasted until 1909, when he founded the firm of Austin and Shambleau.[32]

N. Roy Shambleau was born in Canada and lived in London, Ontario, until the age of eleven. He moved with his family to South Bend, and at the age of seventeen he became an apprentice architect in Parker's office, where he first met Austin. In 1908 he entered into a brief partnership with Ernest Young, and in 1912 he joined in the formation of Austin and Shambleau.[33]

The firm designed numerous houses during the 1910s and 1920s in the East Jefferson and Miami/Ridgedale neighborhoods. It also designed buildings downtown, including the Tower Building, South Bend Tribune Building, and the Federal Post Office (now known as the Robert A. Grant Federal Building), while also becoming active in the city's professional and business community. Austin was a fellow in the American Institute of Architects and served as president of its Indiana Chapter in 1911, 1913, and 1921. Shambleau served as a director of the South Bend Federal Savings and Loan Association for twenty-seven years.

One of the best examples of Austin and Shambleau's Prairie School residences is the Dr. Merritt Keightly House on East Wayne Street, designed in 1912. It is characterized by a low-pitched hip roof with wide overhangs, bands of windows placed between corner piers, a low massive chimney, and white

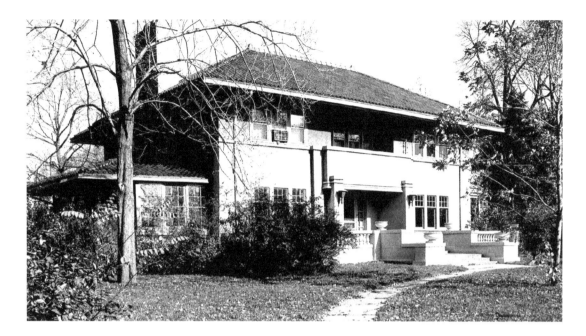

FIGURE 13.9
Frederick Miller
House,
1307 E. Jefferson
Boulevard, 1912,
Austin & Shambleau,
architects.
(Photo by author.)

stucco walls with horizontal trim. Equally outstanding examples by the firm from this period are the George Zinky House on LaMonte Terrace in the Chapin Park neighborhood, and the Morrough O'Brien House at 223 North Scott Street. All of these houses were influenced directly by Wright's DeRhodes House on West Washington Street.

Austin and Shambleau received a commission in 1912 to design a house for Frederick Miller, located on East Jefferson Boulevard at the corner of Jacob Street. Miller was the son of Alfred Miller, a founder of the *South Bend Tribune*, and became the editor and publisher of the newspaper in 1924. Strongly influenced by the Prairie School, this house is an austere two-story, rectangular-plan, hipped-roof structure. Horizontality is stressed by its wide overhanging eaves, a horizontal belt course at the second floor, and a low entranceway framed by piers supporting a second-floor balcony. The most refined of Austin and Shambleau's houses, it strikes a balance between the elegant lines of the Prairie School and the symmetrical massing of the Italian palazzo tradition.

Young, Austin, and Shambleau were all members of the South Bend Architectural Club, which was modeled after the Chicago Architectural Club, noted for its numerous exhibitions and publications featuring its members' work. The president of the South Bend club for many years was Rolland Adelsperger, who served as dean of Notre Dame's Architecture Department from 1905 to 1914.[34] Together these men were responsible for some of the most

innovative works of architecture in South Bend, all contributing to a discernible stylistic type based on the buildings and theories of Frank Lloyd Wright. It was one of the most unique times in the history of South Bend's architecture, reflecting the spirit of the prairies of the American Midwest like none other before or since.

The Arts and Crafts Movement

The Arts and Crafts movement shared with the Prairie School a reaction against the Neoclassical style and an emphasis on natural materials. South Bend has a number of examples of this style, sometimes referred to as the Craftsman style. The major voice of the movement in the United States was Gustav Stickley, an architect, furniture maker, and editor of the magazine *The Craftsman* from 1901 to 1916.[35] After a long career as a furniture builder in Syracuse, New York, Stickley began to study the work of English designer and social activist William Morris, which inspired him in 1901 to embrace the Arts and Crafts movement and join a group of American artists, activists, writers, and architects who sought to reform the world. He and other advocates of the movement produced innovative craft objects, ceramics, furniture, houses, and gardens that, in the words of historian Mark Alan Hewitt, "challenged prevailing views of the relationship among art, work, society, and the production of material goods."[36]

In residential architecture the Arts and Crafts movement was also a reaction to the Queen Anne style. Edward Bok, editor of *Ladies' Home Journal*, the first family magazine to reach a million subscribers, called Queen Anne houses "repellently ornate," with too many "useless turrets, filigree work, or machine-made ornamentation."[37] This reaction was part of a mood to return to a simpler life, the life romanticized by the American transcendental authors Henry David Thoreau and Ralph Waldo Emerson. Besides *Ladies' Home Journal*, Americans by the thousands subscribed to *House Beautiful*, *Country Life*, and *Craftsman*, all of which were critical of machine production, city living, and factory work, praising instead handcrafted objects, a simplified aesthetic, and country living.[38]

First among the principles expressed by Stickley was the idea that human habitation should harmonize with its surroundings. Thus we find, for instance, domestic porches, which are meant to unify life indoors and outdoors. Second

was the need for harmony of life inside the house. He believed cabinets, sideboards, benches, bookshelves, and other furnishings should be built in as integral components of a room. Third was the principle that beauty should arise from the natural function of simple forms, without need of elaborate decoration.[39]

Numerous companies formed, including the Moravian Pottery and Tile Works, Rookwood Pottery, and Newcomb Pottery, to produce Arts and Crafts ceramics. Stickley's Craftsman Workshops made Mission-style furniture. Chicago had its own colony of Arts and Crafts artists and architects, and in 1897 the Chicago Arts and Crafts Society was founded, its charter members including Wright and other members of the Prairie School.[40]

Looking further back to European precedents, the British author, architect, and critic John Ruskin, in his book *The Stones of Venice,* drew parallels between morality and architecture and claimed that the Industrial Revolution had dehumanized artisans, making them nothing more than machines and robbing them of their creativity.[41] The union of arts and crafts can be traced to a reaction against the 1851 World's Fair in London, where more than six million visitors had thronged to Joseph Paxton's Crystal Palace to see a broad range of exhibits, from housewares to industrial machinery, art objects, and clothing and shoes. Many considered those displays to be crude and overly commercial, crass objects of the ubiquitous mass production. William Morris dismissed the exhibits as "wonderfully ugly." If this was the best the most advanced industrial society could do, he thought, then perhaps it was time to learn from the past and get back to preindustrial basics.[42]

Ruskin and Morris, along with A. W. N. Pugin, identified four principles that became synonymous with the Arts and Crafts: design unity, joy in labor, individualism, and regionalism. The aim of these reformers, in the face of the Industrial Revolution, was to reestablish harmony between architects, designers, and craftsmen, and to bring handcraft methods to the production of well-designed, affordable objects and buildings.[43] The four principles became the often-repeated goals of designers in Europe and America alike.

The building that set the standard for the Arts and Crafts movement was the Red House, which Morris built for himself at Bexleyheath, England, in 1858. Designed largely by Morris's longtime friend and associate Philip Webb, it was an unassuming vernacular style, vaguely Gothic in character. It is especially notable for its fine craftsmanship, for its redbrick masonry, pointed brick arches, and lack of symmetry associated with Classical and Renaissance

FIGURE 13.10
George Beitner House,
1317 E. Jefferson
Boulevard, 1909, Austin
& Shambleau,
architects.
(Photo by author.)

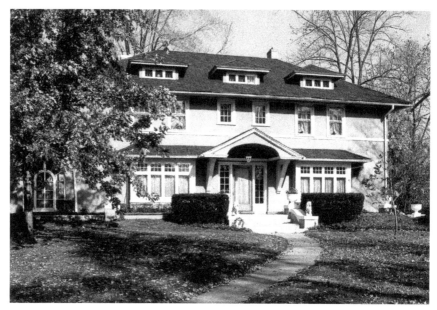

architecture, and for its integration with the landscape.[44] Completed nine years after the Crystal Palace Exhibition, this was one of the first Arts and Crafts buildings in England, and it eventually had a great influence on domestic architecture in the United States.

The Arts and Crafts movement was further defined and promoted by the work of second-generation architects in Victorian England, including C. F. A. Voysey, Edwin Lutyens, and Charles Rennie Mackintosh. One of the first books on the English Arts and Crafts, *The English House* (1904), was written by Hermann Muthesius, a German architect who lived in London at the turn of the century and whose writings spread the movement further throughout Europe.[45]

These architects took advantage of the design freedom offered by this essentially anti-Classical style. They emphasized construction and function through deep enveloping roofs, long bare walls, and asymmetrical window patterns. Bay windows were used extensively, as were buttresses, prominent chimneys, and pronounced gables. Low, sheltered entrances provided a symbolic refuge from the industrialism of late Victorian society.

While the Arts and Crafts movement was promoted in America as a style primarily for the middle class, it also became fashionable for the well-to-do. John Mohler Studebaker constructed in 1907 a large house in the English Cottage style on East Jefferson Boulevard to serve as a country home for

FIGURE 13.11
Fred A. Bryan House,
1325 E. Jefferson
Boulevard, 1912,
Austin & Shambleau,
architects.
(Photo by author.)

members of the Studebaker family. Designed by Shambleau, it is a large stucco-clad house with a broad dormer and front porch supported by thick Tuscan columns.[46]

Two of the most outstanding examples of English-inspired Arts and Crafts houses in South Bend are the George Beitner House at 1317 East Jefferson Boulevard (1909) and the Fred A. Bryan House at 1325 East Jefferson Boulevard (1912). The Beitner House has a broad two-story facade, clad with stucco and topped by a hip roof with three low dormers. The front door is topped by a gable containing an arch, while the door is flanked by sidelights. The composition is further flanked on either side by a projecting row of windows.

The Bryan House is distinguished for its stucco walls and twin front gables, modeled after Voysey's house in Chorleywood, England, designed in 1899. The style is derived from English vernacular rural cottages as well as the Gothic Revival. Voysey combined this tradition with elements of the more avant-garde English designers of the late 1870s and 1880s, particularly Arthur H. Mackmurdo. Austin and Shambleau would have been aware of this movement through architectural periodicals of the time. Their client, Fred Bryan, was a prominent South Bend engineer and business manager who became the president of the Indiana and Michigan Electric Company.

Another Arts and Crafts variation was the bungalow, which became popular after the turn of the century. A single-story structure with a broad,

projecting roof and a front porch, it was first adopted by British colonists in India and then found favor in the United States, especially in California.[47] One architect described the bungalow as "a house that looks as if it had been built for less money than it actually cost."[48] They were a modest response to the Queen Anne, smaller and less decorative, harkening back to a simpler era by evoking the idea of a primitive hut.

One writer called the bungalow the quintessential American house of the early twentieth century. They are easily identified as one- or one-and-a-half-story houses with a low-pitched roof, wide overhanging eaves, decoratively treated rafters, and, most characteristically, an open front porch. Stickley believed the dwelling had great potential for improving the spiritual and physical well-being of individuals and society.[49] While Queen Anne houses had featured turrets and high roofs in a picturesque profile, bungalows hugged the ground and employed simple materials and the most basic ornamentation. Ceiling heights were lower, rooms were smaller, and decorative woodwork was kept to a minimum and often produced in natural pine, maple, or cedar.[50] Bungalows were initially thought of as vacation or summer houses, but their inexpensive construction and flexibility of plan quickly led to their adoption for year-round living. They became so popular by 1910 that for a time they were a national obsession. Entire neighborhoods of bungalows were built in South Bend and in cities and towns across the United States. More bungalows were constructed and sold between 1909 and 1913 than any other type of urban or rural dwelling.

In South Bend, these dwellings were produced almost exclusively by builder-speculators, and the residential streets were lined with them by 1920. They weren't objects of beauty or high art, but they were intelligently planned and functional, reasonably well built, and made of durable materials. Their mechanical systems for plumbing and heating were efficient. In plan they generally had a living room in front with an open porch or veranda. Then followed a dining room and a kitchen at the rear. They generally divided themselves down the middle, with the public spaces on one side and the bedrooms and bathrooms on the other side and upstairs.[51] Examples include the Knowles B. Smith House at 1347 Leeper Avenue (1915) and the Hugo A. Weissbrodt House at 208 Napoleon Street (1923), with its sweeping side gables, open front porch, and central dormer window.

Such houses were an evocation of the Arts and Crafts ideal of design unity, joy in labor, individualism, and regionalism. The aim of each house's builder, as

FIGURE 13.12
Hugo A. Weissbrodt
House, 208 Napoleon
Street, 1923.
(Photo by author.)

it had been for Ruskin, Morris, Stickley, and a host of others, was to reestablish harmony between designers and craftsmen and to express the handcraft process in a well-designed, affordable house that was expressive of its context and the American dream.

The success of both the Prairie School and the Arts and Crafts movement lay in part in the rise of mass culture and advertising in the United States around the turn of the century. Stickley, like Wright, sold his ideas to a willing public, creating through magazine articles and books an extended audience for both ideas and products, even as they claimed to be against consumerism and exploitation of workers. Both movements were based on the ideals of social justice, yet they depended heavily on mass media and its culture to sell their design ideas to a public eager to discover the next great idea in living accommodations and residential development.[52]

Eclecticism and the Commercial Downtown

During World War I and into the 1920s, architecture and urban development in South Bend and Notre Dame took many directions. Architectural styles diverged from both the Neoclassical and the Prairie School into full-fledged eclecticism. Many distinguished works of architecture were built, and several of South Bend's most talented architects—including George Selby, Ernest Young, George Freyermuth, R. Vernon Maurer, Ennis Austin, and N. Roy Shambleau, all introduced in previous chapters—produced some of their most significant work, albeit in styles other than Neoclassical or Prairie School.

The influence of the Columbian Exposition and the City Beautiful movement lingered across the country well into the 1910s and 1920s, not only on civic and residential architecture, but on commercial buildings as well. The transformation of many American cities and towns was well under way, and whether it was a single building or a larger urban setting, the City Beautiful movement aimed to achieve a classical unity of purpose and image. Along with the civic buildings, clubs, and residences influenced by the movement, apartment buildings, railroad stations, office buildings, banks, hotels, movie palaces, and churches rose to the challenge of city beautification. In the words of historian Henry Hope Reed, this "American Renaissance" represented a "bounty" in every community it touched.[1]

With its thriving industrial giants and its close proximity to Chicago, South Bend was in a position to develop its commercial core in a way that was consistent with the ideals of Burnham and the rest of the Columbian Exposition's planners. The distinctive Classical and Renaissance styles of the third

county courthouse, Oliver Opera House, Oliver Hotel, and Studebaker Auditorium had established a strong civic identity for downtown South Bend and set a high standard for the new commercial buildings that followed.

The city's growth and development continued at an unusually rapid pace in the first two decades of the twentieth century. The population nearly doubled, growing from 35,999 in 1900 to 70,983 in 1920.[2] Industry made proportional strides, with new companies of historical importance locating in the city and new transportation links developing to ship their products across the country.

The Commercial Downtown

Banks became an increasingly important building type in the flourishing economy of the 1910s. It was common for these latter-day South Bend banks—almost a century after the 1841 design of the First State Bank of Indiana (seen in chapter 3)—to take on a civic appearance through the use of the Classical orders. This tendency denoted the idea of strength, security, and permanence and was best expressed in the many New York banks designed in the Classical Revival style by McKim, Mead and White, including the Bowery Savings Bank and the Knickerbocker Trust Company.

Several bank buildings were constructed in South Bend during the 1910s, some in the Classical Revival style and others influenced by Louis Sullivan and

FIGURE 14.1
Union Trust Company Building, southeast corner of Michigan and Jefferson, 1915, Austin and Shambleau, architects. (Author's collection.)

Chicago frame construction. One of the most impressive designed in the Classical Revival style, though it no longer stands, was the Union Trust Company Building, located at the southeast corner of South Michigan Street and Jefferson Boulevard. Designed in 1915 by Austin and Shambleau, it featured Corinthian pilasters and engaged half-columns of white Maine granite on a steel-and-concrete frame that rose through three stories and supported an entablature and a fourth floor topped by a prominent cornice. The banking room and corridors on the first floor featured marble floor tiles and travertine wainscoting, and a marble-and-bronze stairway of monumental proportions led to the second level. It was designed to be expanded later to a fifteen-story building, though the expansion was never carried out. The building was demolished in 1970.[3]

Another prominent bank building of the time followed the influence of Louis Sullivan. This is the Farmers Security Bank (later the First Bank and Trust Building) at 133 South Main Street, designed in 1915 by the Chicago firm of Perkins, Fellows and Hamilton. Dwight H. Perkins, a partner in the firm from 1894 to 1925, had studied at MIT and then worked for Burnham and Root before starting his own practice. The firm specialized in the design of office and bank buildings in Chicago and other cities, and it also was known for designing high schools, producing hundreds of them throughout the Midwest.[4]

The Farmer's Trust Building is six stories high, a steel-framed structure with concrete fireproofing. Its facades are composed in a pier-and-spandrel arrangement and are clad with dark brown Greendale Rug brick with a base of polished Minnesota granite. Detailing is done in terra-cotta in shades of red, buff, and brown.[5] This building stands out more than any other in the city for the refinement of its details, the scale and rhythm of its windows, and its stepped profile. Especially intriguing are its decorative terra-cotta panels, which directly reflect the tradition of Sullivan and buildings like the Carson Pirie Scott store in Chicago and its exuberant Art Nouveau–inspired ornamentation.

These panels were derived from Sullivan's floral and fluid ornamental designs composed over geometric grids. One of the most important producers of such terra-cotta panels was the American Terra Cotta and Ceramic Company, whose chief designer, Kristian Schneider, was responsible for the design of the terra-cotta ornamentation of most of Adler and Sullivan's buildings. The company retained molds of terra-cotta designs by Sullivan as well as the firm

FIGURE 14.2
Farmers Security
Bank, 133 S. Main
Street, 1915, Perkins,
Fellows and Hamilton,
architects, Louis V.
Bruggner postcard.
(Author's collection.)

Purcell and Elmslie and reproduced them for use by other architects.[6] Many of Sullivan's original ornamental designs were later replicated by the Midland Terra Cotta Company and sold through their catalog. In general, their terra-cotta pieces were smaller than Sullivan's originals and simplified with dimensions modulated for brick coursing for ease of construction.[7]

The interior of the Farmer's Trust Building featured a large banking room on the first floor with entrances on both Main Street and Jefferson Boulevard. Counters and wainscoting were done in yellow-veined marble and the walls in walnut paneling. It featured a large vault supplied by the Herring-Hall-Marvin Safe Company.[8] The banking spaces were extensively remodeled in 1940 by Austin and Shambleau when the building became the new home of the First Bank and Trust Company.[9]

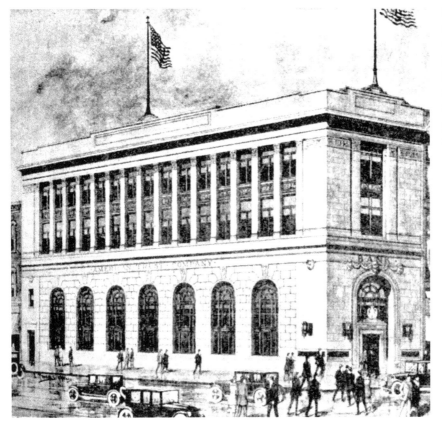

FIGURE 14.3
American Trust
Company Building,
111 W. Washington
Street, 1924, Vitzthum
and Burns, architects,
Gardner News Agency
postcard. (Author's
collection.)

The location of the Farmer's Trust Building adds to its prominence. Its juxtaposition with the county courthouse, composed as they are in a T-shaped configuration framing two sides of the narrow courthouse lawn, provides a visibility that few other office buildings of its size enjoy. It is an eye-catching building, one that leaves an impression on any visitor and sets a high standard of quality for South Bend's commercial architecture. This midrise building also benefits from the fact that, unlike the JMS Building, its facades are all treated equally, making it a building that stands confidently on its own.

A Renaissance Revival design is seen in the American Trust Company Building at 111 West Washington Street, designed in 1924 by Joseph Scheitler, Karl Martin Vitzthum, and John J. Burns of the Chicago firm Vitzthum and Burns. A long, narrow building, it is only one bay wide, with an arched front door in the short end facing Michigan Street. Its south facade, facing Washington Street, features seven elegant round-arched windows illuminating the banking room. Its limestone walls are rusticated on the first level and

FIGURE 14.4
Tower Federal Building,
216 W. Washington
Street, 1929, Austin and
Shambleau, architects.
(*Architectural Forum*,
June 1930.)

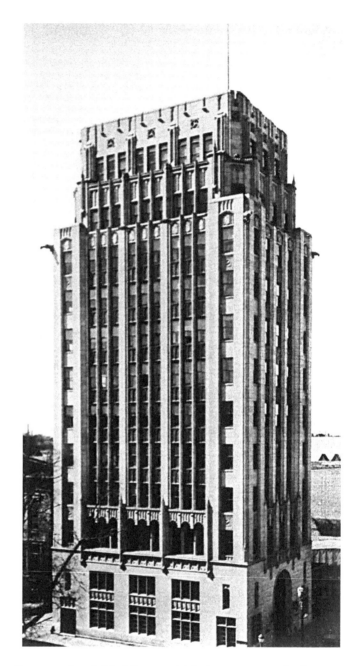

smooth-faced on the second and third floors, which feature engaged pilasters, recessed spandrel panels, and a projecting cornice. The name *American Trust Company* is inscribed on the face of an intermediate cornice. The banking room and the windows were covered over in later remodeling; however, they have been recently restored.[10]

The last bank building constructed in South Bend before the onset of the Great Depression diverged from the Classical tradition. This was the Building and Loan Association (commonly called the Tower Building) at 216 West Washington Street, built in 1929. Designed by Austin and Shambleau, it is a Gothic Revival–style office building, twelve stories high, with the top floors stepped back. Verticality is emphasized with limestone piers and terra-cotta spandrels; gargoyles adorn each corner at the tenth floor, and Gothic details are carved in stone spandrels and cornices. It was modeled directly after the Chicago Tribune Tower (1922) by John Mead Howells and Raymond Hood, though in a much more restrained mode.

While this refined and beautiful building has added a great deal to the architectural character of downtown South Bend, it nevertheless has significant urban issues. First is its location, jabbed as it is into the block containing both of the city's historic courthouses—a block that should have been devoted in its entirety to governmental purposes in the tradition of the courthouse square. Second is its concentration of ornamented facades on only two sides, not all four as is found in the Tribune Tower. It suffers from the same front facade/ rear facade syndrome as the JMS Building and thus contributes to an unresolved urban image in this part of the city.

Hotels

The Oliver Hotel set a high standard in South Bend at the end of the nineteenth century for travel accommodations, banqueting facilities, indoor public space, and architectural detailing. Subsequent hotels were marked by quality architecture, though none of them matched the stature of the Oliver. Experienced hotel architects were employed to design later hotels, but their work was formulaic, representing a standard hotel type that could be found anywhere in cities across the country. Until the day of its demolition the Oliver, with its Italian palazzo facades, remained the most distinctive building of the era.

In the 1920s the Italian Renaissance was looked upon with renewed interest and became a dominant style in hotel design. The first example from this period was the Hotel LaSalle, prominently located at 237 North Michigan Street, where it overlooks the St. Joseph River.[11] Its eight-story steel-and-concrete frame is clad in gray brick with limestone trim. It follows the base, shaft, capital motif. Its first and second floors are lined with tall round-arched

FIGURE 14.5
Hotel LaSalle,
237 N. Michigan
Street, 1921, Nicol,
Scholer and Hoffman,
architects, Louis V.
Bruggner postcard.
(Author's collection.)

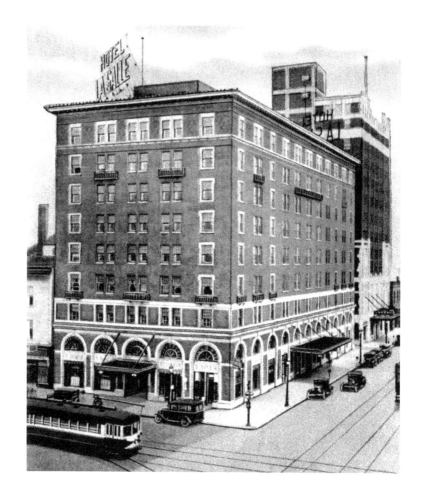

windows framed by spiral terra-cotta colonettes and terra-cotta arches marked by a keystone. The upper floors have smaller, rectangular limestone-framed windows. The top floor is set off by an intermediate string course and capped by a bracketed cornice. The building originally had 233 hotel rooms, though some of the floors have subsequently been changed to office use, and it retains its original grand stairway, dining rooms, bar, and ballroom.

The Hotel LaSalle was designed by Nicol, Scholer and Hoffman, specialists in hotel design based in Lafayette, Indiana. Built at a cost of $750,000, it was developed by Jacob Hoffman and Louis F. Allardt and managed by the Hoffman Hotel Company until 1933.[12] In that year it was transferred to Hotel La-Salle, Inc., which commissioned architect and Notre Dame faculty member Vincent Fagan to design a new banquet hall, grand stairway, and mezzanine balcony. The banquet hall featured a hardwood dance floor and what the *South*

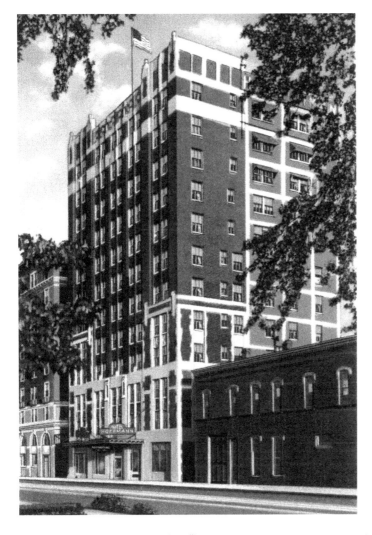

FIGURE 14.6
Hoffman Hotel,
120 W. LaSalle Street,
1930, Willard M.
Ellwood, architect,
City News Agency
postcard. (Author's
collection.)

Bend News-Times described as "bronze ornamentation against Oriental wood and gold mirror paneling."[13]

In 1926 the Hotel LaSalle Annex was opened at the northeast corner of Michigan and LaSalle Streets, a building that incorporated stores, offices, and apartments in addition to Turkish baths, an eighteen-lane bowling alley, and a parking garage for 200 cars. Its top floor accommodated 108 bachelor apartments and a roof garden. The building took unique advantage of its sloped site at the edge of the St. Joseph River, rising five floors on the river side and three facing Michigan Street. Its two primary facades are in an Italian Renaissance style, the LaSalle Street side reflected the slope toward the river.[14] It too was developed by Hoffman and Allardt, and the design is by Willard M. Ellwood.[15]

Just behind the Hotel LaSalle, at 120 West LaSalle, is the former Hoffman Hotel, another design by Willard M. Ellwood. Built in 1930, it is equally decorative with redbrick walls, limestone trim, terra-cotta panels, and decorative corner quoins and belt courses.

Theaters and Movie Palaces

Perhaps more than any other building type, the design and construction of theaters during the 1920s marked a time of extreme excesses in the market system that drove real estate. By 1929 five new theaters had been constructed in South Bend, and, taken together, they had a capacity for more than 10,000 people. Three of them had a seating capacity of over 2,500. All of these buildings were expensive to construct, requiring extensive structural support, long-span trusses, and elaborate brick and terra-cotta facades. Their huge halls were lavishly decorated in period styles, especially Mediterranean modes, to establish a mood of calm, entertainment, or romance. Financing of these theater buildings was heavily leveraged with bond issues and mortgages, some with hundreds of investors, making them especially susceptible to bankruptcy during the economic collapse of the Great Depression.

South Bend's premier theater space since the 1880s had been the Oliver Opera House, which initially opened as a venue for serious opera and theater and gradually shifted to comic opera and variety shows. It was followed in 1898 by Studebaker's Auditorium. The 1890s marked the golden age of the stage, highlighting romantic dramas, musical comedies, and melodramas.[16] Across the country, venues began hosting vaudeville and burlesque performances. Then came nickelodeons, hundreds of which were built in major cities during the decade.

Vaudeville became an important form of entertainment in South Bend in 1910 with the opening of the Orpheum Theater at 222 North Michigan Street. The Orpheum Theater would close in 1934 and was later demolished, but for a period of at least ten years vaudeville built up a remarkable following among people of all walks of life. Indeed, vaudeville was described by one author in the 1920s as "the most democratic form of theatrical amusement."[17]

The early years of the twentieth century had been a time of consolidation in the theater world. The employment of actors was centralized by the formation of booking agencies, which developed the star system and sold talent on a

commercial basis. Theater syndicates owned and built their own theaters all over the country just as motion pictures—silent films—were becoming a major industry.[18] Stage theaters began to be replaced in the 1910s by movie houses, which were often designed as combinations of vaudeville and celluloid photoplay theaters. Moving pictures soon became the star attraction, a good closing act or "chaser" for a vaudeville program.[19]

Theaters built primarily to showcase silent films began to appear after World War I. They featured great pipe organs, whose decorative consoles rose from the orchestra pits before film presentations and during intermissions.[20] Between 1915 and 1945, more than four thousand movie palaces and thousands of smaller theaters were built across the country. Hundreds of films were released, and tens of thousands of people flocked to see them in lavishly decorated auditoriums. Movie palaces were an important new building type, merging architectural design, economics, entertainment, and fast-changing technology. The early palace architects rose to the task demanded of them by the movie moguls, who wanted a larger-than-life showcase—a respite from the real world. Most important, according to architects Joseph M. Valerio and Daniel Friedman, the world of the movie theater invited a suspension of disbelief commensurate with the product its environment was designed to sell.[21] As Konrad Schiecke describes it, "The theatre setting was sumptuous enough to evoke a dreamy atmosphere and allow the audience to forget, for the evening, the ordinary world that remained outside the doors."[22]

As a new building type, movie palaces were complex in program. They were large, encompassing anywhere from a half to a full block. They were square or rectangular in plan, with the auditorium running either parallel or perpendicular to the street. Because the owners wanted to maximize the street frontage for rental storefront spaces, the lobby was often a long narrow element either in the middle or along one side of a block of shops, while the auditorium itself, a tall hulking volume, was at the back of the block.

Movie-theater architecture was characterized by highly decorative Period Revival designs ranging from Classical to Spanish Renaissance. The use of ornate terra-cotta cladding distinguished their facades from neighboring commercial buildings. Both fireproof and impervious to moisture, terra-cotta could be molded in imitation of any stylistic detail, and the use of glazes allowed manufacturers to develop tones and textures representing expensive materials such as marble, limestone, or granite.[23]

The other distinguishing feature of movie-theater design was the marquee, often designed in heroic proportions to extend the stage to the street. Complete with large letters and flashing colored lights, marquees drew the attention of customers from blocks away. They were designed either in a horizontal format rising above a metal canopy or a vertical climb up the building's facade, drawing the viewer's gaze skyward.[24]

Entering the lobby, patrons were meant to be overwhelmed by elaborate and playful settings that subconsciously transported them to an exotic and mysterious world. They were led past lounges, antechambers, and concession stands, up grandiose stairways to balconies with heavy balustrades, columns, arches, niches, and sculptures, and into the upper reaches of vaulted spaces replete with chandeliers, ornamental tilework, wall frescoes, and cornices. Styles set a particular mood ranging from Egyptian, Syrian, and Chinese to Indian, Spanish Renaissance or Baroque, and French Beaux-Arts.

Chicago architects George L. Rapp and C. W. Rapp designed South Bend's first silent-movie palace, the Blackstone Theater (now the State Theater), from 1919 to 1921. Rapp and Rapp were the principal architects for one of the country's leading theater-development firms, Balaban and Katz. Among their most notable buildings in Chicago were the Chicago Theater (1921)—considered the first motion-picture theater in the country—the Uptown Theater (1925), the Oriental Theater (1926), and the Northshore (1926). They also designed the Michigan Theater in Detroit (1926), the St. Louis Theater in St. Louis (1926), and the Paramount Theater in New York (1926), among many others.[25] Like most architects who designed movie palaces, Rapp and Rapp had earned their credentials in the service of vaudeville. They had completed several theaters before the advent of the motion-picture industry, giving them a practical understanding of the theater environment and its technology. They quickly adapted to the rapid changes that made movie theaters possible.[26] Influenced by a trip to Paris early in their career, they employed several recurring architectural motifs, including the triumphal arch, cascading staircase, and grand column-lined lobby.[27]

The Blackstone Theater, located at 212 South Michigan Street, has one of the most imposing Neoclassical facades in the city, with upper floors recessed behind four sets of paired fluted Ionic columns supporting an elaborate entablature. The recessed wall itself is composed of panels of diagonal brick and terra-cotta panels heralding the performing arts. Its structure is fireproof concrete and steel. The ground floor includes, in addition to the theater entrance

itself, four shop fronts. The cost of the building was $350,000, with financial backing from the W. W. Kimball Company of Chicago and the Inland Steel Company of Indiana Harbor.[28]

The W. W. Kimball Company's role in the development of South Bend's theaters is itself an interesting story, as its department manager, Jacob Handelsman, was the one who developed the theaters. He was also involved in South Bend's Granada and Palace Theaters.[29] The connection was the use of Kimball organs in each of the theaters he developed.

The Blackstone opened during the heyday of the silent-movie era, and it included a $20,000 Kimball pipe organ and an orchestra pit for live musical accompaniment.[30] It had a capacity of 2,600 people, with seats on the main floor and a mezzanine. In the later 1920s, as interest in silent movies began to wane, it started showing burlesque shows. It was closed down by the city in 1929 for what many considered to be indecent performances. In 1933 it reopened, now transformed to show talking movies.[31]

Just as the Blackstone Theater was about to open its doors with its run of silent movies, Jacob Handelsman also took over the management of the Oliver Opera House, which was South Bend's only legitimate playhouse from its construction in 1885 until the Studebaker Auditorium was built in 1898.[32] Handelsman remodeled the Oliver to take further advantage of the new trend in silent movies. It operated as a cinema theater through the 1920s and was demolished in 1955.[33]

The year 1921 also saw the design of South Bend's most magnificent theater, the Palace Theater at 211 North Michigan Street, now a civic auditorium. Designed by J. S. Aroner from Chicago, it is an elaborate Spanish Renaissance design with three colossal round-arched windows rising above the entrance doors and marquee.[34] Framed with brightly colored, carved decorative reliefs, they mark one of South Bend's most memorable architectural images.

The designer of the Palace's interior was Edward Eichenbaum, of Marshall Field and Company, who later assisted the architects Levy and Klein with Chicago's Granada and Mabro Theaters (1926–7). The two-story-high lobby features three bronze-and-crystal chandeliers. The auditorium, designed to seat 2,658, includes tiered box seats that slope down along the sides as they approach the proscenium opening.[35] The stage, 54 feet across and 31 feet deep, was said to be the largest in the state and was equipped with a Kimball concert organ. The walls and ceiling, again in the Spanish Renaissance style, were

FIGURE 14.7
Palace Theater (Morris
Civic Auditorium),
211 N. Michigan Street,
1921, J. S. Aroner,
architect. (Photo by
author.)

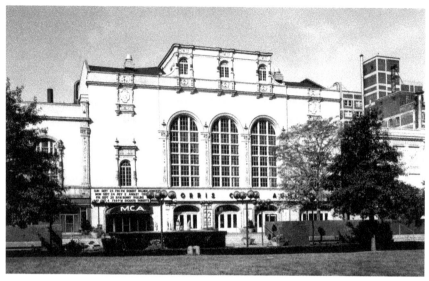

finished in a gold-and-rose color scheme with ivory and touches of blue. The gilded ceiling hosted an elliptical dome colored in sea green.[36]

The Palace was built on the west side of Michigan Street between Colfax and LaSalle, property once owned by the family of the city's former mayor, Schuyler Colfax. A partnership was formed to develop the theater, composed of such local businessmen as Harry G. Somers, owner of the Oliver Theater, and John C. Ellsworth, along with a group of Chicago developers that included again Jacob Handelsman.[37] It was built by the Ralph Sollitt Construction Company for a cost of nearly $1 million.[38]

The developers' plan was to stage high-class dramas, operas and musical plays, vaudeville, and selected motion pictures.[39] It opened primarily as a vaudeville theater on the famed Orpheum circuit, with two shows daily plus a feature film. In April 1929 it was converted to feature films alone, marking the death of vaudeville.[40]

In 1923 Aroner was commissioned to design a second building adjacent to the Palace Theater with commercial rental spaces on the first floor and a grand ballroom on the second. Known as the Palais Royale, it is an even more exuberant version of the Spanish Renaissance style, its facades featuring elaborate two-story-high windows framed by plain and Solomonic columns and divided horizontally by painted terra-cotta spandrels. They are topped by distinctive double-curved segmental hood moldings that carry decorative urns. The ballroom, restored in 2001, features a grand terrazzo staircase, a solid oak dance

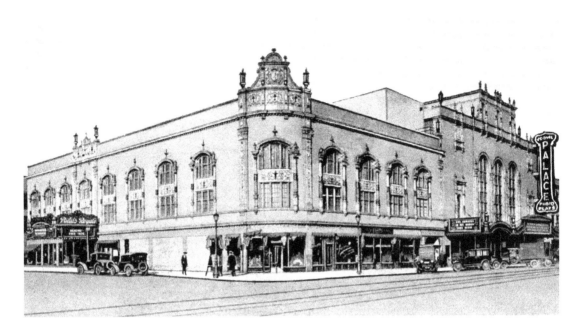

floor, crystal chandeliers, plaster-cast moldings, and colorful stencil designs with gold-leaf applications. The Palais Royale hosted many of the big-band artists of the time, including Tommy Dorsey, Guy Lombardo, Cab Calloway, Count Basie, and the Glenn Miller Orchestra.

Jacob Handelsman was also instrumental in constructing the Granada Theater, located at 212 North Michigan Street, directly across from the Palace Theater. Erected fom 1926 to 1927, it opened on the seventy-fifth anniversary of the founding of the Studebaker Corporation, with the legendary Notre Dame football coach and promoter of Studebaker automobiles, Knute Rockne, in attendance.[41] The featured silent film was *An Affair of the Follies*, accompanied by live music from a Wurlitzer concert pipe organ. The auditorium's decoration was on a Spanish theme, its interior giving the illusion of an open-air theater with red Spanish tile cladding on the walls and a starlit sky overhead, achieved by a series of lights strategically placed to cast shadows on the surface of the high domelike ceiling. A myriad of small electric lights nestled in the ceiling twinkled on and off to produce a realistic summer sky effect.[42]

The Granada was built on a slip of land between Michigan Street and the west bank of the St. Joseph River. Due to the high water table, the Sollitt Construction Company employed caissons as part of the foundation system to anchor the building below the swampy surface. Its basement was designed for automobile parking but never used because it was not adequately ventilated.[43]

FIGURE 14.8
Palais Royale, northwest corner of Michigan and Colfax Streets, 1923, J. S. Aroner, architect, Gardner News Agency postcard. (Author's collection.)

The cost of the Granada Theater was nearly $1 million, with financing in the amount of $500,000 provided by Herman S. Strauss of Chicago and $475,000 by the American Trust Company of South Bend. It could accommodate 2,500 people.[44] The theater would close and reopen under new management in 1933, when a new sound system for talking movies was installed. It went bankrupt in 1938 and was sold at a sheriff's sale for $96,000, less than one-tenth of its construction cost.

The smallest of South Bend's theaters was the Strand, later renamed the Avon, which opened in 1926 to show first-run movies, comedies, and newsreels. Located in the 300 block of South Michigan Street, it was developed by a partnership of Ira W. Ciralsky and Bernard Greenberger and Company for a cost of $125,000. It was of fireproof construction with a decorative terra-cotta facade, two stories high and three bays wide with a marquee above the entrance and a storefront on either side of it. Inside it had a main floor and a balcony to seat an audience of one thousand, and it also had a $15,000 Kimball concert organ. It opened in May 1926 with May McAvoy in *The Road to Glory*.[45] The venue would shift ownership several times through the twentieth century before closing in 1979. In 2007 the St. Joseph County Public Library purchased the building and, after years of wrangling with the Historical Preservation Commission of South Bend and St. Joseph County, demolished it in 2012 and 2013.

While the Blackstone, Granada, and Strand Theaters were all converted to accommodate talking motion pictures within a few years of their construction, the Colfax Theater, built in 1928, was the first movie house in South Bend to be designed specifically for Vitaphone and Movietone talking moving pictures, which were described at the time as "the modern miracle of science."[46] There is evidence that, like the Blackstone Theater, it may have been designed by Rapp and Rapp, who were by this time the chief architects of operators Balaban and Katz of Paramount's Publix Theater Corporation, having built theaters from New York to Portland, Oregon.[47] When the theater opened, a writer for the *South Bend Tribune* predicted correctly, "This will replace the silent drama theaters, because the spoken word would now be part of motion pictures."[48] The first movie shown was *The Lion and the Mouse*, featuring May McAvoy and Lionel Barrymore.

Located at 213 West Colfax Avenue, the Colfax Theater could hold two thousand spectators in a beautiful setting with shades of pale rose, antique gold, and taupe, with elaborate lighting effects.[49] The style was Spanish Renais-

sance. The lobby had a cascading stairway, a mirrored ceiling, and a Persian candelabra.[50] Its facade, a highly eclectic design with decorative terra-cotta cladding, was rather narrow, limited to the entrance lobby and its grand marquee. Adjacent was a separate building lined with shop fronts, with the auditorium placed at the back of the lot. The biggest event marking the Colfax's history was in 1940, when it staged the premiere of *Knute Rockne, All American*. Cast members, including future president Ronald Reagan, attended.

With all of these theaters and movie houses, South Bend's downtown now boasted a significant entertainment district. Patronized by the city's workers, factory managers, and owners alike, these palaces offered a respite from the hard work of industrial labor. They gave people an escape from the drama of everyday life to a land of fantasy, romance, war, or the Wild West. The book *South Bend World Famed* reported, "These magnificent Palaces of Amusement are recognized as being among the finest in the United States. . . . They mark distinct epochs in the history of theatrical construction for both the speaking stage and for the presentation of photoplays."[51]

As instruments of economic exchange, theaters and movie houses were heavily mortgaged, based on the assumption that there would be an endless supply of ticket purchasers in an ever-growing city. As we will see in the epilogue, however, the risks of the real estate market would intervene, eventually sending many of the initial investors into bankruptcy. The buildings would continue to operate off and on for the next few decades, but with one or two exceptions, they would be abandoned and demolished in the 1960s and 1970s.

While these theaters, commercial buildings, banks, and hotels displayed both a link to various styles of the past and movement toward the simplicity and functionalism of modern architecture of the 1960s and 1970s, other buildings constructed during this time held more steadfastly to traditional styles. These Period Revival buildings of the 1920s, while not forward-looking in their design, are nevertheless some of South Bend's most unique structures.

The Erskine Years at Studebaker and the First Signs of Modernism

In 1915, for the first time in company history, the presidency of the Studebaker Corporation was filled by someone other than a member of the Studebaker family. Albert Russel Erskine, who was hired by the company as treasurer in

1911, became its third president, replacing John Mohler Studebaker, who was named 'honorary president' until his death in 1917 at the age of eighty-three. Frederick Fish became chairman of the board, and Clement Studebaker Jr., George M. Studebaker, and Walter Flanders of the EMF Company, served as vice presidents.[52]

Born in Huntsville, Alabama, Erskine took his first job at age sixteen, working for a railroad company. He subsequently worked as a bookkeeper in a warehouse and manager of a cotton mill. From 1904 to 1910 he was treasurer of the Yale and Towne Manufacturing Company, and for a year he served as vice president of the Underwood Typewriter Company.[53]

When Erskine was named president of the Studebaker Manufacturing Company, he ushered in a new era for the firm, bringing organizational skills, a vision of the future, and strong leadership.[54] At the outbreak of World War I in 1914, Vice President Fish traveled to England to offer the company's services to the British government. The company was nearly overwhelmed with orders: three thousand wagons, twenty thousand sets of harnesses, sixty thousand sets of saddles and blankets. Later, an order came in for five thousand military trucks to be outfitted with caterpillar treads instead of tires, foreshadowing the development of highly effective British tanks.[55]

When the United States entered the war in 1917, Erskine made a similar offer to the United States government. This company became almost entirely a manufacturer of military vehicles, and while it was consumed with making war-related goods, total sales and profits actually dropped as the company reduced its production of civilian automobiles in order to fill less-profitable government orders, especially for horse-drawn vehicles.[56] It was not until after the war's end in 1919 that the company's sales and profits rose sharply as automobile production returned to its prewar levels.[57]

After the war Erskine made a stronger commitment to the production of automobiles, and by 1920 wagon production was discontinued. As the Studebaker Corporation grew and expanded its national reputation, it increased its market by building branch sales headquarters in Chicago, New York, Denver, and San Francisco. In Chicago, the company erected a ten-story office building on Wabash Avenue to complement its building on Michigan Avenue.[58]

Historians William Cannon and Fred Fox wrote of Erskine, "From a small-town beginning, he prospered, lived, dined, danced, and built with the elegant and wealthiest Americans of the early twentieth century.... He was a man of tremendous ambition, energy and talent; a self-made man in every

sense of the word."[59] Historian David Byers praised him for his ability to organize, envision the future, promote his ideas, and build enthusiasm for new projects. He credited Erskine with directing "the old Studebaker Corporation from a builder of horse-drawn carriages through wartime manufacturing of the country's military needs, and on to the production of automobiles."[60]

The company's engineering department, which was as advanced as any in the country, was directed by James G. Heaslet and Fred M. Zeder. Their engineering team was staffed with creative designers who helped set the standard for automobile design and production in the United States.[61] A major aspect of the company's success during this period was advertising. From 1912 to 1918 the company spent $6 million in advertising, helping it to become the third- and fourth-best-selling brand in America.[62]

The 1920s thus saw great expansion for the company. Chief among Erskine's accomplishments was the decision to erect a modern automobile plant, half of which was completed in 1920, the last year it made farm wagons. The new plant was made exclusively for the manufacture of the Studebaker Light Six, which by 1922 was being produced at a rate of fifty thousand per year, with nine thousand workers employed in their manufacture. Buildings previously devoted to the Studebaker wagon-and-harness business were converted into closed car body plants and utilized to full capacity. Erskine also announced in 1922 plans to spend $5 million on additional buildings and equipment and to double the company's capacity. An entirely new automobile plant, designated Plant 2, was constructed, as were a forge shop, stamping plant, machine shop, powerhouse, and storage and assembly buildings. Sales of automobiles in 1920 reached more than fifty-one thousand, bringing in an income of $90.7 million.[63]

In many industrial cities across the country, the development of modern architecture paralleled the evolution of mass-production techniques on a grand scale, as seen at Studebaker and on an even grander scale at companies including Ford, Chrysler, and General Motors in Detroit and its suburbs. Industrial buildings that were based on meeting the needs of efficiently managed industrial processes took on a new character with the advent of widespan construction, which employed new advances in the design of reinforced concrete coupled with large expanses of plate glass windows that allowed for adequate light and ventilation.

In 1923 the company built Building 84, a six-story assembly plant designed by the famous Detroit architect Albert Kahn, who pioneered the use of

FIGURE 14.9
Studebaker
Manufacturing
Building 84, 1923,
Albert Kahn, architect.
(*American Architect*,
September 20, 1924,
pl. 224.)

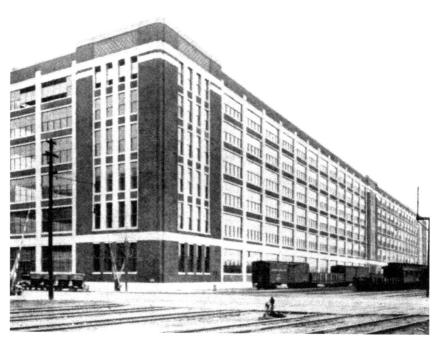

reinforced concrete construction for industrial buildings.[64] Born in Germany in 1869, Kahn was brought by his family to the United States at age twelve in 1881. He began his professional apprenticeship three years later, working as a draftsman for the Detroit architectural firm of Mason and Rice. At age twenty-one he received a scholarship from the *American Architect and Building News* to spend a year in Europe, which allowed him to travel in England, France, Belgium, Germany, and Italy. Upon returning to the United States, he resumed his position in Detroit and, in 1895, established his own firm.[65] Teaming up with his younger brother Julius, a graduate in civil engineering from the University of Michigan, he developed the Kahn system of reinforced concrete, which they first used in an industrial complex for the Packard Motor Car Company in Detroit in 1905. Their system allowed for longer structural spans and more flexibility in the use of space. Exposing the concrete frame on the building's exterior led to a new industrial aesthetic that featured a repetitive geometric frame with brick spandrels and large expanses of glazing.[66]

In 1909 Kahn received his first commission from Henry Ford, president of the Ford Motor Company, a project that would begin a long and fruitful partnership between the businessman and the architect that paralleled the collaboration between Studebaker and Solon Beman. Historian Federico Bucci sug-

gests that in hiring Kahn, Ford was not interested in a monument to his economic success or paving the way for a new tendency in industrial aesthetics. Rather, he wanted a designer capable of responding specifically to the fast-changing needs of mass production. He sought a flexibility that would foster organizational efficiency. The result was a series of buildings that accommodated the mass production of automobiles on a massive scale while serving as laboratories for new principles of labor management and proposing avant-garde solutions in construction.[67]

When Kahn designed Building 84 for the Studebaker Manufacturing Company in 1923, he had already designed several dozen examples that were built for the Ford Motor Company and other car manufacturers in and around Detroit. The long, narrow, multistory structure, built on a strong but efficient concrete frame with nearly floor-to-ceiling windows, had proven to be perfectly suited to assembly-line production of automobiles. Well-lit floors, laid out horizontally and joined efficiently by conveyors and elevators, allowed piecework operations to be carried out on the upper floors and assembled components to work their way down to the lower floors to the body and chassis assembly lines. Kahn's architectural solution accommodated all necessary lighting, cleanliness, ventilation, and economy of interior space in conjunction with the scientific management of labor.[68]

By 1924 the Studebaker factory complex on the southwest side encompassed 225 acres, its buildings totaling 7.5 million square feet. The company employed 23,000 workers and produced 180,000 vehicles per year.[69] During this period Studebaker produced some of the country's most stylish cars: the Pierce-Arrow, the President Eights, the Erskine, and the Land Cruiser. A smooth, racy, Art Deco style predominated, with many of the designs coming from the hand of Raymond Loewy, a renowned French industrial designer of the era.[70]

Writing of the Studebaker Manufacturing Company in 1918, Erskine stated, "Studebaker products have been manufactured and sold for nearly seven decades, and its name is a household word wherever vehicles are used. There are few trade names in American industry older and more highly regarded than the name 'Studebaker,' which has always stood for quality and fair dealing, and this name today is the greatest asset the corporation owns. Buildings, machinery and operating organizations can be replaced for money, but an old and honored trade name can only be acquired by merit and through the lapse of time."[71] Erskine reviews here the values he considered necessary for

success in the world of business, implying a collective behavior that results over time in economic and financial achievement. The booklet in which this reflection appeared was written for and distributed to the company's three thousand stockholders, twelve thousand dealers and agents, and fifteen thousand employees and friends, that is, to the elite of the business world, not just in the region of South Bend, but nationally.[72]

Public Buildings: A Turn toward Modernism

The U.S. Post Office building located at the corner of South Main and East Jefferson Streets has gone through several iterations. The first was built in 1898 in a pseudo-Richardsonian Romanesque style. It was quickly outgrown, however, and was remodeled and enlarged in 1908 to 1909. This second version did away entirely with the original corner tower and added an Ionic colonnade facing Jefferson Boulevard.

The new U.S. Post Office (now the Federal Courthouse) is the best example of a modern version of the style from the 1930s. Its smooth limestone facade, rising above a granite base, is modulated by three-story fluted pilasters framing metal sash windows and spandrels. The top floor is recessed back from the entablature and cornice. As noted in chapter 13, it was designed by

FIGURE 14.10
U.S. Post Office
(now Federal
Courthouse), 1929,
Austin and Shambleau, architects.
(Photo by author.)

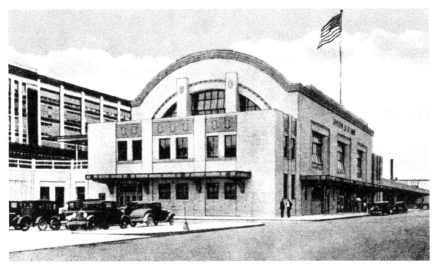

Austin and Shambleau, which had become prominent in the city for its design of Prairie School houses and now was proficient in Period Revival styles.

South Bend Union Station, on South Street, was designed in 1929 by the Cincinnati firm of Fellheimer and Wagner. The firm was known for its Cincinnati Union Station, which featured Guastavino vaulting. It represented modern technology and simplified design.[73] Construction was begun in 1927 in conjunction with the elevation of the tracks along the city's south side.

South Bend's Union Station, designed in the Art Deco style, featured a large main waiting room, appointed with stone, with a vaulted ceiling done in Guastavino tiling. This concourse has a forty-foot-high ceiling, measuring 124 feet long by 55 feet wide. The ceiling was described as having a dome effect, adding to the appearance of height with great arched windows on either end. At the building's south side, a tunnel under the tracks leads to stairs up to the track level. It includes a ticket office and agents' offices. To the west is a wing that accommodated baggage check and shipping. On the east was an entrance from a taxi drop-off. On the concourse's south side was a grill and soda fountain, lunchroom, and newsstand. On the second floor are offices and staff rooms. The platform had four passenger train tracks plus more tracks for freight trains. It had a copper roof, and a broad canopy on the north side sheltered passengers from the elements.[74]

After numerous delays, groundbreaking was held for the station. It opened in May 1929 along with part of the extensive elevation program of the tracks. E. M. Morris, president of the Chamber of Commerce, greeted the delegation

of railroad officials and employees at the opening.[75] In its first decade of use, as many as thirty-two passenger trains a day stopped at Union Station. South Bend residents long remembered the "aura of excitement" around Union Station in its heyday, when, as one *South Bend Tribune* reporter put it in 1971, "A visit to it meant seeing long ticket lines, crowded platforms, a steady stream of arriving and departing trains."[76] In its early years, Union Station played host to special occasions, including when an estimated thirty-five thousand people came to a campaign stop by President Harry Truman in 1948.[77]

Upon the completion of the train station, one more grand urban plan was prepared by a group of citizens: a plaza across the street. The *Tribune* reported that the plan was to extend it all the way from Franklin Street to South Street, thus creating an axial approach to the building's front doors. "Those who vision the future," an anonymous *South Bend Tribune* reporter opined in 1929, "feel that they can see an attractive picture with the Union Station at the South end of the vista, the High school building at the north end. . . . Whether this plan can be carried out seems to depend on how the citizens vision it but those who have it in mind are of the opinion it might make an even more attractive setting than the proposed plaza."[78] Slowed by the Great Depression, the plaza nevertheless reached completion by 1935.[79]

Within two decades, however, Union Station's golden age had passed. In 1958 the railroad offered the building to the city for about half of what it cost in 1929, but the city refused.[80] In 1969, Phil Ault of the *South Bend Tribune* wrote with resignation that "the trappings of the 1920s, when the Union Station was built, have disappeared along with the customers." It had become a "white elephant," Ault continued, diagnosing the key reasons behind Union Station's decline: "Unneeded, unloved, and virtually uninhabited, the station is like a tomb for the opulent dreams of men whose vision of the future did not include jet airliners and interstate highways." He added, somberly, "The South Bend station belongs to the Railroad Mausoleum school of architecture of the 1920s era. High vaulted waiting rooms, walled and floored with marble, were the dominant features of these memorials to the assumed invincibility of the passenger train. . . . Grandeur gone to seed is depressing—and uneconomic." Ault tied the fate of South Bend's Union Station to other train depots in the industrial North: "Having outlived their day, the cavernous stations are disappearing. Penn Station in New York has gone, Union Station in Chicago is under the wrecker's hammer, and Grand Central Station in New York, ultimate destination of the trains passing through South Bend, is scheduled for demoli-

tion."[81] The cavernous station that was once the marvel of the Midwest was sold to a manufacturing company. Its service as a passenger terminal ended in 1971. The adjoining land on which its plaza once sat is now the site of the South Bend Cubs' Four Winds Field.

Conclusion

By 1930 downtown South Bend represented quite a contrast to Notre Dame's pastoral setting. A bustling commercial district now hosted all manner of modern buildings: banks, midrise hotels, office blocks, dry-goods stores, specialty shops, and showcase cinema houses. The latter were especially prominent because they were all part of national theater chains that spared no expense in building their monumental movie palaces.

As we shall see in chapter 15, campus and city remained two separate entities in 1930, three miles apart, one dedicated to education and the Catholic moral code, the other to commerce and governmental services. It was both a contrast and a balance, making South Bend a city unique among those hosting institutions of higher learning.

Notre Dame and Saint Mary's in the Early Twentieth Century
Introducing the Collegiate Gothic

Educational and religious architecture in South Bend from 1900 to the 1930s reflected trends that developed in commercial and residential architecture at the same time. Neoclassical, Gothic Revival, and Georgian Revival are all evident in almost equal measure, with much institutional architecture and landscape design being influenced by the City Beautiful movement. The Neoclassical style had a strong presence after the turn of the century, both downtown and at Notre Dame and Saint Mary's. After World War I and the construction of the Lemonnier Library, however, both schools turned to the increasingly popular Collegiate Gothic style for classroom and dormitory buildings alike. At Notre Dame this included Alumni and Dillon Halls, Rockne Memorial Hall, the Engineering Building, and the famous South Dining Hall. At Saint Mary's College this is especially evident in its largest classroom, office, and dormitory building, Le Mans Hall.

Historian Michael J. Lewis has described educational architecture in the Gothic style as "the highest note" of the Gothic Revival, which had been in continuous use since the 1830s.[1] It first developed in England with the Oxford Movement, which promoted a revitalization of the Catholic Church in England after the Roman Catholic Relief Act of 1829, which permitted members of the Catholic Church to serve in the British Parliament. Politically speaking, it undermined the primacy of the Anglican church, giving Catholicism a legal foundation in England and thus cultural legitimacy. A. W. N. Pugin,

codesigner of the Houses of Parliament, was the most visible proponent of the revival of the Gothic style.[2]

While the Collegiate Gothic emerged first in England, it quickly moved to America with A. J. Davis's design for New York University in 1833. After the Civil War, Gothic Revival design surged at schools including Yale, the University of Pennsylvania, Princeton, and Duke. The firm of Walter Cope and John Stewardson, for instance, beginning in the 1880s, developed a form of the Collegiate Gothic mixed with Jacobean and Elizabethan motifs, based on Oxford and Cambridge precedents, for classroom buildings and dormitories at the University of Pennsylvania and Bryn Mawr.[3] At Notre Dame, Francis Kervick and Vincent Fagan developed a similar formula.

The use of the Gothic style for college buildings was considered by some architects as antithetical to the Beaux-Arts spirit of most campus plans at the time. Others believed it was appropriate to place Gothic Revival buildings within the context of formal, axial settings, even if their plans were irregular or at odd angles.[4] Part of the appeal of the Collegiate Gothic style was its ability to organize buildings into smaller educational units, creating quads, houses, or colleges for communities of liberal learning where students and teachers could have close personal contact. The quadrangle of the English medieval college became the most appropriate model for architects working in a collegiate context.[5]

The Kervick and Fagan Master Plan

The University of Notre Dame experienced spectacular growth from 1919 to 1930, with its student body and faculty nearly tripling in size. At the same time the university initiated a transformation in its architectural character, a change that would have a profound influence on the campus for years to come. This change took place under the leadership of architecture professors Kervick and Fagan. Under their visionary leadership, a modern version of the Collegiate Gothic style came to dominate Notre Dame's campus architecture. In all, some fifteen buildings were constructed during this period, including dormitories, the South Dining Hall, the Law School, and the Engineering College, all designed in the Collegiate Gothic style.

Fagan had received his degree in architecture from Notre Dame in 1920 and was employed for a brief time in Boston before being appointed to the

university's architecture faculty. He later carried on an independent practice in South Bend and designed the All Saints Church in the industrial city of Hammond, Indiana, and St. Matthew's School in South Bend.[6]

University president Father John W. Cavanaugh commissioned Kervick and Fagan to produce a campus master plan to show the locations for the construction of new buildings and the appropriate style for their design. Historian Thomas Schlereth asserted that this plan, published in 1920, "influenced the physical development of Notre Dame for the next thirty-five years."[7] Placing special emphasis on new dormitories, the designers proposed an addition to double the size of Sorin Hall, the construction of the Howard-Lyons-Morrissey dormitory complex, and three new buildings along the campus's southern edge plus several more to the east, behind Washington, LaFortune, and Hoynes Halls.

As Schlereth pointed out, this master plan proposed the creation of two new east–west axes, the first connecting Lemonnier Library with a new art building, to be constructed at the campus's far eastern edge, and the second on the campus's southern edge, which Kervick and Fagan identified as University Road.[8] This plan was followed in spirit, if not in fact, throughout the 1920s, both for fundraising purposes and as a guide for campus expansion. Its importance lay in the fact that it was the university's first comprehensive plan, done in the spirit of the City Beautiful movement, its intention being to outline the nature of its future growth.

The development of the master plan coincided with a serious housing shortage on campus. The university had long put a high priority on the residential life of its students, preferring campus dormitories over rooms and apartments in the city. The Reverend Matthew Walsh, president of the university from 1922 to 1928, was concerned about an increasing number of students who lived off campus, six hundred of them by 1921. He believed off-campus residency weakened school spirit, added to absenteeism and disciplinary problems, and reduced the effectiveness of religious training.[9] Fraternities were not allowed on campus. Thus, there was a great need to build more dormitories. Schlereth referred to them as miniature parishes, each with its own chapel, several resident pastors, study rooms, lounges, and intramural athletic teams. Over time, each developed its own cultural and social traditions. They were essentially cloisters providing a quiet atmosphere for study.[10]

The need for more housing was first alleviated in 1917, when St. Joseph's Hall (now Badin Hall), which had housed an industrial school since the 1890s,

FIGURE 15.1
Howard Hall, 1924,
Francis Kervick and
Vincent Fagan,
architects. (Photo
by author.)

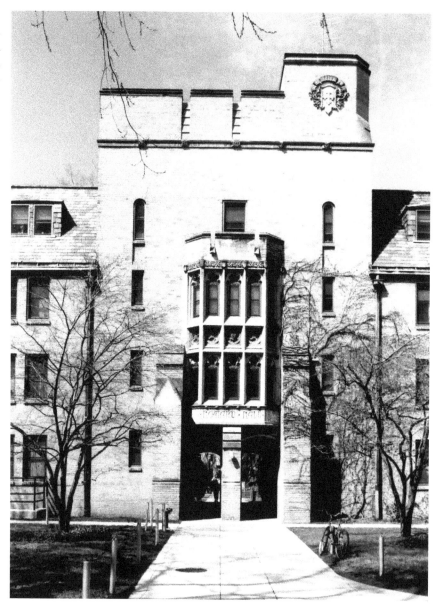

was enlarged by the addition of two wings and converted to a student dormitory with a cafeteria in the lower level.[11] Located southeast of Lemonnier Library, it formed the southern edge of a quadlike space fronting the library and extending eastward to Sorin Hall and the main quadrangle.[12]

In 1923, following the master plan, Father Walsh commissioned three new dormitories: Howard, Morrissey, and Lyons Halls. They were located directly south of Lemonnier Library and west of Badin Hall. Kervick and Fagan took

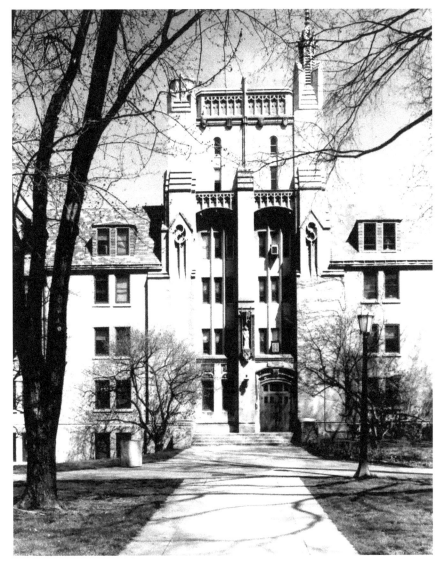

FIGURE 15.2
Morrissey Hall, 1925,
Francis Kervick and
Vincent Fagan,
architects. (Photo by
author.)

special care to spatially link each building to the others and to the landscape by providing a passage through the middle of Howard Hall and an even more magnificent arched passage in a diagonal wing that connected Lyons and Morrissey Halls, which were sited along a ridge overlooking St. Mary's Lake. This arched passage framed a panoramic view of the lake, providing a visual and physical connection between the lake and the complex's main outdoor space.[13] The plans of the three buildings did not adhere precisely to the original plan, but in its actual execution, the complex framed a more coherent space facing south toward University Road than that suggested in the master plan.

FIGURE 15.3
Arched passage
between Morrissey
and Lyons Halls, 1925,
Francis Kervick and
Vincent Fagan,
architects. (Photo by
author.)

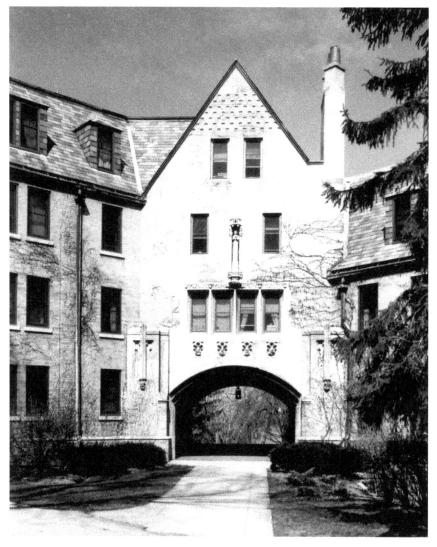

These dormitories, designed by Kervick and Fagan, were the first truly Collegiate Gothic–style buildings to be constructed on the campus. Built of yellow brick and limestone masonry, they featured prominent gabled roofs with dormer windows, Gothic detailing around the main doors, and delightful Gothic tracery that references saints, famous Notre Dame professors, and themes of sports and changing seasons.

While the transformation of campus architecture to the Collegiate Gothic style reflected a national trend in college building design, it also followed an important precedent in Notre Dame's history set by the Gothic-style Sacred

Heart Basilica. Here the style of the religious realm was projected onto the academic realm. The distinction between these new dormitories and the recently built Lemonnier Library could not have been more evident. The change of attitude toward architectural style on the part of the university administration since the completion of the library was clear, and Kervick and Fagan gave it visible expression.

Building the South Quad

By the time the Howard-Lyons-Morrissey complex had been completed, Kervick and Fagan's master plan was already outdated, as they had not envisioned the extent to which the campus would rapidly expand farther to the south, beyond University Road. This area was to become the South Quad, an entirely new academic quadrangle over twice the size of the Latin Quad and its buildings from the time of Sorin and Edbrooke.

The first building to be constructed along the south side of the new quad, and thus the first to define its spatial limits, was the South Dining Hall. The most inspired Collegiate Gothic building on the campus, it was designed in 1924 by Ralph Adams Cram in association with Kervick and Fagan. Cram was a leading figure in the Gothic Revival movement in the United States and architect of St. John the Divine Cathedral in New York. A devout Christian, he lectured widely across the country on the virtue of English Gothic as the most appropriate style for ecclesiastical and campus architecture. Inspired by Ruskin, he extolled the beauty and the uplifting qualities of the Gothic Style as a fitting expression of a Christian society.[14]

Cram's reading of the works of Pugin and Ruskin introduced him to the possibilities of the Gothic style as a way to move beyond both Richardsonian Romanesque and Neoclassicism. He made study tours of England early in his career, in 1885 and 1897, and studied and photographed English medieval churches, including the chapel at Magdalen College, Oxford. He compiled and published this research in the book entitled *English Country Churches* (1898).[15] Cram's first major commission came in 1903 when his firm, Cram, Goodhue and Ferguson, won a competition for the rebuilding of the U.S. Military Academy at West Point. In the words of Paul Venable Turner, it was an "uncompromisingly Gothic and picturesque design" that evoked romantic images of medieval fortresses or monastic strongholds.[16] Shortly after, the firm was

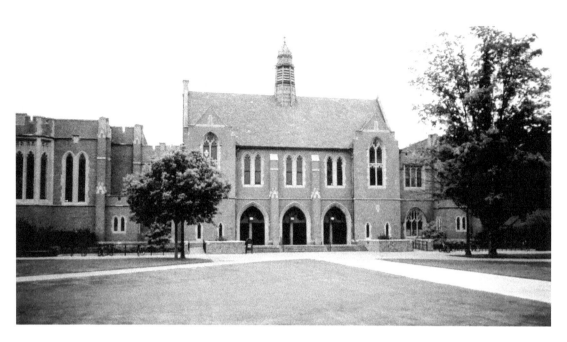

commissioned to design the crossing and nave of St. John the Divine. The choir had already been constructed in the Romanesque style by the firm of Heins and La Farge. Cram continued the building's construction but changed its design to the English Gothic style, which he preferred.[17]

In the 1910s and the 1920s Cram served as the supervising architect of several colleges and universities, including Princeton, Bryn Mawr, Mount Holyoke, and Wellesley, where he further promoted the Gothic Revival as the style for collegiate architecture. He also published several books on architecture, sociology, and religion, including *The Ruined Abbeys of Great Britain*, *The Sins of the Fathers*, and *The Gothic Quest*.[18]

Notre Dame honored Cram with an honorary doctorate degree in 1924, and soon after it commissioned him to design the South Dining Hall.[19] A distinctive structure, the design was based on a medieval guildhall, with two large refectories connected in the middle by a two-story building containing the kitchens, a cafeteria, and a faculty dining hall. Its plan is symmetrical, with the central wing featuring a pair of gabled pavilions framing three lancet-arched doorways. A tapered, domed cupola rises from the center of the roof. The large dining halls on either side are marked by tall lancet windows set high in the walls, with projecting bays marking the main axes. The building is especially distinctive in the context of the campus for its vermilion-colored brick exterior and for its interior dark-oak paneling, terrazzo floors, and beamed ceilings.

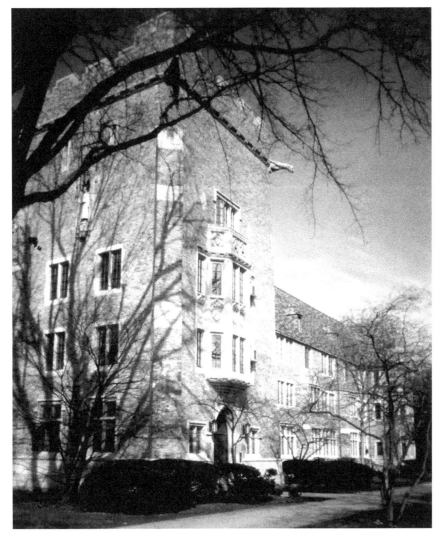

FIGURE 15.5
Alumni Hall, 1931,
Maginnis and Walsh,
architects. (Photo by
author.)

The original cafeteria space was adorned with wall frescoes by the Hungarian artist Augustin Pall.[20]

The South Quad was further defined by the construction in 1931 of a pair of dormitories, Dillon and Alumni Halls, which are among the university's most distinguished works of residential architecture. Located immediately east of the South Dining Hall, they extended the Quad's southern border. Alumni Hall fronts on a circle that terminates the main axis leading from Notre Dame Avenue to the Main Building. Both buildings are designed in a modified U-shaped plan that encloses a common courtyard between them, resembling a medieval cloister.

The architect of Dillon and Alumni Halls was the Boston firm of Maginnis and Walsh, known nationally for their design of Catholic churches and institutional buildings. Timothy F. Walsh was born in Cambridge, Massachusetts, in 1868 and apprenticed in the office of Peabody and Stearns in the 1890s. He spent two years studying and traveling in France before beginning his own practice with Charles Maginnis in 1896.[21] Charles Donagh Maginnis was born in Londonderry, Ireland, in 1867 and was educated at Cusack's Academy in Dublin. He came to Boston as a young man and in 1885 entered the office of city architect Edmund M. Wheelwright. He was noted for his pen-and-ink drawings and published the highly regarded book *Pen Drawing* (1921). He received numerous honors over the course of his career, including the Laetare Medal from Notre Dame and honorary degrees from Boston College, Holy Cross College, Tufts University, and Harvard University. He served two terms as president of the American Institute of Architects in 1937 and 1938, and he received the institute's Gold Medal in 1947.[22] From the 1890s to the 1930s, Maginnis and Walsh designed more than 115 ecclesiastical commissions, including buildings for Boston College, the National Shrine of the Immaculate Conception in Washington, DC, Holy Cross College in Worcester, Massachusetts, the Cathedral of Mary our Queen in Baltimore, and Maryknoll Seminary and Convent in Los Gatos, California.[23]

The Gothic detailing on Dillon and Alumni Halls is finely carved with some of the most intriguing sculpted figures of any campus building. Alumni Hall features an elaborately detailed, deeply shadowed arched entrance facing onto the circle. Maginnis and Walsh would go on to design Cavanaugh, Zahm, and Haggar Halls in 1937 to 1938, Breen-Phillips Hall in 1939, and Farley Hall in 1947, all facing onto the North Quad.

Besides designing many of the university's finest dormitories, Maginnis and Walsh also designed the Law School. Built in 1930, it faces the circle opposite Alumni Hall, the two buildings forming a gateway from Notre Dame Avenue. Consistent with the Collegiate Gothic style of other buildings from this period, it features an entrance tower with a lancet-arched doorway. A long range of lancet-arched windows on the upper stories indicate the location of the impressive reading room of the Law Library. An addition to the library would be constructed in 1972 and a second, extensive addition to the south would be added in 2005.

Continuing the South Quad's eastern extension, the university commissioned Kervick and Fagan in 1933 to design the Cushing Hall of Engineering

FIGURE 15.6
Law School, 1930,
Maginnis and Walsh,
architects. (Photo by
author.)

to replace the Engineering Hall of 1905, which was damaged in a fire caused by a lightning strike.[24] Designed for a site east of the Law School, it was for many decades the largest classroom building on the campus.

Also in 1933, the university commissioned the Chicago firm Graham, Anderson, Probst and White to design a building for the College of Commerce. The college had been established in 1921, and money for the new building was donated by Edward Nash Hurley, who was chairman of the U.S. Shipping Board during World War I and who had received the university's Laetare

FIGURE 15.7
Commerce Building
(Hurley College
of Business
Administration),
1932, Graham,
Anderson, Probst and
White, architects.
(Photo by author.)

Medal in 1926. He encouraged the university to hire the firm, which he knew from his own projects in Chicago.

The building is a large and centrally located structure sited in order to define one corner of the campus's main quad and enhance its overall cross-axial plan. It has two stories and an E-shaped plan. The grand two-story entrance hall is decorated with wall murals depicting international shipping routes and a giant globe at its center, reflecting Hurley's desire that the college have an international perspective.[25]

Both the College of Commerce and the Law School are notable for the fact that they represent a high point on the campus for the Collegiate Gothic style.

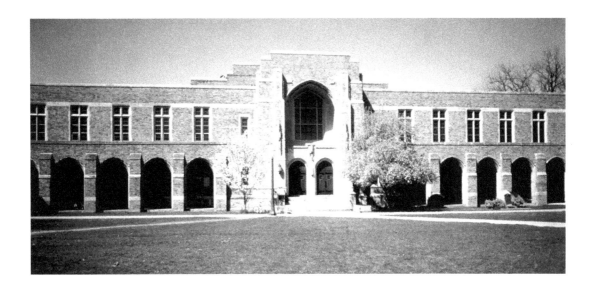

FIGURE 15.8
Rockne Memorial
Hall, 1937,
Maurice Carroll,
architect.
(Photo by author.)

When considered collectively, Kervick and Fagan, Maginnis and Walsh, and Graham, Anderson, Probst and White together made a simplified or modernist-inspired Gothicism a predominant architectural style on the Notre Dame campus in the 1920s and 1930s. The stylistic turn toward Gothicism that these architects advanced was a widespread trend at college and university campuses across the country.[26]

The western end of the South Quad was finished off with the construction from 1937 to 1938 of the Rockne Memorial Hall, named after the university's famed football coach Knute Rockne. Designed by J. Maurice Carroll and C. E. Dean of Kansas City, Missouri, it features a central entrance portico flanked on either side by loggias. It houses a gymnasium, swimming pool, and fitness facilities.

Carroll was a 1919 graduate of Notre Dame's School of Architecture. His first project after graduation was the design of Le Mans Hall on the Saint Mary's campus. He later gained prominence for the design of two churches in his hometown of Kansas City, Missouri: St. Vincent's Church in 1922 and St. Peter's Church in 1947, both of which gained him medals from the American Institute of Architects. He formed the partnership Carroll and Dean at the time of the construction of Rockne gymnasium. In the 1960s he would serve as the vice president of the Notre Dame National Alumni Board.[27]

The development of the South Quad was consistent with the Beaux-Arts system of architectural planning, another manifestation of the influence of the Columbian Exposition and the City Beautiful movement. As Turner has

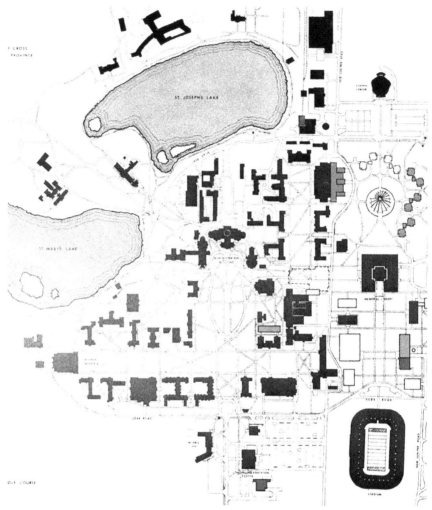

written, the Beaux-Arts system was based on principles of monumental orga-
nization that facilitated orderly planning on a grand scale and was capable
of including many disparate buildings within a unified overall pattern. It was
natural, in Turner's words, "that many of the new American universities, large
both in size and ambition and thinking of themselves as cities of learning,
should turn to the newly fashionable Beaux-Arts system to create their physi-
cal form and self-image."[28] Yet at the same time, the South Quad, with its open
expanses and tree-lined walkways, channeled the pastoral ideal of peaceful se-
clusion that had guided prior generations of campus architects at Notre Dame.
Kervick wrote of the South Quad in 1938, "Several of the buildings erected
since 1930 have been placed on a new campus, to the south of the old one. The

newest development of the campus, is sometimes called a plaza, but is in effect a spacious mall, extending east and west. The place has been planted with elm trees, and it is hoped that as these develop, this part of the campus will be characterized by that sequestered peace one feels on the common of an early American village—rather than by the confusion of a sun-baked market-place which the term 'plaza' connotes."[29] The South Quad thus possessed a degree of formality and grandeur that diverged from the picturesque informality of the Latin Quad while maintaining its pastoral, almost bucolic, ideal.

The 1920s were one of the most important decades for the character of Notre Dame's campus planning and architecture. The development of the Howard-Lyons-Morrissey complex and the South Quad created an entirely new campus center distinct from the Latin Quad, which remained the campus's historical sacred area. The transformations from Victorian Gothic to Classical Revival and then to Collegiate Gothic marked profound changes to the campus's image.

Saint Mary's College

The principal features of the Saint Mary's campus were well established by the turn of the century with the construction of Holy Cross Hall. Saint Mary's Avenue, with the fieldstone gateway at its entrance and its circular drive in front of Holy Cross Hall, provided a picturesque point of arrival to the campus.

The largest building to be constructed at Saint Mary's was Le Mans Hall, begun in 1924 and completed in 1926. Designed in the Collegiate Gothic style, it was adapted from Carroll's thesis from his fifth year as an architecture student at Notre Dame.

Called at the time of its construction "New College," the building housed the upper classes and provided classrooms and office space for the administration. Its cost was nearly $1.5 million, and when the fundraising efforts fell short, the Holy Cross sisters mortgaged two-thirds of the cost. While the hall was still under construction, the college received approval for an additional wing, housing classrooms and a dining hall, to ensure that it would meet the students' needs for several decades to come.[30] A large, imposing structure, it is U-shaped in plan and features a crenellated tower and prominent entrance recessed under a series of arches as well as Tudor and pointed arches, buttresslike pilasters, and Bedford stone trim.

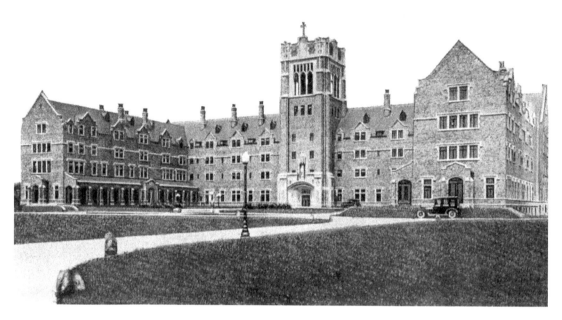

FIGURE 15.10
Saint Mary's College,
Le Mans Hall, 1925,
Maurice Carroll,
architect. (Author's
collection.)

City and Campus

It is interesting that, as of 1930, in a span of some fifteen years between World War I and the onset of the Great Depression, Notre Dame and Saint Mary's achieved an overall unity in the composition of their architecture as they embraced the Collegiate Gothic as the official campus style. South Bend's architecture, however, assumed a different trajectory in this same era. The architects who came of age at the turn of the century with the Prairie School turned to all manner of styles for commercial and residential buildings. The city of South Bend developed a disparate urban image with great variety of Period Revival styles, continuing the Neoclassical while expanding its architectural repertoire in multiple directions. Ironically, as South Bend's residential fringe edged closer to Notre Dame's campus in the 1920s and 1930s, the architectures of city and campus grew further apart.

Epilogue

The Great Depression, the Advent of Modernism,
and the Search for a New Identity

The urban development of South Bend from the 1850s depended on the continuing prosperity of its two largest corporations, the Studebaker Manufacturing Company and the Oliver Corporation, and on their many competitors and supporting industries. The first pinnacle of these corporations' success was reached in the 1860s, at the time of the Civil War, and another pinnacle arrived in the late 1920s before coming to an abrupt but temporary end with the onset of the Great Depression.

When prices broke on the stock market on October 28, 1929, billions of dollars in paper profits were wiped out. The decline continued the next day with more than 16 million shares being dumped in the most disastrous day in the history of the exchange. It became apparent that the country was faced with an overproduction of goods and capital, overambitious expansion of business, and an overproduction of commodities, most of it as a consequence of reckless installment buying.[1] From September to November alone the value of stocks declined nearly 42 percent; eventually the value would drop by 89 percent from its peak in 1929.

By 1933 residential construction nationwide had declined by 82 percent, and other construction—commercial and institutional—declined by 75 percent, all of which had a profound effect on architects, structural engineers, construction workers, the lumber industry, and other industries dependent on construction. Iron and steel construction declined by 59 percent; automobile

production nationwide declined by 65 percent. The direct losses of employment and income decreased demand from local merchants, service industries, builders, and others, thus devastating entire communities nationwide.[2]

During the three years following the crash more than five thousand banks across the country failed, private businesses and city governments went bankrupt, and construction projects halted as banks refused to extend credit.[3] Unemployment would reach 25 percent by 1933, and hundreds of thousands of Americans found themselves homeless and began living in shanty towns, called infamously "Hoovervilles." The situation was made even worse by a devastating and long-lasting drought across the Great Plains and Midwest.[4] In 1933 more than eight thousand men registered at the South Bend City Hall as unemployed. As part of the relief efforts, the Civic Works Program of St. Joseph County employed up to four thousand laborers to maintain and improve the Leeper, Rum Village, Studebaker, Harrison, Bendix, and Erskine city parks, which had been so vital to South Bend's City Beautiful movement.[5]

The stock market crash deeply affected the Studebaker Manufacturing Company, where sales and profits dropped from $12 million in 1929 to $1.5 million in 1930. The next year, profits dropped to less than $1 million. Company president Albert Erskine, along with the rest of the management team, dramatically underestimated the seriousness of the economic collapse and continued to pay out dividends to stockholders as if a full recovery was just around the corner.[6]

The company could no longer pay its bills by the time of the national banking moratorium in March 1933. Its board of directors filed for bankruptcy on March 21, 1933, and Erskine resigned. Members of the board of directors initiated an aggressive marketing and financial-restructuring campaign aimed at pulling the company out of bankruptcy, but the damage was done. It took years for sales to pick up. It was not until 1941, with the success of the Champion automobile, that sales again exceeded 100,000.[7]

The city's banks, commercial businesses, office blocks, and highly leveraged theaters suffered tragic losses as many of them closed and filed for bankruptcy. The decline of the urban businesses and entertainment venues was coincidental with the mass migration away from the inner-city businesses to newer mall shops and stores in the suburbs. When people went to a bank, a store, or the movies, they wanted to park their car nearby, and they didn't want to pay for parking. The city's downtown commercial core came to be seen as outdated and inaccessible, part of an overall decline of cities nationwide.[8]

The Beginnings of Modernism

In the midst of the Depression and war years of the late 1930s and 1940s, a small number of American architects and their clients began to look to the progressive ideas being promoted by architects who moved to the United States from Europe, such as Walter Gropius and Ludwig Mies van der Rohe. Their mode of architecture was beginning to be recognized as the International style. New influences of European Modernism began to take hold, including the Bauhaus and, more directly, the 1932 International Exhibition at the Museum of Modern Art and the publication of *The International Style* by Philip Johnson and Henry-Russell Hitchcock.[9]

The theoretical premise of this new style was the elimination of unnecessary ornamentation, the simplification of plan and massing, and the straightforward expression of structure. The contributions of the engineer were more readily accepted, and functional requirements became a dominant factor in determining architectural form.[10] There was faith in the rigors of science, a belief that all of life's problems could be solved by the scientific method. Architecture and planning were especially overtaken by the methods of science, reducing everything to functionality, efficiency, and rational order. Planning at any scale, whether entire cities, a single building, or a room, came to be thought of in terms of a logical diagram based on purely functional needs, without explicit ornamentation or unnecessary elaboration.

The influence of modern architecture first appeared in South Bend in the 1940s, just after the end of World War II. A number of new houses were built in the city, most in the Art Moderne style, some designed by Austin and Shambleau and others by faculty members of Notre Dame's Architecture Department, including Vincent Fagan, Francis Kervick, Otto Seeler, and Frank Montana. New York architect William Lescaze designed a house for a South Bend client in 1948, and in the same year, Frank Lloyd Wright built his second South Bend house in the Usonian style. By the beginning of the 1950s, modern architecture began to appear in institutional and commercial buildings as well.

The materials most commonly used for this new architecture were concrete, glass, and steel, with stucco finishes. Added to this were a rejection of nonessential decoration and a paring down and abstraction of all architectural forms to simple geometric shapes, with flat roofs, horizontal bands of windows, and generally asymmetrical massing. An Italian palazzo facade, for instance, was no longer a valid design option for a steel-frame office building.

During the 1960s, when many cities across the United States—especially larger cities such as Chicago, Los Angeles, and Atlanta—were being transformed by developments in Modernist architecture, downtown South Bend had its own modest response to modernity. California architect William Pereira was commissioned to design the offices and studios of the WSBT television station at 300 West Jefferson Boulevard (1955). A new public library was constructed at 122 West Wayne Street in 1958, designed by Charles Cole Sr., in association with the New York firm of Eggers and Higgins. This building was radically altered in a renovation and addition done by the Indianapolis firm of Woollen Associates in the 1980s, and in 2020 and 2021 it underwent a substantive renovation by Robert A. M. Stern Architects.

At Notre Dame, three notable buildings constructed in the 1960s introduced Modern architecture onto the campus: the Radiation Lab, McKenna Hall, and Hesburgh Memorial Library. Designed in the early 1960s by the Chicago firm of Skidmore, Owings and Merrill, the Radiation Lab is clad in concrete panels with vertical fins and fixed windows, giving the impression of a sealed container that floats above the landscape. McKenna Hall was designed in 1965 by Notre Dame faculty members Frank Montana and Robert Schultz; its plan and central atrium with skylight are based on that of McGregor Hall at Wayne State University in Detroit (1958) by Minoru Yamasaki, for whom

Montana worked before coming to Notre Dame. McKenna Hall was demolished in 2019.

Hesburgh Memorial Library is notable not only for being the most prominent Modernist building on the Notre Dame campus, but also because it was the campus's first high-rise structure. Reaching 215 feet in fourteen stories, it towers over the campus's east side. Designed from 1964 to 1965 by Ellerbe Associates of Bloomington, Minnesota, it was the largest library in the world when it opened. Its steel-frame structure is clad with Mankato stone. Its 132-foot-high mural, *The Word of Life*, designed by artist Millard Sheets, is composed of eighty-one different kinds of stone from sixteen different countries.[11]

Urban Renewal in the 1960s

While the 1960s saw the introduction of Modern architecture in downtown South Bend, it was also a time of economic calamity that recalled the darkest days of the 1930s. The Studebaker Manufacturing Corporation, which had emerged from the Depression after filing for bankruptcy, closed abruptly in 1963, leaving thousands of skilled workers without jobs, pensions, or health insurance. It was a devastating blow to a community whose identity had always been inextricably tied to the great company that had defined and sustained the city's industrial and commercial image since the 1850s.

After a profound economic disintegration in the 1960s, South Bend then suffered years of urban renewal that were meant to revive the city's economy but ultimately did more harm than good. A master-plan study was produced in 1968 and 1969 by a group of architects and planners working for a local company called City Planning Associates (CPA).[12] The plan followed the trends of the day, the first of which was to close the city's main commercial street and transform it into a pedestrian shopping mall. South Bend's Michigan Street, from LaSalle to Williams, was closed off and "landscaped" with planters, benches, and kiosks. Other streets and boulevards that had once been thought of in aesthetic terms, following the principles of the City Beautiful movement, were now viewed as purely functional entities: a means of moving ever-increasing numbers of automobiles and trucks through and around the city. One-way streets were seen by city officials as a big improvement over two-way thoroughfares, allowing traffic to move even faster through the city.

Tragically, the city initiated a massive demolition campaign, destroying buildings on Michigan Street that would have been vital to the success of the pedestrian mall. Businesses closed because there was no longer any automobile traffic, buildings were demolished, and by the time the pedestrian mall opened to great fanfare, there was little left to attract shoppers.

Among the most long-lasting effects of South Bend's era of urban renewal was the mass displacement of inhabitants from "blighted" residential neighborhoods to make way for new development. Three neighborhoods in particular—Sample Street (1960–1967) southwest of downtown, Chapin Street (1963–1969) southeast of downtown, and LaSalle Park (1966–1974) near the former Studebaker plant—were affected; and all three neighborhoods had housed predominantly Black populations. Data from the University of Rich-

mond's *Renewing Inequality* project reveals that 155 families were displaced from the Lasalle Park neighborhood (149 of whom were families of color), 335 families were displaced from the Sample Street neighborhood (190 of whom were families of color), and 116 families were displaced from the Chapin Street neighborhood (104 of whom were families of color). As urban renewal reshaped South Bend's residential landscape, it disproportionately affected South Bend's African American population.[13]

South Bend's urban-renewal efforts also targeted for demolition the extensive neighborhood and business district that existed along the riverfront, from Colfax Street on the north to Sample Street on the south. The Sample Street Bridge was replaced by a sprawling interchange and raised bridge structure. The CPA master plan called for the construction of several modern high-rise office and residential buildings in the area; however, none were built as envisioned. Instead, a series of two- and three-story private office buildings and a giant post office building were constructed, along with an expansive parking lot for each one.

The problems of the period became especially apparent with the battle over the historic designation of three high-rise buildings downtown: the Odd Fellows Building, the JMS Building, and the former Oliver Opera House. The Odd Fellows Building and the Oliver Opera House were both slated for demolition. The Historic Preservation Commission attempted to nominate the three buildings to the National Register of Historic Places. The city put up a battle against the proposal, and the Odd Fellows Building and Oliver Opera House were eventually demolished.

An example of the excesses of this period is seen in the demolition of the Italianate-style Studebaker headquarters at the corner of Jefferson and Main Streets, which was occupied from 1955 to 1974 by an S. S. Kresge store. One of the city's most distinctive architectural landmarks from the nineteenth century, it had lost much of its original character when its ornate cornice was removed in the late 1960s and the Kresge Company modernized its first floor with plate glass windows and giant sign letters, painting out all the windows on the upper floors. The ever-prevalent modernist ideologies convinced building owners, store managers, and the public alike that older buildings were somehow outdated and needed to be streamlined, stripped of their details, and whitewashed to convey newness, cleanliness, and efficiency. Anything that reflected character, tradition, or the past was reputedly no longer of value to

society or to the city. Within a few years of the plan's implementation, it became apparent that what urban-renewal efforts had accomplished paled in comparison to what they had irrevocably disrupted.

At the same time, most commercial, office, and housing developments moved to suburban locations northeast, south, and west of the city, further draining downtown of its economic vitality. Suburban developers were seen as more competent at making their developments successful because they were dealing with new properties, where the development costs were lower because they did not have to worry about demolition or renovating old buildings that did not easily adapt to new functions.

Downtown Renaissance

It was not until 1976, when New York architects Philip Johnson and John Burgee were commissioned to design Century Center on the riverfront, that interest in downtown was rekindled. This civic center consists of five separate structures knitted together with skylit brick corridors, which Johnson called interior streets. Separate functions include a convention hall, an industrial museum, a theater with 718 seats in a thrust-stage design, an art center, and a large multiuse central hall with an expansive glass wall facing the river. Stylish skylights set at a 45-degree angle cover the interior walkways, two of them forming a projecting canopy at the main entrance.

Although the Century Center blocks physical access between downtown and the riverfront, it has been a generally successful building, providing a panoramic view of the river and creating an inviting space that feels like the city's center. The corridors are meant to be extensions of the streets. It directs focus to the island, which is used throughout the summer for recreation, musical events, and exhibits. The convention hall and the atrium both serve as banquet halls that can accommodate hundreds of people. The detailing is spare, the scale monumental. The geometry is angular—a group of resolved triangles following the course of the river.

In the late 1970s another proposal was made for downtown South Bend, this one a plan by the New York architect Gruen Associates in association with César Pelli. They were commissioned to produce a design proposal that included several new office buildings and a new commercial shopping mall. The plan proposed to build a large enclosed mall on Michigan Street and an open-

FIGURE 16.3
Century Center
(1977) as viewed from
the St. Joseph River.
(Photo by author.)

air market across from the courthouse. It was extensively promoted, but ultimately no developers could be attracted to invest in the mall project.

One of the last Modernist buildings of note to be constructed in downtown South Bend was the 1st Source Bank/Marriott Center (now DoubleTree Hotel), located between Michigan and St. Joseph Streets, overlooking the river and Century Center. Designed by Helmut Jahn of the Chicago firm of Murphy/ Jahn Associates, it consists of two buildings clad with smooth metal panels and glass and connected by a glass-enclosed atrium with a trapezoidal glass roof. At the time of its construction, it was a dramatic new addition to the city and the region, one of Jahn's most outstanding designs. Its popularity quickly faded, however, as heating and cooling costs increased, glass roofs began to leak, sheets of ice began falling off the south roof slopes onto the sidewalk, and large umbrellas had to be installed over the bank's counters so that the tellers could see their computer screens.

Beyond Modernism at Notre Dame

The sense of place at Notre Dame was so strong that after limited forays into Modern architecture in the 1960s and 1970s, the administration, at the urging

of the School of Architecture (and as architect Robert A. M. Stern famously argued), began to consider the campus's sense of place rather than its sense of time. The Collegiate Gothic style, which had been so dominant in the first three decades of the century, saw a resurgence. This decision in favor of conventional stylistic motifs made perfect sense. The Notre Dame vernacular, with its many variations of Gothic motifs, expressed the university's institutional functionality with a cloak of Catholic character. While the Modernist buildings designed by Ellerbe and Skidmore, Owings and Merrill denied the existence of style, revivalist designs by SLAM, Hardy Holtzman Pfeifer, and others recognized that the functional requirements of any building could be equally served regardless of the stylistic character, but that the sense of place could be reinforced with the inclusion of Gothic stylistic elements.

The 1990s witnessed a dramatic change in architectural theory and practice across the country. The playfulness of the Postmodern style of the 1980s was replaced by a split in the architectural profession that manifested itself in a simultaneous return to Modernism and to literal Classicism and traditional architecture. In terms of urban design, this period was also marked by the advent of New Urbanism, a city design based on principles of traditional city planning adapted to modern-day needs. Notre Dame's endowment grew at an unprecedented rate during this decade as well, and major building campaigns were undertaken, including new buildings for the Theater and Drama Department, the Chemical Engineering Department, the Law School, the Engineering College, and the School of Architecture, and a renovation and expansion of the Morris Inn.

South Bend, in contrast, languished. At one of the most prosperous moments in the nation's history, very little was built downtown. Aside from a renovation of the Morris Center for the Performing Arts and construction of the Leighton Medical and Fitness Center, virtually no progress was made in filling its many vacant lots or bringing back commercial activity.

Retrospect and Prospect

South Bend was not alone in experiencing economic and urban decline in the 1960s and 1970s. Hundreds if not thousands of other medium-sized cities across the United States faced the same problem. In a sense, South Bend is a metaphor for such cities, which came to prominence in the late nineteenth

century through industrial expansion and prospered during the war and inter-war years of the first half of the twentieth century. One by one they saw their prominent industries, commercial downtowns, and residential neighborhoods erode and disappear. Then they suffered through years of well-intentioned but physically disastrous urban-renewal schemes, most of them funded and promoted by the federal government.

The challenge for South Bend today is to redefine its identity in response to the social, economic, and political changes of recent decades. There is definite promise for the future, seen in the recent developments around the city's minor league baseball stadium, housing along the East Race, the Eddy Street Commons mixed-use development near Notre Dame, the construction of new office buildings downtown, and the return of two-way streets in the commercial core. Most important is a renewed focus on residential development in and around downtown with the construction of single-family houses, town-houses, and apartment buildings of all scales.

Finally, it is hoped that proposals for the city's future development will seek to preserve the historical character of its landmark buildings and neighborhoods while recentering traditional values in planning for South Bend's growth and its transformation from an industrial city to one of service, education, and tourism. The ideals of historic preservation and New Urbanism can be brought to bear on the city's renewal. The goal should be to increase the density of both commercial and residential areas while transforming its urban image to one of prosperity, growth, and delight.

Notes

Preface

1. For a discussion of historic buildings and their urban context see Diane Favro, *The Urban Image of Augustan Rome* (New York: Cambridge University Press, 1996), xix; Dorothy Metzger Habel, *The Urban Development of Rome in the Age of Alexander VII* (New York: Cambridge University Press, 2002), 1–5; and Wolfgang Braunfels, *Urban Design in Western Europe: Regime and Architecture, 900–1900*, trans. Kenneth J. Northcott (Chicago: University of Chicago Press, 1988), 1–10.

2. Favro, *Urban Image*, xx.

3. *Bulletin of the University of Notre Dame 1*, no. 1, Part 3: Law Department (1904–1905): 6, https://archives.nd.edu/bulletin/Bu_01-1-3.pdf.

Introduction

1. Charles C. Chapman, *History of St. Joseph County, Indiana; Together with Sketches of Its Cities, Villages, and Townships, Educational, Religious, Civil, Military, and Political History; Portraits of Prominent Persons, and Biographies of Representative Citizens* (Chicago: Charles C. Chapman, 1880), 7.

2. Chapman, *History of St. Joseph County*, 7.

3. Anderson and Cooley, comp., *South Bend and the Men Who Have Made It: Historical, Descriptive, Biographical* (South Bend, IN: Tribune Printing, 1901), 63.

4. Timothy E. Howard was born in Ann Arbor, Michigan, and attended the University of Michigan before transferring to Notre Dame, where he graduated in 1862. He served in the Union army during the Civil War and afterward returned to South Bend and began his teaching career at Notre Dame. *South Bend*

Tribune, July 10, 1916; *South Bend News-Times*, July 10, 1916; *South Bend News-Times*, July 11, 1916.

5. Timothy Edward Howard, *A History of St. Joseph County, Indiana*, 2 vols. (Chicago: Lewis, 1907), 1:iii–iv.

6. *Art Work of South Bend and Vicinity* (Chicago: W. H. Parish, 1894), n.p.

7. J. J. McVicker, *Pictorial Souvenir of South Bend, Indiana 1919* (Chicago: J. J. McVicker, 1919), n.p.

8. C. E. Young, ed., *South Bend World Famed* (South Bend, IN: Handelsman and Young, 1922), 1.

9. Thomas Schlereth, *The University of Notre Dame: A Portrait of Its History and Campus* (Notre Dame, IN: University of Notre Dame Press, 1976), xv.

Chapter One

1. Howard, *A History*, 1:10–18; Anderson and Cooley, *South Bend*, 9; George A. Baker, *The St. Joseph-Kankakee Portage* (South Bend, IN: Northern Indiana Historical Society, 1899), 5–6.

2. Francis Parkman, *The Oregon Trail/The Conspiracy of Pontiac* (New York: Library Classics of America, 1984), 397. On La Salle's life, see Anka Muhlstein, *La Salle: Explorer of the North American Frontier* (New York: Arcade, 1994).

3. Fort Miami was a mere eighty feet long by forty feet wide, with great square pieces of timber laid one upon the other. Howard, *A History*, 1:41; John D. Barnhart and Donald F. Carmony, *Indiana: From Frontier to Industrial Commonwealth* (New York: Lewis Historical Publishing, 1954), 1:32; and Logan Esarey, *History of Indiana from Its Exploration to 1922; Also an Account of St. Joseph County from Its Organization*, 3 vols., edited by John B. Stoll (Dayton, OH: Dayton Historical Publishing), 3:23.

4. Howard, *A History*, 1:27–28; Anderson and Cooley, *South Bend*, 10.

5. Barnhart and Carmony, *Indiana*, 1:32–34.

6. Howard, *A History*, 1:29.

7. After his return trip through the area in 1681, LaSalle continued across the portage, through Illinois, and down the Mississippi River. On yet another voyage, this one across the Gulf of Mexico, he was eventually killed in a mutiny by his own men. Barnhart and Carmony, *Indiana*, 1:34; Howard, *A History*, 1:38.

8. Esarey, *History*, 3:23.

9. Barnhart and Carmony, *Indiana*, 1:27.

10. John Reps, *Town Planning in Frontier America* (Columbia: University of Missouri Press, 1980), 58.

11. Father Claude Jean Allouez established a mission on the southern shore of Lake Superior in 1658, before coming to South Bend. Barnhart and Carmony,

Indiana, 1:30; "Log Chapel/Shrine (1832–)," Series 0010-Lo-2, Notre Dame Printed and Reference Material (PNDP), University of Notre Dame Archives, Notre Dame, IN.

12. Howard, *A History*, 1:39. On Fort St. Joseph, see Michael S. Nassaney, ed., *Fort St. Joseph Revealed: The Historical Archaeology of a Fur Trading Post* (Gainesville: University Press of Florida, 2019).

13. Schlereth, *University of Notre Dame*, 3–4; Thomas Schlereth, *A Spire of Faith: The University of Notre Dame's Sacred Heart Church* (Notre Dame, IN: University of Notre Dame Alumni Association, 1991), 2; "Log Chapel and Shrine."

14. Esarey, *History*, 3:27.

15. Barnhart and Carmony, *Indiana*, 1:42.

16. William Henry Smith, *The History of the State of Indiana from the Earliest Explorations by the French to the Present Time*, vol. 1 (Indianapolis: B. L. Blair, 1897), 23.

17. Howard, *A History*, 1:41–43; "Log Chapel and Shrine."

18. Esarey, *History*, 3:27.

19. Bernard Bailyn, *The Ideological Origins of the American Revolution,* 3rd ed. (Cambridge, MA: Belknap Press of Harvard University Press, 2017).

20. Howard, *A History*, 1:32.

21. The Congress of the United States, sitting in New York City on July 13, 1787, enacted an ordinance for the government of the Northwest Territory. The great triangle of land was bounded by the Great Lakes and the Ohio and Mississippi Rivers. It was eventually divided into the states of Ohio, Indiana, Illinois, Michigan, Wisconsin, and Minnesota. Rexford Newcomb, *Architecture of the Old Northwest Territory* (Chicago: University of Chicago Press, 1950), 1.

22. Howard, *A History*, 1:49.

23. John Jacob Astor emigrated from Germany in 1783 and established the American Fur Trading Company in New York in 1809. Howard, *A History*, 1:103–4, 127.

24. Esarey, *History*, 3:26.

25. Howard, *A History*, 1:104.

26. Howard, *A History*, 1:130–32; Chapman, *History of St. Joseph County*, 331–32.

27. Howard, *A History*, 1:132–34; Anderson and Cooley, *South Bend*, 11.

28. A debate has ensued over the years, some claiming that the original Navarre cabin had been destroyed years earlier. Clipping File ("Parks, City, H–L"), Local and Family History Department, St. Joseph County Public Library, South Bend, IN.

29. Howard, *A History*, 1:48.

30. Anderson and Cooley, *South Bend*, 12; Chapman, *History of St. Joseph County*, 464–65; Esarey, *History*, 3:28–29.

31. Esarey, *History*, 3:28–29.

32. Anderson and Cooley, *South Bend*, 13; Edythe Brown, *The Story of South Bend* (South Bend, IN: South Bend Vocational School Press, 1920), 22, 35; Howard, *A History*, 1:132–35; Esarey, *History*, 3:3, 29.

33. In 1840 Coquillard and Navarre were appointed to direct the removal of the remaining Potawatomi, a process which ended virtually all official Native American presence in the area. Howard, *A History*, 1:55. Some Potawatomi who remained in the region were eventually federally recognized as the Pokagon Band.

34. Howard, *A History*, 1:55.

35. Chapman, *History of St. Joseph County*, 332.

36. Frederick A. Karst, "A Rural Black Settlement in St. Joseph County, Indiana, before 1900," *Indiana Magazine of History* 74, no. 3 (September 1978): 252–67; *The Huggart Settlement* (Indianapolis: Historic Landmarks Foundation of Indiana, ca. 2000), Michiana Memory Digital Collection, Civil Rights and African American History, St. Joseph County Public Library Archives, https://michianamemory.sjcpl.org/digital/collection/p16827coll4/id/971. On free African American communities in former Northwest Territory during the antebellum period, see Kate Masur, *Until Justice Be Done: America's First Civil Rights Movement From the Revolution to Reconstruction* (New York: W.W. Norton, 2021), 24–30; Samantha Seeley, *Race, Removal, and the Right to Remain: Migration and the Making of the United States* (Chapel Hill: University of North Carolina Press, 2021), 296–303.

37. William Brookfield had moved to the area in 1827 and settled on a farm near the portage of the St. Joseph River. In 1830 he laid out there the town of St. Joseph, which he intended to be the county seat; however, this town was never developed and South Bend was officially made the county seat in 1831. Howard, *A History*, 1:173–75, 276; Anderson and Cooley, *South Bend*, 16.

38. New Haven was laid out by surveyor John Brockett in 1639 near the coast of Connecticut. Encompassing a half-mile square, it was divided by two parallel streets running east and west and two running north and south. The center of these nine equal squares was assigned as a common space, or town green, with a meeting house in the center. Leland M. Roth and Amanda C. Roth Clark, *American Architecture: A History* (Boulder, CO: Westview Press, 2016), 64.

39. Roth and Roth Clark, *American Architecture*, 64–71; Vincent Scully, Jr., *American Architecture and Urbanism* (New York: Praeger, 1976), 31–34; Ben Nicholson and Michelangelo Sabatino, eds., *Avant-Garde in the Cornfields: Architecture, Landscape, and Preservation in New Harmony* (Minneapolis: University of Minnesota Press, 2019).

40. Erik Vogt, "A New Haven & a New Earth: The Origin and Meaning of the Nine-Square Plan," in *Yale in New Haven: Architecture and Urbanism*, ed. Vincent Scully, Catherine Lynn, Erik Vogt, and Paul Goldberger (New Haven: Yale University Press, 2004), 37.

41. Reps, *Town Planning in Frontier America*, 141, 154.

42. Michael J. Lewis, *City of Refuge: Separatists and Utopian Town Planning* (Princeton, NJ: Princeton University Press, 2016), 216.

43. Lewis, *City of Refuge*, 216.

44. Steven Hurtt, "The American Continental Grid: Form and Meaning," *Threshold* 2 (Autumn 1983): 32.

45. The original plat was bordered on the north by a triangular block north of Navarre Street; the natural eastern edge was formed by the river; the southern boundary was Division Street (Western Avenue); and the western boundary was formed by the edge of a half block along Lafayette Street. Certain lots were designated for schools and churches, and the rest were to be sold for development.

46. Nearby towns with prominent courthouse squares, for instance, include LaPorte, Plymouth, Knox, and Rochester. Many others are found in counties in southern Michigan.

47. Vogt, "A New Haven & a New Earth," 49.

48. *South Bend Tribune*, January 26, 2015.

49. Anderson and Cooley, *South Bend*, 20; Howard, *A History*, 1:171–72; Brown, *The Story*, 33.

50. Howard, *A History*, 1:603–4.

51. Chapman, *History of St. Joseph County*, 604–5.

52. Howard, *A History*, 1:206–7.

53. The complete transcript of the specifications for the first county courthouse issued by the county commissioners is in Howard, *A History*, 1:208–11.

54. Talbot Hamlin, *Greek Revival Architecture in America: Being an Account of Important Trends in American Architecture and American Life Prior to the War between the States* (London: Oxford University Press, 1944), 299.

55. Howard, *A History*, 1:211–12.

56. Anderson and Cooley, *South Bend*, 28.

57. Howard, *A History*, 1:231.

58. Anderson and Cooley, *South Bend*, 21, 28.

59. Howard, *A History*, 1:309.

60. For information on the industrial town of Lowell, Massachusetts, see Hardy Green, *The Company Town: The Industrial Edens and Satanic Mills That Shaped the American Economy* (Philadelphia: Basic Books, 2010), 13–26.

61. Howard, *A History*, 1:232.

62. Howard, *A History*, 1:233.

Chapter Two

1. Father Edward Sorin and his six religious brothers had sailed from Le Havre to New York in the summer of 1841. They then trekked to Vincennes via the

Hudson River and Erie Canal, Lake Erie, then on foot from Toledo, the journey from New York taking twenty-four days. Hope, *Notre Dame*, 14–18.

2. Sorin, *Chronicles of Notre Dame du Lac*, xvi.

3. Anderson and Cooley, *South Bend*, 65–66.

4. For information on Father Stephen Theodore Badin, see Hope, *Notre Dame*, 38–41.

5. O'Connell, *Edward Sorin*, 106–7.

6. In 1838 a militia rounded up some eight hundred Potawatomi from north central Indiana and some from the St. Joseph River valley and herded them westward in what became the infamous "Trail of Death," in which at least one-fifth of the victims had died by the time they reached the Mississippi River. O'Connell, *Edward Sorin*, 113; Hope, *Notre Dame*, 40–41.

7. O'Connell, *Edward Sorin*, 107, 113; Howard, *A History* 1:55; Schlereth, *University of Notre Dame*, 8.

8. James J. Trahey, *Dujarie Hall* (Notre Dame, IN: University of Notre Dame Press, 1906), 2–7.

9. Schlereth, *University of Notre Dame*, 10; Vonada, *Notre Dame*, 70–71; Howard, *A History*, 2:622; Hope, *Notre Dame*, 52.

10. O'Connell, *Edward Sorin*, 132–42. The cost to build Father Sorin's new chapel was $250 in 1840s currency.

11. Hope, *Notre Dame*, 59.

12. O'Connell, *Edward Sorin*, 116–17.

13. Hope, *Notre Dame*, 65.

14. Hope, *Notre Dame*, 65.

15. Hope, *Notre Dame*, 90.

16. Hope, *Notre Dame*, 66.

17. O'Connell, *Edward Sorin*, 139–40.

18. Father Sorin planned Old College in the summer of 1843 with the assistance of Brother Francis Xavier Patois, a carpenter from Clermont, France, who also supervised construction of several of the university's other early buildings, most of them utilitarian structures. Vonada, *Notre Dame*, 73–74; Anderson and Cooley, *South Bend*, 65.

19. A state representative of St. Joseph County, John Dougherty Defrees, shepherded the bill through the legislature to grant a charter for the university, as well as for incorporating the Manual Labor School for the Brothers. See Sorin, *Chronicles*, 35; O'Connell, *Edward Sorin*, 139–40; Hope, *Notre Dame*, 56–57; University of Notre Dame, *A Brief History of the University of Notre Dame du Lac, Indiana, from 1842 to 1892, Prepared for the Golden Jubilee* (Chicago: Werner Company, 1895), 58–59.

20. Kenneth William McCandless, "The Endangered Domain: A Review and Analysis of Campus Planning and Design at the University of Notre Dame" (Master's thesis, University of Notre Dame, 1974), 40; Hope, *Notre Dame*, 56–57.

21. Howard, *A History*, 2:629.

22. Hope, *Notre Dame*, 71.

23. Each added wing measured forty by sixty feet in plan. Howard, *A History*, 2:629; Schlereth, *University of Notre Dame*, 26; Anderson and Cooley, *South Bend*, 67.

24. Mark C. Pilkinton, *Washington Hall at Notre Dame: Crossroads of the University 1864-2004* (Notre Dame, IN: University of Notre Dame Press, 2011), 21–22, 46.

25. *A Guide to South Bend, Notre Dame du Lac and Saint Mary's Indiana* (Baltimore, MD: John Murphy, 1859), 8.

26. Francis Kervick, *Architecture at Notre Dame: A Review to Commemorate the Fortieth Anniversary of the Department of Architecture, 1898-1938* (Notre Dame, IN: University of Notre Dame Press, 1938), 2.

27. Schlereth, *University of Notre Dame*, 24.

28. Schlereth, *University of Notre Dame*, 12–14.

29. Hope, *Notre Dame*, 57–58.

30. For information about the first church, dedicated to the Sacred Heart of Jesus, see Sorin, *Chronicles*, 74, 81–82.

31. Schlereth, *Spire of Faith,* 6.

32. Hope, *Notre Dame*, 72.

33. Hope, *Notre Dame*, 72.

34. Sorin, *Chronicles*, 82.

35. Schlereth, *Spire of Faith*, 6.

36. Sorin, *Chronicles*, 82.

37. Sorin, *Chronicles*, 87.

38. O'Connell, *Edward Sorin*, 275–76.

39. Esarey, *History*, 3:26.

40. Mother Gillespie was born in 1824 in Pennsylvania and graduated from Georgetown Academy at a time when education for women was rare. In 1869 she established the American branch of the Sisters of the Holy Cross. See *South Bend Tribune*, February 2, 2015.

41. Father Sorin had purchased the property west of Notre Dame for $8,000. He then donated it along with $5,000 to build the first structures on the Saint Mary's campus. O'Connell, *Edward Sorin*, 246–47; Anderson and Cooley, *South Bend*, 81; Hope, *Notre Dame*, 93–95; Amanda Divine and Colin-Elizabeth Pier, *Saint Mary's College: The College History Series* (Chicago: Arcadia, 2001), 13–16.

42. Sorin, *Chronicles*, 147; Divine and Pier, *Saint Mary's College*, 15.

43. Trumbull's notes are written on his site plan for the new buildings at Yale, which is in the Beinecke Library. Paul Venable Turner, *Campus: An American Planning Tradition* (New York: Architectural History Foundation, 1984; Cambridge, MA: MIT Press, 1984), 41; and Anne S. Pratt, "John Trumbull and the Old Brick Row," *Yale University Library Gazette*, July 1934, 11–20.

44. Turner, *Campus*, 41, 46.

45. Howard, *A History*, 2:614.

46. Howard, *A History*, 2:614.

Chapter Three

1. The Georgian style was named after the British monarchs who occupied the throne from 1714 to 1830. It is sometimes referred to as English Colonial. Roth and Roth Clark, *American Architecture*, 69.

2. Virginia McAlester and Lee McAlester, *A Field Guide to American Houses* (New York: Alfred A. Knopf, 1984), 142.

3. William H. Pierson Jr., *American Buildings and Their Architects*, Vol. 1, *The Colonial and Neo-Classical Styles* (Garden City, NY: Doubleday, 1970), 111–14.

4. Sterling Boyd, "The Adam Style in America: 1770–1820," Ph.D. diss., Princeton University, 1966, 3.

5. Pierson, *American Buildings and Their Architects*, 212.

6. McAlester and McAlester, *Field Guide*, 158.

7. David King, *The Complete Works of Robert and James Adam* (Oxford: Butterworth-Heineman, 1991), 2–6.

8. Wilbur D. Peat, *Indiana Houses of the Nineteenth Century* (Indianapolis: Indiana Historical Society, 1962), 10.

9. Pierson, *American Buildings and Their Architects*, 210.

10. T. Hamlin, *Greek Revival Architecture in America*, 36.

11. W. Barksdale Maynard, "The Greek Revival: Americanness, Politics and Economics," in *American Architectural History: A Contemporary Reader*, ed. Keith L. Eggener (New York: Routledge, 2004), 132–34.

12. Pierson, *American Buildings and Their Architects*, 349–52.

13. Pierson, *American Buildings and Their Architects*, 402.

14. Roth, *American Architecture*, 89.

15. Pierson, *American Buildings and Their Architects*, 335–36.

16. Pierson, *American Buildings and Their Architects*, 336.

17. Anderson and Cooley, *South Bend*, 28.

18. *South Bend News*, June 10, 1900.

19. *South Bend News-Times*, June 10, 1900.

20. *South Bend News-Times*, June 10, 1900.

21. The other two Greek Revival courthouses in Indiana are located in the towns of Paoli and Rising Sun. Jon Dilts, *The Magnificent 92 Courthouses of Indiana* (Bloomington: Indiana University Press, 1999), 148.

22. A description of the second county courthouse's construction specifications is given in Howard, *A History*, 1:212–23.

23. *South Bend Tribune*, September 18, 1939.

24. Henry F. Withey and Elsie Rathburn Withey, *Biographical Dictionary of American Architects (Deceased)* (Los Angeles: Hennessey & Ingalls, 1970), 616–17. Van Osdel based his design of the Chicago City Hall on Faneuil Hall in Boston. Daniel D. Reiff, *Houses from Books; Treatises, Pattern Books, and Catalogs in American Architecture, 1738–1950: A History and Guide* (University Park: Pennsylvania State University Press, 2000), 81.

25. Henry Ericsson, *Sixty Years a Builder: The Autobiography of Henry Ericsson* (Chicago: A. Kroch & Son, 1942; repr., New York: Arno Press, 1972), 131.

26. I. T. Frary, *Early Homes of Ohio* (New York: Dover, 1970), 19.

27. Roth and Roth Clark, *American Architecture*, 64.

28. Roth and Roth Clark, *American Architecture*, 87.

29. Roth and Roth Clark, *American Architecture*, 65.

30. Carole Rifkind, *A Field Guide to American Architecture* (New York: New American Library, 1980), 38; Reiff, *Houses from Books*, 45–46.

31. Reiff, *Houses from Books*, 46.

32. Boyd, "The Adam Style," 139, 148.

33. Boyd, "The Adam Style," 160.

34. For a discussion of the publications of Stuart and Revett see Dora Wiebenson, *Sources of Greek Revival Architecture* (University Park: Pennsylvania State University Press, 1969), 1–35; and Robin Middleton's introduction to Julien-David LeRoy, *The Ruins of the Most Beautiful Monuments of Greece*, trans. David Britt (Los Angeles: Getty Research Institute, 2004), 2–3, 22–23.

35. LeRoy, *Ruins*, 82.

36. Wiebenson, *Sources*, 62–74.

37. T. Hamlin, *Greek Revival Architecture in America*, 300.

38. *South Bend Tribune*, April 4, 1954.

39. Mary Ellen Hayward and Frank R. Shivers Jr., *The Architecture of Baltimore: An Illustrated History* (Baltimore, MD: Johns Hopkins University Press, 2004), 101.

40. Howard, *A History*, 1:367.

41. Howard, *A History*, 1:213–14.

Chapter Four

1. Leland Roth, *A Concise History of American Architecture* (New York: Harper and Row, 1979), 85.

2. Peat, *Indiana Houses of the Nineteenth Century*, 85.

3. John Maass, *The Gingerbread Age: A View of Victorian America* (New York: Rinehart, 1957), 64.

4. Peat, *Indiana Houses of the Nineteenth Century*, 85–86.

5. Chapman, *History of St. Joseph County*, 495–96; Howard, *A History*, 2:620–22.

6. Chapman, *History of St. Joseph County*, 496.

7. Andrew Jackson Downing, *A Treatise on the Theory and Practice of Landscape Gardening, Adapted to North America; With a View to the Improvement of Country Residences* (New York: Wiley and Putnam, 1841), reprinted as A. J. Downing, *Landscape Gardening and Rural Architecture*, with an introduction by George Tatum (New York: Dover, 1991); and Andrew Jackson Downing, *Cottage Residences; or, A Series of Designs for Rural Cottages and Cottage Villas, and Their Gardens and Grounds*, 4th ed. (New York: John Wiley, 1852; reprint, Watkins Glen, NY: American Life Foundation, 1967).

8. Reiff, *Houses from Books*, 58. Alexander Jackson Davis, *Rural Residences, Etc. Consisting of Designs, Original and Selected, for Cottages, Farm-Houses, Villas, and Village Churches* (New York: New York University, 1837; reprinted, with an introduction by Jane B. Davies, New York: Da Capo Press, 1980).

9. Roth, *American Architecture*, 101.

10. Reiff, *Houses from Books*, 58.

11. Peat, *Indiana Houses*, 96; Andrew Jackson Downing, *The Architecture of Country Houses: Including Designs for Cottages, Farm-Houses, and Villas* (Philadelphia: D. Appleton, 1850; reprinted, with introduction by George Tatum, New York: Da Capo Press, 1968), ix.

12. George Tatum, introduction to Downing, *Architecture of Country Houses*, ix.

13. Downing, *Architecture of Country Houses*, ix.

14. Reiff, *Houses from Books*, 60.

15. For an early account of South Bend's African American history, see Buford F. Gordon, *The Negro in South Bend: A Social Study* (South Bend, IN: n.p., 1922); "United States Census, 1850," database and digital images, *FamilySearch.org* (accessed June 9, 2022); "United States Census, 1880," database and digital images, *FamilySearch.org* (accessed June 9, 2022).

16. Gordon, *Negro in South Bend,* 23; John Charles Bryant, "A Share in South Bend," *South Bend Tribune* (February 21, 1999), F8; "Dedication of Plaque and Memorial Bench—Powell Family House Site" (June 1, 2018), Indiana University South Bend Archives, Box 5, Folder 49, South Bend Civil Rights History Collection, https://archive.org/details/CRHC.SMALL.228a/mode/2up.

17. Gordon, *Negro in South Bend,* 36; Bryant, "A Share in South Bend"; "Dedication of Plaque and Memorial Bench."

18. Bryant, "A Share in South Bend"; "Dedication of Plaque and Memorial Bench."

19. Maass, *Gingerbread Age*, 98.

20. Downing, *Architecture of Country Houses,* 262–63. On Downing, the Italian Revival, and the nineteenth-century Midwest, see Peter Schmitt and Balthazar Korab, *Kalamazoo: Nineteenth-Century Homes in a Midwestern Village* (Kalamazoo: Kalamazoo City Historical Commission, 1976), 98–99.

21. Downing, *Landscape Gardening and Rural Architecture*, 333. The original title of the 1865 publication was *A Treatise on the Theory and Practice of Landscape*

Gardening, Adapted to North America: With a View to the Improvement of Country Residences.

22. Reiff, *Houses from Books*, 70–72.

23. Reiff, *Houses from Books*, 74.

24. Peat, *Indiana Houses*, 96.

25. The latter was the boyhood home of the famous kinetic sculptor George Rickey, who lived in South Bend until moving to Scotland at the age of seven. *South Bend Tribune*, February 1, 1987; *South Bend Tribune Michiana Magazine*, February 1, 1987.

26. On Schuyler Colfax's upbringing in South Bend, see Willard H. Smith, *Schuyler Colfax: The Changing Fortunes of a Political Idol* (Indianapolis: Indiana Historical Society, 1952), 4–45.

27. Smith, *Schuyler Colfax*, 369–416.

28. Anderson and Cooley, *South Bend*, 258.

29. McAlester and McAlester, *Field Guide*, 211.

30. Peat, *Indiana Houses*, 127.

31. The Anderson house was originally built on the lot immediately south of its present location. It was moved and its porch added in 1901.

32. Reiff, *Houses from Books*, 84.

Chapter Five

1. For a similar discussion of a city's hodgepodge industrial development, see Hayward and Shivers, *Architecture of Baltimore*, 153.

2. For information on the founding and early years of the Studebaker Company, see Cannon and Fox, *Studebaker*; Anderson and Cooley, *South Bend*, 374; Clipping File ("Industry-Industries-Studebaker Corporation to 1940"), Local and Family History Department, St. Joseph County Public Library, South Bend, IN; and *The Life of Clement Studebaker*, a manuscript held by the St. Joseph County Public Library and transcribed by Jan B. Young (Raleigh, NC: Lulu.com, 2009).

3. Clipping File ("Industry-Industries-Studebaker Corporation to 1940"), Local and Family History Department, St. Joseph County Public Library, South Bend, IN.

4. For information on John Clement Studebaker, see Chapman, *History of St. Joseph County*, 487–88; Howard, *A History*, 1:395, 399; and Thomas E. Bonsall, *More Than They Promised: The Studebaker Story* (Stanford, CA: Stanford University Press, 2000), 14–5.

5. Bonsall, *More Than They Promised*, 11.

6. By the time they had fulfilled the Milburn contract, the brothers found themselves in dire financial straits. They had expanded so rapidly and hired so many new people that they couldn't afford to maintain their business once the contract was finished. They were essentially bailed out, however, by one of their

younger brothers, John Mohler Studebaker, who had joined the gold rush to California in 1853. He became wealthy in a short time by making the wheelbarrows used by gold miners, and when he returned to South Bend in 1858, he invested much-needed cash into his brothers' company, enough to keep it running and allow it to expand.

7. Cannon and Fox, *Studebaker*, 17–18; Howard, *A History*, 1:399.

8. Cannon and Fox, *Studebaker*, 18.

9. Cannon and Fox, *Studebaker*, 19.

10. Bonsall, *More Than They Promised*, 24–25.

11. A detailed history of South Bend's early railroads can be found in Howard, *A History*, 1:236–40.

12. Howard, *A History*, 1:236–40.

13. The former seminary was the first state-chartered high school in South Bend. It was built of brick, two stories high, and measured forty feet long by thirty feet wide. Its gable roof was surmounted by a cupola. Chapman, *History of St. Joseph County*, 659–60.

14. At the time of the construction of Central High School, Williams Street, today a major north–south traffic corridor, terminated at Washington. The high school was thus located at the middle of a very long block that extended from Lafayette to Taylor Streets, essentially three city blocks.

15. Howard, *A History*, 1:449.

16. Asa E. Hall and Richard M. Langworth, *The Studebaker Century: A National Heritage* (Contoocook, NH: Dragonwyck, 1983), 28.

17. Bonsall, *More Than They Promised*, 29.

18. Edwin Corle, *John Studebaker: An American Dream* (New York: E. P. Dutton, 1948).

19. Cannon and Fox, *Studebaker*, 20; *Chicago Tribune*, December 28, 1997.

20. For information on the Pullman Building in Chicago, see Irving K. Pond, *The Autobiography of Irving K. Pond: The Sons of Mary and Elihu*, ed. David Swan and Terry Tatum (Oak Park, IL: Hyoogen Press, 2009), 93–96; 121–27.

21. Withey and Withey, *Biographical Dictionary*, 49–50.

22. Withey and Withey, *Biographical Dictionary*, 49–50; Thomas Schlereth, "Solon Spencer Beman, 1853–1914: The Social History of a Midwest Architect," *Chicago Architectural Journal* 5 (December 1985): 8–12; and John S. Garner, "S. S. Beman and the Building of Pullman," in *The Midwest in American Architecture*, ed. John S. Garner (Urbana: University of Illinois Press, 1991), 231–48.

23. Pond, *Autobiography*, 127.

24. Albert Russel Erskine, *History of the Studebaker Corporation* (South Bend, IN: Studebaker Corporation, 1924), 29; Bonsall, *More Than They Promised*, 27.

25. *South Bend Tribune*, July 19, 1940.

26. Howard, *A History*, 1:480.

27. *South Bend Tribune*, January 19, 1932; Howard, *A History*, 1:401–2.

28. The Milburn Manufacturing Company was for a time one of Studebaker's biggest competitors. It prospered in Mishawaka until a fire in 1873 caused it to relocate to Ohio.

29. *South Bend News-Times*, October 22, 2005; and *South Bend Today*, July–August 1916.

30. In the 1950s, the company was purchased by the Stone Container Company of Mishawaka.

31. Anderson and Cooley, *South Bend*, 378. On James Oliver, see Douglas L. Meikle, "James Oliver and the Oliver Chilled Plow Works" (Ph.D. diss., University of Indiana, 1958).

32. Joan Romine, *Copshaholm: The Oliver Story* (South Bend: Northern Indiana Historical Society, 1978), 4–5.

33. Romine, *Copshaholm,* 12–16; Howard, *A History*, 1:400–402.

34. *South Bend Tribune*, July 1, 2015.

35. Howard, *A History*, 1:482.

36. *South Bend Tribune*, October 23, 1938.

37. Anderson and Cooley, *South Bend*, 378–79.

38. *South Bend Tribune*, January 1, 1979.

39. *South Bend Tribune*, June 9, 1901.

40. Anderson and Cooley, *South Bend*, 380.

41. *South Bend Tribune,* June 3, 1917.

42. Anderson and Cooley, *South Bend*, 378.

43. The first subdivision in the neighborhood, the area around Our Lady of Hungary Catholic Church, was platted in 1890 by Barclay Kemble. The same year, Thomas Byerly platted the northwest corner of the neighborhood, and in 1891 City View Place was platted south of Kemble's Addition. In 1899 James Oliver himself platted Liddesdale Addition, located at the neighborhood's western edge. The central portion of the neighborhood, between Oliver School and Our Lady of Hungary Church, was platted by Ferdinand Raff in 1920.

44. Romine, *Copshaholm*, 34–35.

45. Romine, *Copshaholm*, 40.

46. The $200,000 price tag is given in *South Bend Tribune*, June 25, 1978; Howard, *A History*, 1:450–51.

47. *South Bend Tribune*, October 30, 1885.

48. *South Bend News-Times*, August 28, 1921.

49. Kathleen Curran, *The Romanesque Revival: Religion, Politics and Transnational Exchange* (University Park: Pennsylvania State University Press, 2003), 225.

50. Curran, *Romanesque Revival*, 226.

51. Curran, *Romanesque Revival*, 226.

52. *South Bend News-Times*, May 2, 1936.

53. Romine, *Copshaholm*, 87.

54. Howard, *A History*, 1:240–43.

1. Hope, *Notre Dame*, 202.

2. William Tutin Thomas (1833–1892) was born in England and came with his parents to Canada in 1843, at the age of ten. He grew up in Toronto, where he and his brother, Cyrus, apprenticed under their father, William Thomas (1799–1860), a noted architect. They moved to Montreal in the early 1850s, and Cyrus established an office in Halifax, Nova Scotia, in the late 1850s. Cyrus moved back to Montreal in 1862 to join his brother in the firm of Thomas Brothers, Architects. In 1870 he moved to Chicago, where he established a successful practice, while William continued his practice in Montreal until his death in 1892. Schlereth and Hope both refer to a Mr. Thomas from Chicago; however, there is no record of an architect in Chicago by the name of Thomas before 1870. See Schlereth, *University of Notre Dame*, 37; Hope, *Notre Dame*, 138–41; "Thomas, William Tutin," in *Biographical Dictionary of Architects in Canada, 1800–1950*, ed. Robert G. Hill (2023), http://www.dictionaryofarchitectsincanada.org/node/1356 (accessed June 10, 2022); and Anna McAllister, *Flame in the Wilderness: Life and Letters of Mother Angela Gillespie, C.S.C., 1824–1887* (Paterson, NJ: St. Anthony Guild Press, 1944), 159.

3. A chapel, musical recital hall, and recitation rooms were added to the Academy Building in 1892 to 1893. *Art Work of South Bend*, n.p.

4. Schlereth, *University of Notre Dame*, 37.

5. Schlereth, *University of Notre Dame*, 37.

6. Marcus Whiffen and Frederick Koeper, *American Architecture,* vol. 2: *1860–1976* (Cambridge, MA: MIT Press, 2001), 9; Peat, *Indiana Houses*, 129.

7. Maass, *Gingerbread Age*, 118.

8. Quoted in Marcus Whiffen, *American Architecture Since 1780: A Guide to the Styles* (Cambridge, MA: MIT Press, 1981), 103; Henry-Russell Hitchcock, *Architecture: Nineteenth and Twentieth Centuries* (New York: Penguin Books, 1968), 170.

9. Peat, *Indiana Houses*, 129.

10. Reiff, *Houses from Books*, 86.

11. Reiff, *Houses from Books*, 88; Marcus Cummings, *Cummings' Architectural Details, Containing 387 Designs and 967 Illustrations of the Various Parts Needed in the Construction of Buildings, Public and Private . . . also Plans and Elevations of Houses, Stores, Cottages and Other Buildings* (New York: Orange Judd, 1873).

12. Amos J. Bicknell, *Bicknell's Village Builder: Elevations and Plans for Cottages, Villas, Suburban Residences, Farm Houses . . . also Exterior and Interior Details . . . with Approved Forms of Contracts and Specifications* (Troy, NY: A. J. Bicknell, 1870).

13. Chapman, *History of St. Joseph County*, 629.

14. Thomas Schlereth, *A Dome of Learning: The University of Notre Dame's Main Building* (Notre Dame, IN: University of Notre Dame Alumni Association, 1991), 5.

15. Schlereth, *Dome of Learning*, 4.

16. The closest contemporary was an even more monumental Second Empire building at the University of Illinois in Champaign-Urbana, designed in 1874 by John Mills Van Osdel, who had been the architect of the St. Joseph County Courthouse but by now had adopted the Second Empire style. See Turner, *Campus*, 152.

17. Father Dillon later became the assistant general of the Congregation of the Holy Cross in France. See Notre Dame, *Brief History*, 97.

18. Withey and Withey, *Biographical Dictionary*, 333; Francis W. Kervick, *Patrick Charles Keely, Architect: A Record of His Life and Work* (South Bend, IN: n.p., 1953), 33–35.

19. Schlereth, *University of Notre Dame*, 37–39.

20. Francis W. Kervick, *Architects in America of Catholic Tradition* (Rutland, VT: Charles E. Tuttle, 1962), n.p.; Hope, *Notre Dame*, 233; *Notre Dame Alumnus* 11, no. 9 (June 1933), 243, University of Notre Dame Archives.

21. James Newberry, "Brother Charles Borromeo Harding: 1838–1922, Amateur Architect," *Proceedings of the 2010 Conference on the History of the Congregation of Holy Cross, Holy Cross College* (Notre Dame, IN: University of Notre Dame, 2010), 1–4.

22. Schlereth, *University of Notre Dame*, 37–40; and see the unpublished paper by Margaret Barrett, "Finding the Roots of the Basilica of the Sacred Heart: An Architectural History," independent study term paper, University of Notre Dame School of Architecture (May 9, 2014), 6. Barrett traveled to La Roche in the commune of Ahuillé in 2013, while a student at Notre Dame, to explore Father Sorin's childhood home and document the Church of Saint Benoît as well as other Gothic churches and cathedrals in and around Le Mans.

23. Thomas Brady was born in Ireland in 1829 and established his architectural practice in St. Louis in 1865. He was joined in his practice by John Mitchell in 1870. In St. Louis he designed the Temple of the Gates of Truth Synagogue. See Kervick, *Architects in America*, 22; Hope, *Notre Dame*, 216–17.

24. "Here and There," *The Notre Dame Scholastic* 3, no. 10 (January 22, 1870), 78, University of Notre Dame Archives.

25. Schlereth attributed the design of the Basilica to Brothers Harding and Granger. See Schlereth, *University of Notre Dame*, 39. Francis Kervick attributed it to Patrick Keely in the booklet *Architecture at Notre Dame*, 9; however, in later publications Kervick credited Thomas Brady with its design. See Kervick, *Patrick Charles Keely*, 33–35; and Kervick, *Architects in America*, 22. Brady is credited with the design in Barrett's unpublished paper, "Finding the Roots of the Basilica of the

Sacred Heart," 6. See also "Here and There," 78; and Newberry, "Brother Charles Borromeo Harding," 1–4.

26. "The Solemn Pontifical High Mass and the Laying of the Corner-Stone of the Church of Our Lady of the Sacred Heart," *The Notre Dame Scholastic* 4, no. 10 (January 28, 1871), 2, University of Notre Dame Archives; and Schlereth, *University of Notre Dame*, 40.

27. Schlereth, *University of Notre Dame*, 37–40; Vonada, *Notre Dame*, 32.

28. Schlereth, *University of Notre Dame*, 40–41. Gregori had been a student of Tommaso Mirandi, the founder of the Purismo Movement, which emphasized the study of early Renaissance artists such as Giotto, Perugino, and Fra Angelico. He served as artist in residence for Pope Pius IX, restoring paintings in the Vatican.

29. Schlereth, *University of Notre Dame*, 40.

30. Schlereth, *University of Notre Dame*, 43; Hope, *Notre Dame*, 218.

31. Clipping File ("St. Joseph Church"), Local and Family History Department, St. Joseph County Public Library, South Bend, IN. On St. Joseph's Church, see also Edmund V. Campers, *History of St. Joseph's Parish, South Bend, Indiana, 1853–1953* (South Bend, IN, n.p., 1953).

32. *An Illustrated History of St. Joseph's Church, South Bend, Indiana* (South Bend, IN: n.p., 1901), 21.

33. *An Illustrated History of St. Joseph's Church*, 4–5.

34. *An Illustrated History of St. Joseph's Church*, 9–10.

35. The contractors of St. Joseph's Church were Charles Cofler and George Knoblock. The cost of construction was $18,000. *South Bend Tribune*, August 1, 1947; and *An Illustrated History of St. Joseph's Church*, 21.

36. The architecturally undistinguished building that currently occupies the site was designed by Anthony J. Panzica and built at a cost of nearly $400,000. *South Bend Tribune*, July 6, 1964.

37. *South Bend Tribune*, October 27, 1963.

38. St. Hedwig's was built at a cost of $33,000. See Clipping File ("St. Hedwig's Church"), Local and Family History Department, St. Joseph County Public Library, South Bend, IN.

39. Clipping File ("St. Patrick's Church"), Local and Family History Department, St. Joseph County Public Library, South Bend, IN.

40. *An Illustrated History of St. Joseph's Church*, 7–8.

Chapter Seven

1. Turner, *Campus*, 101.

2. Turner, *Campus*, 116–17.

3. At the top of the composition is a cameo portrait of Father Sorin flanked by the words *Notre Dame University / Est. 1842 / St. Joseph Co., Indiana*. This com-

position was produced by the Chicago lithographer Charles Shober and Company and published by the Chicago firm of Higgins, Belden and Company.

4. Howard, *A History*, 2:656–57; Schlereth, *Dome of Learning*, 7; quoted from Donald Tewkesbury, *The Founding of American Colleges and Universities before the Civil War* (New York: New York City Teachers College, Columbia University, 1932).

5. Willoughby J. Edbrook began his practice in Chicago in 1867. Withey and Withey, *Biographical Dictionary*, 189; Schlereth, *Dome of Learning*, 13–14; Vonada, *Notre Dame*, 20; Antoinette J. Lee, *Architects to the Nation: The Rise and Decline of the Supervising Architect's Office* (New York: Oxford University Press, 2000), 149.

6. Schlereth, *Dome of Learning*, 15.

7. Kervick, *Architecture at Notre Dame*, 3.

8. Chapman, *History of St. Joseph County*, 629–30.

9. Schlereth, *Dome of Learning*, 24.

10. Turner, *Campus*, 101.

11. Vonada, *Notre Dame*, 24.

12. Schlereth, *Dome of Learning*, 25.

13. Schlereth, *Dome of Learning*, 35.

14. Vonada, *Notre Dame*, 22; Schlereth, *Dome of Learning*, 24–25; Hope, *Notre Dame*, 218.

15. Hayward and Shivers, *Architecture of Baltimore*, 198.

16. Mary N. Woods, "Henry Van Brunt: 'The Historic Styles, Modern Architecture,'" in *American Public Architecture: European Roots and Native Expressions*, ed. Craig Zabel and Susan Scott Munshower (University Park: Pennsylvania State University Press, 1989), 86–87.

17. Eugène-Emmanuel Viollet-le-Duc, *Entretiens sur l'Architecture*, 2 vols. (Paris: A. Morel, 1863–1872); Woods, "Henry Van Brunt," 87.

18. Bruno Foucart, ed., *Viollet-le-Duc*, exhibition catalog, Galeries nationales du Grand Palais (Paris: Éditions de la Réunion des musées nationaux, 1980), 369.

19. Pilkinton, *Washington Hall*, 31–45.

20. Pilkinton, *Washington Hall*, 84–89.

21. Pilkinton, *Washington Hall*, 90–103.

22. Vonada, *Notre Dame*, 51.

23. Pilkinton, *Washington Hall*, 17.

24. Vonada, *Notre Dame*, 52–53.

25. Edbrooke was in partnership with Franklin P. Burnham from 1887 to 1891, the period of time in which he was commissioned to design Sorin Hall. Burnham later moved to Los Angeles, where he practiced until his death in 1909. In 1892 he was appointed by President William Henry Harrison to the post of supervising architect of the U.S. Treasury. Withey and Withey, *Biographical Dictionary*, 100, 189; Hope, *Notre Dame*, 219.

26. Vonada, *Notre Dame*, 41–48.

27. Schlereth, *Dome of Learning*, 13–14; Vonada, *Notre Dame*, 20; Lee, *Architects to the Nation*, 149.

28. Thomas J. Schlereth, *The Notre Dame Main Building: Fact and Symbol, 1879–1979* (Notre Dame, IN: Archives of the University of Notre Dame, 1979), 6; Schlereth, *Dome of Learning*, 13–14; Vonada, *Notre Dame*, 20; Lee, *Architects to the Nation*, 149.

29. Sorin, *Chronicles*, 147.

30. McAllister, *Flame in the Wilderness*, 257.

31. *An Illustrated Historical Atlas of St. Joseph Co., Indiana*, 12–13.

32. *Illustrated Historical Atlas*, 15–16; this master plan is also illustrated in Divine and Pier, *Saint Mary's College*, 15.

33. *Illustrated Historical Atlas*, 44.

34. *Illustrated Historical Atlas*, 38.

35. For information on Notre Dame de Chicago, see Denis McNamara, *Heavenly City: The Architectural Tradition of Catholic Chicago* (Chicago: Liturgy Training, 2005), 106.

36. After an inspection in 1954, it was determined that the wooden structure of the church of the Loretto had deteriorated to the point of rendering the building unsafe. Divine and Pier, *Saint Mary's College*, 58.

37. Divine and Pier, *Saint Mary's College*, 93.

38. Schlereth, *University of Notre Dame*, 54.

39. Curran, *Romanesque Revival*, 225.

Chapter Eight

1. Howard, *A History*, 1:367.

2. *Art Work of South Bend and Vicinity*, n.p.

3. The first steps toward paving the city's streets were made in 1865, when cobblestones were used to pave part of Michigan Street through downtown and part of Washington Street. In 1888 these cobblestones were replaced with cedar block pavers. In 1898 the city began to use asphalt as a paving material, which replaced brick entirely. Howard, *A History*, 1:369–70.

4. Howard, *A History*, 1:233.

5. Antoinette F. Downing and Vincent J. Scully Jr., *The Architectural Heritage of Newport, Rhode Island, 1640–1915* (New York: Clarkson N. Potter, 1967), 144–46.

6. Downing and Scully, *Architectural Heritage*, 145, 148.

7. Marcus Whiffen, *American Architecture Since 1780*, 111. Two earlier pattern books containing Stick-style designs were Henry W. Cleaveland, William Backus, and Samuel D. Backus, *Village and Farm Cottages* (New York: D. Appleton, 1856); and Gervase Wheeler, *Rural Homes; or Sketches of Houses Suited to American Country Life with Original Plans, Designs, &c.* (Auburn, NY: Alden and Beardsley, 1855).

8. Reiff, *Houses from Books*, 86. See also Sarah Bradford Landau, "Richard Morris Hunt: The Continental Picturesque and the 'Stick Style,'" *Journal of the Society of Architectural Historians* 42, no. 3 (1983): 272–89; Vincent J. Scully Jr., *The Shingle Style and the Stick Style*, rev. ed. (New Haven, CT: Yale University Press, 1971); Henry Hudson Holly, *Holly's Country Seats: Containing Lithographic Designs for Cottages, Villas, Mansions, etc.* (New York: D. Appleton, 1863; reprinted, with a new introduction by Michael Tomlan, as *Country Seats and Modern Dwellings: Two Victorian Domestic Architectural Stylebooks by Henry Hudson Holly* [Watkins Glen, NY: Library of Victorian Culture, 1977]).

9. Reiff, *Houses from Books*, 86; George E. Woodward, *Woodward's New Country Homes, a Practical, and Original Work on Rural Architecture* (1865; reprint, Watkins Glen, NY: American Life Foundation, 1979).

10. Reiff, *Houses from Books*, 86.

11. Anderson and Cooley, *South Bend*, 121.

12. Anderson and Cooley, *South Bend*, 212–13.

13. The Rum Village neighborhood is located southwest of downtown, directly south of the Studebaker factory complex. Much of the land was originally owned by James Oliver, who gradually sold it off to developers. It was developed as a workers' neighborhood for laborers in the Oliver and Studebaker factories. The first subdivision in the neighborhood, the area around Our Lady of Hungary Catholic Church, was platted in 1890 by Barclay Kemble. The same year, Thomas Byerly platted the northwest corner of the neighborhood, and in 1891 City View Place was platted south of Kemble's Addition. In 1899 James Oliver platted Liddesdale Addition, located at the neighborhood's western edge. The central portion of the neighborhood, between Oliver School and Our Lady of Hungary Church, was platted by Ferdinand Raff in 1920.

14. Schmitt and Korab, *Kalamazoo*, 163.

15. Reiff, *Houses from Books*, 108; Palliser, Palliser and Company, *Palliser's New Cottage Homes and Details, Containing Nearly Two Hundred and Fifty New and Original Designs in All the Modern Popular Styles* (1887; reprint, New York: Da Capo Press, 1975), n.p.

16. Reiff, *Houses from Books*, 110–14, 150–64.

17. Reiff, *Houses from Books*, 122–24, 131–32.

18. Peat, *Indiana Houses*, 149–50.

19. Scully, *Shingle Style*, 10–11.

20. George Ford also worked in the legal department of the Oliver Chilled Plow Works and was vice president of the Indiana Northern Railway Company. He was later appointed as a judge in the Superior Court. Most recently, the house has functioned as a bed-and-breakfast inn.

21. John W. Stamper, ed., *City of South Bend Summary Report: Indiana Historic Sites and Structures Inventory* (South Bend, IN: Historic Preservation Commission of South Bend and St. Joseph County, 1982), 41; Goodspeed Brothers, *Pictorial and Biographical Memoirs of Elkhart and St. Joseph Counties* (Chicago:

Goodspeed Brothers, 1893), 320–21; *South Bend Tribune Sunday Magazine*, August 25, 1957.

22. Stamper, *City of South Bend*, 202; Kervick, *Architects in America*, 22.

23. Anderson and Cooley, *South Bend*, 263–64.

24. John Mohler Studebaker died in 1917. His son, John Mohler Jr., lived in the house until his death in 1947. The house was demolished in the 1950s. *South Bend Tribune*, April 28, 1947; *South Bend Tribune*, June 12, 1955; Howard, *A History*, 1:480.

25. James Stevens Curl, *Oxford Dictionary of Architecture* (Oxford: Oxford University Press, 1999), 448.

26. Howard, *A History*, 1:479.

27. After Jacob F. Studebaker died in 1887, several family members lived in the house at various times until it was sold in 1919 to make way for the Cyrus C. Shafer house, which currently occupies the site. *South Bend Times*, December 23, 1887.

28. Mary Corbin Sies, "God's Very Kingdom on Earth: The Design Program for the American Suburban Home 1877–1917," in *Modern Architecture in America: Visions and Revisions*, ed. Richard Guy Wilson and Sidney K. Robinson (Ames: Iowa State University Press, 1991), 5–6.

29. Sies, "God's Very Kingdom," 3–5.

30. Sies, "God's Very Kingdom," 5.

31. McAlester and McAlester, *Field Guide*, 289–90.

32. Reiff, *Houses from Books*, 163.

33. Reiff, *Houses from Books*, 164.

34. Reiff, *Houses from Books*, 164–65.

35. Anderson and Cooley, *South Bend*, 120.

36. Anderson and Cooley, *South Bend*, 120–21.

37. Anderson and Cooley, *South Bend*, 121.

Chapter Nine

1. Howard, *A History*, 1:477.

2. Joan Romine, *Tippecanoe Place: A History* (South Bend, IN: Southold Restorations, 1972), 17.

3. Withey and Withey, *Biographical Dictionary*, 128–29.

4. Edward W. Wolner, *Henry Ives Cobb's Chicago: Architecture, Institutions, and the Making of a Modern Metropolis* (Chicago: University of Chicago Press, 2011), 1.

5. For H. H. Richardson, see James O'Gorman, *H. H. Richardson: Architectural Forms for an American Society* (Chicago: University of Chicago Press, 1987); Mariana Griswold Van Rensselaer, *Henry Hobson Richardson and His Works* (New York: Dover, 1969).

6. Thomas C. Hubka, "H. H. Richardson's Glessner House: A Garden in the Machine," *Winterthur Portfolio* 24, no. 4 (Winter 1989): 209–29.

7. *American Architect and Building News,* January 11, 1890, 18.

8. Montgomery Schuyler, *American Architecture and Other Writings*, 2 vols., ed. William H. Jordy and Ralph Coe (Cambridge, MA: Belknap Press of Harvard University Press, 1961), 1:224.

9. Montgomery Schuyler, "The Romanesque Revival in America," *Architectural Record* 1, no. 2 (October 1891): 194.

10. Schuyler, "Romanesque Revival in America," 194.

11. Jon Dilts, *Magnificent 92*, 138, 146.

12. Romine, *Tippecanoe Place*, 18.

13. Romine, *Tippecanoe Place*, 30.

14. Romine, *Tippecanoe Place*, 28.

15. *Unrivaled Chicago* (Chicago: Rand, McNally, 1897), 68.

16. Peat, *Indiana Houses*, 161.

17. Wolner, *Henry Ives Cobb's Chicago*, 61–62.

18. Romine, *Tippecanoe Place*, 29.

19. Romine, *Tippecanoe Place*, 33.

20. Gwendolyn Wright, *Moralism and the Model Home* (Chicago: University of Chicago Press, 1980), 31–32.

21. Romine, *Tippecanoe Place*, 35.

22. Romine, *Tippecanoe Place*, 29.

23. Romine, *Tippecanoe Place*, 42.

24. Romine, *Tippecanoe Place*, 42–49.

25. Romine, *Tippecanoe Place*, 50.

26. Bonsall, *More Than They Promised*, 32–33.

27. *South Bend Times*, October 11, 1889.

28. Peat, *Indiana Houses*, 161.

29. Withey and Withey, *Biographical Dictionary*, 360, 506; Eric Johannesen, *Cleveland Architecture 1878–1976* (Cleveland, OH: Western Reserve Historical Society, 1979), 16.

30. Anderson and Cooley, *South Bend*, 104.

31. *South Bend Tribune*, May 31, 1961.

32. *South Bend Tribune*, May 31, 1961.

33. Joan Romine, *Copshaholm: The Oliver Story* (South Bend, IN: Northern Indiana Historical Society, 1978), 40.

34. Romine, *Copshaholm*, 58.

35. Other houses in the New York area they found especially appealing were the Elizabeth Milbank House in Greenwich, Connecticut, built in 1886, and the John Matthews House of 1889, on Riverside Drive in New York. Romine, *Copshaholm*, 58–59.

36. Romine, *Copshaholm*, 59; Withey and Withey, *Biographical Dictionary*, 360, 506.

37. Anderson and Cooley, *South Bend*, 396.

38. Anderson and Cooley, *South Bend*, 229.

39. Romine, *Copshaholm*, 59–64.

40. Romine, *Copshaholm*, 64.

41. Romine, *Copshaholm*, 118.

42. Romine, *Copshaholm*, 62, 120–24.

43. Ann Durkin Keating, *Building Chicago: Suburban Developers and the Creation of a Divided Metropolis* (Columbus: Ohio State University Press, 1988), 51–55.

44. Romine, *Copshaholm*, 62.

45. *South Bend Tribune*, October 3, 1998.

46. *South Bend News-Times*, October 22, 1905.

47. *South Bend Tribune*, July 16, 1993; *South Bend Tribune*, November 11, 2000.

Chapter Ten

1. Bonsall, *More Than They Promised*, 21.

2. Clipping File ("Religion—Baptist—First Baptist Church"), Local and Family History Department, St. Joseph County Public Library, South Bend, IN.

3. *South Bend Times*, December 23, 1887.

4. William H. Pierson Jr., *American Buildings and Their Architects*, vol., 3, *Technology and the Picturesque, the Corporate and the Early Gothic Styles* (Garden City, NY: Anchor Books, 1980), 173–74.

5. Thomas Schlereth, "A High Victorian Gothicist as Beaux-Arts Classicist: The Architectural Odyssey of Solon Spencer Beman," *Studies in Medievalism* 3, no. 2 (Fall 1990): 129.

6. Schlereth, "High Victorian Gothicist," 140–42.

7. The masonry work for the First Baptist Church was done by Charles Woolman for a cost of $27,000.

8. Clipping File ("Religion—Baptist—First Baptist Church"), Local and Family History Department, St. Joseph County Public Library, South Bend, IN.

9. *South Bend Tribune*, January 17, 1965.

10. Clipping File ("Religion—Presbyterian—First Presbyterian"), Local and Family History Department, St. Joseph County Public Library, South Bend, IN.

11. *South Bend Tribune*, May 8, 1924; *South Bend Tribune,* June 19, 1938.

12. Bonsall, *More Than They Promised*, 29.

13. *South Bend Tribune*, June 19, 1938.

14. Other notable South Bend residents active in the First Presbyterian Church included C. W. Martin, Samuel F. Allen, and a local amateur historian, Dr. Louis Humphries. *South Bend Tribune, Michiana Magazine*, April 22, 1984.

15. *South Bend Tribune*, June 19, 1938.

16. *South Bend Tribune, Michiana Magazine*, April 22, 1984.

17. A new First Presbyterian Church was built in the 300 block of West Colfax Street in 1950, a Georgian Revival–style building designed by Harold W. Wagoner of Philadelphia. *South Bend Tribune, Michiana Magazine*, April 22, 1984.

18. *South Bend Tribune*, March 9, 1950.

19. *South Bend Tribune*, October 13, 1999.

20. The property for the new library was purchased in 1895 by Albert Listenberger, C. A. Daugherty, and H. F. Elbel. *South Bend News-Times*, May 2, 1936; Howard, *A History*, 1:450–51.

21. *South Bend Tribune*, March 21, 1896; *South Bend Tribune*, February 19, 1937.

22. Anderson and Cooley, *South Bend*, 35; *South Bend Tribune*, March 21, 1896; *South Bend News-Times*, May 2, 1936.

23. Kenneth A. Breich, *Henry Hobson Richardson and the Small Public Library in America* (Cambridge, MA: MIT Press, 1997), 14.

24. *South Bend Tribune*, February 19, 1937; *South Bend Tribune*, August 3, 1930; *South Bend Tribune*, December 3, 1933.

25. *South Bend Tribune*, January 1, 1958; *South Bend Tribune*, April 10, 1958.

26. *South Bend Tribune*, November 15, 1953; *South Bend Tribune*, February 13, 1954.

27. *South Bend News-Times*, June 14, 1898; *South Bend Tribune*, November 29, 1898.

28. The stained glass window in the facade of St. James Cathedral was a gift of Mrs. E. L. Kuhns and was made in Kokomo, Indiana, out of two thousand pieces of stained glass. It was designed and made by Thomas A. O'Shaughnessy of Chicago. *South Bend Tribune*, December 17, 1926.

29. *South Bend Tribune*, June 15, 1933; *South Bend News-Times*, July 28, 1932.

30. *South Bend News-Times*, February 17, 1933.

31. *South Bend News-Times*, October 28, 1932.

32. Johannesen, *Cleveland Architecture*, 51–52; Withey and Withey, *Biographical Dictionary*, 30. R. L. Braunsdorf was the superintendent of construction. *South Bend News-Times*, January 22, 1928.

33. The family had built the Milburn Church in 1883, located at the corner of Thomas and McPherson Streets. *South Bend Tribune, Michiana Magazine*, September 11, 1983.

34. *South Bend News-Times*, October 25, 1927.

35. *South Bend News-Times*, October 25, 1927.

36. *South Bend Tribune*, August 13, 1910; *South Bend Tribune*, October 1, 1910; *South Bend Tribune*, October 3, 1910.

37. The First Christian Church purchased the former Frederick Fish House at the corner of Eddy Street and East Jefferson Boulevard in 1961. The new church was constructed in 1970. *South Bend Tribune*, April 31, 1961.

38. An older Methodist church, demolished in 1915, was located at the northwest corner of Jefferson and Main Streets. The architect of the new church is unrecorded, though the contractor was Kimble and Kuehn. *South Bend Tribune*, December 4, 1938.

39. H. Gregory Haygood, ed., *Pilgrim Missionary Baptist Church, 1890–1990* (South Bend, IN: n.p., 1990), 34, in box 1, folder 59, South Bend Civil Rights Heritage Collection, Indiana University South Bend Archives; David H. Healey, "Tugging on the Reins of Power: Persons and Events That Encouraged the Development of Political Power within the Black Community of South Bend" (master's thesis, Indiana University South Bend, 2007), 39; Gordon, *Negro in South Bend*, 36–38.

40. Gordon, *Negro in South Bend,* 38.

41. O'Dell, *Our Day*, 19.

42. Healey, "Tugging on the Reins of Power," 39–45.

43. Haygood, *Pilgrim Missionary Baptist Church,* 34; Healey, "Tugging on the Reins of Power," 39; Gordon, *Negro in South Bend*, 66.

44. Gordon, *Negro in South Bend*, 67; Haygood, *Pilgrim Missionary Baptist Church,* 63.

45. Gordon, *Negro in South Bend*, 42; O'Dell, *Our Day*, 20–21.

46. Healey, "Tugging on the Reins of Power," 45.

47. Schlereth, *University of Notre Dame,* 87–88.

48. Schlereth, *University of Notre Dame*, 83.

49. *Art Work of South Bend and Vicinity*, n.p.

50. Schlereth, *University of Notre Dame*, 37, 83.

51. Hope, *Notre Dame*, 257.

52. Schlereth, *University of Notre Dame*, 105–6.

53. Turner, *Campus*, 167–69.

54. Schlereth, *University of Notre Dame*, 105–6.

55. Schlereth, *University of Notre Dame*, 109.

56. The College of Engineering had been established as part of the university's science program in 1873. It instituted courses in civil engineering, the first Catholic university in the country to do so. Mechanical engineering was added in 1886 and electrical engineering in 1891. Schlereth, *University of Notre Dame*, 108–9.

57. Vonada, *Notre Dame*, 55–56; Schlereth, *University of Notre Dame*, 108–10.

58. Already in 1902, the Chemistry and Pharmacy Departments had begun taking over the building, and in 1905 Engineering moved to the new Engineering Hall, which was located in the present-day south quad at the approximate site of Dillon Hall. Schlereth, *University of Notre* Dame, 110.

59. Schlereth, *University of Notre Dame*, 109–10.

60. Notre Dame, *Brief History*, 184; Howard, *A History*, 2:674.

61. Leo Marx, *The Machine in the Garden: Technology and the Pastoral Ideal in America* (New York: Oxford University Press, 2000), 3.

62. Turner, *Campus*, 101.

63. Marx, *Machine in the Garden*, 6.

64. Turner, *Campus*, 101.

65. Carroll Hall was later converted to a dormitory for Notre Dame undergraduates. Vonada, *Notre Dame*, 84.

66. Schlereth, *Spire of Faith*, 38; Schlereth, *University of Notre Dame*, 54–55.

67. Hope, *Notre Dame*, 264.

68. St. Joseph's Industrial School provided a two-year vocational program for students aged eighteen to twenty-one. It was phased out in 1917. The building became a dormitory in 1917, when its name was changed to Badin Hall and wings were added to the north and south. Vonada, *Notre Dame*, 107–8; Schlereth, *University of Notre Dame*, 137–39.

69. The fieldhouse housed studios for the art department in its later years until it was demolished in 1983. Schlereth, *University of Notre Dame*, 185–87.

70. Vonada, *Notre Dame*, 179.

71. Vonada, *Notre Dame*, 48–50.

72. For discussion of the planning of Stanford, Chicago, and Columbia, see Turner, *Campus*, 169–82.

73. Schlereth, *University of Notre Dame*, 86.

74. Hope, *Notre Dame*, 266.

75. Schlereth, *University of Notre Dame*, 95.

76. Marx, *Machine in the Garden*, 19.

77. Marx, *Machine in the Garden*, 13–16.

Chapter Eleven

1. Leland Roth and Amanda C. Roth Clark, *Understanding Architecture: Its Elements, History, and Meaning*, 3rd ed (Boulder, CO: Westview Press, 2014), 561–62; John C. Poppeliers and S. Allen Chambers Jr., *What Style Is It? A Guide to American Architecture* (New York: John Wiley and Sons, 2003), 90–99.

2. "The City of Chicago," *Engineering* 55 (April 21, 1893): 516.

3. Withey and Withey, *Biographical Dictionary*, 96–97.

4. Withey and Withey, *Biographical Dictionary*, 525.

5. George Selby attended school in Mansfield, Pennsylvania. He gained his first architectural experience with the Utica architectural firm of Jacob Agne.

6. Paul R. Baker, *Richard Morris Hunt* (Cambridge, MA: MIT Press, 1980), 396; Charles Moore, *The Life and Times of Charles Follen McKim* (New York: Da Capo Press, 1970), 113; Charles Moore, *Daniel H. Burnham: Architect, Planner of Cities* (New York: Da Capo Press, 1968), 43; Henry Van Brunt, *Architecture and So-*

ciety; Selected Essays by Henry Van Brunt (Cambridge, MA: Belknap Press of Harvard University Press, 1969), 229, 235.

7. The building's structure was a steel frame with cantilevered roof trusses 115 feet in span and spaced at 65 foot intervals. They had arched lower chords, and in the center was a raised clerestory. The central nave was flanked by wide side aisles, and around the building's perimeter were three smaller side aisles, each framed with a combination of wood and iron members and supporting a balcony level. A large portion of the roof was covered with glass. For descriptions of the Mines and Mining Building see Stanley Appelbaum, *Spectacle in the White City: The Chicago World's Fair of 1893* (Mineola, NY: Galla Editions, 2009), 38; David F. Burg, *Chicago's White City of 1893* (Lexington: University of Kentucky Press, 1976), 131; "Mines and Mining Building," *World's Columbian Exposition Illustrated* 1, no. 9 (November 1891): 24; Van Brunt, *Architecture and Society*, 261–63; James Dredge, "The Columbian Exposition of 1893," *Engineering* 52 (December 25, 1891): 766.

8. Thomas Tallmadge, *The Story of Architecture in America* (New York: W. W. Norton, 1927), 197.

9. For detailed plans of the third county courthouse, see *American Architect and Building News* 59 (January 22, 1898): 31, pl. 1152. See also *South Bend Times*, September 29, 1896. For information about the moving of the second county courthouse, see *South Bend Tribune*, April 4, 1954.

10. Burg, *Chicago's White City*, 57. The Art Institute was erected in Grant Park in conjunction with preparations for the exposition, and it was used during the exposition for World Congress meetings. It opened permanently as an art museum in the following year. The public library served its purpose until the mid-1980s, when it was converted into a cultural center.

11. McAlester and McAlester, *Field Guide*, 379.

12. Dilts, *Magnificent 92*, 5–6.

13. Jeffrey Karl Ochsner and Dennis Alan Andersen, *Distant Corner: Seattle Architects and the Legacy of H. H. Richardson* (Seattle: University of Washington Press, 2003), 114.

14. Withey and Withey, *Biographical Dictionary*, 136–37.

15. Alan Gowans, *Images of American Living: Four Centuries of Architecture and Furniture as Cultural Expression* (Philadelphia: J. B. Lippincott, 1964), 372.

16. George Selby attended school in Mansfield, Pennsylvania. He gained his first architectural experience with the Utica architectural firm of Jacob Agne.

17. Rolland Adelsperger, "The Work of Messrs. Selby and Young," *Ohio Architect and Builder* 15, no. 5 (1910): 27; Anderson and Cooley, *South Bend*, 291.

18. For a rendering of the Rush and Son design for the county courthouse, see *South Bend Times*, August 6, 1895.

19. Dilts, *Magnificent 92*, 148.

20. Dilts, *Magnificent 92*, 148.

21. The covering of the dome was replaced in 1996. See *South Bend Tribune*, August 8, 1996.

22. *South Bend Times*, September 29, 1896.

23. Charles H. Bartlett and Richard H. Lyon, "LaSalle in the Valley of the St. Joseph" (1899); Clipping File ("Public Buildings, Courthouse"), Local and Family History Department, St. Joseph County Public Library, South Bend, IN; and *South Bend Tribune*, February 26, 1921.

24. *South Bend Times*, September 29, 1896.

25. *South Bend Tribune*, November 5, 1898.

26. *South Bend Tribune*, November 5, 1898.

27. The cost of construction of the Oliver Hotel was $600,000. *South Bend Daily Tribune*, December 31, 1899.

28. For information on the Drake Hotel in Chicago, see John W. Stamper, *Chicago's North Michigan Avenue: Planning and Development, 1900–1930* (Chicago: University of Chicago Press, 1991), 118–22.

29. *South Bend Times*, December 22, 1899.

30. *South Bend Times*, December 22, 1899.

31. Gustave Brand had studied under masters in Berlin and Paris and had come to the United States in 1893 to do a project for the World's Columbian Exposition. *South Bend Tribune*, January 1, 1967.

32. *South Bend Times*, December 22, 1899.

33. Romine, *Copshaholm*, 80–81.

34. *South Bend Tribune*, June 4, 1967.

35. *South Bend Tribune*, June 4, 1967.

36. The Dean Building was once the home of the architectural firm Ogden, Mauer, Natali and Van Ryan.

37. *South Bend Times*, December 2, 1898.

38. Withey and Withey, *Biographical Dictionary*, 49–50; Thomas J. Schlereth, "Solon Spencer Beman, 1853–1914," 16–29.

39. *South Bend Times*, October 4, 1898.

40. *South Bend Times*, October 4, 1898.

41. *South Bend Times*, October 4, 1898.

42. R. Conrad Stein, *The Pullman Strike and the Labor Movement in American History* (Berkeley Heights, NJ: Enslow, 2001), 20–21.

43. Stein, *Pullman Strike*, 21–22.

44. Garner, "S. S. Beman and the Building of Pullman," 234.

45. Garner, "S. S. Beman and the Building of Pullman," 235.

46. *South Bend News-Times*, August 26, 1934; *South Bend Tribune*, May 17, 1967; *South Bend Tribune*, December 21, 1970; *South Bend Tribune*, December 14, 1969.

47. Anderson and Cooley, *South Bend*, 56; *South Bend Tribune*, December 20, 1970.

48. *South Bend Tribune*, August 3, 1979.

49. *South Bend Tribune*, March 18, 1927; *South Bend Tribune*, May 31, 1958; Anderson and Cooley, *South Bend*, 276–77.

50. *South Bend Tribune*, February 2, 1963; *South Bend Tribune*, October 14, 1960; Anderson and Cooley, *South Bend*, 278.

51. *South Bend Tribune*, August 7, 1979.

52. *South Bend Tribune*, August 3, 1979.

53. Museum of Science and Industry, Chicago, *A Guide to 150 Years of Chicago Architecture* (Chicago: Chicago Review Press, 1985), 26.

54. Withey and Withey, *Biographical Dictionary*, 191.

Chapter Twelve

1. Charles Mulford Robinson, "Improvement in City Life: Aesthetic Progress," *Atlantic Monthly* 83 (June 1899): 77.

2. William H. Wilson, "J. Horace McFarland and the City Beautiful Movement," *Journal of Urban History* 7 (May 1981): 315–34.

3. David Gebhard and Tom Martinson, *Guide to the Architecture of Minnesota* (Minneapolis: University of Minnesota Press, 1977), 12.

4. Richard Guy Wilson, *McKim, Mead and White, Architects* (New York: Rizzoli, 1983), 30.

5. Jane Jacobs, *The Death and Life of Great American Cities* (New York: Random House, 1961), 33.

6. Jacobs, *Death and Life*, 24–25.

7. Jacobs, *Death and Life*, 24.

8. David Gosling with Maria Cristina Gosling, *The Evolution of American Urban Design: A Chronological Anthology* (Chichester, UK: Wiley-Academy, 2003), 7.

9. A. D. F. Hamlin, "Twenty-Five Years of American Architecture," *Architectural Record* 40 (July 1916): 8–10.

10. A. D. F. Hamlin, "Twenty-Five Years," 14.

11. Howard, *A History*, 1:386.

12. *South Bend Tribune*, May 9, 1922; Howard, *A History*, 1:387.

13. *South Bend Tribune*, September 4, 1938; Clipping File ("City Parks—Early"), Local and Family History Department, St. Joseph County Public Library, South Bend, IN.

14. Its basin was eventually filled in, and in 1941 it was removed.

15. James L. Cooper, *Artistry and Ingenuity in Artificial Stone: Indiana's Concrete Bridges, 1900–1942* (Greencastle, IN: Historic Bridge Books/James L. Cooper, 1997), 3.

16. *South Bend Tribune*, May 9, 1922.

17. Clipping File ("Parks, City, H–L"), Local and Family History Department, St. Joseph County Public Library, South Bend, IN.

18. Herman H. Beyer was born in La Porte. He spent two years at Notre Dame studying landscape drawing and engineering. His family had established South Bend's first floral shop in 1874. *South Bend Tribune*, July 28, 1996.

19. As indicated in chapter 2, a debate over the Navarre log house has ensued over the years, some suggesting the original Navarre cabin was destroyed years earlier. The structure that was moved to the site, whatever its origin, was renovated in 1918.

20. Clipping File ("Rivers—St. Joseph River—Bridges—101"), Local and Family History Department, St. Joseph County Public Library, South Bend, IN; Howard, *A History*, 1:231–32.

21. Clipping File ("Rivers—St. Joseph River—Bridges—101"), Local and Family History Department, St. Joseph County Public Library, South Bend, IN.

22. Cooper, *Artistry and Ingenuity*, 14, 33n12.

23. *South Bend Tribune*, July 23, 2018. In 2003 and 2004 the bridge was rebuilt to strengthen the structure and to restore its architectural features.

24. *South Bend Tribune*, November 30, 1997.

25. *South Bend Tribune*, September 4, 1938.

26. *South Bend Tribune*, June 15, 1972.

27. *South Bend Tribune*, November 30, 1997; Cooper, *Artistry and Ingenuity*, 119, 182–83.

28. *South Bend Tribune*, June 15, 1972. When the new concrete bridge was constructed, linking LaSalle Street to downtown, the old 330-foot iron-truss bridge was floated down the river to Darden Road, where it now serves as a pedestrian bridge.

29. Clipping File ("Rivers—St. Joseph County River—Bridges 101"), Local and Family History Department, St. Joseph County Public Library, South Bend, IN.

30. *South Bend Tribune*, November 30, 1997; Cooper, *Artistry and Ingenuity*, 27.

31. Moore's bridge designs included, in addition to those in South Bend, the Lexington Avenue Bridge (1926) and Main Street Memorial Bridge (1927) in Elkhart, the County Line Bridge (1929) in Osceola, and the Pike Street and Lincoln Avenue Bridges (1926–1927) in Goshen. *South Bend Tribune*, July 3, 1981; Cooper, *Artistry and Ingenuity*, 213–14, 253.

32. Cooper, *Artistry and Ingenuity*, 176, 182.

33. Adelsberger, "Work of Messrs. Selby and Young," 21.

34. Born in Germany, but raised in Missouri, Wisconsin, and Texas, George Kessler was taken by his mother as a teenager to Weimar, Germany, where he began private instruction in forestry, botany, and landscape design. He studied at Potsdam and Charlottenburg, then studied civil engineering at Jena. He then embarked on a yearlong tour from Paris to Moscow to study civic design. Upon returning to the United States at the age of twenty, he worked briefly on New York's Central Park, and in 1882 he moved to Kansas City, where he eventually estab-

lished his practice as a civic designer and landscape architect. See Cooper, *Artistry and Ingenuity*, 24; William H. Wilson, *The City Beautiful Movement* (Baltimore, MD: Johns Hopkins University Press, 1989), 107–8.

35. George Ehrlich, *Kansas City, Missouri: An Architectural History, 1826–1976* (Kansas City, MO: Historic Kansas City Foundation, 1979), 54. See also George B. Ford, "The Park System of Kansas City, Missouri," *Architectural Record* 40 (December 1916): 497–504.

36. *South Bend Tribune*, August 4, 1996.

37. Jack J. Detzler, *South Bend 1910–1920: A Decade Dedicated to Reform* (South Bend: Northern Indiana Historical Society, 1960), 27.

38. Cannon and Fox, *Studebaker*, 23.

39. Hall and Langworth, *Studebaker Century*, 51.

40. Robert Lacey, *Ford: The Men and the Machine* (Boston: Little, Brown, 1986), 36; John B. Rae, *American Automobile Manufacturers: The First Forty Years* (Philadelphia: Chilton, 1959), 28; Floyd Clymer, *Treasury of Early American Automobiles, 1877–1925* (New York: McGraw-Hill, 1950), 4.

41. Lacey, *Ford*, 41.

42. Clymer, *Treasury*, 25–33.

43. Hall and Langworth, *Studebaker Century*, 40.

44. Hall and Langworth, *Studebaker Century*, 41–44; Cannon and Fox, *Studebaker*, 43; *Chicago Tribune*, December 28, 1997.

45. For a complete description of the Studebaker Company's electric automobile production, see Cannon and Fox, *Studebaker*, 23, 26–32.

46. Cannon and Fox, *Studebaker*, 37–38.

47. *South Bend Tribune*, March 9, 1922; *South Bend News-Times*, March 11, 1932.

48. *South Bend Tribune*, March 9, 1922.

49. *South Bend Tribune*, March 9, 1922.

50. Erskine, *History of the Studebaker Corporation*, 37.

51. Rifkind, *Field Guide*, 219; Thomas J. Schlereth, "Solon Spencer Beman, Pullman, and the European Influence on and Interest in his Chicago Architecture," in *Chicago Architecture, 1872–1922: Birth of a Metropolis*, edited by John Zukowsky (Munich: Prestal-Verlag in association with The Art Institute of Chicago, 1987), 180.

52. J. D. Oliver reserved the interior woodwork of the James Oliver house, along with the conservatory in the backyard, to reuse in Copshaholm. *South Bend Tribune*, January 17, 1911.

53. For information on William B. Ittner, see Withey and Withey, *Biographical Dictionary*, 316.

54. *South Bend Tribune*, January 17, 1911.

55. Central High School opened in 1914 and served as the city's principal high school until the 1960s. It had a stellar history and famous basketball teams, of which a young John Wooden served as a coach in the 1930s.

56. *South Bend Tribune Supplement*, April 1, 1973.

57. *South Bend News-Times*, March 27, 1918.

58. *South Bend News-Times*, March 27, 1918; *South Bend News-Times*, May 28, 1941; Letter from Donna Eberhart Blair, April 16, 1936, Clipping File ("Religion-Christian Science"), Local and Family History Department, St. Joseph County Public Library, South Bend, IN.

59. John Palmer, *South Bend in Vintage Post Cards* (Charleston, SC: Arcadia, 2005), 70; *South Bend Tribune*, September 13, 1918.

60. *South Bend Tribune Supplement*, April 1, 1973.

61. Palmer, *South Bend in Vintage Post Cards,* 70; *South Bend Tribune*, September 13, 1918.

62. *South Bend Tribune*, December 24, 1921; June 6, 1926.

63. A complete description of the building and its furnishings is provided in the *South Bend Tribune*, June 6, 1926.

64. *South Bend Tribune*, June 6, 1926.

65. *South Bend News-Times*, June 14, 1926.

66. *South Bend News-Times*, June 14, 1926.

67. *South Bend Tribune,* June 6, 1926.

68. *South Bend Tribune,* June 6, 1926.

69. *South Bend Tribune*, December 2, 1927; December 4, 1927; October 4, 1934; May 27, 1993; *South Bend News-Times*, December 8, 1935.

70. On Notre Dame's School of Architecture, see Jane A. Devine, ed., *100 Years of Architecture at Notre Dame: A History of the School of Architecture, 1898–1998* (South Bend, IN: University of Notre Dame School of Architecture, 1999).

71. Schlereth, *University of Notre Dame*, 73–75.

72. Kervick, *Architecture at Notre Dame,* n.p.

73. *Bulletin of the University of Notre Dame* (1904–1905), 6, University of Notre Dame Archives.

74. *Bulletin of the University of Notre Dame* (1904–1905), 3–4, University of Notre Dame Archives.

75. Schlereth, *University of Notre Dame*, 142.

76. *Bulletin of the University of Notre Dame* (1912), 96–97, University of Notre Dame Archives.

77. Schlereth, *University of Notre Dame*, 139–40.

78. Schlereth, *University of Notre Dame*, 139–40.

Chapter Thirteen

1. McAlester and McAlester, *Field Guide*, 326.

2. *American Architect and Building News*, May 17, 1879, 151; quoted in Reiff, *Houses from Books*, 139.

3. Reiff, *Houses from Books*, 139.

4. The first, from the September 1896 volume of *The American Architect*, has a projecting classical portico sheltering a second-floor balcony and with a one-story side wing. A second is from October 1896, which has a projecting classical portico with paired corner columns flanked by a balustraded terrace. The third, a two-story hipped-roof house with corner pilasters and a front terrace, was published in February 1897. Reiff, *Houses from Books*, 194.

5. Reiff, *Houses from Books*, 166.

6. Reiff, *Houses from Books*, 168.

7. Reiff, *Houses from Books*, 170; *Architecture and Building* (January 1891), 23.

8. Reiff, *Houses from Books*, 170–71.

9. Reiff, *Houses from Books*, 194–95.

10. Leonard K. Eaton, *Two Chicago Architects and Their Clients: Frank Lloyd Wright and Howard Van Doren Shaw* (Cambridge, MA: MIT Press, 1969), 28–29.

11. H. Allen Brooks, *The Prairie School: Frank Lloyd Wright and His Midwest Contemporaries* (Toronto: University of Toronto Press, 1972), xxi.

12. For information on Frank Lloyd Wright's education and early career, see Brooks, *Prairie School,* 3–44; Neil Levine, *The Architecture of Frank Lloyd Wright* (Princeton, NJ: Princeton University Press, 1996), 1–73.

13. For information on Sullivan's career, see Hugh Morrison, *Louis Sullivan: Prophet of Modern Architecture* (New York: W.W. Norton, 1935); Lauren S. Weingarden, *Louis H. Sullivan and a 19th-Century Poetics of Naturalized Architecture* (Burlington, VT: Ashgate, 2009); Lauren S. Weingarden, *Louis H. Sullivan: The Banks* (Cambridge, MA: MIT Press, 1987); and David Van Zanten, *Sullivan's City: The Meaning of Ornament for Louis Sullivan* (New York: W. W. Norton, 2000).

14. Morrison, *Louis Sullivan*, 229.

15. Morrison, *Louis Sullivan*, 269.

16. Brooks, *Prairie School*, 27–32.

17. Brooks, *Prairie School*, 34–37.

18. William Allen Storrer, *The Architecture of Frank Lloyd Wright: A Complete Catalog* (Cambridge, MA: MIT Press, 1978), nos. 54, 91, 125.

19. Brooks, *Prairie School*, 5

20. Richard Guy Wilson and Sidney K. Robinson, *The Prairie School in Iowa* (Ames: Iowa State University Press, 1977), xii.

21. Henry-Russell Hitchcock, *In the Nature of Materials, 1887–1941* (New York: Duell, Sloan and Pearce, 1942), 39–48.

22. Lewis Mumford, *The Brown Decades: A Study of the Arts in America, 1865–1895* (New York: Dover, 1971), 76.

23. Wilson and Robinson, *Prairie School in Iowa*, 8–9.

24. Eaton, *Two Chicago Architects*, 52–53.

25. Wilson and Robinson, *Prairie School in Iowa*, 9.

26. Richard Schmidt's office was located in the Teutonic Building at 172 Washington Street. Brooks, *Prairie School*, 50–54.

27. Richard Schmidt eventually formed a partnership with Hugh Garden and Edgar Martin, which flourished for the next twenty years. Martin left the firm in 1925 and was replaced by Carl A. Erikson. Carl Condit, *The Chicago School of Architecture* (Chicago: University of Chicago Press, 1964), 192; Brooks, *Prairie School*, 52.

28. Young lived here only until 1910, when he sold it to Benjamin Burke.

29. In 1911 the bronze tablet was awarded for Young's design for the Mr. and Mrs. F. L. Stedman Residence in Chapin Park, and in 1914 he was awarded the tablet for the Mary L. Hines Residence on West Colfax.

30. Young was a member of the American Institute of Architects, the Round Table Club, and the South Bend Country Club. He died in 1959 at the age of seventy-five. *South Bend Tribune,* January 31, 1959.

31. The Talcott House was owned and occupied for many years by Notre Dame architecture professor Brian Crumlish.

32. *South Bend Tribune*, March 2, 1927; *South Bend Tribune*, March 17, 1927, *South Bend Tribune,* July 15, 1933.

33. *South Bend Tribune*, May 6, 1927.

34. Kervick, *Architecture at Notre Dame*, n.p.

35. Clay Lancaster, *The American Bungalow, 1880–1930* (New York: Abbeville Press, 1985), 209–15; Anthony D. King, *The Bungalow: The Production of a Global Culture* (London: Routledge and Kegan Paul, 1984), 134–35.

36. Mark Alan Hewitt, *Gustav Stickley's Craftsman Farms: The Quest for an Arts and Crafts Utopia* (Syracuse, NY: Syracuse University Press, 2001), 1.

37. Quoted in Schmitt and Korab, *Kalamazoo*, 212.

38. Schmitt and Korab, *Kalamazoo*, 211–12; Adrian Tinniswood, *The Arts and Crafts House* (New York: Watson-Guptil, 1999), 108–9; Brooks, *Prairie School*, 23–25.

39. A. King, *Bungalow*, 134.

40. Brooks, *Prairie School*, 17.

41. John Ruskin, *The Seven Lamps of Architecture* (London: Smith, Elder, 1849), 81.

42. Tinniswood, *Arts and Crafts House*, 6.

43. Peter Davey, *Architecture of the Arts and Crafts Movement* (New York: Rizzoli, 1980); Gillian Naylor, *The Arts and Crafts Movement: A Study of Its Sources and Influence on Design Theory* (Cambridge, MA: MIT Press, 1971); and Wendy Kaplan, ed., *The Arts and Crafts Movement in Europe and America: Design for the Modern World* (New York: Thames & Hudson, 2004).

44. Tinniswood, *Arts and Crafts House*, 12–21; Davey, *Architecture*, 30–32.

45. Davey, *Architecture*, 9.

46. The Studebaker family sold it in 1919 to Howard Woolverton, secretary-treasurer of the South Bend Range Corporation and vice president of the St. Joseph Bank and Trust Company.

47. For information of the origins of the bungalow, see William Phillips Comstock and Clarence Eaton Schermerhorn, *Bungalows: Camps and Mountain Houses* (Washington, DC: American Institute of Architects Press, 1990); A. King, *Bungalow*, 14–64; Lancaster, *American Bungalow*; Gustav Stickley, ed., *Craftsman Bungalows: 59 Homes from "The Craftsman"* (New York: Dover, 1988). See also Mary Raddant Tomlan and Michael A. Tomlan, *Richmond, Indiana: Its Physical Development and Aesthetic Heritage to 1920* (Indianapolis: Indiana Historical Society Press, 2003), 166.

48. Schmitt and Korab, *Kalamazoo*, 213.

49. Tomlan and Tomlan, *Richmond*, 165–67.

50. Schmitt and Korab, *Kalamazoo*, 213.

51. The conditions of bungalow construction as found in other cities across the country are described in Gebhard and Martinson, *Guide*, 11.

52. Hewitt, *Gustav Stickley's Craftsman Farms*, 6.

Chapter Fourteen

1. Henry Hope Reed, *The Golden City* (New York: W.W. Norton, 1970), 80.

2. Detzler, *South Bend 1910-1920*, 23; "Indiana City/Town Census Counts, 1900 to 2020," *Stats Indiana*, accessed July 31, 2023, http://www.stats.indiana.edu/population/poptotals/historic_counts_cities.asp.

3. *South Bend Today* (1915), 10, St. Joseph County Public Library Archives; *South Bend Tribune,* March 15, 1915; *South Bend Tribune*, July 3, 1949.

4. Withey and Withey, *Biographical Dictionary*, 468–69.

5. *South Bend Tribune*, March 9, 1922.

6. Kristian Schneider worked for the Northwestern Terra Cotta Company before moving to the American Terra Cotta and Ceramic Company in 1906, where he stayed until 1930.

Ronald E. Schmitt, "Sullivanesque Architecture and Terra Cotta," in *The Midwest in American Architecture*, ed. John S. Garner (Urbana: University of Illinois Press, 1991), 163–84, esp. 164.

7. Schmitt, "Sullivanesque Architecture," 172–73.

8. *South Bend Tribune*, March 9, 1922.

9. *South Bend Tribune*, January 14, 1940; *South Bend Tribune*, January 21, 1940. The First Bank and Trust Company was formed in 1931 through a merger between the First National Bank and the Indiana Trust Company. Ernest M. Morris, founder of the Associates Investment Company, was president, and Vincent

Bendix was on the board of directors. Its first headquarters was in the Union Trust Company Building at the southeast corner of Michigan Street and Jefferson Boulevard. *South Bend News-Times*, June 5, 1931.

10. *South Bend Tribune*, May 11, 1924; *South Bend Tribune*, March 28, 1929. The Union Trust Company first opened on this site in 1905, and it was remodeled in 1908. In 1920 two adjoining lots were purchased, and in 1924 the present building was begun. *South Bend Tribune*, February 16, 1930.

11. *South Bend Tribune*, April 7, 1921.

12. *South Bend News-Times*, April 8, 1921; *South Bend News-Times*, May 4, 1921; *South Bend News-Times*, September 26, 1934. Of the financing for the building, $500,000 was provided by the Meyer-Kizer Bank of Indianapolis. *South Bend Tribune*, January 15, 1926.

13. *South Bend News-Times*, April 18, 1937; see also *South Bend Tribune*, November 20, 1935; *South Bend News-Times*, July 13, 1936.

14. *South Bend Tribune*, February 3, 1925.

15. *South Bend News-Times*, January 17, 1926; *South Bend Tribune*, January 17, 1926.

16. Konrad Schiecke, *Downtown Chicago's Historic Movie Theatres* (Jefferson, NC: McFarland, 2012), 7–8.

17. Young, *South Bend World Famed*, 76.

18. Johannesen, *Cleveland Architecture*, 139.

19. Schiecke, *Downtown Chicago's Historic Movie Theatres*, 14.

20. David Naylor, *Great American Movie Theaters* (Washington, DC: Preservation Press, 1987), 15.

21. Joseph M. Valerio and David Friedman, *Movie Palaces: Renaissance and Reuse* (New York: Educational Facilities Laboratory Division, 1982), 9.

22. Schiecke, *Downtown Chicago's Historic Movie Theatres*, 22.

23. Valerio and Friedman, *Movie Palaces*, 21.

24. Valerio and Friedman, *Movie Palaces*, 22.

25. David Naylor, *American Picture Palaces: The Architecture of Fantasy* (New York: Van Nostrand Reinhold, 1981), 216–18.

26. Valerio and Friedman, *Movie Palaces*, 31.

27. Valerio and Friedman, *Movie Palaces*, 31.

28. *South Bend News-Times*, January 27, 1921.

29. *South Bend Tribune*, April 28, 2012; *South Bend Tribune*, November 11, 1993.

30. *South Bend Tribune*, December 19, 1987.

31. *South Bend Tribune*, February 11, 1993.

32. *South Bend News-Times*, August 28, 1921; Young, *South Bend World Famed*, 81.

33. *South Bend Tribune*, September 23, 1980.

34. Young, *South Bend World Famed*, 81.

35. D. Naylor, *Great American Movie Theaters*, 141; *South Bend Tribune*, August 21, 1959.

36. *South Bend News-Times*, August 10, 1922.

37. The Chicago developers included, in addition to Handelsman, Edgar C. Smith and Sam Parker. *South Bend News-Times*, March 1, 1921; *South Bend News-Times*, June 7, 1922; *South Bend Tribune*, April 28, 1951.

38. *South Bend Tribune*, November 23, 1959; *South Bend News-Times*, March 16, 1931.

39. *South Bend Tribune*, June 3, 1921.

40. *South Bend Tribune*, April 4, 1951.

41. *South Bend Tribune*, March 7, 1971.

42. *South Bend Tribune*, March 7, 1971.

43. *South Bend Tribune*, March 7, 1971.

44. *South Bend News-Times*, February 17, 1927.

45. *South Bend News-Times*, May 11, 1926. The Strand closed in the 1930s and, after an extensive remodeling, reopened in 1949 as the Avon Theater. It was closed again in the mid-1970s. *South Bend Tribune*, May 5, 1929; *South Bend Tribune*, August 3, 1987.

46. *South Bend Tribune*, July 29, 1928.

47. Valerio and Friedman, *Movie Palaces*, 33.

48. *South Bend Tribune*, July 29, 1928.

49. The Colfax Theater was constructed by the H. G. Christman Company. *South Bend News-Times*, August 3, 1928.

50. *South Bend Tribune*, December 14, 1991.

51. Young, *South Bend World Famed*, 78.

52. Cannon and Fox, *Studebaker*, 43–44.

53. David Byers, "Albert Russell Erskine," *Huntsville Historical Review* 24 (Summer–Fall 1997): 11.

54. Erskine, *History of the Studebaker Corporation*, xxiii.

55. Bonsall, *More Than They Promised*, 99–113.

56. Bonsall, *More Than They Promised*, 105–8.

57. Bonsall, *More Than They Promised*, 99–113.

58. Hall and Langworth, *Studebaker Century*, 41–44.

59. Cannon and Fox, *Studebaker*, 101.

60. Byers, "Albert Russel Erskine," 11.

61. Hall and Langworth, *Studebaker Century*, 42–43.

62. Erskine, *History of the Studebaker Corporation*, 9; Bonsall, *More Than They Promised*, 96.

63. Bonsall, *More Than They Promised*, 110–13.

64. *South Bend Tribune*, March 3, 2015.

65. Federico Bucci, *Albert Kahn: Architect of Ford* (New York: Princeton Architectural Press, 2002), 27–28.

66. Bucci, *Albert Kahn*, 32–35.

67. Bucci, *Albert Kahn*, 38–39.

68. Bucci, *Albert Kahn*, 40.

69. Hall and Langworth, *Studebaker Century*, 43.

70. Hall and Langworth, *Studebaker Century*, 64–65.

71. Erskine, *History of the Studebaker Corporation*, 9.

72. Erskine, *History of the Studebaker Corporation*, 9.

73. *City of South Bend Historical Sites and Structures: An Interim Report of the Indiana Historic Sites and Structures Inventory* (South Bend, IN: Historic Preservation Commission of South Bend and St. Joseph County, 2007), 115.

74. *South Bend Tribune*, May 6, 1928; *South Bend News-Times*, March 10, 1929; *South Bend News-Times*, August 24, 1928. The elevated system included concrete bridges over ten city streets.

75. *South Bend Tribune*, August 25, 1969.

76. *South Bend Tribune*, July 31, 1929; *South Bend Tribune*, June 1934 supplement; *South Bend Tribune*, April 4, 1971.

77. *South Bend Tribune*, April 4, 1971.

78. *South Bend Tribune*, July 31, 1929.

79. *South Bend Tribune,* February 2, 1933; *South Bend Tribune*, August 16, 1935.

80. *South Bend Tribune*, July 31, 1929; *South Bend Tribune*, August 3, 1975.

81. *South Bend Tribune,* August 24, 1969.

Chapter Fifteen

1. Michael J. Lewis, *The Gothic Revival* (London: Thames & Hudson, 2002), 185.

2. Ethan Anthony, *The Architecture of Ralph Adams Cram and His Office* (New York: W.W. Norton, 2007), 17.

3. Lewis, *Gothic Revival*, 185.

4. Turner, *Campus*, 202.

5. Turner, *Campus*, 215; see also Alex Duke, *Importing Oxbridge: English Residential Colleges and American Universities* (New Haven, CT: Yale University Press, 1997).

6. Kervick, *Architects in America*, 48.

7. Schlereth, *University of Notre Dame*, 129.

8. Schlereth, *University of Notre Dame*, 143.

9. Schlereth, *University of Notre Dame*, 140.

10. Schlereth, *University of Notre Dame*, 140.

11. Schlereth, *University of Notre Dame*, 139.

12. A formal quad was planned, with new entrances proposed for the west facades of Sorin Hall and Walsh Hall, but it was not developed as planned. Schlereth, *University of Notre Dame*, 140.

13. Schlereth, *University of Notre Dame*, 140.

14. Lewis, *Gothic Architecture*, 175–76; Anthony, *Ralph Adams Cram*, 18–21.

15. Anthony, *Ralph Adams Cram*, 17–18.

16. Turner, *Campus*, 230.

17. Withey and Withey, *Biographical Dictionary*, 145–47.

18. Withey and Withey, *Biographical Dictionary*, 146.

19. Schlereth, *University of Notre Dame*, 155.

20. Schlereth, *University of Notre Dame*, 155.

21. Kervick, *Architects in America*, 136.

22. Kervick, *Architects in America*, 90.

23. Withey and Withey, *Biographical Dictionary*, 629; Kervick, *Architects in America*, 90.

24. Schlereth, *University of Notre Dame*, 157–58.

25. Schlereth, *University of Notre Dame*, 175.

26. Schlereth, *University of Notre Dame*, 140–44; Kervick, *Architecture at Notre Dame*, n.p.

27. *South Bend Tribune*, April 7, 1991.

28. Turner, *Campus*, 167.

29. Kervick, *Architecture at Notre Dame*, n.p.

30. *South Bend Tribune*, April 7, 1991.

Chapter Sixteen

1. Frederick Lewis Allen, *Only Yesterday: An Informal History of the 1920s* (New York: Harper, 1931), 337–38; Lester V. Chandler, *America's Great Depression 1929-1941* (New York: Harper and Row, 1970), 19; David M. Kennedy, *Freedom from Fear: The American People in Depression and War, 1929–1945* (Oxford: Oxford University Press, 1999), 37–38.

2. Chandler, *America's Great Depression*, 21–22.

3. Irving Fisher, *The Stock Market Crash and After* (New York: Macmillan, 1930), xviii.

4. Kennedy, *Freedom from Fear*, 91–92, 194–97.

5. *South Bend Tribune*, December 12, 1933.

6. They distributed $8 million in dividends in 1930, $3 million in 1931, and $1 million in 1932, the latter at a time when the company was losing nearly $9 million. While such large payouts were done in the hopes of bolstering investor confidence, it was clear that Erskine did not acknowledge the precarious state of the nation's economy, and that his actions only further undermined the company's ability to survive the economic downturn. Cannon and Fox, *Studebaker*, 46.

7. Hall and Langworth, *Studebaker Century*, 66; Cannon and Fox, *Studebaker*, 47–48.

8. *South Bend Tribune*, November 3, 1977; see also Lizabeth Cohen, *A Consumers' Republic: The Politics of Mass Consumption in Postwar America* (New York: Vintage Books, 2004), 257–89.

9. Henry-Russell Hitchcock and Philip Johnson, *The International Style: Architecture since 1922* (New York: W.W. Norton, 1932).

10. Whiffen and Koeper, *American Architecture*, 2:334.

11. Vonada, *Notre Dame*, 192.

12. CPA was headed by Tom Brademas, who was the brother of local congressman and majority whip John Brademas. Architects included Donald Sporleder, Brian Crumlish, and Gary Gabrich.

13. Data taken from the University of Richmond Digital Scholarship Lab, "Renewing Inequality: Urban Renewal, Family Displacements, and Race 1950–1966," *American Panorama,* ed. Robert K. Nelson and Edward L. Ayers, accessed June 24, 2022, https://dsl.richmond.edu/panorama/renewal/#view=-487.34/- 39.74/1.62& viz=cartogram&city=southbendIN&loc=13/41.6639/- 86.2653&project=2640.

Bibliography

Books and Periodical Articles

Adelsperger, Rolland. "The Work of Messrs. Selby and Young." *Ohio Architect and Builder* 15, no. 5 (1910): 27–46.

Allen, Frederick Lewis. *Only Yesterday: An Informal History of the 1920s*. New York: Harper, 1931.

American Architect and Building News 59, no. 1152 (January 22, 1898): 31, pl. 1152.

Anderson and Cooley, comp. *South Bend and the Men Who Have Made It: Historical, Descriptive, Biographical*. South Bend, IN: Tribune Printing, 1901.

Anthony, Ethan. *The Architecture of Ralph Adams Cram and His Office*. New York: W. W. Norton, 2007.

Appelbaum, Stanley. *Spectacle in the White City: The Chicago 1893 World's Fair*. Mineola, NY: Galla Editions, 2009.

Art Work of South Bend and Vicinity. Chicago: W. H. Parish, 1894.

Bailyn, Bernard. *The Ideological Origins of the American Revolution*. 3rd ed. Cambridge, MA: Belknap Press of Harvard University Press, 2017.

Baker, George A. *The St. Joseph-Kankakee Portage*. South Bend, IN: Northern Indiana Historical Society, 1964.

Baker, Paul R. *Richard Morris Hunt*. Cambridge, MA: MIT Press, 1980.

Barnhart, John D., and Donald F. Carmony. *Indiana: From Frontier to Industrial Commonwealth*, vol. 1. New York: Lewis Historical Publishing, 1954.

Barrett, Margaret. "Finding the Roots of the Basilica of the Sacred Heart: An Architectural History." Unpublished independent study term paper, University of Notre Dame School of Architecture, May 9, 2014.

Bicknell, Amos J. *Bicknell's Village Builder: Elevations and Plans for Cottages, Villas, Suburban Residences, Farm Houses . . . also Exterior and Interior Details . . .*

with Approved Forms of Contracts and Specifications. Troy, NY: A. J. Bicknell, 1870.

Blantz, Thomas E. *The University of Notre Dame: A History*. Notre Dame, IN: University of Notre Dame Press, 2020.

Bonsall, Thomas E. *More Than They Promised: The Studebaker Story*. Stanford, CA: Stanford University Press, 2000.

Boyd, Sterling. "The Adam Style in America: 1770–1820." Ph.D. diss., Princeton University, 1966.

Braunfels, Wolfgang. *Urban Design in Western Europe: Regime and Architecture, 900–1900*. Translated by Kenneth J. Northcott. Chicago: University of Chicago Press, 1988.

Breich, Kenneth. *Henry Hobson Richardson and the Small Public Library in America*. Cambridge, MA: MIT Press, 1997.

Brooks, H. Allen. *The Prairie School: Frank Lloyd Wright and His Midwest Contemporaries*. Toronto: University of Toronto Press, 1972.

Bucci, Federico. *Albert Kahn: Architect of Ford*. New York: Princeton Architectural Press, 2002.

Burg, David F. *Chicago's White City of 1893*. Lexington: University of Kentucky Press, 1976.

Byers, David. "Albert Russel Erskine," *Huntsville Historical Review* 24 (Summer–Fall 1997): 11–20.

Campers, Edmund V. *History of St. Joseph's Parish, South Bend, Indiana, 1853–1953*. South Bend, IN: n.p., 1953.

Cannon, William A., and Fred K. Fox. *Studebaker: The Complete Story*. Blue Ridge Summit, PA: TAB Books, 1981.

Chandler, Lester V. *America's Great Depression, 1929–1941*. New York: Harper and Row, 1970.

Chapman, Charles C. *History of St. Joseph County, Indiana; Together with Sketches of Its Cities, Villages, and Townships, Educational, Religious, Civil, Military, and Political History; Portraits of Prominent Persons, and Biographies of Representative Citizens*. Chicago: Charles C. Chapman, 1880.

Charles Shober and Company. *South Bend, Indiana, 1874*. Madison, WI: J. J. Stoner, 1874.

"The City of Chicago." *Engineering* 55 (April 21, 1893): 516–18.

City of South Bend Historical Sites and Structures: An Interim Report of the Indiana Historic Sites and Structures Inventory. South Bend, IN: Historic Preservation Commission of South Bend and St. Joseph County, 2007.

Cleaveland, Henry W., William Backus, and Samuel D. Backus. *Village and Farm Cottages*. New York: D. Appleton, 1856.

Clymer, Floyd. *Treasury of Early American Automobiles, 1877–1925*. New York: McGraw-Hill, 1950.

Cohen, Lizabeth. *A Consumers' Republic: The Politics of Mass Consumption in Postwar America*. New York: Vintage Books, 2004.

Comstock, William Phillips, and Clarence Eaton Schermerhorn. *Bungalows: Camps and Mountain Houses*. Washington, DC: American Institute of Architects Press, 1990.

Condit, Carl. *The Chicago School of Architecture*. Chicago: University of Chicago Press, 1964.

Cooper, James L. *Artistry and Ingenuity in Artificial Stone: Indiana's Concrete Bridges, 1900–1942*. Greencastle, IN: Historic Bridge Books/James L. Cooper, 1997.

Corle, Edwin. *John Studebaker: An American Dream*. New York: E. P. Dutton, 1948.

Critchlow, Donald T. *Studebaker: The Life and Death of an American Corporation*. Bloomington: Indiana University Press, 1996.

Cummings, Marcus. *Cummings' Architectural Details, Containing 387 Designs and 967 Illustrations of the Various Parts Needed in the Construction of Buildings, Public and Private . . . also Plans and Elevations of Houses, Stores, Cottages and Other Buildings* (New York: Orange Judd, 1873).

Curl, James Stevens. *Oxford Dictionary of Architecture*. Oxford: Oxford University Press, 1999.

Curran, Kathleen. *The Romanesque Revival: Religion, Politics and Transnational Exchange*. University Park: Pennsylvania State University Press, 2003.

Davey, Peter. *Architecture of the Arts and Crafts Movement*. New York: Rizzoli, 1980.

Davis, Alexander Jackson. *Rural Residences, etc. Consisting of Designs, Original and Selected, for Cottages, Farm-Houses, Villas, and Village Churches*. New York: New York University, 1837. Reprinted with a new introduction by Jane B. Davies. New York: Da Capo Press, 1980.

Davis, H. Gail. *The Story of James Oliver and the Oliver Chilled Plow Works*, 11 vols. N.p.: Oliver Family, 1946.

Detzler, Jack J. *South Bend 1910–1920: A Decade Dedicated to Reform*. South Bend: Northern Indiana Historical Society, 1960.

Devine, Jane A., ed. *100 Years of Architecture at Notre Dame: A History of the School of Architecture, 1898–1998*. South Bend, IN: University of Notre Dame School of Architecture, 1999.

Dilts, Jon. *The Magnificent 92 Courthouses of Indiana*. Bloomington: Indiana University Press, 1999.

Divine, Amanda, and Colin-Elizabeth Pier. *Saint Mary's College: The College History Series*. Chicago: Arcadia, 2001.

Downing, Andrew Jackson. *The Architecture of Country Houses; Including Designs for Cottages, Farm-Houses, and Villas*. Philadelphia: D. Appleton, 1850. Reprinted with an introduction by George Tatum. New York: Da Capo Press, 1968.

———. *Cottage Residences; or, A Series of Designs for Rural Cottages and Cottage Villas, and Their Gardens and Grounds*. 4th ed. New York: John Wiley, 1852. Reprint, Watkins Glen, NY: American Life Foundation, 1967.

———. *Landscape Gardening and Rural Architecture.* Reprinted with an introduction by George Tatum. New York: Dover, 1991. Originally published as *A Treatise on the Theory and Practice of Landscape Gardening, Adapted to North America; With a View to the Improvement of Country Residences.* New York: Wiley and Putnam, 1841.

———. *Rural Residences, Etc., Consisting of Designs, Original and Selected, for Cottages, Farm-Houses, Villas and Village Churches.* New York: New York University, 1837. Reprinted with an introduction by Jane B. Davies. New York: Da Capo Press, 1980.

Downing, Antoinette, and Vincent J. Scully Jr. *The Architectural Heritage of Newport, Rhode Island, 1640–1915.* New York: Clarkson N. Potter, 1967.

Dredge, James. "The Columbian Exposition of 1893." *Engineering* 52 (December 25, 1891): 766.

Duke, Alex. *Importing Oxbridge: English Residential Colleges and American Universities.* New Haven, CT: Yale University Press, 1997.

Eaton, Leonard K. *Two Chicago Architects and Their Clients: Frank Lloyd Wright and Howard Van Doren Shaw.* Cambridge, MA: MIT Press, 1969.

Ehrlich, George. *Kansas City, Missouri: An Architectural History, 1826–1976.* Kansas City, MO: Historic Kansas City Foundation, 1979.

Ericsson, Henry. *Sixty Years a Builder: The Autobiography of Henry Ericsson.* Chicago: A. Kroch & Son, 1942. Reprint, New York: Arno Press, 1972.

Erskine, Albert Russel. *History of the Studebaker Corporation.* South Bend, IN: Studebaker Manufacturing Corporation, 1924.

Esarey, Logan. *History of Indiana from Its Exploration to 1922; Also an Account of St. Joseph County from Its Organization*, 3 vols. Edited by John B. Stoll. Dayton, OH: Dayton Historical, 1923.

Favro, Diane. *The Urban Image of Augustan Rome.* New York: Cambridge University Press, 1996.

Fisher, Irving. *The Stock Market Crash and After.* New York: Macmillan, 1930.

Ford, George B. "The Park System of Kansas City, Missouri." *Architectural Record* 40 (December 1916): 497–504.

Foucart, Bruno, ed. *Viollet-le-Duc.* Exhibition catalog. Galeries nationales du Grand Palais, Paris. Paris: Éditions de la Réunion des musées nationaux, 1980.

Frary, I. T. *Early Homes of Ohio.* New York: Dover, 1970.

Garner, John S. "S. S. Beman and the Building of Pullman." In *The Midwest in American Architecture*, edited by John S. Garner, 231–48. Urbana: University of Illinois Press, 1991.

Gebhard, David, and Tom Martinson. *Guide to the Architecture of Minnesota.* Minneapolis: University of Minnesota Press, 1977.

Goodspeed Brothers. *Pictorial and Biographical Memoirs of Elkhart and St. Joseph Counties.* Chicago: Goodspeed Brothers, 1893.

Gordon, Buford F. *The Negro in South Bend: A Social Study.* South Bend, IN: n.p., 1922.

Gosling, David, with Maria Cristina Gosling. *The Evolution of American Urban Design: A Chronological Anthology*. Chichester, UK: Wiley-Academy, 2003.

Gowans, Alan. *Images of American Living: Four Centuries of Architecture and Furniture as Cultural Expression*. Philadelphia: J. B. Lippincott, 1964.

Green, Hardy. *The Company Town: The Industrial Edens and Satanic Mills That Shaped the American Economy*. Philadelphia: Basic Books, 2010.

A Guide to South Bend, Notre Dame du Lac and Saint Mary's, Indiana. Baltimore, MD: John Murphy, 1859.

A Guide to the University of Notre Dame du Lac and the Academy of St. Mary of the Immaculate Conception, Near South Bend, Indiana. Philadelphia: J. B. Chandler, 1865.

Habel, Dorothy Metzger. *The Urban Development of Rome in the Age of Alexander VII*. New York: Cambridge University Press, 2002.

Hall, Asa E., and Richard M. Langworth. *The Studebaker Century: A National Heritage*. Contoocook, NH: Dragonwyck, 1983.

Hamlin, A. D. F. "Twenty-Five Years of American Architecture." *Architectural Record* 40 (July 1916): 8.

Hamlin, Talbot. *Greek Revival Architecture in America: Being an Account of Important Trends in American Architecture and American Life Prior to the War between the States*. London: Oxford University Press, 1944.

Haygood, H. Gregory, ed. *Pilgrim Missionary Baptist Church, 1890–1990*. South Bend, IN: n.p., 1990.

Hayward, Mary Ellen, and Frank R. Shivers Jr. *The Architecture of Baltimore: An Illustrated History*. Baltimore, MD: Johns Hopkins University Press, 2004.

Healey, David H. "Tugging on the Reins of Power: Persons and Events That Encouraged the Development of Political Power within the Black Community of South Bend." Master's thesis, Indiana University–South Bend, 2007.

Hewitt, Mark Alan. *Gustav Stickley's Craftsman Farms: The Quest for an Arts and Crafts Utopia*. Syracuse, NY: Syracuse University Press, 2001.

Hitchcock, Henry-Russell. *Architecture: Nineteenth and Twentieth Centuries*. New York: Penguin Books, 1968.

———. *In the Nature of Materials, 1887–1941*. New York: Duell, Sloan and Pearce, 1942.

Hitchcock, Henry-Russell, and Philip Johnson. *The International Style: Architecture since 1922*. New York: W.W. Norton, 1932.

Holly, Henry Hudson. *Holly's Country Seats: Containing Lithographic Designs for Cottages, Villas, Mansions, etc.* New York: D. Appleton, 1863. Reprinted, with a new introduction by Michael Tomlan, as *Country Seats and Modern Dwellings: Two Victorian Domestic Architectural Stylebooks by Henry Hudson Holly*. Watkins Glen, NY: Library of Victorian Culture, 1977.

Hope, Arthur. *Notre Dame: One Hundred Years*. Rev. ed. Notre Dame, IN: University of Notre Dame Press, 1948.

Howard, Timothy Edward. *A History of St. Joseph County Indiana*. 2 vols. Chicago: Lewis, 1907.

Hubka, Thomas C. "H. H. Richardson's Glessner House: A Garden in the Machine." *Winterthur Portfolio* 24, no. 4 (Winter 1989): 209–29.

Hurtt, Steven. "The American Continental Grid: Form and Meaning." *Threshold* 2 (Autumn 1983): 31–40.

An Illustrated Historical Atlas of St. Joseph Co., Indiana. Chicago: Higgins, Belden, 1875.

An Illustrated History of St. Joseph's Church, South Bend, Indiana. South Bend, IN: n.p., 1901.

Jacobs, Jane. *The Death and Life of Great American Cities*. New York: Random House, 1961.

Johannesen, Eric. *Cleveland Architecture 1878–1976*. Cleveland, OH: Western Reserve Historical Society, 1979.

Kaplan, Wendy, ed. *The Arts and Crafts Movement in Europe and America: Design for the Modern World*. New York: Thames & Hudson, 2004.

Karst, Frederick A. "A Rural Black Settlement in St. Joseph County, Indiana, before 1900." *Indiana Magazine of History* 74, no. 3 (September 1978): 252–67.

Keating, Ann Durkin. *Building Chicago: Suburban Developers and the Creation of a Divided Metropolis*. Columbus: Ohio State University Press, 1988.

Kennedy, David M. *Freedom from Fear: The American People in Depression and War, 1929–1945*. Oxford: Oxford University Press, 1999.

Kervick, Francis W. *Architects in America of Catholic Tradition*. Rutland, VT: Charles E. Tuttle, 1962.

———. *Architecture at Notre Dame: A Review to Commemorate the Fortieth Anniversary of the Department of Architecture, 1898–1938*. Notre Dame, IN: University of Notre Dame Press, 1938.

———. *Patrick Charles Keely, Architect: A Record of His Life and Work*. South Bend, IN: n.p., 1953.

King, Anthony D. *The Bungalow: The Production of a Global Culture*. London: Routledge and Kegan Paul, 1984.

King, David. *The Complete Works of Robert and James Adam*. Oxford: Butterworth-Heineman, 1991.

Lacey, Robert. *Ford: The Men and the Machine*. Boston: Little, Brown, 1986.

Lancaster, Clay. *The American Bungalow, 1880–1930*. New York: Abbeville Press, 1985.

Landau, Sarah Bradford. "Richard Morris Hunt: The Continental Picturesque and the 'Stick Style.'" *Journal of the Society of Architectural Historians*, 42, no. 3 (1983): 272–89.

Lee, Antoinette J. *Architects to the Nation: The Rise and Decline of the Supervising Architect's Office*. New York: Oxford University Press, 2000.

Leeper, David. *Some Early Local Footprints: The Pokagon Village, the Notre Dame Lakes, Our Savage Predecessors*. South Bend, IN: South Bend Daily Times, 1898.

LeRoy, Julien-David. *The Ruins of the Most Beautiful Monuments in Greece*. Translated by David Britt. Los Angeles: Getty Research Institute, 2004.

Levine, Neil. *The Architecture of Frank Lloyd Wright*. Princeton, NJ: Princeton University Press, 1996.

Lewis, Michael J. *City of Refuge: Separatists and Utopian Town Planning*. Princeton, NJ: Princeton University Press, 2016.

———. *The Gothic Revival*. London: Thames & Hudson, 2002.

The Life of Clement Studebaker. Transcribed by Jan B. Young. Raleigh, NC: Lulu.com, 2009.

Longstreet, Stephen. *A Century on Wheels: The Story of Studebaker—A History 1852–1952*. New York: Henry Holt, 1952.

Maass, John. *The Gingerbread Age: A View of Victorian America*. New York: Rinehart, 1957.

Marx, Leo. *The Machine in the Garden: Technology and the Pastoral Ideal in America*. New York: Oxford University Press, 2000.

Masur, Kate. *Until Justice Be Done: America's First Civil Rights Movement from the Revolution to Reconstruction*. New York: W. W. Norton, 2021.

Maynard, W. Barksdale. "The Greek Revival: Americanness, Politics and Economics." In *American Architectural History: A Contemporary Reader*, edited by Keith L. Eggener, 132–41. New York: Routledge, 2004.

McAlester, Virginia, and Lee McAlester. *A Field Guide to American Houses*. New York: Alfred A. Knopf, 1984.

McAllister, Anna. *Flame in the Wilderness: Life and Letters of Mother Angela Gillespie, C.S.C., 1824–1887*. Paterson, NJ: St. Anthony Guild Press, 1944.

McCandless, Kenneth William. "The Endangered Domain: A Review and Analysis of Campus Planning and Design at the University of Notre Dame." Master's thesis, University of Notre Dame, 1974.

McNamara, Denis. *Heavenly City: The Architectural Tradition of Catholic Chicago*. Chicago: Liturgy Training, 2005.

McVicker, J. J. *Pictorial Souvenir of South Bend, Indiana 1919*. Chicago: J. J. McVicker, 1919.

Meikle, Douglas L. "James Oliver and the Oliver Chilled Plow Works." Ph.D. diss., Indiana University, Bloomington, IN, 1958.

"Mines and Mining Building." *World's Columbian Exposition Illustrated* 1, no. 9 (November 1891): 24.

Moore, Charles. *Daniel H. Burnham: Architect and Planner of Cities*. 2 vols. New York: Da Capo Press, 1968.

———. *The Life and Times of Charles Follen McKim*. New York: Da Capo Press, 1970.

Morrison, Hugh. *Louis Sullivan: Prophet of Modern Architecture*. New York: W. W. Norton, 1935.

Muhlstein, Anka. *La Salle: Explorer of the North American Frontier*. New York: Arcade, 1994.

Mumford, Lewis. *The Brown Decades: A Study of the Arts in America, 1865–1895*. New York: Dover, 1971.

Museum of Science and Industry, Chicago. *A Guide to 150 Years of Chicago Architecture*. Chicago: Chicago Review Press, 1985.

Nassaney, Michael S., ed. *Fort St. Joseph Revealed: The Historical Archaeology of a Fur Trading Post*. Gainesville: University Press of Florida, 2019.

Naylor, David. *American Picture Palaces: The Architecture of Fantasy*. New York: Van Nostrand Reinhold, 1981.

———. *Great American Movie Theaters*. Washington, DC: Preservation Press, 1987.

Naylor, Gillian. *The Arts and Crafts Movement: A Study of Its Sources and Influence on Design Theory*. Cambridge, MA: MIT Press, 1971.

Newberry, James. "Brother Charles Borromeo Harding: 1838–1922, Amateur Architect." *Proceedings of the 2010 Conference on the History of the Congregation of the Holy Cross, Holy Cross College*. Notre Dame, IN: University of Notre Dame, 2010.

Newcomb, Rexford. *Architecture of the Old Northwest Territory*. Chicago: University of Chicago Press, 1950.

Nicholson, Ben, and Michelangelo Sabatino, eds. *Avant-Garde in the Cornfields: Architecture, Landscape, and Preservation in New Harmony*. Minneapolis: University of Minnesota Press, 2019.

Notre Dame, University of. *A Brief History of the University of Notre Dame du Lac, Indiana, from 1842 to 1892, Prepared for the Golden Jubilee*. Chicago: Werner, 1895.

Ochsner, Jeffrey Karl, and Dennis Alan Andersen. *Distant Corner: Seattle Architects and the Legacy of H. H. Richardson*. Seattle: University of Washington Press, 2003.

O'Connell, Marvin R. *Edward Sorin*. Notre Dame, IN: University of Notre Dame Press, 2001.

O'Dell, Katherine. *Our Day: Race Relations and Public Accommodations in South Bend, Indiana*. South Bend, IN: Wolfson Press, 2010.

O'Gorman, James. *H. H. Richardson: Architectural Forms for an American Society*. Chicago: University of Chicago Press, 1987.

Our City: South Bend, Ind., Its Factories, Business Houses, Residences, Churches, Colleges and Picturesque Surroundings. South Bend, IN: L. C. Ball and G. C. Davis, 1889.

Palliser, Palliser and Company. *Palliser's New Cottage Homes and Details. Containing Nearly Two Hundred and Fifty New and Original Designs in All the Popular Styles*. 1887. Reprint, Watkins Glen, NY: American Life Foundation, 1975.

Palmer, John. *South Bend in Vintage Post Cards*. Chicago: Arcadia, 2005.

Parkman, Francis. *The Oregon Trail: The Conspiracy of Pontiac.* New York: Library Classics of America, 1984.

Peat, Wilbur D. *Indiana Houses of the Nineteenth Century.* Indianapolis: Indiana State Historical Society, 1962.

Pictorial Souvenir of South Bend, Indiana, 1919. Chicago: J. J. McVicker, 1919.

Pierson, William H., Jr. *American Buildings and Their Architects.* Vol. 1, *The Colonial and Neoclassical Styles.* Garden City, NY: Doubleday, 1970.

———. *American Buildings and Their Architects.* Vol. 2, *Technology and the Picturesque, the Corporate and the Early Gothic Styles.* Garden City, NY: Anchor Books, 1980.

Pilkinton, Mark C. *Washington Hall at Notre Dame: Crossroads of the University, 1864–2004.* Notre Dame, IN: University of Notre Dame Press, 2011.

Piranesi, Giovanni Battista. *Différentes vues de quelques restes de trois grands édifices : qui subsistent encore dans le milieu de l'ancienne ville de Pesto autrement Posidonia qui est située dans la Lucanie, 1778.* Available at https://archive.org /embed/gri_33125014447854.

Pond, Irving K. *The Autobiography of Irving K. Pond: The Sons of Mary and Elihu.* Edited by David Swan and Terry Tatum. Oak Park, IL: Hyoogen Press, 2009.

Poppeliers, John C., and S. Allen Chambers Jr. *What Style Is It? A Guide to American Architecture.* New York: John Wiley and Sons, 2003.

Pratt, Anne S. "John Trumbull and the Old Brick Row." *Yale University Library Gazette* (July 1934): 11–20.

Rae, John B. *American Automobile Manufacturers: The First Forty Years.* Philadelphia: Chilton, 1959.

Reed, Henry Hope. *The Golden City.* New York: W. W. Norton, 1970.

Reiff, Daniel D. *Houses from Books; Treatises, Pattern Books, and Catalogs in American Architecture, 1937–1950: A History and Guide.* University Park: Pennsylvania State University Press, 2000.

Reps, John. *Town Planning in Frontier America.* Columbia: University of Missouri Press, 1980.

Rifkind, Carole. *A Field Guide to American Architecture.* New York: New American Library, 1980.

Robinson, Charles Mulford. "Improvement in City Life: Aesthetic Progress." *Atlantic Monthly* 83 (June 1899): 77.

Robinson, Gabrielle. *Better Homes of South Bend: An American Story of Courage.* Charleston, SC: History Press, 2015.

Romine, Joan. *Copshaholm: The Oliver Story.* South Bend, IN: Northern Indiana Historical Society, 1978.

———. *Tippecanoe Place: A History.* South Bend, IN: Southold Restorations, 1972.

Roth, Leland. *A Concise History of American Architecture.* New York: Harper and Row, 1979.

Roth, Leland, and Amanda C. Roth Clark. *American Architecture: A History.* Boulder, CO: Westview Press, 2016.

————. *Understanding Architecture: Its Elements, History, and Meaning.* 3rd ed. Boulder, CO: Westview Press, 2014.

Ruskin, John. *The Seven Lamps of Architecture.* London: Smith, Elder, 1849.

Schiecke, Konrad. *Downtown Chicago's Historic Movie Theatres.* Jefferson, NC: McFarland, 2012.

Schlereth, Thomas J. *A Dome of Learning: The University of Notre Dame's Main Building.* Notre Dame, IN: University of Notre Dame Alumni Association, 1991.

————. "A High Victorian Gothicist as Beaux-Arts Classicist: The Architectural Odyssey of Solon Spencer Beman." *Studies in Medievalism* 3, no. 2 (Fall 1990): 129–51.

————. *The Notre Dame Main Building: Fact and Symbol, 1879–1979.* Notre Dame, IN: Archives of the University of Notre Dame, 1979.

————. "Solon Spencer Beman, 1853–1914: The Social History of a Midwest Architect." *Chicago Architectural Journal* 5 (December 1985): 8–30.

————. "Solon Spencer Beman, Pullman, and the European Influence on and Interest in his Chicago Architecture." In *Chicago Architecture, 1872–1922: Birth of a Metropolis*, edited by John Zukowsky, 172–87. Munich: Prestal-Verlag in association with The Art Institute of Chicago, 1987.

————. *A Spire of Faith: The University of Notre Dame's Sacred Heart Church.* Notre Dame, IN: University of Notre Dame Alumni Association, 1991.

————. *The University of Notre Dame: A Portrait of Its History and Campus.* Notre Dame, IN: University of Notre Dame Press, 1976.

Schmitt, Peter, and Balthazar Korab. *Kalamazoo: Nineteenth-Century Homes in a Midwestern Village.* Kalamazoo, MI: Kalamazoo City Historical Commission, 1976.

Schmitt, Ronald E. "Sullivanesque Architecture and Terra Cotta." In *The Midwest in American Architecture,* edited by John S. Garner, 163–84. Urbana: University of Illinois Press, 1991.

Schuyler, Montgomery. *American Architecture and Other Writings.* 2 vols. Edited by William H. Jordy and Ralph Coe. Cambridge, MA: Belknap Press of Harvard University Press, 1961.

————. "The Romanesque Revival in America." *Architectural Record* 1, no. 2 (October 1891): 151–98.

Scully, Vincent J., Jr. *American Architecture and Urbanism.* New York: Praeger, 1976.

————. *The Shingle Style and the Stick Style.* Rev. ed. New Haven, CT: Yale University Press, 1971.

Seeley, Samantha. *Race, Removal, and the Right to Remain: Migration and the Making of the United States.* Chapel Hill: University of North Carolina Press, 2021.

Sies, Mary Corbin. "God's Very Kingdom on Earth: The Design Program for the American Suburban Home 1877–1917." In *Modern Architecture in America:*

Visions and Revisions, edited by Richard Guy Wilson and Sidney K. Robinson, 2–31. Ames: Iowa State University Press, 1991.

Smith, Willard H. *Schuyler Colfax: The Changing Fortunes of a Political Idol.* Indianapolis: Indiana Historical Society, 1952.

Smith, William Henry. *The History of the State of Indiana from the Earliest Explorations by the French to the Present Time.* Vol. 1. Indianapolis: B. L. Blair, 1897.

Sorin, Edward. *The Chronicles of Notre Dame du Lac.* Translated by John M. Toohey. Edited by James T. Connelly. Notre Dame, IN: University of Notre Dame Press, 1992.

Stamper, John W. *Chicago's North Michigan Avenue: Planning and Development, 1900–1930.* Chicago: University of Chicago Press, 1991.

———, ed. *City of South Bend Summary Report: Indiana Historic Sites and Structures Inventory.* South Bend, IN: Historic Preservation Commission of South Bend and St. Joseph County, 1982.

Stein, R. Conrad. *The Pullman Strike and the Labor Movement in American History.* Berkeley Heights, NJ: Enslow, 2001.

Stickley, Gustav D., ed., *Craftsman Bungalows: 59 Homes from "The Craftsman."* New York: Dover, 1988.

Storrer, William Allen. *The Architecture of Frank Lloyd Wright: A Complete Catalog.* Cambridge, MA: MIT Press, 1978.

Swedarsky, Lisa. *A Place with Purpose: Hering House, 1925–1963.* South Bend, IN: Wolfson Press, 2009.

Tallmadge, Thomas. *The Story of Architecture in America.* New York: W. W. Norton, 1927.

Tewkesbury, Donald. *The Founding of American Colleges and Universities before the Civil War.* New York: New York City Teachers College, Columbia University, 1932.

Tinniswood, Adrian. *The Arts and Crafts House.* New York: Watson-Guptil, 1999.

Tomlan, Mary Raddant, and Michael A. Tomlan. *Richmond, Indiana: Its Physical Development and Aesthetic Heritage to 1920.* Indianapolis: Indiana Historical Society Press, 2003.

Trahey, James J. *Dujarie Hall.* Notre Dame, IN: University of Notre Dame Press, 1906.

Turner, Paul Venable. *Campus: An American Planning Tradition.* New York: Architectural History Foundation, 1984; Cambridge, MA: MIT Press, 1984.

Unrivaled Chicago. Chicago: Rand, McNally and Company, 1897.

Valerio, Joseph M., and Daniel Friedman. *Movie Palaces: Renaissance and Reuse.* New York: Educational Facilities Laboratories Division, 1982.

Van Brunt, Henry. *Architecture and Society: Selected Essays by Howard Van Brunt.* Cambridge, MA: Belknap Press of Harvard University Press, 1969.

Van Rensselaer, Mariana Griswold. *Henry Hobson Richardson and His Works.* New York: Dover, 1969.

Van Zanten, David. *Sullivan's City: The Meaning of Ornament for Louis Sullivan.* New York: W. W. Norton, 2000.

Viollet-le-Duc, Eugène-Emmanuel. *Entretiens sur l'Architecture.* 2 vols. Paris: A. Morel, 1863–1872.

Vogt, Erik. "A New Haven & a New Earth: The Origin and Meaning of the Nine-Square Plan." In *Yale in New Haven: Architecture and Urbanism,* edited by Vincent Scully, Catherine Lynn, Erik Vogt, and Paul Goldberger, 37–52. New Haven: Yale University Press, 2004.

Vonada, Damaine. *Notre Dame: The Official Campus Guide.* Notre Dame, IN: Notre Dame University Press, 1998.

Weingarden, Lauren S. *Louis H. Sullivan and a 19th-Century Poetics of Naturalized Architecture.* Burlington, VT: Ashgate, 2009.

———. *Louis H. Sullivan: The Banks.* Cambridge, MA: MIT Press, 1987.

Wheeler, Gervase. *Rural Homes; or Sketches of Houses Suited to American Country Life with Original Plans, Designs, &c.* Auburn, NY: Alden and Beardsley, 1855.

Whiffen, Marcus. *American Architecture Since 1780: A Guide to the Styles.* Cambridge, MA: MIT Press, 1981.

Whiffen, Marcus, and Frederick Koeper. *American Architecture.* Vol. 2, *1860–1976.* Cambridge, MA: MIT Press, 2001.

Wiebenson, Dora. *Sources of Greek Revival Architecture.* University Park: Pennsylvania State University Press, 1969.

Wilson, Richard Guy. *McKim, Mead and White, Architects.* New York: Rizzoli, 1983.

Wilson, Richard Guy, and Sidney K. Robinson. *The Prairie School in Iowa.* Ames: Iowa State University Press, 1977.

Wilson, William H. *The City Beautiful Movement.* Baltimore, MD: Johns Hopkins University Press, 1989.

———. "J. Horace McFarland and the City Beautiful Movement." *Journal of Urban History* 7 (May 1981): 315–34.

Withey, Henry F., and Elsie Rathburn Withey. *Biographical Dictionary of American Architects (Deceased).* Los Angeles: Hennessey & Ingalls, 1970.

Wolner, Edward W. *Henry Ives Cobb's Chicago: Architecture, Institutions, and the Making of a Modern Metropolis.* Chicago: University of Chicago Press, 2011.

Woods, Mary N. "Henry Van Brunt: 'The Historic Styles, Modern Architecture.'" In *American Public Architecture: European Roots and Native Expressions*, edited by Craig Zabel and Susan Scott Munshower, 82–113. University Park: Pennsylvania State University Press, 1989.

Woodward, George E. *Woodward's New Country Homes, a Practical and Original Work on Rural Architecture.* 1865. Reprint, Watkins Glen, NY: American Life Foundation, 1979.

Wright, Gwendolyn. *Moralism and the Model Home.* Chicago: University of Chicago Press, 1980.

Young, C. E., ed. *South Bend World Famed*. South Bend, IN: Handelsman and Young, 1922.

Archival Materials and Public Records

The Alumnus archives. University of Notre Dame Archives. Hesburgh Library, Notre Dame, IN. https://archives.nd.edu/Alumnus/.

Indiana Memory. Indiana State Library, Indianapolis, IN. https://digital.library.in.gov.

Indiana University South Bend Archives. South Bend Civil Rights History Collection. South Bend, IN. https://archive.org/details/CRHC.SMALL.228a/mode/2up.

Local and Family History Department. St. Joseph County Public Library. South Bend, IN.

Michiana Memory Digital Collection. St. Joseph County Public Library. South Bend, IN.

National Archives, Record Group 79: Records of the National Park Service, Series: National Register of Historic Places and National Historic Landmarks Program Records, Indiana. College Park, MD. United States Department of Interior, National Park Service. National Register of Historic Places Inventory—Nomination Form. "Chapin House." West Washington Street National Register Historic District. https://catalog.archives.gov/id/102251957.

The Scholastic archives. University of Notre Dame Archives. Hesburgh Library, Notre Dame, IN. https://www.archives.nd.edu/Scholastic/.

South Bend News-Times Archives. Hoosier State Chronicles. https://newspapers.library.in.gov.

South Bend Tribune. America's Historic Newspapers. NewsBank. https://southbendtribune.newsbank.com/.

University of Notre Dame Archives. Hesburgh Library, Notre Dame, IN. https://www.archives.nd.edu/.

Index of Images

General Index

Art Deco style, 299, 301
Art Institute of Chicago, 204, 206, 220,
 228, 264, 268, 358n10
Art Moderne style, 323
Arts and Crafts movement, 246, 257,
 272–77
Astor, John Jacob, 16, 93, 335n23
Atwood, Charles, 209
Augusta Hall (Saint Mary's College),
 130, 131
Ault, Phil, 302–3
Austin, Ennis R.
 Art Moderne homes by, 323
 Arts and Crafts movement and,
 275
 bank buildings and, 281, 282, 285
 Copshaholm and, 169, 173
 Prairie School movement and,
 268–72, 301
 South Bend Public Library and, 181
 St. James Episcopal Church and,
 185
automobile industry, 84, 98, 236–38,
 243, 296–99, 321–22

B
Backus, William and Samuel, 350n7
Badgley, Sydney Rose, 186, 188
Badin, Stephen Theodore, 30, 31
Bainter-Smith House, 24
Baker, Arthur, 141, 142
banks, 25, 47–49, 62, 215, 247, 280–85,
 322, 329
Barber, George F., 144
Barker, John G., 228
Baroque style, 13, 43, 50, 108, 112, 212,
 290, 340n1
Barrett, Margaret, 347n22
Bartlett, Charles H., 247
Bartlett, Joseph, 45–46
Bartlett House, 45–46, 58
Bauhaus style, 323
Beach and Company paper mill, 75

Beaux-Arts style
 civic architecture and, 204, 208–11,
 227
 commercial architecture and, 290
 educational architecture and, 198,
 306, 317–18
 Notre Dame architecture program
 and, 253–54
 World's Columbian Exposition and,
 204, 205, 209
Beitner, George, 274, 275
Beman, Solon S.
 background of, 82
 church design and, 176, 178, 246
 death of (1914), 246
 JMS Building and, 242
 Mines and Mining Building by, 203–4
 Pullman projects, 82, 176, 177,
 216–18
 Studebaker commissions, 82, 157,
 177, 216, 239, 240
Bendix, Vincent, 366–67n9
Bendix Corporation, 55
Benjamin, Asher, 34, 51, 60
Bertrand, Joseph, 16, 39
Beyer, Herman H., 229, 361n18
Bicknell, Amos, 105
Biddle, Nicholas, 47, 51–52
Biddle, Owen, 34, 51
Birdsell, Emma, 186
Birdsell, John C., 173
Birdsell, Joseph B., 84, 173, 174
Birdsell Manufacturing Company, 55,
 84, 85, 173
Black communities. See African
 Americans
Blackstone Theater, 290–91, 294
Blantz, Thomas E., 4
Blose, Enoch, 269
Bok, Edward, 272
Bond Hall (Notre Dame), 254–55
Bonsall, Thomas, 163
Boring, William, 254

Bracketed style. *See* Italianate style

Brademas, Tom, 371n12

Brady, Thomas, 108–9, 195, 347n23, 347n25

Brand, Gustave, 213, 359n31

Brandl, Ernest H., 114

Braunsdorf, Robert L., 152–53, 160, 355n32

Brehmer, Charles, 147–48

bridges
 City Beautiful movement and, 230–33
 industrial development and, 26–27, 98
 Melan-arch, 138, 230–33
 urban renewal and, 327
 See also specific bridges

Broadway United Methodist Church, 250

Brockett, John, 336n38

Brookfield, William, 19–20, 22, 53, 336n37

Brooks, H. Allen, 265–66

Brown, Scott, 239

Bryan, Fred A., 275

Bucci, Federico, 298–99

builders' handbooks. *See* pattern books

Bulfinch, Charles, 44, 52

Bulla, Ann, 69

bungalows, 257, 275–77, 366n51

Bunker, Samuel, 269

Burgee, John, 328

Burnham, Daniel, 203–4, 206, 225–26, 234, 240, 279, 281

Burnham, Franklin P., 349n25

Burns, John J., 283

Buskirk, Clarence A., 247

Byerly, Thomas, 345n43, 351n13

Byers, David, 297

Byrne, Barry, 264

C

Caldwell, Francis, 148

Campbell, Colen, 43

Campbell, Marvin, 86

Campbell Paper Box Company, 86, 345n30

Cannon, William, 4, 296–97

Carlisle, Charles A., 152, 153, 160, 186

Carpenter Gothic style, 36, 64, 107

Carroll, J. Maurice, 317, 319

Carroll, Thomas, 115, 197

Carroll Hall (Notre Dame), 197, 357n65

cars. *See* automobile industry

Catholicism
 institutionalized, 30, 31
 missions and missionaries, 14, 15, 27, 29–31, 334n11
 Oxford Movement and, 305
 See also religious architecture; Saint Mary's College; University of Notre Dame; *specific churches*

Cavanaugh, John W., 307

Centennial Exhibition of 1876 (Philadelphia), 81, 112, 139

Central High School, 80, 89, 183–84, 243–45, 344nn13–14, 362n55

Century Center, 328–29

Chapin, Edward, 64

Chapin, Horatio, 61–64, 179

Chapin, Mary, 64, 71

Chapin House, 61, 62, 64–65, 160

Chapin Park neighborhood, 65, 139, 271, 326–27, 365n29

Chapman, Charles C., 2, 24

Châteauesque style, 219, 220

Chess, James, 89

Chicago School, 240, 264

Christian Scientists, 178, 245–47

Christman, Henry G., 186, 219

churches
 for African Americans, 66, 189–91
 for indigenous peoples, 114
 in residential neighborhoods, 175
 See also religious architecture; *specific churches*

Congregation of the Holy Cross, 31, 32, 38, 115, 194, 347n17

Coolidge, Charles A., 206

Cooper, James L., 233

Cope, Walter, 306

Copshaholm, 90, 141, 155, 167–74, 185, 362n52

Coquillard, Alexis, 18–19, 22–24, 26, 29, 165, 336n33

Corby, William, 120–21, 254

Corby Hall (Notre Dame), 193–94, 197

Corinthian order, 51, 170, 252, 258, 260, 281

Costigan, Francis, 53

Cottrell, Samuel, 26

courthouses

 Beaux-Arts, 208–11

 Greek Revival, 49–53, 340n21

 Neoclassical, 228

 as public squares, 22, 86, 207, 211, 216, 285, 337n46

 Richardsonian Romanesque, 159, 208

 See also St. Joseph County Court-house

CPA (City Planning Associates), 326, 327, 371n12

Craftsman style. *See* Arts and Crafts movement

Cram, Ralph Adams, 311–12

Crédit Mobilier scandal, 70

Critchlow, Donald T., 4

Crowe, Norman, 4

Crumlish, Brian, 365n31, 371n12

Cummings, Marcus, 105

Cunningham, Charles Frederick, 181

Curran, Kathleen, 93

Czyzewski, Valentine, 115

D

Davis, Alexander Jackson, 47, 63, 64, 306

Dean, C. E., 317

Dean Building, 215–16, 359n36

Deane, Thomas Newenham, 124

Defrees, John Dougherty, 338n19

Denniston, Garrett V., 26

DeRhodes House, 264–66, 268, 271

Dillon, Patrick, 103, 105, 347n17

Dillon Hall (Notre Dame), 305, 313–14

Dilts, Jon, 159, 205

domestic architecture. *See* residential architecture

Doric order, 49, 51, 52, 60, 166, 213, 250

Downing, Andrew Jackson, 61, 63–64, 67, 68, 151

Downing, Antoinette, 138

Druiding, Adolphus, 115

Drummond, William E., 264

Dunkard Brethren Church, 176, 180

DuShane, James, 139–40

E

Eastlake, Charles, 138

Eaton, Leonard K., 263, 267

Ecclesiological movement, 177

Edbrooke, Willoughby J., 121, 124–29, 132–35, 192, 195, 222, 349n5, 349n25

educational architecture

 Beaux-Arts, 198, 306, 317–18

 City Beautiful movement and, 252, 253, 305, 307, 317

 Classical Revival, 243

 Collegiate Gothic, 158, 198, 243, 305–6, 310–17, 319–20, 330

 Federal, 33, 36, 44

 Georgian Revival, 305

 Gothic Revival, 305, 306, 312

 High Victorian Gothic, 121–22, 124

 Italianate, 79–80, 102, 129–30

 linear alignment of buildings at, 40

 Modernism and, 324–25, 330

 Neoclassical, 228, 305

 Prairie School, 243

 religious-based, 31, 33, 41, 119

Gothic Revival style
 commercial architecture and, 285
 educational architecture and, 305,
 306, 312
 fieldstone construction and, 175–76
 pattern books, 60, 61, 63
 religious architecture and, 82, 110,
 112, 115, 176–77, 179, 185–88, 223
 residential architecture and, 60–65,
 157
Gothic style
 Carpenter, 36, 64, 107
 Collegiate, 158, 198, 243, 305–6,
 310–17, 319–20, 330
 English, 311–12
 French, 112, 181
 High Victorian, 121–22, 124, 150
 Perpendicular, 189
 Victorian, 135, 147, 191, 319
government buildings. *See* civic archi-
 tecture
Gowans, Alan, 206
Granada Theater, 291, 293–94
Granger, Alexis, 108–9, 192, 347n25
Graves, W. E., 229
Great Depression, 163, 288, 302, 321–22,
 326
Greek Revival style
 civic architecture and, 47–53, 340n21
 commercial architecture and, 25,
 47–49, 51
 emergence and adoption of, 28, 46–47
 pattern books, 51–52
 religious architecture and, 36, 107
 residential architecture and, 59–60
Green, Herbert H., 214
Greenberger, Bernard, 294
Gregori, Luigi, 112, 123, 348n28
grid patterns, 20–22, 26
Griffin, Marion Mahony, 264
Griffin, Walter Burley, 264, 268
Griffith, Nehemiah B., 23, 26
Grillo, Paul, 132

Gropius, Walter, 323
Grotto (Notre Dame), 197

H
Hailandière, Célestine de la, 29, 31, 32,
 38–39
Hamlin, A. D. F., 228
Hamlin, Talbot, 46–47
Hammond, Alonzo J., 229–31
Handelsman, Jacob, 291–93
Harding, Charles Borromeo, 108–9,
 191–95, 197, 347n25
Harrison, Benjamin, 159
Harrison, William Henry, 159
Harvard University Memorial Hall, 124
Haviland, John, 51, 60
Hawksmoor, Nicholas, 52
Heaslet, James G., 297
Herbulis, A. O., 197
Hesburgh Memorial Library (Notre
 Dame), 4, 324–25
Hewitt, Mark Alan, 272
High Victorian Gothic style, 121–22,
 124, 150
Hitchcock, Henry-Russell, 104, 323
Hoban, Martin, 115, 148–49
Hodson, George, 140, 141
Hoffman, Jacob, 286, 287
Hoffman Hotel, 287, 288
Holly, Henry Hudson, 139
Holy Cross Hall (Saint Mary's College),
 134, 222–23, 319
Home Insurance Company Building
 (Chicago), 94
Hood, Raymond, 285
Hope, Arthur J., 4, 32, 346n2
hospitals
 Châteauesque style, 220
 High Victorian Gothic, 150
 Memorial Hospital, 65, 245
 Neoclassical, 228
 Romanesque Revival, 93
 St. Joseph's Hospital, 219–21

Hotel LaSalle, 285–87

housing. *See* residential architecture

Howard, Timothy E.

background of, 333n4

on Central High School, 80

A History of St. Joseph County, Indiana, 2–3

on Notre Dame campus, 196

on Oliver (James), 87

Sorin as described by, 40–41

on Studebaker (Clement), 155–56

on Studebaker (Jacob), 83

on Studebaker (John Mohler), 150

on Sunnyside House, 149

Howard Hall (Notre Dame), 308–11

Howard Park, 149, 229–31

Howells, John Mead, 285

Hoynes Hall (Notre Dame), 194–95

Huggart, Samuel, and Huggart Settlement, 19, 66

Humphreys, L., 24

Hunt, Richard Morris, 138, 150, 163, 202, 203

Hurley, Edward Nash, 315–16

I

immigrant populations, 57, 81, 190

Indiana

Constitution of, 65

population growth in, 16

state capitol building, 25, 47

statehood granted to, 16

See also specific cities and regions

indigenous peoples

church attendance by, 114

as depicted in Gregori's mural, 123

forced migration of, 13, 18–19, 27, 336n33, 338n6

fur trade involving, 15, 17

land cessions by, 16, 18

missionaries to, 14, 30, 31

subsistence lifestyle of, 12–14

See also specific groups of people

industrial architecture

design requirements and, 74

Italianate, 77–78

Kahn system of reinforced concrete in, 298

Romanesque, 82, 94

Second Empire, 75, 84

See also specific structures

industrial development

electricity and, 140, 214

labor supply and, 57, 74, 78, 81, 89

mass-production techniques, 297, 299

prosperity resulting from, 64, 73, 151, 225

transportation and, 26, 28, 55, 74, 78, 89, 98–99, 201

water-powered, 24, 28, 74–75, 97

See also specific companies

Industrial Revolution, 273

International style, 323

Ionic order

Châteauesque and, 219

Classical Revival and, 245, 247, 250

Colonial Revival and, 261

Greek Revival and, 47, 51, 52

Neoclassical and, 258, 260, 262, 290

Queen Anne and, 147

Iroquois, 13

Italianate style, 63, 67–72, 77–80, 102, 129–30, 211

Italian Palazzo style, 258, 271, 285, 323

Italian Renaissance style, 68, 204, 212, 249, 254, 285–87

Italian Villa style, 71–72

Ittner, William B., 243

J

Jacobs, Jane, 226, 227

Jahn, Helmut, 329

Jefferson Boulevard Bridge, 230–31

Jenney, William Le Baron, 94, 203, 215, 240

Mary of Saint Angela, 38, 102–3, 129

Masonic Temple, 247–50

Maurer, R. Vernon, 219, 220, 245

Maynard, W. Barksdale, 47

McAlester, Virginia and Lee, 258–59

McIntire, Samuel, 44, 52

McKenna Hall (Notre Dame), 324–25

McKim, Mead and White, 143, 151, 169, 198, 202–3, 226, 254, 280

McVicker, J. J., 3

Meagher, Edmund, 140–42

Melan, Josef, 230

Melan-arch bridges, 138, 230–33

Meli, Giovanni, 124

Memorial Hospital, 65, 245

Miami people, 12, 13

Michigan Street Bridge, 17, 232–33

Mies van der Rohe, Ludwig, 323

Milburn, George, 87, 186

Milburn Church, 355n33

Milburn Wagon Company, 76, 77, 84, 176, 345n28

Miller, Alfred, 271

Miller, Eugene, 260

Miller, Frederick, 271

Mills, Robert, 47, 52

Mirandi, Tommaso, 348n28

missions and missionaries, 14, 15, 27, 29–31, 334n11

Mitchell, John, 347n23

Modernism, 295, 297, 300–303, 323–25, 329–30

Monier, Joseph and Jean, 230

Montana, Frank, 323–25

Moore, William S., 229–31, 233, 361n31

Moreau, Basil, 31

Morey, George, 146

Morris, Ernest M., 163, 301–2, 366n9

Morris, William, 272, 273, 277

Morris Center for the Performing Arts, 330

Morrison, Hugh, 264

Morrissey, Andrew, 192–93, 197

Morrissey Hall (Notre Dame), 308–11

motorized vehicles. *See* automobile industry

Mount Zion Missionary Baptist Church, 189–91

movie theaters, 289–95, 303

Mumford, Lewis, 266–67

Murphy, Joseph F., 114

Muthesius, Hermann, 274

Myers, Gertrude, 59, 60

N

Nash, John, 47, 67

National Register of Historic Places, 58, 163, 327

Native Americans. *See* indigenous peoples

Navarre, Pierre, 16–19, 40, 336n33

Navarre Log House, 17, 229–30, 335n28, 361n19

Neale, Alice E., 173

Near East neighborhood, 26–27, 138, 186, 188, 220

Near Northwest neighborhood, 138, 184

neighborhoods. *See* residential neighborhoods

Neoclassical style. *See also* Beaux-Arts style

civic architecture and, 206, 225–28, 263

commercial architecture and, 215, 263, 290

educational architecture and, 228, 305

religious architecture and, 178

residential architecture and, 257–63

World's Columbian Exposition and, 203, 204, 225, 259

Neo-Grec style, 150

Neo-Jacobean style, 149–51, 153, 166, 176, 185

Neo-Renaissance style, 202, 215

rebuilding plan following fire, 120

Saint Mary's College and, 5, 40, 129–30, 192, 339n41

second-generation building projects, 101–3, 105, 107–8, 112

St. Joseph Parish founded by, 112

third Main Building and, 123–25

See also University of Notre Dame

Sorin Hall (Notre Dame), 128, 307

South Bend

African American residents of, 65–66, 190

architecture of (*see* architecture)

City Hall, 96, 201, 218–20, 322

downtown revitalization, 328–29

founding of, 1, 20

Great Depression in, 163, 288, 302, 321–22, 326

high-rise construction in, 240, 242

historical source materials on, 1–5

immigrant populations in, 57, 81, 190

industry in (*see* industrial development)

master plan for, 234–36, 326–28

natural resources of, 28, 73, 74, 89, 100

neighborhoods (*see* residential neighborhoods)

platting of, 3, 19–22, 26, 58, 336n37, 337n45

population of, 23, 26, 55, 137, 218, 253, 280

preservation movement in, 115

race relations in, 19, 190, 243

topographical description, 11

urban renewal in, 80, 115, 188, 227, 326–28, 331

weather patterns, 11–12

See also City Beautiful movement; *specific structures*

South Bend Architectural Club, 253, 268, 271–72

South Bend Civic Theater, 247

South Bend Public Library, 91, 94, 139, 181–82, 201, 324

South Bend Pumping Station, 229–30, 245

South Dining Hall (Notre Dame), 305, 306, 311–13

Southold village, 18–20

South Quad (Notre Dame), 311–19

Spanish Renaissance style, 289–92, 294–95

Spencer, Robert C., Jr., 264

Sporleder, Donald, 371n12

Staley Manufacturing Company, 85

St. Andrew Greek Orthodox Church, 250, 251

Stanfield, William, 179

Stanford, Leland, 193

Stanhope, Leon E., 246

State Bank of Indiana, 25, 48–49, 62, 280

St. Edward's Hall (Notre Dame), 191, 192, 197

Stern, Robert A. M., 330

Stewardson, John, 306

St. Hedwig's Church, 115, 116, 149, 348n38

Stickley, Gustav, 257, 272–73, 276, 277

Stick style, 65, 138–44, 153, 350n7

St. James Episcopal Church, 176, 185–86, 244, 355n28

St. Joseph County Courthouse
first, 24–25, 32, 337n53
second, 49–54, 203, 207, 340n22
third, 204–11, 215, 227, 260, 268

St. Joseph River valley
agriculture in, 18, 19, 28
exploration of, 12–14, 27
forts in, 12–15–16, 334n3
fur trading in, 14–18, 27, 39
growth objectives for, 41
settlement of, 14–19, 27
warfare in, 14–16, 27
See also indigenous peoples; *specific locations*

wagon and carriage production, 76–78, 81–82, 296

Sullivan, Louis, 93, 203, 215, 240, 257, 263–64, 280–82

Sunday, Billy, 181

Sunnyside neighborhood, 149–50, 165

Sunnyside Presbyterian Church, 250, 252

Swedarsky, Lisa, 4

T

Talcott House, 269, 365n31

Tallmadge, Thomas, 204, 264

Tatum, George, 63–64

Taylor, Lathrop, 18, 22–23

theaters, 288–95, 303, 322. *See also specific theaters*

Thomas, Conrad Arthur, 209–10

Thomas, Cyrus, 346n2

Thomas, William Tutin, 102–3, 105, 126, 191, 346n2

Thoreau, Henry David, 272

Tilton, Edward L., 254

Tippecanoe Place, 155–65, 167–69, 173–74, 176, 182

Tower Building (Saint Mary's College), 133–35, 222

Tower Federal Building, 284, 285

Town, Ithiel, 47, 63

Trinity Church (Boston), 177, 178

Trinity Church (New York), 82, 110, 177

Trumbull, William, 40, 339n43

Turner, Paul Venable, 40, 119, 122, 196, 311, 317–18

Twyckenham Drive Bridge, 233

Tyler, John, 159

U

Union Station, 301–3

Union Trust Company Building, 280, 281, 366n9, 367n10

Universal Expositions (Paris), 81, 103–4

University of Chicago, 158, 193, 198

University of Notre Dame

Alumni Hall, 305, 313–14

architecture program, 252–55, 271, 317

Bond Hall, 254–55

Carroll Hall, 197, 357n65

charter granted to, 33, 338n19

Church of the Sacred Heart of Jesus, 29, 31, 36–37, 107

City Beautiful movement and, 252, 253, 307, 317

Columba Hall, 197

Commerce Building, 315–16

Corby Hall, 193–94, 197

Dillon Hall, 305, 313–14

Engineering College, 194, 253, 305–6, 314–15, 330, 356n56, 356n58

fieldhouse, 197–98, 357n69

fire of 1879 at, 120

founding of, 29, 31

Grotto, 197

Hesburgh Memorial Library, 4, 324–25

historical source materials on, 1–5

Howard Hall, 308–11

Hoynes Hall, 194–95

Latin Quad, 125–29, 194, 198, 318, 319

Law School, 306, 314–16, 330

Lemonnier Library, 254–55, 305, 307, 311

log chapel, 30–31, 33, 338n10

Lyons Hall, 308–11

master plan for, 307–11

McKenna Hall, 324–25

Morrissey Hall, 308–11

Old College, 32, 33, 338n18

Radiation Lab, 324

Rockne Memorial Hall, 305, 317

Mines and Mining Building, 203–4, 358n7

Neoclassical style and, 203, 204, 225, 259

Oliver Chilled Plow Works at, 87

Romanesque Revival style and, 203

stained glass from, 146, 186

World's Fair of 1851 (London), 273

Wren, Christopher, 43, 52

Wright, Frank Lloyd, 257, 263–69, 271–73, 323

Wright, Gwendolyn, 162

Y

Yale Row, 40

Yamasaki, Minoru, 324–25

Young, C. E., 3

Young, Ernest William, 268–72, 365nn28–30

Young Men's Christian Association (YMCA), 140, 201, 238–39

Young Women's Christian Association (YWCA), 201

Z

Zahm, John, 127, 192, 194, 198–99

Zeder, Fred M., 297

Zieber, George, 97

Zinky, George, 270, 271

Zion Evangelical Church, 186

JOHN W. STAMPER

served for thirty-eight years on the faculty of the School of Architecture at

the University of Notre Dame. He paints a narrative portrait of South Bend

and the campuses of the University of Notre Dame and Saint Mary's College

from their founding and earliest settlement in the 1830s through the boom of

the Roaring Twenties. Industrialist giants such as the Studebaker Brothers

Manufacturing Company and Oliver Chilled Plow Works invested their

wealth into creating some of the city's most important and historically

significant buildings.